The Art of Silver Jewellery

The Art
of Silver Jewellery

*from the minorities of China,
the Golden Triangle, Mongolia and Tibet*

The René van der Star Collection

Essays by
John Beringen, Hugo E. Kreijger,
Ien Rappoldt, René van der Star

Photographs by
Michiel Elsevier Stokmans

SKIRA

Design
Marcello Francone

Editorial Coordination
Marzia Branca

Editing
Martine Buysschaert & Francesca Malerba

Layout
Eliana Gelati

First published in Italy in 2006 by
Skira Editore S.p.A.
Palazzo Casati Stampa
via Torino 61
20123 Milano
Italy

Printed and bound in Italy. First edition

ISBN-13: 978-88-7624-383-7
ISBN-10: 88-7624-383-6

Distributed in North America by Rizzoli
International Publications, Inc., 300 Park
Avenue South, New York, NY 10010.
Distributed elsewhere in the world by
Thames and Hudson Ltd., 181A High
Holborn, London WC1V 7QX, United
Kingdom.

Note to the reader

The texts of captions of the sections
*Chinese Minorities Jewellery, Golden Triangle
Jewellery, Textiles, Tibet and Mongolia*
are by René van der Star

The following abbreviations have
been used

Ag	silver
Alpaca	zinc, nickel, copper alloy
Au	aurum, gold
Cd	cadmium
Co	cobalt
Cu	copper
Fe	iron
Ni	nickel
Niëllo	an alloy made of silver, lead and copper adding a certain amount of sulfur
Pb	lead
Sb	antimony, stibium
Zn	zinc

The dimensions of the works, unless
indicated otherwise, are expressed
in the form:

L	length
W	Width
H	height
Ø	diameter

Cover
Neckrings
Miao; Guizhou, Jianhe area
photo by Michiel Elsevier Stokmans

Back cover
Young girl with back ornament,
Miao Ginzui village
photo by Ien Rappoldt

Cover flap
René van der Star
photo by Jan van der Schilt

Contents

Preface

China is a country on the move, a country filled with hard-working people. When I arrived in China in the late Eighties, everyone was still dressed in blue Mao uniforms. There were one or two cars in the streets of Beijing and the rest a vast multitude of cycling people. I saw several very attractive *hutongs* (old Chinese quarters) but all this is changing rapidly: today Beijing is characterised by traffic jams, people in brightly-coloured clothes, dyed hair, mobile phones and personal computers.

Renovation is rife – renovation meaning tearing down buildings and rebuilding them in an entirely new style. Unfortunately the *hutongs* are disappearing rapidly and the approaching Olympics have only accelerated this process.

Still, China has remained a country where I feel at home, where I can be myself. Chinese cuisine offers a great variety of delicious food. There is a saying that roughly translates as "A Chinese eats everything that flies except a plane, and everything with four legs except a table". I am always up for some new delicacy but baked wasps and fried scorpions are one bridge too far, however rich their protein content.

Language remains a problem: only few Chinese speak English, especially outside the big cities, but non-verbal communication in combination with a calculator will go a long way.

Most Chinese are traders by nature. My name being a decided handicap my Chinese friends quickly invented a Chinese name for me, Wei Shen Li, which means "victory". I consider it a compliment.

I have long been interested in the Chinese minorities. This interest started after my first journey through northern Thailand where I came into contact with an entirely different culture, with people wearing the most magnificent jewellery in combination with colourful clothes. These various peoples migrated from China to North Vietnam, Thailand, Myanmar (Burma) and Laos. Thailand, Myanmar and Laos are also known as the "Golden Triangle" due to their former vocation as opium producers.

In the Nineties the spirit of enterprise took hold in China and the minorities started selling their textiles and jewellery. Splendidly designed jewels, which had been carefully hidden during the Cultural Revolution, appeared on the market. Textiles are inextricably bound up with jewellery and that is the reason that I have added several examples. Embroidery, often made with minute stitches, and patchwork are of high quality.

Personally I prefer Li textiles. The Li live on Hainan Island. Li textiles are completely different from those of the other minorities. Some are *ikat* – a type of weaving where the warp, weft or both are tie-dyed before weaving to create designs on the finished fabric. It is a resist dye process in which small bundles of yarn are tied with palm leaf or similar material to prevent dye penetration. Subsequently resists are cut away or new ones added for each colour. After dyeing, all resists are cut away, leaving patterned yarns for weaving. The Li also use supplementary weft yarns (a decorative technique of weaving whereby a pattern yarn is added to two regular foundation yarns). Li textiles are often woven in narrow strips and then added together. *Ikat* sarongs clearly resemble those of the Eastern islands of Indonesia, such as Flores and Savu.

In most villages traditional jewellery and clothing are still worn at festivals, weddings and funerals. Most people among the minorities are too poor to be able to afford high-grade silver, which

is a prerogative of rich families. At best they can afford silver alloy jewellery, but most of the time they have to make do with alpaca – a copper, zinc and nickel alloy.

This book does not pretend to be complete, but I hope it gives a good overview of the jewellery of the Chinese minorities. I collect on the basis of personal taste, and my choices are guided by craftsmanship and quality. As I have mentioned, China is a country in transition, and the same is true for the minorities. Tourism, also Chinese tourism, is on the rise and this has a positive influence on the population. So far mainly people from the West are interested in the culture of the minorities and not Han Chinese, who are themselves a minority in Guizhou and Guangxhi provinces. I hope that the minorities will try to hold on to their traditions for years to come. They are the ones who lend extra colour to China.

As far as I know, this is the first book about ethnographic jewels to give their metal composition. Chinese jewellery is typified by the use of many different alloys, including. alpaca, thus it seemed a good idea to have all the jewels tested to increase our knowledge about them. This was done with great enthusiasm and thoroughness by John Beringen, an assayer at the Dutch Assay Office (Waarborg Holland) in Gouda, for which I owe him a debt of gratitude. He also took the b/w photographs of the hallmarks and some other details.

The Tibetan skull-cup and the bone ornament from a Tibetan apron, two of my favourites, are so beautiful that I have added them to the collection – the compiler's privilege.

I want to thank the Kunsthal in Rotterdam and its director Wim Pijbes in particular. For the sec-

ond time both an exhibition and a book have become a reality. Thanks also go to the entire museum staff. I would like to single out for special mention Charlotte van Lingen (Head of Exhibitions / Curator), Esther Kolvenbach (Project Coordinator) and Jan Moerer (Head of Production). I want to thank the architect Herman Postma for his efforts to make the perfect exhibition.

My thanks go to Michiel Elsevier Stokmans for his incomparable photographs. This is the second time we have worked together and his enthusiasm has produced a result as perfect as the first: *Ethnic Jewellery from Africa, Asia and The Pacific Islands - Bijoux Ethniques D'Afrique , D'Asie et des Îles du Pacifique*, The Pepin Press, Amsterdam 2002-2004.

I am also indebted to Ien Rappoldt. Not only her extensive knowledge of textiles, but also her large collection of field photographs have contributed greatly to this book. Together we looked at thousands of these photographs and made a selection from them.

Grateful thanks are also due to Hugo Kreijger for his contribution to this book, to Jan Wartena for the drawings, and to Eric van den Ing for translating the Dutch texts.

And not to forget my partner and friend Jan Dees, with whom I selected the textiles, and who has been my companion these last thirty years.

René van der Star

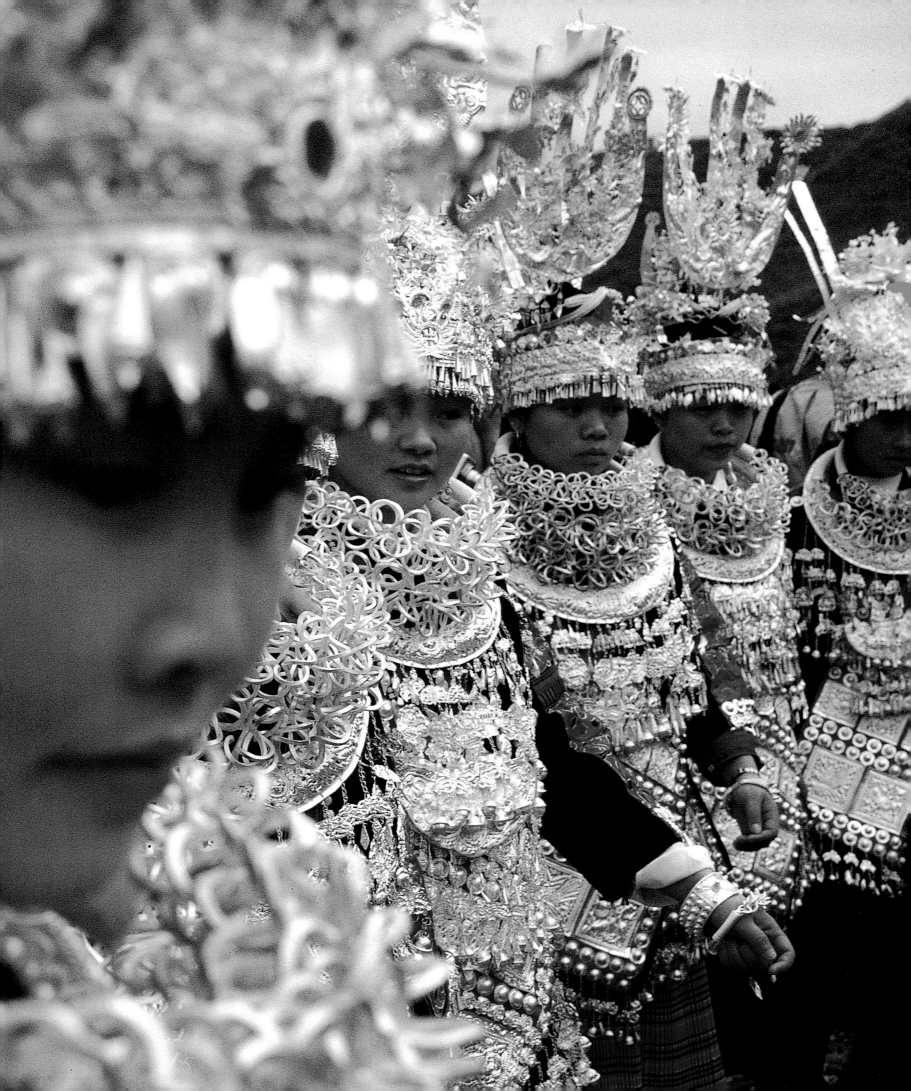

René van der Star

Chinese Minorities

China has 1.3 billion inhabitants, of whom 92% are Han Chinese and the remaining 8% belong to 55 minority groups. The latter live spread out over 9,6 million square miles (64% of China). All minorities have their own life-styles, which determine the way they dress. Minorities who depend on raising livestock wear fur and leather, minorities from agricultural communities use cotton and silk, and the peoples largely dependent on the proceeds of hunting wear fur. Its women are all skilled in needlecraft and embroidery patterns and designs are different for each group.

Northern minorities wear long thick clothes to protect them from the cold, whereas southern minorities wear thin, short clothes on account of the heat and the long rainy season. There is also a great variety of headgear. Dietary patterns also vary considerably: in the north many meat and milk products are eaten, in the south mainly rice. Even tea is found in many varieties: butter tea, milk tea, flower (chrysanthemum) tea and various other mixtures.

Equally varied are the different religions: Buddhism (Lamaism, Hinayana), Islam, Christianity, Taoism, shamanism and primitive animism, totemism and polytheism.

Of the 55 minorities, 53 have their own language, 21 of which have their own script, including 1000-year-old pictograms. Not every minority has a written language, for example, the Miao: as late as the Fifties a written language for the Miao was romanised, but nowadays most Miao use Chinese characters. The various languages differ greatly: the Yi use a syllabic script, whereas Mongols, Tibetans, Kazaks and Dai use alphabetic script. The Dai language alone has four different notations.

China has a long agricultural tradition. Both Han Chinese and the minorities depend heavily on traditional farming. The rapidly developing commercial economy has ushered in a more modern lifestyle among the ethnic peoples.

Almost every ethnic group has a unique way of building, dependent upon its living conditions; Mongols live in yurts (tents), Hani (called Akha in the Golden Triangle) live in mushroom-shaped houses, Dai in bamboo houses, and Miao and Dong in wooden houses, sometimes two or three-storeyed houses constructed on stone foundations. The cattle are housed on the ground floor, the people live above.

All minorities have their own festivals. Some of these 100-odd festivals have to do with agriculture, others with religion, yet others with sacrificial ceremonies. Some festivals are restricted to the family only, but most are village or regional gatherings. The number of participants varies from several hundreds to more than a thousand people. There is singing and dancing, wrestling and rowing matches and contests between horses and buffaloes. During the festivals everyone, young or old, male or female, wears his or her finest clothes and jewellery. Cultural identity is emphasized by both clothes and jewellery.

Guizhou province has 39.5 million inhabitants belonging to 14 nationalities. The size of the province is 170,000 square kilometres (more than five times the size of Holland). Han Chinese call the province Guizhou because of its many mountains – "the country without a square yard of flat ground". It is also referred to as "the country without three successive sunny days".

Guizhou has a rugged countryside. Abundant rainfall has resulted in extensive erosion in a karst landscape with numerous stalactite caves and underground rivers. Guizhou is one of the poorest economic regions in China, but it is rich in eth-

Young Miao women dancing,
Sister Meal Festival, Shidong village.

nic groups: these constitute as much as 72% of the population in the southeast. We find Buyi, Shui, Dong, Miao, Yi, Yao, Zhuang a.o., Dong and Miao being most populous.

A second province that is the home of many jewel-wearing minorities is neighbouring Guangxi province. Its 46 million inhabitants live on 236,300 square kilometres of land. The Zhuang form the largest section of the population. Some of the most spectacular landscapes in all of China can be seen in Guangxi. Its vegetation is subtropical, and 325 million years ago this part of China lay below sea level. When the ocean floor started to rise, soft stone layers were gradually washed away, leaving the hard layers and creating an idyllic mountain landscape which was to inspire poets and painters in the centuries that followed.

Not all minorities wear jewellery to the same extent. The Miao, who call themselves Hmong – Miao being the name given to them by the Han Chinese – are by far the most important group in this respect, followed by the Dong. But other groups have their own styles, such as the Yi, the Zhuang, the Shui, and the Li of Hainan Island. In my opinion Li jewellery represents but a small but very attractive and special subset.

Hainan Island, which measures 34,000 square kilometres and lies 48 kilometres off the Guangdong coast, is home to some 8.2 million people. It has a tropical flora and fauna and a large part of it is covered by tropical rainforest. Palm trees line the sandy beaches on the south of the island, and pearl diving and fishing provide the main sources of income. The original inhabitants belong to the Miao and Li minorities and live in the southwest, the Islamic Hui live in the southeast, and the Han Chinese live primarily in the northeast.

There are many silversmiths in Guizhou province though most of them also till their fields for half the year. In Shidong we stayed in the house of a silversmith. It was very interesting and instructive to see the techniques he used. A silversmith draws his own silver wire and uses homemade lead moulds, which have a life of up to seven years. November is the busiest month for a silversmith because this is the time that many that weddings take place. One of the reasons is that November marks the start of the cold season and therefore food for the guests can be preserved more easily. The second busy season is in April at the time of the "Sister festival", which is the young people's courting festival.

The silversmith's wife proudly displayed her jewellery, including a necklace made of pure silver and weighing 5 kilograms, which had been a present from her husband on the occasion of their 30th wedding anniversary. During important festivals she sometimes wears up to 15 kilograms of silver jewellery, the main function of which is to show the family's wealth. Ten silversmith families live in Shidong, a remarkably high number, since not all villages employ a silversmith, and other villages employ no more than one or two. Gold jewellery is unknown among the minorities of southern China, though gilded jewellery does occur. In Tibet, however, gold jewels are worn. Daughters inherit their mother's jewellery, sons inherit the house and the land.

Tradition is very important in the hard and often poor life of the minorities. The many festivals form a welcome distraction and serve to maintain social contacts. Silver jewellery has an important function at the start of a relationship and during courtship. Most parents gladly provide their daughters with a complete outfit of silver wedding jewellery. A set of Miao jewellery worn at festivals can weigh up to 6 to 9 kilograms, which is the equivalent of a year's wages. The silver is indicative of a family's wealth and forms a large part of the dowry. The family of the man must pay for the bride. This can be done in the form of food, such as pigs or chickens, but also a television, a video or any other domestic appliance may serve as payment. Everything is then shown to neighbours, relatives and friends during the wedding as a token of their wealth.

The quality of the silver used for jewellery shows a great deal of variety. Before communism opium was the main source of income for the minorities in southern China. Because of the resulting wealth the population could afford high-grade silver but these times are long past; now many people are very poor and only a few can afford good quality silver jewellery. Silver alloy, in which the silver content is no more than 20%, is common today but in the past the silver was practically pure. There are also may jewels made of alpaca, which is an alloy made from copper, zinc and nickel, and originally a Chinese invention. Alpaca may be cheap, but it is very difficult to work because of its hardness. It is sometimes found with silver plating. The jewels are, however, original and ethnic because they are made for the native population.

Nowadays many villages (especially Miao villages) are flooded with flashy, newly made alpaca jewels, which are quickly donned by young and old when a group of tourists is spotted – the result of greater commercial mindedness even of the minorities!

Some jewels have hallmarks; they do not indicate silver content, but rather maker or workshop. They are often found on high-quality jewels. Some silversmiths also work under government

contract, even if for only part of the year. The rest of the time they work on their land. Many silversmiths were taught by their fathers and grandfathers. Forging is done by hand on primitive fires, using bellows and home-made tools.

The motifs most often found on jewellery made by the Chinese minorities are animals and plants, such as dragons, butterflies, phoenixes, fishes and the like, each with its own meaning. Not all connotations are known by the silversmiths, however, and for an explanation of symbols and legends they refer to the village elders.

Every year the Chinese government sells measured quantities of silver to the minorities. It claims this is done to preserve their culture and traditions but it is certainly also a good way to remain on good terms with them and to prevent bloody uprisings, like the ones that happened in the past during the struggle for independence. Another way for the minorities to acquire silver is to buy up old silver coins or to melt down old jewels and family heirlooms in order to create new ones. This is why the jewellery of the minorities is seldom older than 70 or 80 years, and mostly not even that.

As a rule silversmithing is a man's job but there are exceptions. The scarcity of land around some Guizhou villages has resulted in the existence of female silversmiths out of economic necessity. Moreover, there are Han silversmiths who are trying to take over the market in minorities' villages. Most Han Chinese will never wear minorities' jewellery and show no interest in it.

In the early years of communism the government provided the minorities with small quantities of silver, but this was strictly forbidden during the Cultural Revolution (1966–76). Making and wearing jewellery was completely prohibited. Silversmiths were seen as "outlaws", so they started working in secret in order to preserve their techniques. Silver that was not hidden was confiscated. Minorities' women were forced to cut their hair and to adapt to Han hairstyles. Also banned were embroidered clothes and festivals, and silversmiths became fulltime farmers and farmhands.

The manufacture and wearing of jewels was allowed once more when the Cultural Revolution came to an end. Improved communications have facilitated contacts among the minorities, even to the point of taking over each others' jewellery, and thereby making their origin hard to determine.

Map of the people's Republic of China.

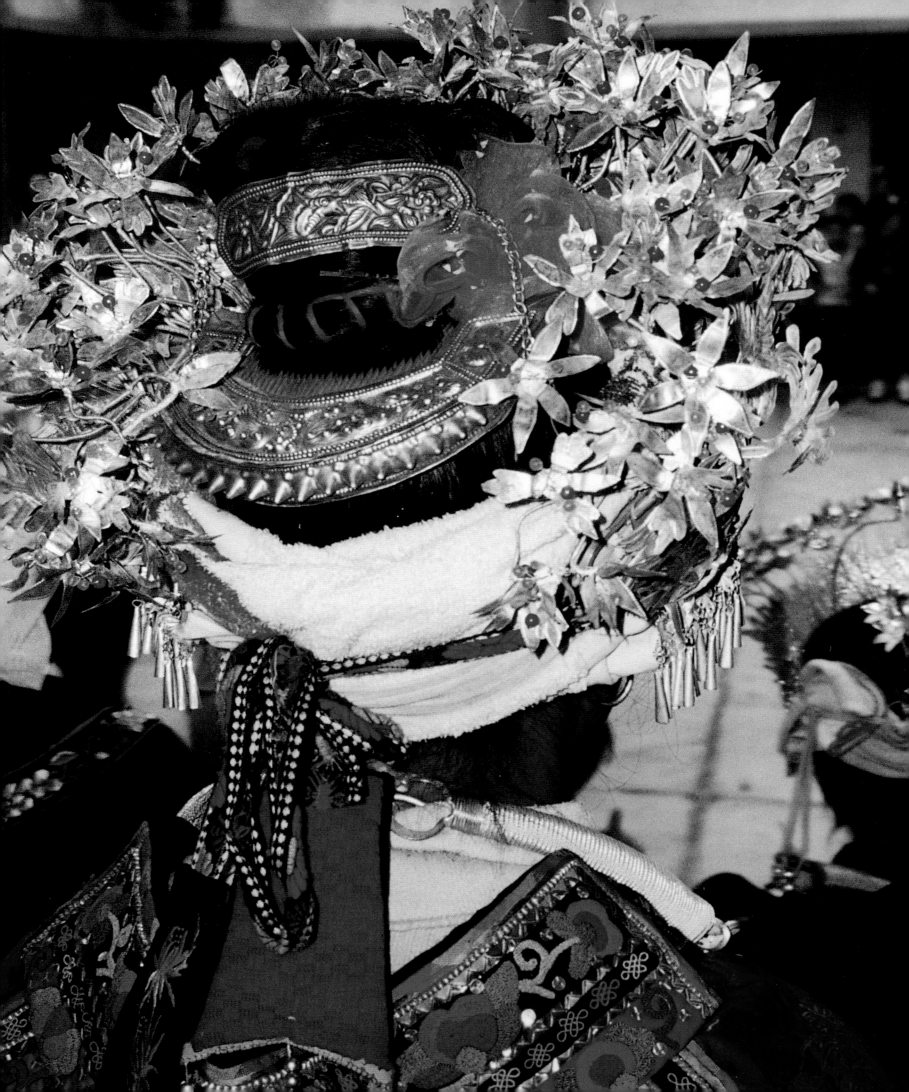

Ien Rappoldt

The Ancient Peoples of Southwest China and Beyond

The People's Republic of China is home to 56 different population groups totalling some 1,3 billion people. Together they constitute 20% of the world's population. The largest and best-known group is the Han, who represent 92% of the total population. The 55 other peoples live in 60% of the total landmass, mainly in the periphery. The western and southwestern areas are often inhospitable and difficult to access, which has kept them poor and underdeveloped. Generally speaking these areas are thinly populated but their strategic situation and their ample supplies of raw materials underline their importance to China as a whole.

In these areas the different peoples have managed to retain their own identity: this has mainly been determined by their common history but separate languages and cultures, as is apparent from their traditional dress.

In 1911 the Chinese Republic was founded, followed by the People's Republic of China in 1949. The different peoples could apply for the status of national minority. The central government made an assessment on the basis of common history, culture and costume but the spoken language could also be a decisive factor. In 1950, 55 nationalities were acknowledged other than the Han but not every population group agreed with the choices made. Up to the present day protests have been made and the Gejia have claimed the status of a separate minority. In 2002 their claim was turned down once more, and they remain a subgroup of the Miao.

On 9 August 1952 the central government proclaimed the General Programme of the People's Republic of China in order to establish "organs of self-government [...] for the exercise of the right of autonomy". The most important stipulation was in article 2, which stated that any area with organs of self-government was an integral part of the People's Republic of China, that organs of self-government were established for the exercise of the right of autonomy, and that all national autonomous areas were inalienable parts of the People's Republic of China.

The constitution of 1954 and all further legislation established the right of regional self-government. The situation has remained the same ever since: a multicultural united state dominated by the Han. The prompting of Han citizens to migrate to the autonomous areas has resulted in the following situation: at present Han Chinese often form the largest and best-educated population group in the autonomous areas, and they hold the political and administrative positions.

From the Fifties onward a number of spoken languages have been put into writing and large-scale educational programmes for the masses have been established all over the country, up to the smallest mountain village. Nowadays local government officials are recruited from local communities and the interests of the minorities receive a lot of attention. The prevention of social unrest is high on the agenda of the central government.

Deng Xiaoping's introduction of the socialist market economy in the Eighties has profoundly changed China. Government control is still strong, but economic development has received a high priority. The local population in the southwest see their situation greatly improved. Everywhere infrastructural projects are started, public transport has been improved, and the villages are provided with electricity. Land reforms have been taking place since 1978. The commune system is being abolished: families are granted land and are responsible for their own food supplies. The state receives 10% in

Miao alpaca headdress with comb, Xijiang village.

exchange for the use of the land. When there is a good harvest the surplus can be sold on the market, and in this way extra money is earned.

The influence of Han Chinese culture is substantial: old habits are disappearing and new ones taking their place. Next to the minorities' own languages Chinese is the common language. Many marriages are arranged according to Chinese tradition. The strict Chinese system of birth control is also practised among the minorities: two children are allowed in the country, one in the city.

The transition of isolated agricultural communities into the twenty-first century is not without its complications: satellite dish aerials are appearing in remote valleys and mobile phones are beginning to be used. The appearance of people too is changing rapidly; clothing has become a mixture of old and new except in the remotest areas, where several Miao, Dong, Shui, Yao and Yi villages still exist in a sort of time capsule. Every people has its own history and is now looking for its own place in this new century.

The Miao

History

Chinese history mentions various names of peoples who played a role in the genesis of the great Chinese empire. The non-Chinese peoples are generally referred to as barbarians. During the Shang dynasty (sixteenth-eleventh centuries BC), Guizhou province was known as Guifan. From 1027 BC, under the western Zhou dynasty, Guifan became known as Zhang Ke. According to Chinese historians, many different ethnic groups inhabited these southern territories and they were not yet part of the Chinese empire. This era is known as the period of the hundred minorities, the "Bai Yue". In the next thousand years various peoples entered the area.

The earliest history of the ancestors of the Miao is shrouded in mist. We know for sure that between four and two thousand years ago Chinese tribes, and later the Han, fought competing tribes and gradually drove them southward. During the Han dynasty (221 BC – 220 AD) the Chinese empire expanded strongly, and Han authorities were in constant conflict with local tribes on whom they wanted to inflict both taxes and slavery. The Miao resisted for a long time but subsequently withdrew, however, in great waves of migration they spread over the entire southwest. In the third century AD they reached south Sichuan and north Guizhou, in the ninth century they entered Yunnan and in the sixteenth century they inhabited Hainan Island. The Miao are mentioned in Chinese documents from

the Tang (618–907) and Song (960–1279) dynasties. Many Chinese historians are trying to find out what happened exactly, with the result that a great variety of stories and interpretations exist.

One thing is more than clear: the relationship between the central government and the Miao gradually grew closer. A feudal economy developed and the emperor appointed officials who held the actual power. They collected taxes and fought their own conflicts. Miao communities became socially differentiated and feudal landlords started calling themselves "officials". Agriculture and crafts developed and there was a steady flow of trade between the Han and the Miao.

In the Yuan (1279–1368) and early Ming periods the feudal power of the Miao landlords reached it zenith. From 1500 onward the Ming dynasty (1368–1644) tried to break their power by sending its own civil servants to the outer territories. They were supposed to take over the power of the landlords, but they met with a lot of opposition. Some landlords were able to maintain their power, but others moved further south. During the Ming and Qing (1644–1911) dynasties the Miao reached Vietnam, Cambodia and Thailand. In these countries they are known as the Hmong. The year 1911 saw the foundation of the Chinese Republic and the migration of the Miao came to an end.

Next to the official history the Miao also have their own version, which has been preserved in many stories and legends. The Miao do not have a written language and oral tradition is very important. Symbolism connected with this oral tradition can be found back in embroidery and jewellery designs. In the distant past, some 5000 years ago, they were defeated by the legendary Yellow Emperor in the valleys of the Yellow River and the Yangtse-kiang, and they moved south. Creation stories and stories of the Flood are widespread in the legends and mythologies of the south. Examples are the birth of human figures from eggs, and marriages between brothers and sisters: "In this story of the Flood only two people were saved, A-Zie and his sister, who used a large bottle gourd[1] as a boat [In Han mythology a gourd is one of the eight symbols of the eight immortals, see W. Eberhard, *Lexicon Chinesischer Symbole*]. After the flood the brother wished his sister to become his wife, but she objected to this as not being proper. At length she proposed that one should take the upper and one the lower millstone, and going to opposite hills should set the stones rolling to the valley between. If the stones came to rest one on top of the other, she would be his wife, but not otherwise.

The young man – considering it unlikely that

Below
Woman with festival headdress, Miao, Yahui village.

Bottom
Woman in festival dress, Miao, Gaopo village.

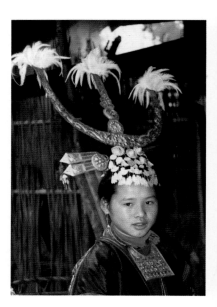

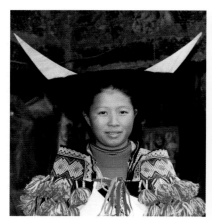

Left
Young girl with big headdress.
Long-horn Miao, Suoga village.

Right
Woman with festival dress and jewellery.
Miao, Wong Xiang village.

Below
Young woman's headdress with hairpin.
Gejia Miao.

Bottom
Miao woman with hair comb, coming
from the market. Guizhou province.

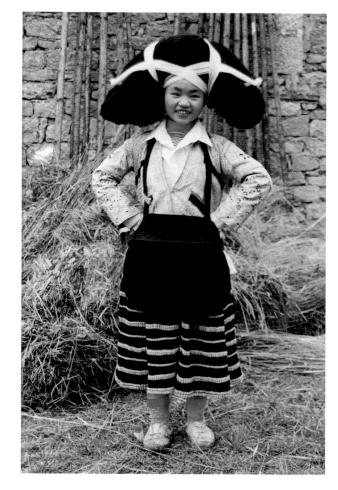

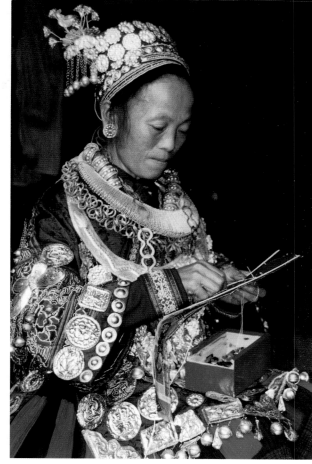

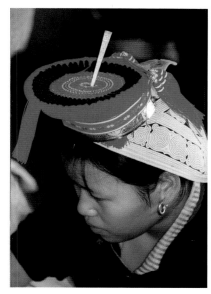

two stones rolled down from opposite hills would end in the valley one on the other – while pretending to accept the test suggested, secretly placed two other stones in the valley, one upon the other. The stones rolled from the hills were lost in the tall wild grass, and on descending into the valley, A-Zie called his sister to come and see the stones he had placed.

She, however, was not satisfied, and suggested as another test that each should take a knife from a double sheath and, going again to the opposite hilltops, hurl them into the valley below. If both these knives were found in the sheath in the valley, she would marry him, but if the knives were found apart, they would live apart.

Again the brother surreptitiously placed two knives in the sheath, and, the experiment ending as A-Zie wished, his sister became his wife. They had one child, a misshapen thing without arms or legs, which A-Zie in great anger killed and cut to pieces. He threw the pieces all over the hill, and next morning, on awaking, he found these pieces transformed into men and women. Thus the earth was re-peopled." (E.T.C. Werner, *Myths and legends of China*.)

Floods are a recurring theme; see W. Eberhard, *The local cultures of South and East China* (Gaine 42) for an extensive treatment of this subject.

The following creation story is found in southeast Guizhou. The maple tells the story of a butterfly and an air bubble falling in love; they go off together and the butterfly lays twelve eggs. Jiyu, the mythical bird, hatches them for years. Then finally twelve creatures come out: the Miao man Jiang Yang, a dragon, a snake, an elephant, the god of thunder, a water buffalo, and phenomena such as accidents, disasters and ghosts.

The Miao constitute one of the largest population groups in southwest China. Some 7 million people belong to this ethnic minority. They can be found in the provinces of Sichuan, Yunnan, Guizhou, Hunan, Guangxi and on Hainan Island, south of Guangdong.

When looking for traditional Miao villages it pays to take a relief map of an area and to try and find the remotest locations: the Miao prefer building their villages as high in the mountains as possible. Legend has it that when the Miao arrived in east Guizhou the most fertile places had already been taken by the Dong. After heavy fighting the Miao fled into the mountains, leaving the fertile valleys to the Dong. The latter have always been slightly better off than the Miao.

Until the Fifties a lot of opium was grown in these regions. The Miao used the proceeds to buy silver for jewellery but cultivating the drug also led

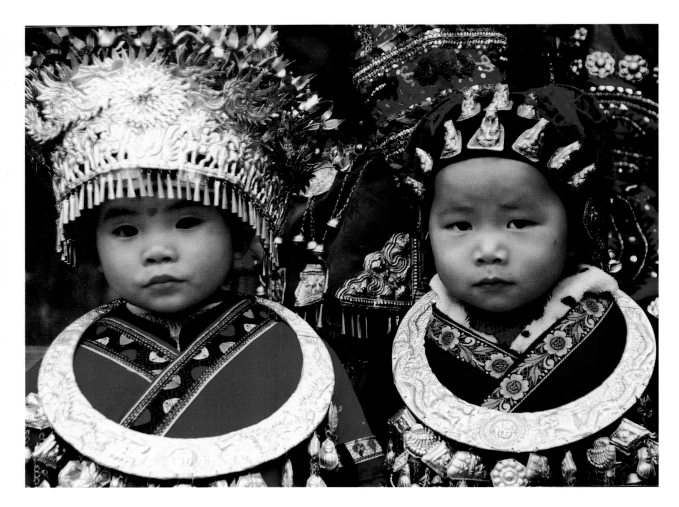

to drug-dependence and bitter poverty. Stern government measures have banned opium and have replaced it with new products that can be sold in the market.

Generally speaking the Miao live in accessible villages and agriculture is their main source of income but this is supplemented by other options that the new economy has made possible. A consequence of this is that many men are away from home for months trying to find work elsewhere. Usually, rice grown in paddies irrigated by bamboo pipes is the staple food but in northern regions, where the climate is colder, the staple is maize. This is cheaper but less nutritious. In addition to these crops, there are sweet potatoes, wheat and many different vegetables. Most households have a pig and some geese, chickens or ducks. In wet rice paddies there are fish farms to supplement the demand for animal protein. "Slash-and-burn" agriculture has been forbidden and has slowly disappeared, but in this technique, farmers would strip an area of its vegetation, burn it and use the resulting ashes to grow crops. After a few years, the soil wore out and the farmers moved on and started all over again. This "shifting" cultivation has since been replaced by sedentary agriculture. Stepped rice terraces go up the mountain slopes, and in the valleys too irrigation is everywhere. Trees are often planted in places dif-

ficult to access and reforestation is stimulated to compensate for erosion caused in the past.

Most work on the land is done by women. Both before and after the season they are joined by the men. Houses are built by men using local building materials, such as wood or stone. Roofs made of bark or straw are indicative of a low standard of living – roof tiles the opposite.

Language

The Miao can be found all over southwest China. They do not have a written language and their habits can show marked regional differences. Language is often the decisive factor for a people to be recognised. The Miao have three spoken dialects that belong to the Miao-Yao branch of the Chinese-Tibetan language family. This common language unites the Miao wherever their dwelling place. Many Miao also speak Chinese, or the language of the people they coexist with.

Religion

The Miao are animists, and in a village a shaman is responsible for the population's spiritual well-being. The Miao believe that spirits are everywhere and that evil spirits must be repelled. Sacrifices are made at special places in and around the villages. There are holy trees that must not be cut down.

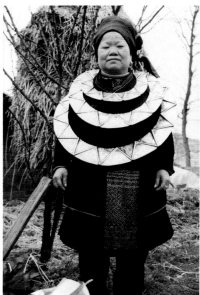

Miao woman with large V-shaped neckring, Jian he area.

Grandmother with grandson, Gejia Miao.

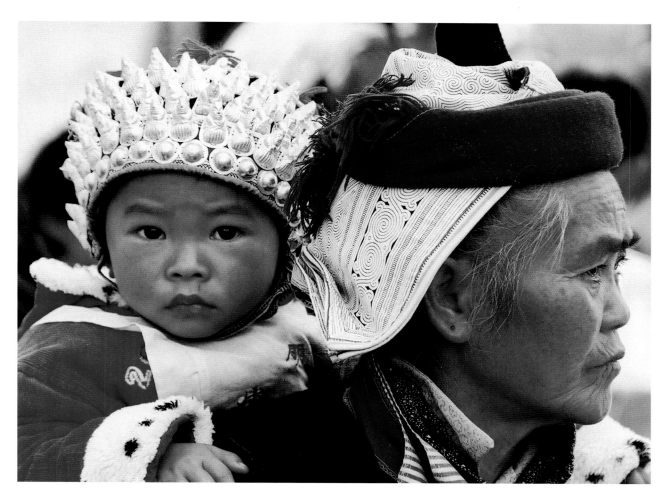

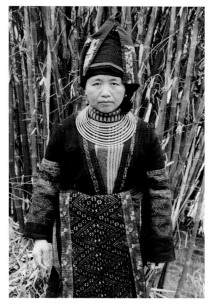

Miao woman with eight-ring neckring, Pin ba area.

Many sacrifices are made at the beginning of the agricultural season. The importance of both fertility and a good harvest are evident, and rituals such as these are still found in the poorer regions.

Sometimes traditional religion is mixed with Buddhism or Christianity, the latter a remnant of the activities of British missionaries in the Thirties.

Miao who die return to their ancestors. It is important to be buried in the correct dress so that you are recognised by your ancestors and your spirit does not return to the village. Funerals can last for several days, the duration being determined by the status of the deceased and by relatives wanting to show off their status, the result of which may be a great deal of expense.

The central room of a Miao house contains the house altar. Here prayers are recited for the ancestors, sacrificial money is burnt, and small gifts are deposited during festivals.

Diversity

Various anthropologists have tried to create a semblance of order by naming the Miao on the basis of their appearance. The Japanese anthropologist Torii Ryuzo made a subdivision based on the colour of their clothing: White, Black, Red, Blue and Flower-patterned Miao. These main groups were then subdivided into subgroups, but the resulting

categories did not quite fit. Though some of these names still exist, Miao culture has more to offer than just a dominant colour or the difference between a long and short skirt.

In the end The Cultural Palace of Nationalities started an extensive research project, which took many more aspects into account, such as the dialects spoken, the common past and similarities in material and spiritual culture. This has resulted in a classification of five geographic units, each with a subdivision into style groups. The more than one hundred different groups of Miao are based on the following system of classification: the western Hunan model, the eastern Guizhou model, the mid-south Guizhou model, the Sichuan-Guizhou-Yunnan model and the Hainan Island model.

Dress is identity

Miao women generally possess two types of clothing: daily clothing and special festival clothing. Men wear western-style dress, except in remote mountain villages, where traditional dress is worn by everybody.

Women's daily clothing is more and more supplemented, or even replaced, by stretch trousers, sweaters or jackets bought in the market. Only their traditional hairdress reveals their origin.

The peoples of southwest China have always

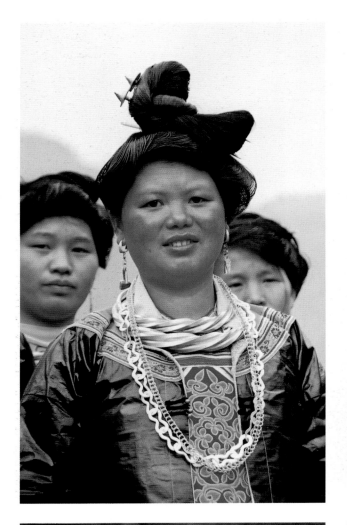

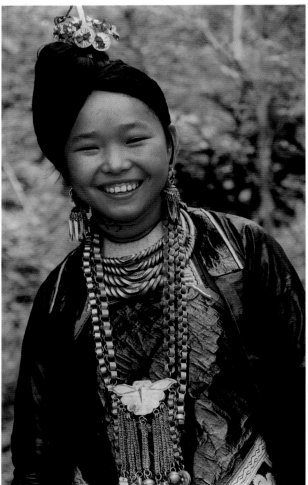

Left
Woman in daily dress and jewellery. Miao, Jia weng village.

Right
Young girl in daily dress with jewellery, Miao, Baisha village.

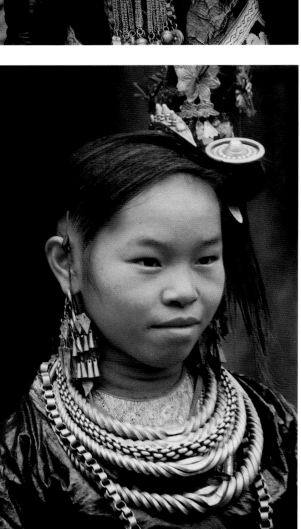

Left
Young woman with big earrings and daily dress, Miao, Gaoqin village.

Right
Young girl with jewellery, Miao, Baisha village.

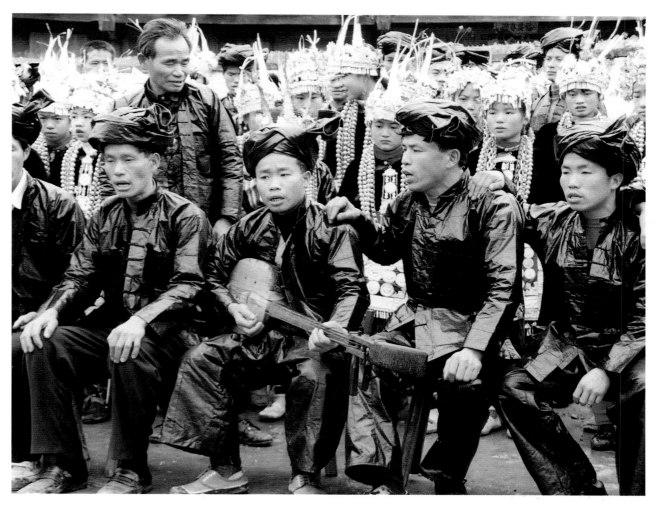

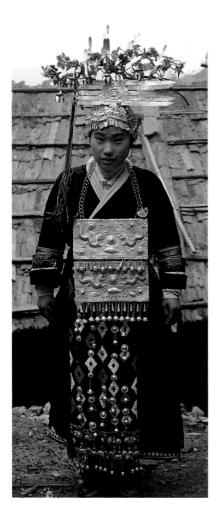

been part of the Chinese empire whether they wanted it or not and have all been influenced by ancient Han traditions. Long before the start of the Christian era a class system was developed on the basis of strict dress codes and clothing rules. Clothing revealed class and occupation. Men and women from the lower classes wore the same type of jacket, and in addition women wore pleated skirts while men wore trousers. During the Han dynasty the dyeing of clothes (blue or green) was allowed for the first time. Before that time clothes simply had the colour of the material they were made from. The cut of minority clothing reflects ancient Chinese dress.

The traditional dress of Miao women consists of a jacket, skirt and apron, and the legs are covered by puttees or leggings. Straw sandals have transmogrified into sneakers, and the jacket mostly follows the kimono model in which the left side overlaps the right. A jacket can also be worn open; in that case the apron is worn underneath, covering the body. Both front and back aprons exist and, during festivals, the more the better.

Skirts are always pleated and quite different in length and appearance, depending on regional differences. A skirt may consist of two half skirts, which in their turn are made of very delicate strips of pleated textile. There are also long skirts that consume many yards of material. One is dyed gold, another adorned with pieces of coloured silk, and yet another is a batik with wonderful patterns. Another special dress item is the baby-carrier. These are technical showpieces made with a great deal of loving care and equipped with many symbols of a long, rich and happy life.

Men's clothing consists of a short, glossy indigo-dyed jacket with fitting trousers. The legs are very baggy and the seat is at knee height, so very low. It is an ancient model, also seen among Mongolian horsemen. The jacket is fastened in the middle, in traditional Chinese fashion. The loops are of the same material as the jacket.

Festival dress

Most festivals are held either before or after the agricultural season. The Ancestor Worship Festival is the main festival in many regions and is celebrated once every thirteen years. Preparations are extensive and valuable water-buffaloes are sacrificed. The Miao in particular are quite fond of festivals and every month there is some reason to have a party somewhere. Well-known festivals are the Sister's Meal Festival in Shidong, and the Dragon Boat Festivals along the rivers. The Sister's Meal Festival takes

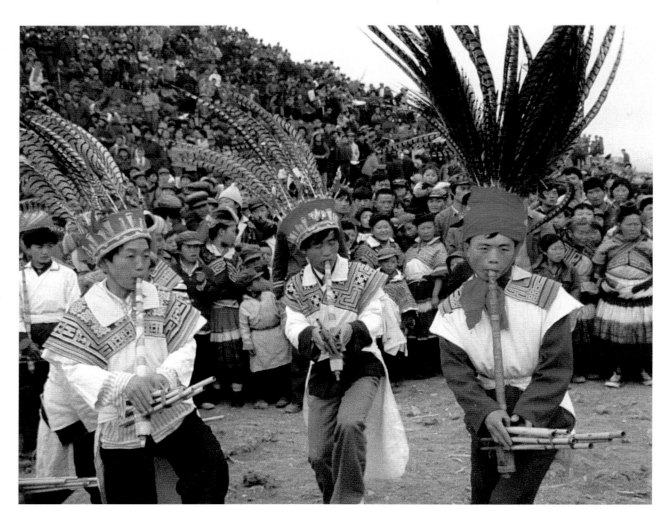

Left
*Group of Miao men with festival capes,
Bijie area, Guizhou province.*

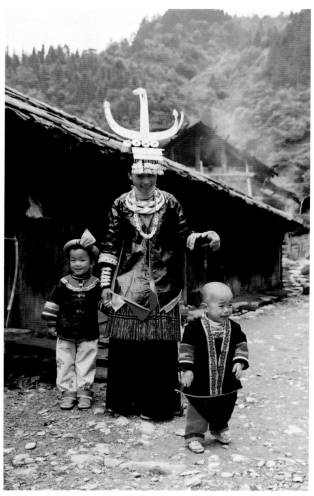

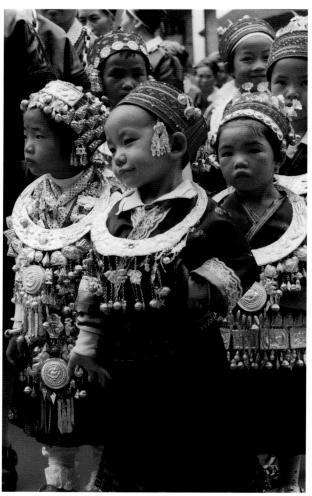

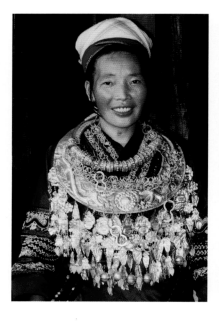

a couple of days. Young unmarried women boil glutinous rice (known as "sister's rice"), and dye this in different colours. They knead it into small balls and put small symbols inside. The dancing and singing become more animated towards the evening when people from different villages come to a big clearing. The girls are accompanied by their mothers, for the weight of their headdresses prevents them from walking unsupported. Large circles of dancing women gradually start forming. When it is nearly dark the boys receive the prepared rice-balls. These give an indication as to the girls' true feelings for them. When a ball contains garlic or chilli the boy receiving it will have to look elsewhere. Pine needles tell him to send the girl silk and coloured threads, because she will embroider something for him. Still he must be patient, for the girl has not made up her mind yet. One chopstick means that his love is not reciprocated, a pair of red chopsticks means that the girl accepts his hand in marriage. Miao girls still take the initiative when trying to find a suitable wedding candidate.

The elaborately decorated dragons' boats are wonderful to watch and they attract many spectators. Folk stories tell why the races are held along the QingShui river: "Once upon a time a cruel black dragon lived in the QingShui river. He terrorised the people living near the river. They hated the dragon so deeply that they wanted to do anything to get rid of it. Near the river lived a friendly old man with his only son. They earned their living fishing and depended on each other. One day in the fifth month of his sixteenth year, the son was unexpectedly caught and dragged down into the dragon's cave. The old man became extremely angry and decided to avenge his son. He dove into the dragon's cave, lit a fire and killed the dragon after a terrible fight that lasted nine days. In the end the old man cut the dragon into three parts and rescued his son. With his torch he set fire to the dragon's stinking den. The whole region of the QingShui river was covered in thick black smoke. Pieces of dragon floated in the river and the light of the sun was eclipsed. Not long afterwards a Miao woman came to the river to fetch water. She knocked her wooden pail against something submerged under the water. From that moment on the black smog dissolved and the sun shone brightly as before".

The Miao still celebrate the Dragon Boat Festival to commemorate these events and to honour the man who killed the black dragon and the woman who restored the light.

Big regional festivals are supported by the government. Singing and dancing competitions are held and water-buffalo fights are very popular. The annual festivals, the Lushing Festivals, are especially boy-meets-girl events. The girls wear their best dress and a great deal of silver. Their crowns resemble the ancient crowns of the Ming dynasty, with large silver water-buffalo horns. Hundreds of people with the same traditional costumes come from the neighbouring villages.

Skills

Daughters get an all-round textile education. They may not be able to read or write, but they are second to none when it comes to weaving and embroidering.

Clothes are made of cotton, hemp, ramie and silk. In the higher and colder parts of northeast Yunnan and northwest Guizhou there is a lot of sheep farming. Wool and hemp are the basic materials for clothes here but synthetic fabrics have been introduced, as have cotton and silk yarn, and today these materials are applied in clothing.

In southeast Guizhou a lot of cotton is grown and silk-worms are bred in spring. The looms stand exactly beneath the windows so that the women who are weaving can benefit most from the light. In many households a hundred metres of cloth is woven every year, enough to provide every member of the family with new clothing. The width of the bolt is adapted to the cut (to a flat pattern), and it varies from 35 to 45 cm. The jacket's cut shows this quite well: the front continues to the back and there the jacket has a seam in the middle. Not a centimetre of cloth is wasted. A loom using two shafts produces a tight weft, and with four shafts a twill weave or a variation thereof. More intricate patterns are made with the help of pattern slats.

Various minorities dye the woven cloth with vegetable indigo and this forms the basis of their traditional costumes. Synthetic textile dye is available on the market for colours other than blue. Synthetic indigo is also found but most mountain women grow their own indigo. Southeast Asia as a whole has an age-old dyeing tradition, and quite a number of blue-dyeing plants are indigenous. *Strobilanthes cusia* (Chin. *qing dai*) is grown widely in Guizhou and Chinese indigo (*Poligonum tinctorium*) can also be found there. Indigo is harvested in summer, dyeing itself is done in winter. The flow of the seasons determines the precise nature of the activities connected with making clothes. Before the fields are tilled the dyeing vats are made ready. This must be done very carefully, and the entire process is shrouded in mystery and ritual. In February and March ever-darkening pieces of cloth are hung to

Opposite page:
Right
Woman with festival dress and jewellery, Miao village near Wong Xiang.

Centre
Children in festival dress, Huang Ping Miao, Panghai village.

Left
Woman in festival dress and jewellery, Miao, Jiaweng village.

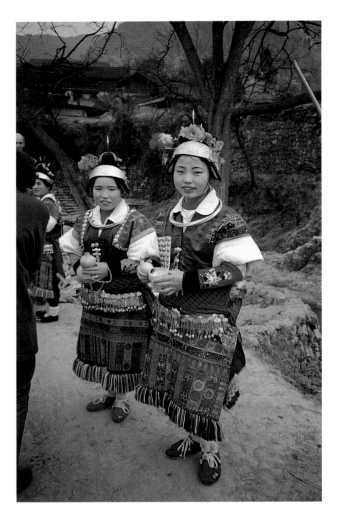

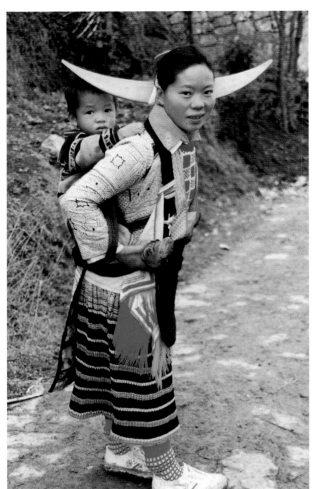

dry in the villages. The darker the colour the more often the pieces have been inside the dyeing vat. After every pull an extra layer of white is formed on the fibre. Oxidization by drying turns the white into indigo blue. The cloth is treated in different manners, resulting in colour gradations and other surface structures. These are all carefully guarded secrets. In order to obtain a deep glossy surface all manner of ingredients are used, such as blood, albumen and extract made of boiled cowhide. Calendaring forms an important part of this process. A piece of cloth is put on a flat stone and worked with a wooden hammer to polish the fibres, thus creating the glossy finish.

Wax-resist dyeing is an ancient technique to decorate textiles and is still used by various minorities. Both hemp and cotton are suitable as a base. The designs are drawn on the cloth with a home-made wax-pen. After dyeing, the wax is removed and the decorations remain. The "Sichuan–Guizhou–Yunnan" Miao generally use this technique. Coats and skirts are completely covered with minute geometric or figurative batik patterns. This Miao minority has a spectacular hairstyle, but few jewels are worn.

The Gejia Miao, in Huangping, are also known for their delicate batik, which during festivals is seen in all parts of their dress in combination with orange-red embroidery and silver necklaces.

The Miao in Pojiao, Dandu style, adhere to their ancient spiral patterns used to adorn their coats; they wear silver horns during festivals. Babei Miao banners are covered with birds, butterflies, flowers and dragons, each with their symbolic significance. Many metres long, these banners are carried along during ancestor festivals.

Embroidery techniques

Miao girls learn embroidery at an early age. Six-year-old girls walk through the village with small scrubby scraps of cloth, practising stitches all the while. The combination of technical skills and the quality of the work makes it absolutely unique. China has an age-old embroidery tradition and many of the stitches used by the Miao are typically Chinese.

The Chinese knot stitch is also referred to as the forbidden stitch; it is supposed to be forbidden among young girls because its fineness may contribute to eyestrain. Still, Weng Xiang women do not seem to be bothered by that. Their coats are not only adorned by gaudily coloured embroidery, but extra silver ornaments are added as well. In Shidong the same ornaments can be seen but the nature of the embroidery is quite different. In that re-

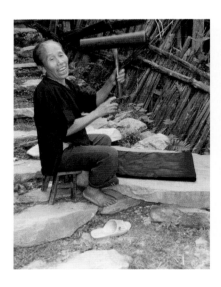

Left
Miao woman waiting for the daily bus.

Right
Woman with baby-carrier, Gejia Miao.

Below
Boy's head with cap. Miao, Ginzui village.

Bottom
Dong woman in traditional dress doing embroidery, Zhaoxing village.

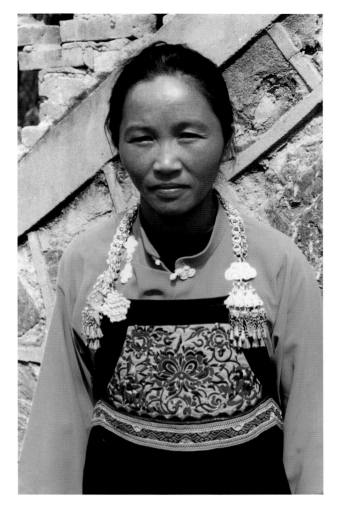

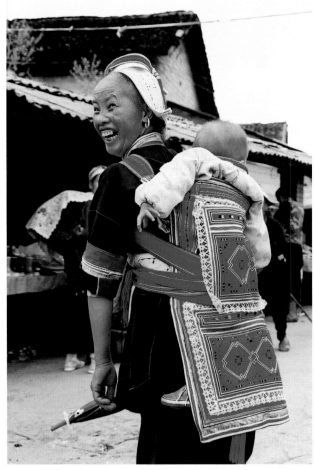

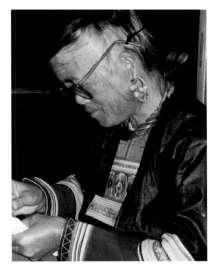

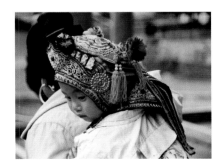

gion many mythological depictions are embroidered in red silk. A decoupage serves as a model for the embroidery. All embroidery is done in satin-stitches and trimmed with narrow chain stitches.

The women from Huangping district embroider in minute cross-stitches. A baby-carrier or the back panel of a coat will take at least a year to make. Very special is the appliqué technique which employs endless small pieces of silk. Originally small bits of cocoon were used, but nowadays thin silk can be bought on the market. Dyed and starched strips of silk are folded into small triangles and then sown together in layers, thus resulting in wonderful patterns. This is also referred to as Miao patchwork.

Silk felt is made by some Miao in east Guizhou by not allowing a silkworm to wrap the silk fibre around itself and keeping it flat on a board instead. Hundreds of silkworms deposit layers of silk in this manner, building up successive layers that eventually form a very precious silk felt. The application work on Zhouxi bridal aprons is made of dyed silk felt. This technique is handed down from mother to daughter.

Ornamental symbolism

Dress ornaments are indicative of the group one belongs to. Girls will marry boys from other families but they will always belong to the same dress tradition. Many of the symbols used find their roots in Chinese culture. Fertility, wealth and long life are often expressed. In Miao textiles other themes can also be found, such as regional flora and fauna, which may either be instantly recognisable or highly stylised. Animals play an important part in myths and legends. The butterfly is worshipped as an ancestor by the Miao. The Han see the butterfly as representative of beauty.

Birds, fish and water-buffaloes are part of daily life, and every animal has a special significance. In Chinese mythology the frog is an old fertility symbol. The Chinese phoenix is female, passive and changeable and is represented as a domesticated fowl. We also see long-tailed peacocks, colourful pheasants and cranes. Historians report that when the Miao visited the Tang emperor Tai-Zung they were dressed in Niao Zhang, a bird costume that imitates a pheasant, and which is still worn by the Gaopo Miao. During the Lusheng festivals Dadi Miao wear strip skirts ending in feathers and the "hundred bird coat".

Fish symbolise the good life and infinite procreation among the Miao, and the image of a fish gives power to the parents and health to the children. During a traditional Miao wedding, fish is

prepared in the groom's house. It is eaten as soon as the bride has arrived and the newly-wed couple are wished fertility and a long life. A related symbol, the fish-dragon, represents the dream of a peaceful and happy life.

Life without water-buffaloes is unimaginable for the Miao. These creatures are venerated by the many poor farmers because of their power, stolidity and perseverance. On special occasions women wear jewels in the shape of buffalo horns on their heads.

Dragons are depicted with the characteristics of other useful animals. The Chinese dragon is a mythological animal and the Han see it as the representative of the Middle Kingdom, China the Eternal and the Authority of the State. The Miao look at it their own way: the buffalo-dragon means power, and the fish-dragon stands for wealth and fertility. The silkworm-dragon helps breeding silkworms, water-dragons cause the rain to fall and they make crops plentiful and animals healthy.

In Taipei the Fu Jen Catholic University Textiles and Clothing Graduate Institute has researched the occurrence of dragons in Miao textiles: "The Miao dragon looks friendly and benign, for the Miao believe the dragon is a kindly god who gives blessings to human beings. The Ying Long Song, a mythology of the Miao, says that raising pigs without the water dragon is impossible the pigs will not grow to full size. Without the water dragon, raising chickens is impossible for the same reason. The water-dragon also blesses the fields with a bountiful harvest. Because of the dragon, the Miao have plenty to eat and wear, every family becomes rich. It is dragons who pour down the rains that feed crops, they save heroes who suffer misfortune and they help the poor obtain treasures. These dragons are not despotic or menacing, but lively and good-natured. For the Miao, dragons are a symbol of the good life.

The shape of the dragon is not fixed like the Han's; on the contrary, it is highly stylised. It may be composed of the head of a cow, the body of a snake, the feet of insects and the tail of a fish. These variations impose startling and colourful images. The basic transformations are as follows: buffalo dragon, fish dragon, snake dragon, silkworm dragon, centipede dragon, shrimp-body dragon, human-head dragon, flower dragon, leaf-body dragon and the fly dragon.

In addition to these dragon patterns there are other examples. Ying Long Song presents twelve different kinds of water dragon and twelve different kinds of land dragons. The shapes are varied, especially at the hands of the Miao women, for the

Water Dragon

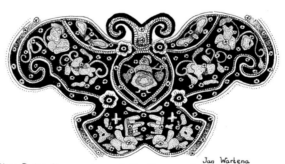

Two phoenixes and a shrine

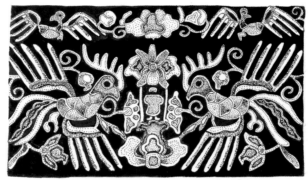

Mother Butterfly, ancestress of the Miao-people

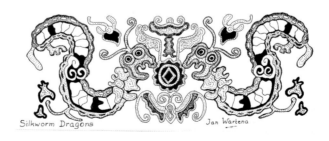

Silkworm Dragons

Fish Dragon with a Miao-man

Miao boy in Wong Xiang touching his mother's alpaca festival crown.

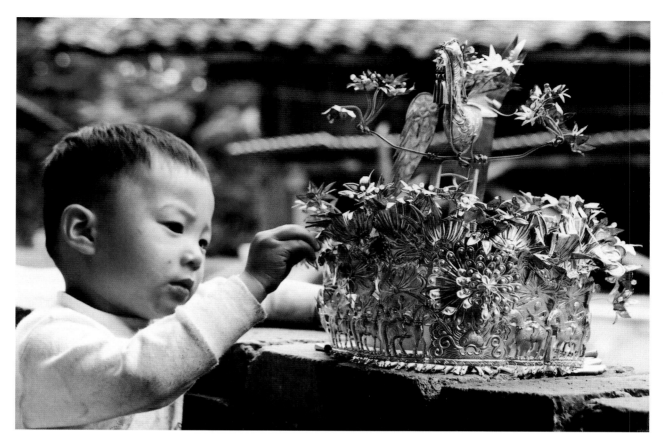

dragon can be potentially transformed into any animal shape. All of them display a simple and graceful sense of beauty. This is extremely popular in Qian Dongnan, where Taijiang county is the most representative of this art".

The Miao believe that good people can change into dragons after their death. Depictions of a dragon with a human head are found and are based on the following story: "An old man was told by a soothsayer that he would change into a dragon if he was to be buried in a particular spot. After his death his relatives buried him exactly as they had been asked to do. They were so curious about his transformation that they dug up the coffin after only a few days. When they opened it they saw a dragon with the old man's head. They had been too hasty and should have waited a bit longer" (see ill. 109, page 116).

Jewellery
The Miao prefer silver for their jewellery. Silver means a lot to them and jewels are the symbols of wealth, beauty and tradition. It is known that as early as the Ming dynasty silver neck jewels were worn, and in times of slavery the Miao had to wear heavy padlocked chains. Chains and neck-rings are supposed to be modelled on those ancient times.

The Miao can buy silver in government shops; this is melted down and subsequently worked by the village silversmiths. The technique is handed down from father to son and is a craft that sup-

plements the family income. Silver is expensive and the silver content varies considerably. Jewellery is also made in cheaper silver-coloured alloys, such as alpaca. This Chinese invention is an alloy of copper, zinc and nickel. If anything, it taxes the craftsmanship of the village smiths even more.

In the poorer mountainous regions the occurrence of silver jewellery is rare or even non-existent. In southeast Guizhou, which is more fertile, families possess much more. A young woman takes her jewellery with her when she marries and moves in with her in-laws. Her jewellery represents a considerable fortune and it remains her property for the rest of her life. Five to ten kilograms of silver are no exception. Part of it will be handed down to her daughter(s). The husband in his turn pays a dowry to his wife's family, partly to recompense their investment in their daughter.

Of all the peoples in these regions the Miao display their jewellery most exuberantly. During weddings and festivals every woman looks her best, and onlookers can assess the young women's wealth by looking at their dress and jewellery. There is a large variety, also among the different regions. Very characteristic are the enormous crowns, with and without horns, which are worn around Kaili in Guizhou province. During the Sister's Meal Festival in Shidong the girls wear huge necklaces, and the clothing itself is also trimmed with silver ornaments.

The Miao live all over southwest China and the differences between them are considerable. There

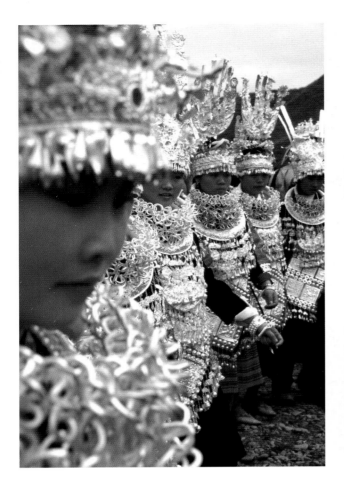

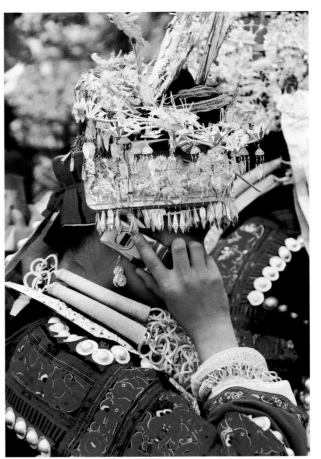

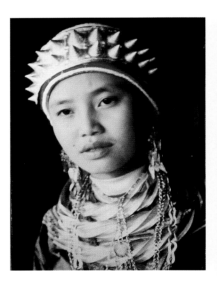

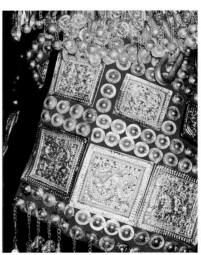

Left
"Sister's Meal Festival", young women dancing, Miao, Shidong village.

Right
"Sister's Meal Festival", young woman with mobile phone, Miao, Shidong village.

Below
Miao woman with headband, Congjiang area

Bottom
Detail of festival dress of young woman in Shidong area, decorated with silver ornaments.

is a seemingly endless variety of neck jewels. During festivals a complete set of rings is worn with extra bracelets and earrings, the hair is made up with silver hairpins, and little children walk around with wonderfully embroidered bonnets adorned with silver buddhas, flowers, butterflies and lots of bells. All these things protect the child from evil and frighten the bad spirits away.

The symbols on the silver platelets sewn on the clothes correspond to the embroidered symbols. The spiral is a recurring form. Spiral patterns are found on Chinese Neolithic funeral urns and are also known from the Bronze Age (the Chinese Bronze Age started earlier than its European equivalent). The spiral pattern has also been found among the Celts in Europe. Each culture has given its own meaning to the symbol, and the Chinese have associated it with endless time, endless movement and endless energy. The semantics of symbols are obscure to say the least: tradition and habit tend to obscure their original meaning and questions are no longer asked by the people using them.

The Dong

The Dong live in Guangxi, Guizhou and Hunan. From ancient times they have lived in the border regions of these provinces. The Dong Nationality represents 1,4 million people.

History

The Dong are first referred to as "Qian Zhong Man" in Chinese sources of the Qin dynasty (221–207 BC). They are the descendants of one of the many tribes that lived in the south long before this period.

"The Dong are believed to have originated from a branch of the ancient "Luo Yue" people and are known to have lived in Guizhou during the end of the eastern Han dynasty (206 BC–220 AD). The Luo Yue were natives of the area now inhabited by the Dong. Through time, The ancient "Ba Yue" people migrated into this same region, mingling with the native population. The Dong are thought to have derived from these people" (Gail Rossi, *The Dong People of China*).

Just like the Miao, the Dong were part of the feudal society that developed under the Chinese emperors. They were never free, their slavery being replaced by the yoke of the feudal landlords, a situation that lasted until the end of the Qing dynasty (1644–1911). After the Opium War of 1840–42, a period of decline began in the south. Following the foundation of the Chinese Republic in 1911, it was many years before any stability was reached. In 1934 the Red Army of the Chinese Communist Party started its famous Long March, which took them through the southern provinces. Eyewitness accounts tell of the incredible poverty among the

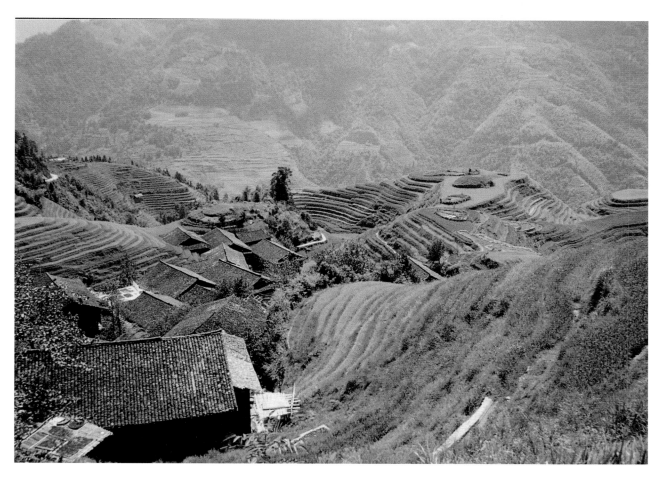

local population, especially in Guizhou. The Kuomintang was defeated in 1949, after which the consolidation of China began. In 1951 the Dong acquired the status of Autonomous Minority and the Dong Autonomous Counties were registered.

The Dong are famous for their architecture. They build their villages along meandering rivers, and the surrounding hills are covered with rice terraces. Bamboo waterwheels transport the river-water from terrace to terrace. Glutinous rice is the Dong's favourite food and a decided must at festivals, next to their homemade rice wine. Sweet potatoes, maize, rice, rapeseed, tobacco, cotton and a variety of vegetables are all grown on the terraces. Some villages have special fishponds, at other villages there are fish farms in the wet rice fields. Red peppers make the food very spicy. Pickled pork and pickled fish are delicacies and can be stored for years.

On average, three generations of a family live in large two-, three- or four-storeyed houses, built of home-grown Chinese pine. Domestic animals inhabit the ground floor, next to the storage rooms. People live on the first floor, and it is here that the large open communal room lies. Weaving looms stand in the light, and TV sets are a present-day commodity. Another modern invention is a separate cooking space. The members of the family have their own bedrooms where they keep their clothes

and valuables. Old houses still have a *kang*, a small wainscoted room with a raised floor and a fireplace in the middle, suitable for older people.

The drum tower is the most striking edifice in any village. Small villages have one tower, but villages inhabited by several clans will have a tower for every clan. Indispensable for each tower is a bronze drum, either hanging high in the tower or installed on the ground during festivals, which, in the past, was used to warn people in the event of trouble or danger. "A carpenter capable of building a drum tower is hard to find", is an old Dong saying. Strict rules apply: no preliminary drawing is made; the builder can only rely on his own experience and on the guidelines dating back to the great master Lu Ban, who lived during the Spring and Autumn period (770–476 BC). The height, the number of storeys and the number of corners are all determined by ancient guidelines. These also hold good for beams, for joints and for other building materials. Nails are not used. As soon as all preparations have been completed the villagers choose a sunny "lucky day" to raise the tower. The day is started with a ceremony asking Lu Ban for "guidance".

Big towers are up to twenty metres tall and are constructed entirely of wood. The tower has a pagoda roof, whose ends show elaborate woodcarvings of dragons, monkeys and tigers. The paintings on

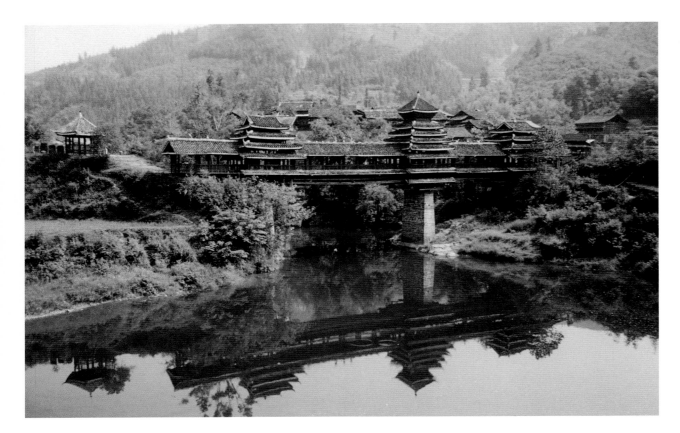

the wooden edges show many details from the life of the Dong. A well-constructed tower is the pride of every village and its most important meeting place. The tower is cool in summer, and a fire heats the people that gather there in winter. It is a place meant for singing, dancing and celebrating, and thus traditions are maintained.

The magnificent "wind and rain" bridges are only found in Dong villages. They are covered and offer excellent protection. In large bridges wooden panels depict glorious deeds as well as scenes from everyday life. Sometimes there are niches with ancestor statues where offerings can be deposited.

Lately bridges and towers, which can certainly be considered real landmarks, have been restored and renovated. In the more remote southern areas of Guizhou, and in Hunan and Guangxi, most traditions have survived. Chengyang Bridge across the Linxi river in Guangxi is one of the biggest and best-known. The northern Dong, having been under Han influence for a longer period, have lost many of their traditions.

Language

The Dong language belongs to the Zhuang-Dong branch of the Sino-Tibetan language family. At the end of the Fifties a written form was created for this language, just as with many other unwritten languages in the southern regions.

The Dong language can be divided into a northern and a southern Dong dialect, each with three sub-dialects. Most Dong also speak Chinese.

Religion

The Dong are animists practising ancestor worship. Everything around them is animated and should be treated with respect. The villages have a shaman, who plays an important role at funerals, and who guides the villagers through his knowledge and experience.

Old trees around the villages are inhabited by good spirits. For that reason they cannot be cut down. If they must be felled, a water-buffalo has to be sacrificed and the wood used for the construction of a drum tower. In the south trees are planted when a child is born. When the boy or girl has reached marriageable age the trees are cut down and used to build a house.

Dress and traditions

About thirty different traditional Dong costumes are known. As a result of the Dong's geographical spread there is a great variety in outward appearance and the frequency with which these costumes are worn. In the south young people are more traditional and tend to marry within their own clan. A couple consisting of a Dong boy and a Han girl is entitled to only one child – in such a case the city rules apply.

A Dong couple can have two children. In the past young people were free to choose partners. Young people met at festivals and at singing competitions. The families then exchanged many gifts, and eventually the bride moved in with her in-laws, but not until she was pregnant. Nowadays many

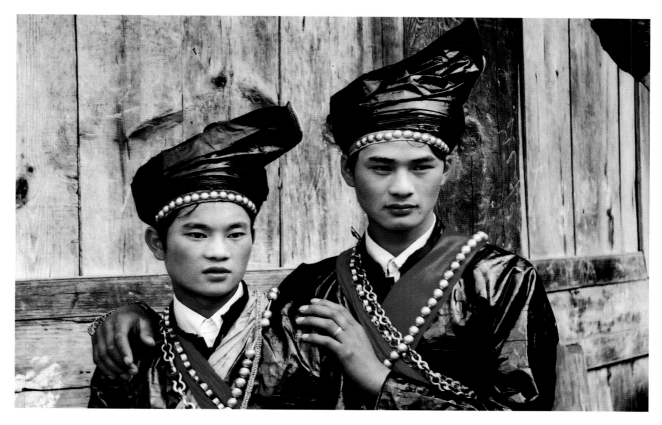

marriages are arranged Chinese fashion. This cannot of course be done without the cooperation of both parties and their families.

Village dress traditions are learned by the young girls within their family. In remote river valleys traditional costumes have been preserved best of all, and sometimes no other clothes are worn. The spinning and weaving of cotton is comparable to the methods used by the Miao. The lengths of cotton are dyed with indigo. The methods used by Dong women are unsurpassed and individual colour and structure highlights are part of this process. The cotton is treated in various ways to obtain the favoured glossy dark-red colour. The sound of big wooden hammers pounding the cloth resounds through the villages. After this process of calendaring the cloth is rubbed with albumen and submitted to steam. This is done repeatedly and the bolt of cotton intermittently submerged in a wooden tub containing a dark-red solution. On the days that I witnessed the process, a vegetable solution was used. But blood is also said to contribute to the red gloss. After these immersion baths the lengths of dyed cotton are dried horizontally. The moisture is not supposed to sag to one side of the cotton, for the lengths are meant to dry evenly. It is to be hoped that Dong women will hand down their secrets to their daughters for many years to come as outsiders will never completely discover them.

Dong women wear indigo-dyed jackets edged with woven ribbons and embroidery. The sleeves are also partially embroidered or adorned with coloured ribbons. When clearly visible beneath the jacket, the apron top is elaborately adorned. An apron worn over the coat can be embroidered from top to bottom. During festivals, finely pleated indigo skirts are worn. In daily life these are mostly replaced by trousers and a simpler jacket. Market days are the best opportunity to meet the different groups from a region. On the market everything is for sale, synthetic fabrics, machine-made ribbons, rushes and finery. Traditional dress has to keep pace with the changing times; Dong girls go to school, leaving them less time for embroidering. The market solves some of their problems, and then there is always granny!

Baby-carriers are once again showpieces of traditional dress and manifestations of the wide variety of techniques available.

Most men and boys wear Western clothes. During festivals indigo coats and wide indigo trousers are worn, together with an indigo turban, which is slightly different in every community.

Children in traditional costume look like small adults. When a festival approaches, new clothes are made that are to last another year.

Festivals

Festivals are opportunities where marriageable young people can meet and where family and friends can see each other again. Dong festivals often have a theme that is rooted in the past. There is the Landlord Festival, in which the landlord distributes money to the poor. During the "Carry-

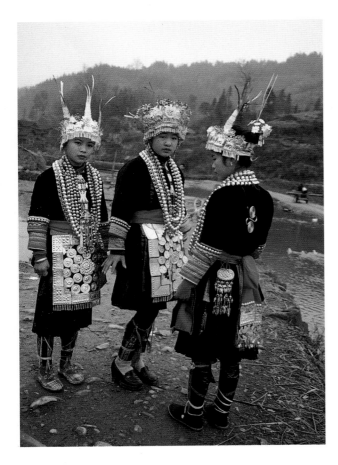

ing the Officials Festival" villagers from neighbouring villages dress as officials and are carried through the village on palanquins. Everywhere they are stopped by singing women and children asking for money and they are only let through only after paying. The whole tour through the village can take hours and the pageant is accompanied by men playing tall bamboo Lusheng flutes. In the evening the young dance, make music and sing to one another. Singing plays an important part in every Dong festival. Learning to sing is as important as learning to speak.

Jewellery

Children wear silver jewellery at a very early age, for example, silver buddhas on their bonnets, bracelets and earrings. The festivals are the times in the year when the best jewels are worn in the largest quantities: wide silver neck-rings, many necklaces, bracelets and earrings. A rich girl will have more jewels than a poor one. Regional differences make for a wide variety of shapes. Long hair is gathered up with hairpins and combs.

Southern Dong women have a special jewel: a silver weight hanging down from the apron neck rings. It exists in different forms (see ill. 85, page 97.) and offers protection against evil spirits while guaranteeing long life. It is worn every day and is indicative of a family's wealth. In the middle of the Dong region there are a few Miao villages where

women also wear a pendant on their backs. Cultural crossovers happen everywhere.

The Dong are gifted craftspeople. Apart from being able jewellers they are also very competent wood engravers and basket-makers.

The Shui

The 350,000 Shui live in northwest Guangxi and southeast Guizhou. There are many different theories about the origin of this people. They are probably the descendants of the Luoyues, one of the peoples that dwelled along the south-eastern coast of China long before the Han dynasty. They moved westward, and since the Ming dynasty (1368-1644) they have been known as the Shui.

Village life

The Shui are an agricultural people who also have many fish farms. Rice is the staple food; it is supplemented with vegetables, maize and sweet potatoes. In any village you will be treated to a delicious meal, and there are many local specialities. It is remarkable how many men can cook. They are often away from home for long periods in order to earn money, so they are used to looking after themselves.

Houses have one or two storeys and are inhabited by more than one generation. The Shui are monogamous, and marriage partners are preferably chosen from families with a similar social status. Personal choice in selecting a partner is a thing from the distant past.

Every village, irrespective of its population group, has a village head appointed by the government. The regional party officials must be informed of all that happens in the village: are not too many children born? Is the harvest good and can taxes be paid? Or is it insufficient and must help be provided? But the interests of the village must be looked after as well. They must lobby for electricity and road improvement, or for a village school to improve the children's prospects. Being a village head is not easy, but generally speaking the ability in the village to do things independently is well-developed. Outside interference is avoided as much as possible. Also the shaman plays a positive role. He knows the village traditions and exactly what must be done at weddings and funerals. The Shui are polytheists and they believe in the animation of all living things. Any dead person has twelve souls and he or she makes a long journey back to his or her ancestors. All prescribed ceremonies and rituals must be executed carefully in order to prevent a soul from remaining in the house as a bad spirit.

Language

Just like the language of the Dong, that of the Shui belongs to the Zhuong-Dong branch of the Sino-Tibetan language family. The Shui used to have their own script, the Shuishu. It consisted of more than a hundred peculiar pictographic characters, resembling Chinese ones, but then written upside-down or back-to-front. They were only used by local sorcerers, the "Masters of Shuishu" (*Shuishu hsien sheng*) and had no function in everyday life.

Dress

Men's and women's clothing is blue and black. Black turbans and traditional long coats are commonly worn by older men. Other men wear Western dress.

Women have replaced their long skirts with long trousers and wear a loose blue or green jacket on top. The edges of clothes and baby-carriers are richly embroidered, a characteristic of Shui dress. An old legend tells the reason why: "In the place where the Shui people lived, a long time ago, there were high mountains and dense forests. And in the underbrush there were poisonous snakes. A young Shui woman thought day and night about what she could do about those dangerous snakes. She was intelligent and skilled at embroidery, using threads of every colour to decorate her clothes, embroidering around the neck, cuffs and where it buttoned down the front, as well as on the hems of her trousers and anywhere else she could think of. On her shoes she embroidered flower and grass patterns. She put on all her embroidered clothing and set out to test her idea. Men who often went deep into the mountains to cut timber would have never imagined that those fearsome reptiles ran far away from her in fear. She was beside herself with joy. She rushed back to the village and told all the people about her method for repelling the snakes. Later it become customary for all Shui women to embroider their clothes and shoes that way."

In everyday life women put up their hair and hide it beneath a white towel. Shui women can easily be recognised in the marketplace.

During festivals women wear their skirts, embroidered shoes and silver jewellery. The silver represents a considerable value and constitutes a family's economic reserve. A young woman moving in with her in-laws takes her own jewels with her, which she can use, in case of need, to sell. The price to be paid for a rich bride with much silver is very high.

Festivals

The Duan Festival is the most important festival of the Shui. It is celebrated each September after the crops have been harvested and represents the beginning of the new year. The villages are full of flags and the sound of Lusheng flutes and bronze drums is heard everywhere. The bronze drums are cylindrical and have a diameter of 60 centimetres. The top is richly decorated, the bottom is open. The rich dark sounds herald the start of the New Year's Festival. During "The Big Leap Forward" many drums were melted down to provide the government with sufficient metal. Hence lots of drums have been lost, but they can again be seen in the villages and they play an important part in the festival. The ancestors are honoured with a special meal without meat or animal fat and with the Dance for the Ancestors. This is one of the many dances dedicated to the most important aspects of life, others being the Bronze Drum Dance, the Harvest Celebration Dance, the Dance for Prosperity of Future Generations and the Abundant Harvest Dance.

Very popular with the people are the horse races. The winner gains status and respect for his family. Horse races are an ideal opportunity for young people to cast an eye over a possible partner, preferably one that the family also considers worth entering negotiations for.

The Yi

The 6.5 million people belonging to this minority form one of the oldest ethnic groups of southwest China. They live in the valleys and along the rivers of the mountainous areas of Sichuan, Yunnan and Guizhou, and the Guangxi Zhuang Autonomous Region. Yi is the collective name of a number of different groups that formed one minority group after 1949.

History

The ancestors of the Yi were part of the nomadic tribes that moved from the northwest of China in a southerly direction long before the beginning of the Christian era. Eventually they settled in Yunnan, south Sichuan, west Guizhou and west Guangxi. In the eighth century the kingdom of Nanzhao was founded, which existed until 902 AD. After that they became vassals of the Chinese emperors.

Everywhere the Yi lived a class society based on slavery developed. The White Yi were the slaves, the rightless subclass, who were totally exploited by the Black Yi, the ruling aristocracy. These local tyrants cleverly manipulated Chinese officials and thus managed to maintain their position of power for centuries. Due to the Yi's isolated position this system of serfdom was allowed to fester in places until 1949.

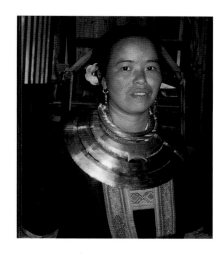

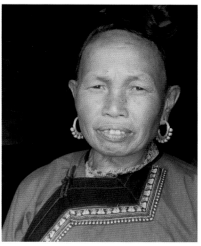

Language

The Yi language belongs to the Tibetan-Burmese language group of the Chinese-Tibetan language family. The language has six dialects and most Yi speak standard Chinese or Mandarin next to their local language. The oldest manuscripts in written "old Yi script" date from the thirteenth century. They refer to Yi history, literature and medicine and the genealogy of the ruling classes. The pictographic syllabic script has been compared with the script from the Shang dynasty (1700–1027 BC), as found in Shaanxi.

Some Chinese researchers think that Yi script could be at least that old. For those conversant with Yi script, it contains a mine of information about ancient cultures. The Yi developed their own variety of agriculture and cattle breeding, they practised astrology, they had their own solar calendar and a twelve-animal zodiac. The medicine men of the White Yi in Yunnan province have passed on their secret recipes for generations and are still held in high regard.

The Yi form a large population group, and many have adapted to the Chinese way of life: they wear Western dress, go to school and have become town-dwellers. Others have remained faithful to village life and live from agriculture. All through the southwest, agricultural methods have improved and the number of products has greatly increased. Yet life remains harsh for those living high in the mountains, in northwest Guizhou and northeast Yunnan. It is too cold to grow rice so this is substituted with maize and potatoes. There are herds of sheep and goats, and some Yi still wear felt capes.

In spite of a past of great social inequality, Yi culture is very rich.

Yi clothing has been extensively studied and has been divided into six main (geographic) groups, then each group has been subdivided into different styles, like the Miao. Traditional dress differs from place to place. A Yi woman wears a laced or embroidered jacket and a pleated long skirt hemmed with colourful multi-layer laces. The front of the jacket has buttons on the right side. The jackets of unmarried girls show wonderful embroidery along the collar and sleeves, and sometimes even the complete front is embroidered.

A Yi woman covers her head with an embroidered square kerchief. In daily life, trousers have replaced the skirt and men wear Western dress. But in the market, traditional dress still reveals your origin, status and married state.

Festival days show how colourful Yi traditional dress is. It appears firmly rooted in the past: the wide men's trousers and felt capes are direct descendants of the clothing worn by the horse-riding nomads of the distant past.

Young Yi women from the Honghe region in Yunnan prefer an embroidered headdress in the shape of a cockscomb. Such a hat symbolises prosperity and happiness. It is made of strong material and is sometimes adorned with as many as 1200 silver beads.

Myth

A long time ago a young man and a young woman were caught by a demon in a forest. The demon killed the young man and tried to seize the woman. She ran for her life and reached a small village. When she entered it a cock crowed and the demon recoiled in horror. Seeing this the woman grabbed the cock and ran back into the forest. The sound of the crowing cock restored the young man to life, and the demon was seen no more. The man and woman married and from that day on Yi women have preferred wearing cockscomb-shaped hats.

Jewellery

Silver is the symbol of beauty and wealth. The Yi love rings, earrings and bracelets. They wear lots of loose necklaces. But interestingly enough a lot of silver is sown onto the clothing itself. At the end of belts, on bags and apron hems lots of jingling silver ornaments are attached. We see jackets lined with rows of silver buttons and bonnets studded with silver flowers.

Liangshan brides wear gilded silver. A bridal necklace consists of up to seven gilded silver ornaments and has a clasp in the neck.

In villages only weddings between members of one's own clan and social class take place. In the past the rules were even stricter and then a girl had to wed her mother's brother's son. Nowadays things are changing rapidly. People leave their villages and determine their own lives.

The Yi are still animists; they believe in many gods. Their motto is "keep the balance in all aspects of life". Villages have a shaman who is able to read the ancient Yi manuscripts and can thus pass on their own history. Funerals are conducted by more than one shaman, and like many other minorities the Yi believe that the soul makes a long journey to its ancestors.

The Li

There are 1,150,000 Li, most of whom live on Hainan Island. Almost as big as Taiwan, the island lies south of Guangdong province and is a tropical paradise for a growing number of Chinese

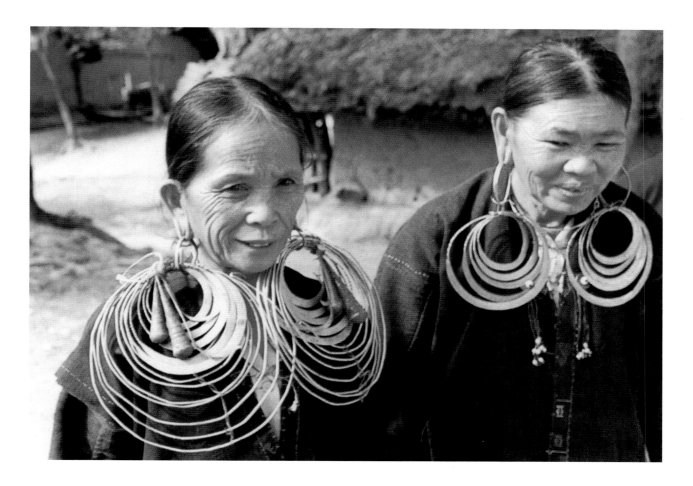

Li women with large earrings, Hainan Island.

tourists. The island is has become attractive to foreign investors, who are building hotels next to the white beaches. The land is fertile and rainfall is abundant. In some places people reap three crops of rice a year and there is a profusion of tropical agricultural products. Rubber plantations yield more than 60% of China's rubber. Hainan has 8,000,000 inhabitants and since 1988 it has been China's smallest autonomous prefecture.

History
Archaeological finds have proved that the island was inhabited as early as 3000 years ago. The Li themselves believe that they are the descendents of the Luoyue, "the ancient people from the south". The island was populated from Guangdong and Guangxi, long before the Qin dynasty (221–206 BC).

Ethnically the Li are closely related to the Zhuang, the Dong and the Shui. Their unwritten language belongs to the Chinese-Tibetan language family and was put to writing in 1957. Cantonese is the official language and is spoken by almost everyone. The Li have always shared the island with the Han. The laws and rules of the empire applied on Hainan as well. Most of the land was in the hands of feudal landlords and the population had little to say. In the past there were many uprisings, but none to any real avail. Real change has only taken place since 1952. The ethnic minorities are ac-

knowledged and are actively supported by the government.

The island Li are divided into five regional groups: the Xiao Li, the Meifu Li, the Zi Li, the local Li and the Detou Li. In the Wuzhi mountains traditional villages can still be found. There the Li live in clans, and in some villages 200 families with the same name may live.

The population mainly consists of farmers. Women are familiar with the secrets of dyeing fabrics with intricate multicoloured patterns. Already during the Song dynasty (960–1279 AD) silk and brocade from Hainan were famous all over China.

Huang Daopo was born in the late Song dynasty and lived with the Li for forty years. She originally lived in Wujing near Songjiang (Shanghai). At the age of eight she was married off, but life with her future in-laws was a living hell. So on a rainy night she ran off to the nearest Tao monastery and became a nun. Still not feeling safe she hid on a boat bound for Hainan. Li women adopted the young Han woman. She was taught how to spin cotton, dye yarns in every colour and weave brocade in the most intricate patterns. Huang Daopo left the island in 1295 with a loom, and she passed the Li techniques to the Han, thus profoundly influencing them.

Li women also make pottery, and the ancient traditions are still preserved in some mountain villages. The clay is kneaded into long strips, mould-

ed into the desired shape and smoothed. The pots are then baked in a wood pile or in harvest refuse.

Fifty years ago people still lived in boat-shaped huts. They may have been typhoon-proof but they were still no more than oval holes in the ground topped by straw roofs. Without proper latrines men and animals lived dismal lives here. Since the liberation of 1949 living conditions have improved drastically. Most huts are a thing of the past.

The Li revere their ancestors and believe in many gods. Out of respect for the deceased and his or her journey to the ancestors, funerals are cloaked in ritual.

Li weddings are enjoyable festivals. On an auspicious day two marriage-brokers are sent to the bride's house. She has been beautifully dressed and wears her silver jewels. She rubs her arms with soot and peanut oil to show that she would rather not leave the parental home. The faces of the marriage-brokers are also blackened before the three of them leave for the groom's house. The marriage-brokers are to guarantee the bride's safe arrival. After an elaborate meal with family and friends the singing starts. Boys and girls take turns singing to each other and these song- and drink-filled nights are often the beginning of new loves.

Many old customs have been passed down but are no longer practised. In earlier times women covered their whole bodies with tattoos. It was considered a thing of beauty and they started when they were fifteen. First the face, then the neck, the arms and the hands; the legs later. The tattoo was added to year after year and was to be finished before the woman's wedding. The tattoos have, or rather had, different forms and meanings, e.g. the degree of consanguinity, the woman's social status, and the sign of the totem.

According to Li legend they are descended from a frog, so a frog is often used as a main motif. Tattoos also protected young women from being robbed by other tribes. Individual Li men might have a small tattoo on their hands, but never the involved patterns seen with women.

It is easy to understand that Hainan youngsters no longer feel attracted to these traditions. Singing and dancing during festivals is their thing. One of the favourite dances is the bamboo pole dance. Long bamboo poles are quickly moved to and fro on the floor, and the dancers have to avoid touching them with their feet. Young people are still prepared to wear traditional costume, quite a few girls still learn how to weave and the family silver is cherished, but young people of today make up their own minds when it comes to whom they want to marry or how they want to look.

The Yao

For many thousands of years economic and political factors have stimulated people to migrate. The Yao are no exception; the last two thousand years of their history are pretty well documented. From central China they moved through west Hunan, to all the southern provinces of China, and many on to North Vietnam, Laos or Thailand.

In China the Yao is the collective name for more than thirty different groups, which were united as the Yao people after 1949. It is a motley collection of peoples with their own lifestyles dictated by the areas in which they live and by their own history. Some 2,1 million people are generally assumed to be Yao.

Some 70% of the Yao live in Guangxi, while smaller communities are found in Hunan, Yunnan, Guangdong, Guizhou and Jiangxi.

Originally they had their own language, one closely related to the language spoken by the Miao, whose ancestors they probably share. The languages spoken by the Yao belong to the Miao-Yao branch of the Sino-Tibetan language family. Nowadays many Yao speak Chinese plus the language of the people in their neighbourhood, such as Miao, Dong or the language of the Zhuang. The Yao have used Chinese characters since at least the Ming dynasty (1368–1644). Ancient Yao religious writings are based on medieval Chinese Taoism. The Yao venerate their ancestors and they know many gods. The Chinese myth of the dog Phan Hu is a recurring theme in stories about the Yao ancestors. The same story is familiar among the Mien, the Yao living in Thailand (see page 36).

Most Yao people engage in agriculture while others cultivate sustainable forests or are hunters. The proceeds from hunting are a welcome addition to the daily fare.

Like other peoples the Yao have always had to pay taxes to the Han landlords. Taxes could be gathered in the form of goods, labour or even reforestation of the mountain slopes denuded by themselves. The latter practice resulted in many Yao moving on every few years. The old systems have been abolished, slash-and-burn cultivation is forbidden and farmland has been redistributed. But they still love to hunt. A favourite dish is "pickled birds": birds are cleaned, rubbed with a mixture of salt and rice flour and preserved in an airtight stone jar. In northern Guangxi the Yao and the Dong have "oily tea" for lunch or breakfast. To make this, tea-leaves are fried in oil, boiled into a thick salty soup and mixed with puffed rice or soya beans.

Yao women are expert at weaving and em-

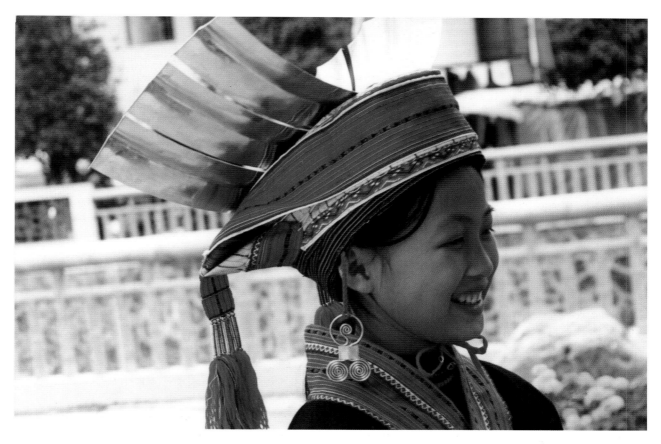

Yao woman with headdress, Zhuang autonomous region, Guangxi province.

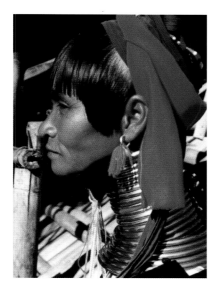

Long Neck Karen women can wear up to twenty-two rings. Myanmar 2000.

broidering and they are familiar with the batik technique. Some 60 to 70 different styles of traditional dress are known among the Yao. In some regions little traditional dress is worn. Like with the Miao, the more remote a village, the greater the chance that traditional dress is worn on a daily basis. Yao women love wearing silver bracelets, earrings and neck-rings. Silver decorations and fine geometrical patterns are often added to festival clothes.

In the past festivals involved initiation rites. Boys became men if they could walk barefoot across a glowing bed of coal, or if they could climb a pole with knives as footrests. These rites have been abolished. What have remained are the music, singing and dancing. But not quite: I have seen it all happen once – not as an initiation rite, but to amuse a group of Chinese visitors.

The Golden Triangle

The countries south of China are inhabited by different peoples originating from China. They migrated to these countries for various reasons and it has been a slow process. One of the oldest was the traditional slash-and-burn method of farming, which necessitated a permanent state of migration in a southward direction, unhampered by political boundaries.

During the last two hundred years, the north of Thailand has become populated by peoples from Myanmar and Laos. Others have crossed the Chi-nese border to North Vietnam and from there spread over southeast Asia.

Recent migrations were also the result of the turmoil and war in the surrounding countries; many fought against communism and fled across the southern borders.

Excavations show that man has lived here for thousands of years. From the Bronze Age (*ca.* 1500 BC) a society developed of rice-growing farmers, who possessed bronze tools, painted pottery and woven clothing.

Until the twelfth century AD, north and northeast Thailand were primarily inhabited by the Mon, originating from west China, and by the Lawa and Khmer. From the thirteenth century the Thai started playing a dominant role in this region, moving south and cultivating the very fertile river valleys. Buddhism was the most important religion and a rich culture developed. For centuries three kingdoms existed side by side: in the north the Kingdom of Lanna, in the northeast Isan, and in the centre the Kingdom of Siam. In 1782 king Rama I united the Kingdoms of Lanna and Siam, and took residence in Bangkok. The north became a tributary to the central government, paying taxes in gold and silver, but it retained a high degree of independence and its own government structure. Present-day Thailand was proclaimed in 1939.

The most well-known mountain peoples living in the Golden Triangle in Thailand are the Hmong (known as the Meo or Miao by the Han

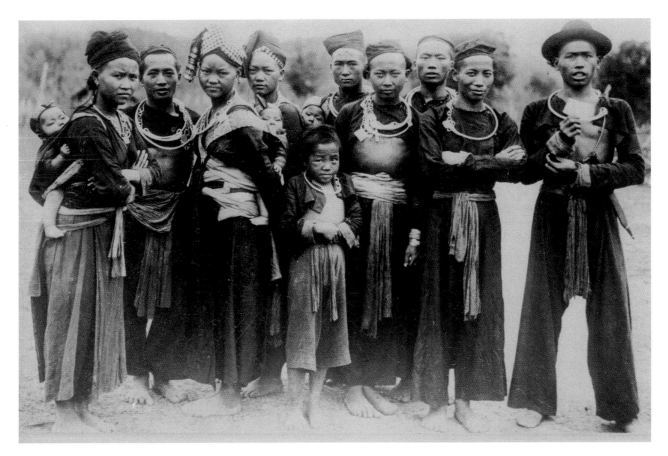

Chinese), the Mien (Yao), the Lahu, the Akha and the Lisu. They each have a unique identity, as is evident from their culture, religion, language, art and traditional dress. There are also a number of smaller mountain peoples, such as the Palong, the Khamu and the Mlabri. The Padaung, better known as the Longnecks, are a Karen subgroup. Padaung girls are adorned with coils around their neck already at a tender age. One coil is added every year. In time the neck muscles weaken so much that the neck would collapse if the coils were removed. Padaung women have now become a tourist attraction, and an important source of village income. In earlier days these rings protected women against being robbed.

The Hill Tribes live in the upland plains and are farmers. Growing opium has become illegal, which has impoverished many families since other crops are far less profitable. As in Chinese villages, women are responsible for the daily running of things. They look after the family, work the land and make their own (magnificent) clothes. Traditional dress is still generally worn and silver plays an important part in their lives. A grand display of the family silver can be witnessed at special occasions, e.g. the New Year's Festival. Being a good craftsman is important in the community. A silversmith who can distinguish himself can make extra money to supplement the meagre family income.

The Mien or Yao

The Mien live in Vietnam, Laos and Thailand. In China they are known as the Yao. They are spread across southeast Asia but the similarities in language and culture are striking. They speak different languages and dialects belonging to the Sino-Tibetan language family.

Around 1850 the first Mien families from Laos settled in north Thailand. Nowadays some 55,000 Mien live in the provinces of Phayao, Nan and Chiang Rai. Along the Laos border some 10,000 Yao live in refugee camps.

The Mien in Thailand speak a Miao-Yao language, and for centuries they have used Chinese characters to record important things, such as legends and rituals. For generations shamans have written down the family records, and these manuscripts still exist.

A unique document has often been referred to as the "Mien Passport". It includes a copy of the Imperial Edict issued by Pien Hung to the Mien living in China, permitting them to migrate and engage in cultivation anywhere in the mountainous areas.

The emperor Pien Hung of China was attacked by the very powerful emperor Kao Wang, and faced defeat. The dog, Phan Hu, was able to get through the lines, kill the aggressor, and bring Kao Wang's head back to emperor Pien Hung.

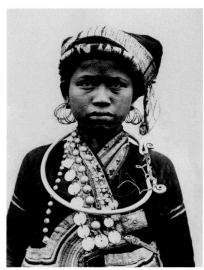

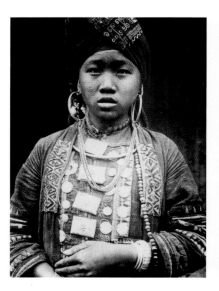

Phan Hu was rewarded with one of Pien Hung's daughters as a wife. He took her up to the mountains to live with him. They produced twelve children, six boys and six girls, from whom sprung the 12 clans of the Mien.

The legend of the dog Phan Hu figures widely in Chinese and Yao literature. The Mien are still familiar with ancient Chinese Taoism, combined with ancestor worship and the belief in an animated world. At important life events such as birth, marriage and death the appropriate rituals, as laid down in the manuscripts, are carried out. Men teach their sons Chinese script, but tradition is on the wane. The children go to school and learn Thai. The family manuscripts are getting rare, and only those capable of reading and writing Chinese can continue the family annals.

Embroidery is held in high esteem among Mien women. Girls are taught their first stitches and patterns during infancy. The costume of the women is very distinctive, with long black or indigo dyed jackets with lapels of bright scarlet wool. Heavily embroidered loose trousers in intricate designs are worn, and similarly embroidered black turbans. A piece of embroidery can be so technically superb that both sides are identical. The babies' skullcaps and boys' bonnets are very beautiful, richly embroidered with red pom-poms. Girls' bonnets have a broad red stripe on top. Girls are dressed like their mothers, boys wear T-shirts and jeans. Traditional men's clothing can only be seen during religious or other official gatherings.

Silver plays an important role in the life of the Mien. Silver is indicative of status, wealth, age and personal taste. The Mien Yao keep their jewellery in specially embroidered bags, or special custom-made engraved boxes. One reason for doing so is to keep their jewellery safe, another is to prevent the silver from oxidizing. At festivals or on special occasions the silver is taken to the silversmith, who holds it in the fire or boils it with high-acid berries to remove every trace of oxidisation.

Until the end of the Fifties the economy boomed thanks to the production of opium. An important part of the profit was invested in silver, a stable commodity. The value of all goods is still expressed in silver, even the value of a bride. For a marriage, the groom, or his family, must pay the family of the bride a particular amount of silver to compensate for the loss of labour the bride's family sustains when she marries. An intermediary is used to negotiate the precise amount, the wealth of the family being an important factor. Sometimes the bride's mother gives her daughter an important family heirloom to take to her in-laws. Apart from

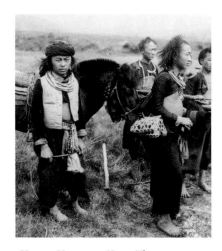

Hmong Horsemen, Xieng Khouang province, North Laos. Photo taken in 1920.

that the girl has her own bracelets, breastplates, earrings, silver buttons and neck-rings with silver chains that hang down her back and are decorated with silver ornaments. At any rate, during weddings a lot of silver moves from one family to the other. Silver jewellery is generally believed to keep the soul within the body and to protect the body against disease. Every child wears a bracelet or neck-ring for reasons of personal protection.

Silversmiths are extremely able and the jewels are very refined. The best wrought Mien silver can be found in Laos and Thailand. Similarities in shape and ornaments between this type of jewellery and the jewellery made by the Yao in south China can still be found. In the Seventies and Eighties much old silver was sold throughout this region. Young people especially felt the pull of the West, and bought jeans and motorbikes. A great part of the silver jewellery was and still is melted down to manufacture new jewels.

The Hmong or Meo

Some 50,000–60,000 Hmong live in Thailand across the entire north and the central provinces. They are called Meo by the Thai but it is clear they are part of the Miao people from south China. They speak several dialects of a Miao-Yao language belonging to the Chinese-Tibetan language family. The Blue and White Hmong most probably originate from Yunnan, where this minority can still be found. The Chinese government has classified the Hmong from Yunnan among the Miao. Their dress strongly resembles that of several groups of Miao, and Hmong legends tell stories about ancestors living on the banks of the Yellow River three thousand years ago.

In the eighteenth and nineteenth centuries there were many clashes with the Chinese government. To complicate matters further, the Hmong are best known as opium growers and opium no longer has a place in China. After the Opium War of 1839–1842 it took more than a hundred years before the growth of opium could be eradicated in China. Hence many Hmong took the production of opium across the border.

The dependency on opium impoverished the population in the south of China and made them easy targets for anyone wanting to exploit them. This also included the western powers. The suppression during World War II was also a powerful stimulant to the freedom-loving Hmong to migrate from Yunnan across the border.

In Thailand and Laos the Hmong live fairly high in the mountains. Their villages are not large,

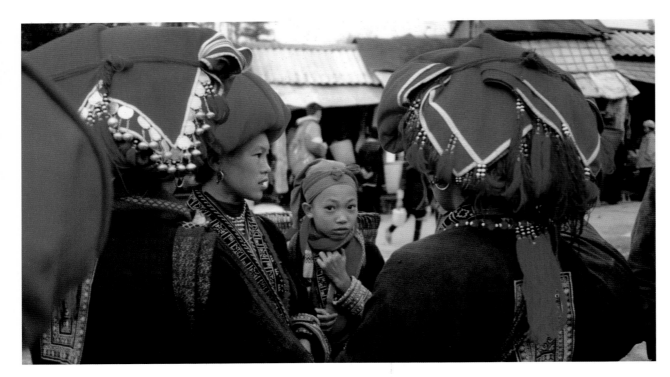

Yao women with colourful headdresses, Sapa, North Vietnam.

some eight to thirty households. Opium is still grown here. A little land yields a profitable crop, and that is the reason why the official ban is circumvented. Still, more and more Hmong are building their villages in the lower regions and are switching to local farming methods, growing products such as coffee, soy beans and tobacco.

In spite of all changes and modern influences the Hmong stay loyal to their ancestors and adhere to their faith, rituals and traditions.

Like Miao women in China, Hmong women are well-versed in a great variety of textile techniques. There is a garment for every age and for every period in life, and everything is made with the greatest possible care. Cotton and hemp are grown and indigo is used for dyeing. The pleated skirts of the Blue Hmong are adorned with exquisite batik patterns and cross-stitch embroidery. The traditional dress of the Blue Hmong resembles that of the Miao most closely. Hmong fabrics are in great demand. They are sold on the market and tourists pay Hmong women good money for their clothes and embroidery.

Silver is considered very important and it plays an important part in the life of the Hmong. According to tradition a young man has to pay a sum to the parents of the girl he wants to marry. If he has insufficient funds, the young man has to work for his father-in-law until his debt has been settled. Sometimes it takes years before he can take his bride (and their small children) home with him.

During the New Year festivals men and women wear their beautiful jewels, such as the hollow silver neck-rings and characteristic earrings. The Hmong are adapting to modern society, but no more than suits them. Although their children go to school and learn different languages they adhere to their own traditions – "Once a Hmong, always a Hmong".

The Lisu

The Lisu live primarily in Myanmar and China. After 1900 a small number of Lisu settled in Thailand. Nowadays some 21,000 Lisu live in the northern provinces of Chiang Mai, Mae Hong Song and Chiang Rai. They speak a Yi language of the Tibetan-Burmese language family and they know the myth of the Flood.

Like the Hmong, the Lisu grow opium and are trying to come to terms with a world that no longer allows that. They have not retreated into the mountains but they are looking for alternatives. They are clearly recognisable as a group. They no longer wear the heavy pleated hemp skirts worn in Myanmar and China. Brightly coloured synthetic fabrics are bought in the market and are used to make the unique Lisu dress. At the New Year's Festival a modern Lisu girl will wear a sleeveless vest covered with silver buttons over her tunic. She will have silver rings with umpteen silver dangles, and silver chains under her chin attached to both earrings. Lisu men and women do things Lisu style.

The Akha

The Akha originate from Yunnan, which is inhabited by 1 million Hani, who are closely related to the Akha. For centuries the Akha migrated in a southward direction. First primarily to Myan-

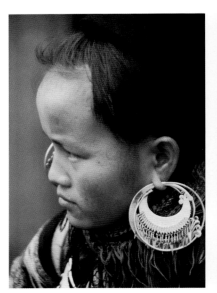

Hmong woman with earrings. Sapa, North Vietnam.

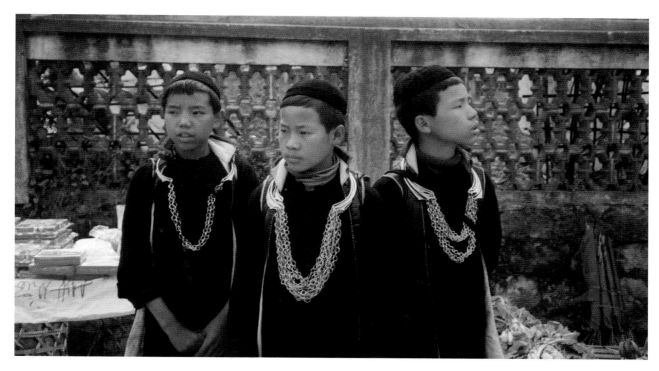

Hmong boys with silver necklaces, Sapa, North Vietnam.

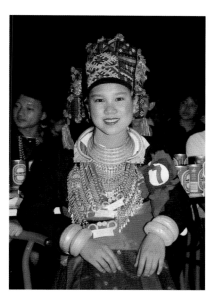

Hmong woman with big silver necklaces, North Thailand.

mar via the eastern Shan state, where some 180,000 Akha still live, and from there further south in the direction of Thailand. Others went straight from China to Laos and Vietnam.

In 1903 the first Akha village was built in Thailand near the Myanmar border. In Thailand they constitute a small population group of some 20,000 people who scratch a living by slash-and-burn farming.

The Akha have no written language, but there is a great wealth of legends, rituals and proverbs that unite them. The Akha language is part of the Yi (Lolo) branch of the Tibetan-Burmese language family. It is a tonal language with five pitches and different dialects. Nearly all Akha in Thailand speak the same dialect, Jeu G'oe. This dialect is also spoken in southwest Yunnan, in Kentung State (Myanmar) and in northeast Laos.

The Akha are a special people: they learn the genealogy of their clan by heart and can recite long lines of male ancestors in order to prove or disprove consanguinity. This may be relevant for a young couple wanting to marry. The migration route of their ancestors is kept alive in similar fashion and is recited on special occasions. Some Yao (Mien) also know the names of their ancestors, but they could be written down in ancient Chinese script.

The Akha have a strong bond with their ancestors, who play an important part in their daily lives. Every household has an altar where offerings are made to them.

In the distant past the Akha were supposed to have lived in harmony with the world around them. Evil spirits causing problems were forced to leave the villages. Ritual gates at the entrance still pre-

vent evil spirits in the shape of diseases, plagues and wild animals from entering villages.

Akha women wear very special silver-ornamented headdresses and their costume consists of broad horizontal-striped leggings, a short black skirt with a white beaded sporran, and a loose-fitting black jacket with heavily embroidered cuffs and lapels. The combination of embroidery and brightly coloured appliqué patterns makes their dress very conspicuous. Many silver ornaments are sewn onto their clothes but it is the silver headdress that attracts most attention of all. As an Akha girl grows older her headdress becomes more elaborate, and different styles and characteristics can be distinguished. A marriageable Akha girl can be instantly recognised by her dress and accoutrements. If an Akha man wants to court a woman, he must own or borrow a pipe and a tobacco box. Without these objects his courting will be in vain.

Many people are trying to get an insight into the lives of these ancient peoples, into their spirituality, legends and myths. Their spoken languages are studied and put to writing, and their traditional dress and jewellery are bought. But in the villages young Akha people complain to their parents: "the customs were fine for your generation, and the embroidery patterns were possible for you to imitate, but how can we follow the ancient Akha Way in today's world?"

From 1997 I have been travelling to China in search of non-Chinese people: oppressed for centuries, hiding in the mountains, living in their own culture. What of this culture remains, and what can it teach me?

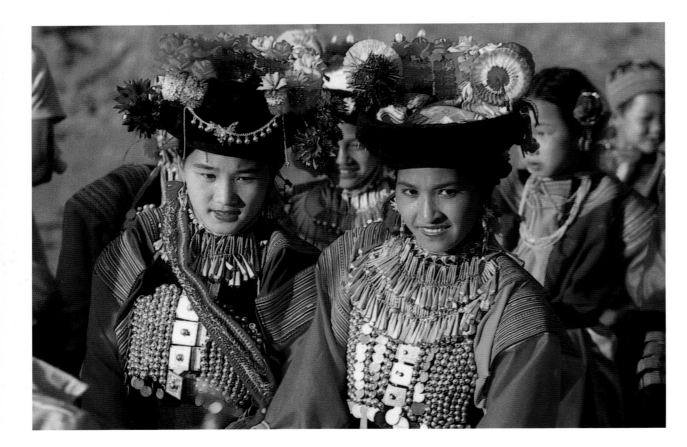

I am fascinated by the women I have met, who spend so much time making and adorning clothes, and who do this out of necessity, not luxury.

For decades I have been occupied with fabrics, with spinning, dyeing and weaving and all related techniques. In my earlier quests for Western European prehistoric textiles I have learned many techniques, such as sprang, tablet weaving, the building and erecting of upright looms and Iron Age unending twill weaving. For the Museum in Drenthe (The Netherlands) I have woven replicas of prehistoric fabrics. Still, the world in which these techniques developed is buried in the past forever.

In China I found what I had been looking for: past cultures living in the present. Once every year I am away for a month. Each time in a different season in order to experience all the production stages until the finished product. All these peoples have their own traditional clothes with their own specific characteristics. Weaving and indigo dyeing is an economic necessity for many. Walking through a village on a fine and cold February day, seeing the pieces of blue cloth flapping in the wind takes you back a thousand years in time.

The women show me very much; they teach me how to weave, to dye and to embroider in their fashion, according to their tradition. And that is exactly what I want to do. For hours on end I sit on a small stool with a piece of cloth, a rusty needle and the finest silk thread in the world. There I keep practising until they approve of my stitches.

In 2001 I used my collection for the exhibition "Geweven Verhalen" (A Fabric of Stories) in the Museon in The Hague. On show were the traditional clothes of a large variety of Miao peoples, and their lives were illustrated by films and photos. This exhibition was accompanied by the publication of my book *Geweven Verhalen*.

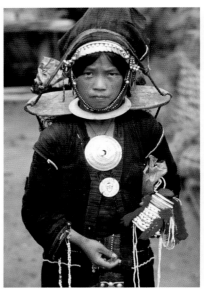

Akha woman with big buttons and neckring, North Thailand 1978.

Left
Laowe woman with big ivory earrings, North Laos.

Right
Iko woman with silver jewellery and glass beads, North Laos.

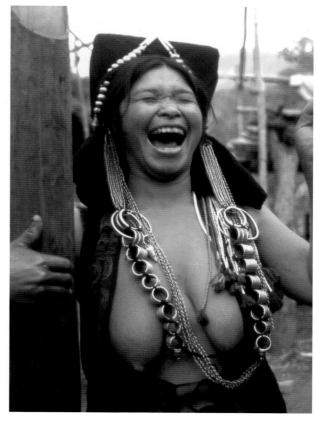

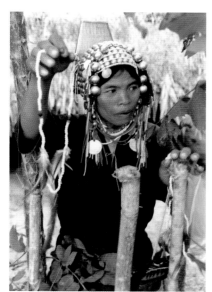

Akha woman with headdress, North Thailand 1982.

Bibliography

J. Balfour-Paul, *Indigo*, British Museum Press, London 1998.

K. Buchanan, *The Southeast Asian World*, Camelot Press Ltd, London 1973.

S. Conway, *Thai Textiles*, British Museum Press, London 1992.

G. Corrigan, *Guizhou Province. Costume and Culture in Remote China*, Airphoto International Ltd, Hong Kong 2002.

W. Eberhard. *Kultur und Siedlung der Randvölker Chinas*, Brill, Leiden 1942.

W. Eberhard, *Lexicon chinesischer Symbole*, Munich 1983.

W. Eberhard, *The local cultures of south and east China*, Brill, Leiden 1968.

Ethnic Jewellery. From Africa, Asia and the Pacific Islands. The René van der Star Collection, The Pepin Press, Amsterdam/Singapore 2002 -2004.

J. Hall, *Hall's Illustrated Dictionary of Symbols in Eastern and Western Art*, John Murray, London 1994.

Kuang, Shizhao et al., *Clothing and Ornaments of China's Miao People*, Nationality Press, Beijing 1995.

M. Laumann (ed.), *Miao Textile Design*, Fu Jen Catholic University Press, Taipei 1993.

P. and E. Lewis , *Peoples of the Golden Triangle*, Thames and Hudson, London 1984.

Muo, Fushan et al., *Life-styles of China's Ethnic Minorities*, Peace Book Company Ltd, Hong Kong 1991.

J. G. Pourret, *The Yao. The Mien and Mun-Yao in China, Vietnam, Laos and Thailand*, Thames and Hudson, London 2002.

I. Rappoldt, *Geweven Verhalen. De cultuur van de Miao in China*, Uniepers, Amsterdam 2001.

G. Rossi, *A Hidden Civilization. The Dong people of China*, Hagley and Hoyle, Singapore 1990.

T. M. Reilly, *Richly Woven Traditions. Costumes of the Miao of Southwest China and Beyond*, China House Galley, New York 1988.

S. Shi, *The Costumes and Adornments of Chinese Yi*, Nationality Picture Album, Beijing 1989.

V. Wilson, *Chinese Dress*, Victoria and Albert Museum, London 1986.

Zhang, Weiwen. *In search of China's Minorities*, New World Press, Beijing 1993.

Chinese Minorities
Jewellery

1. *Neckrings*
Ag 99%
H 21 cm, W 19.5 cm; H 24 cm, W 22 cm
672 and 908 g, 1580 g together
Dong; Guizhou
Set of two separate solid twisted
neckrings with flat bottoms; both bands
end in spirals; the fastener is formed by
a twisted spiral.

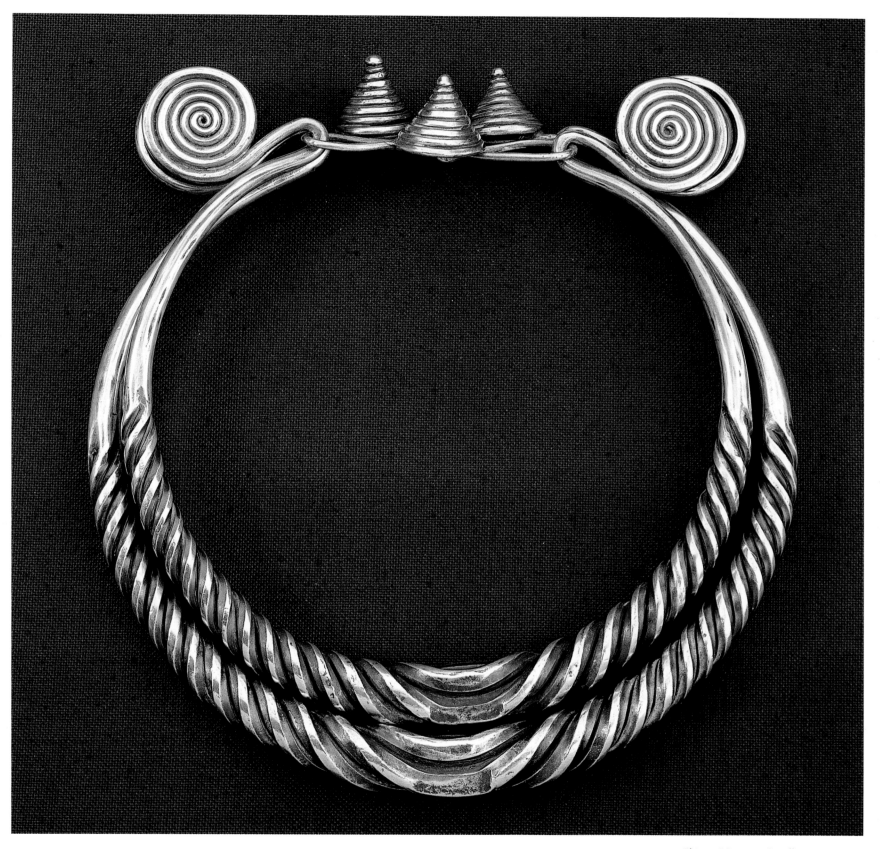

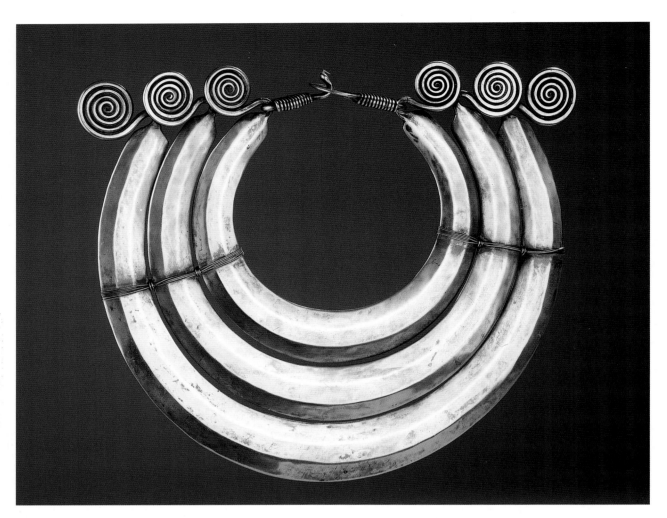

2. *Neckring*
Ag 99%
H 24.5 cm, W 27 cm; 1285 g
Miao; Guangxi, Sanjiang area
Neckring consisting of three smooth,
plain bands; each band has three surfaces
and ends in a spiral at both ends.

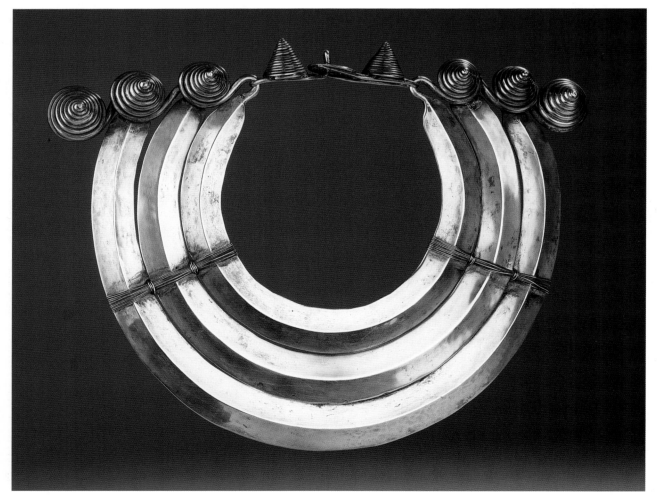

3. *Neckring*
Ag 99%
H 23 cm, W 27 cm; 1320 g
Miao; Guangxi, Sanjiang area
Neckring consisting of three smooth, plain
bands; each band has two surfaces and
ends in a pyramid-shaped torsade at both
ends; also the fastener has two torsades.

4. *Neckrings*
Ag 99%
Ø 20 cm; 563 g
Miao; (West) Guizhou, Pin Ba area
Two separate engraved bands, each with
a row of spirals on the inside; the fastener
connects the two bands.

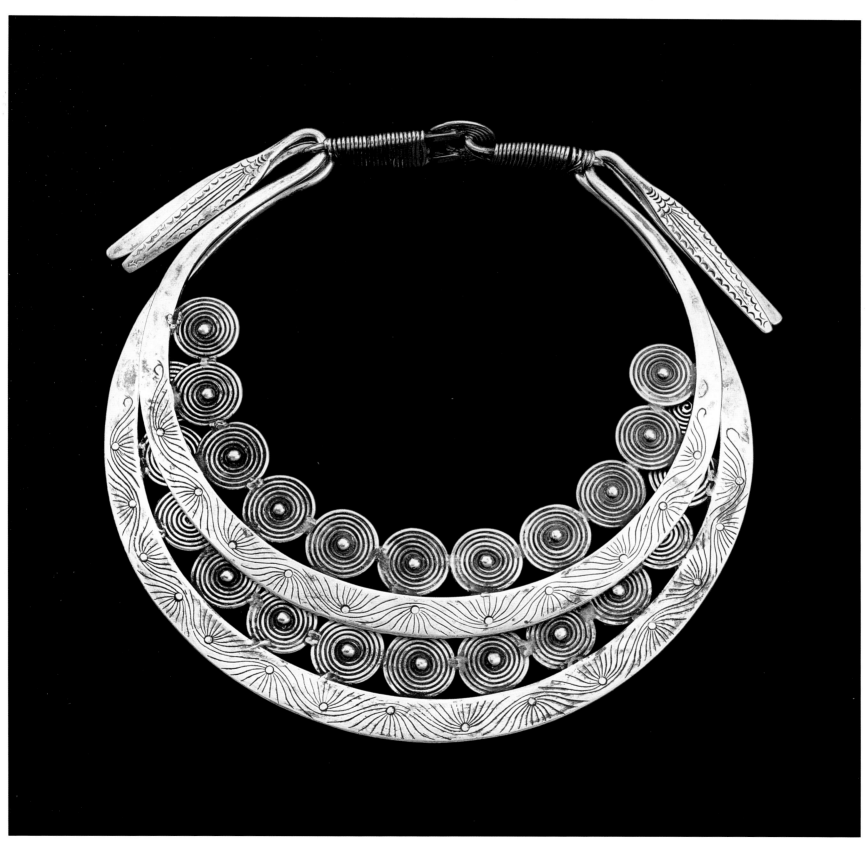

5-6. *Neckring*
Ag 99%
H 32 cm, W 30 cm; 2325 g
Miao; Guangxi, Sanjiang area
Engraved six-tiered neckring, each tier
ending in large spirals at both ends; the
sun in mirror-image on either side in the
middle of each tier; clear signs of wear
near the fastener.

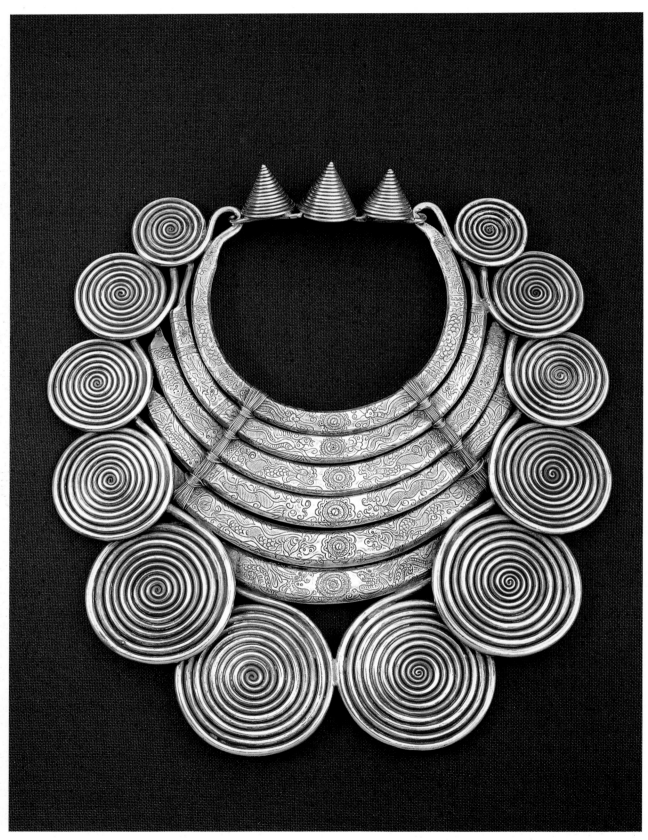

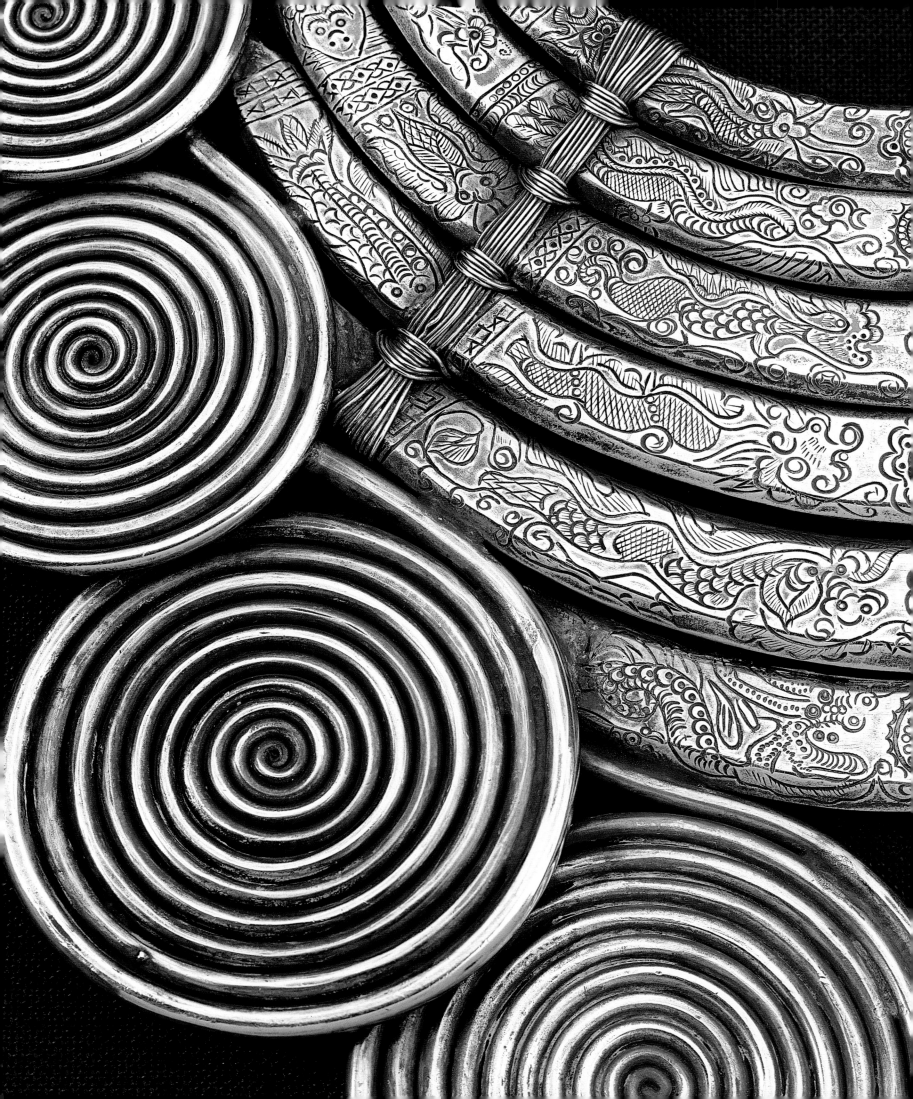

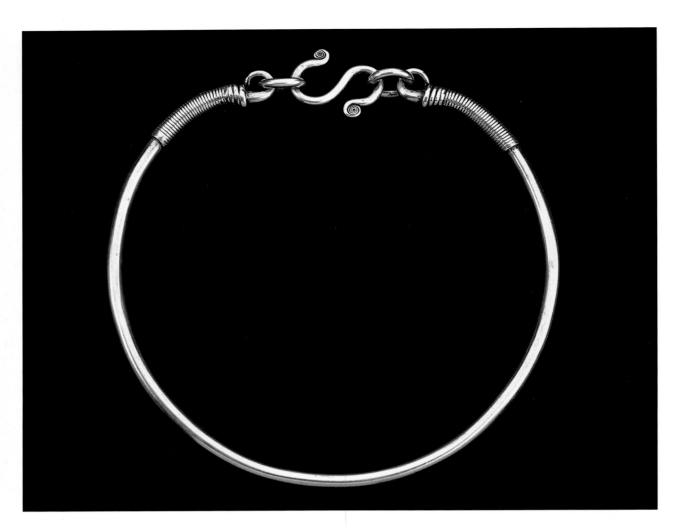

7. *Neckring*
Ag 54%, Cu 44%, Zn 2%
Ø 18.2 cm; 213 g
Zhuang; Yunnan

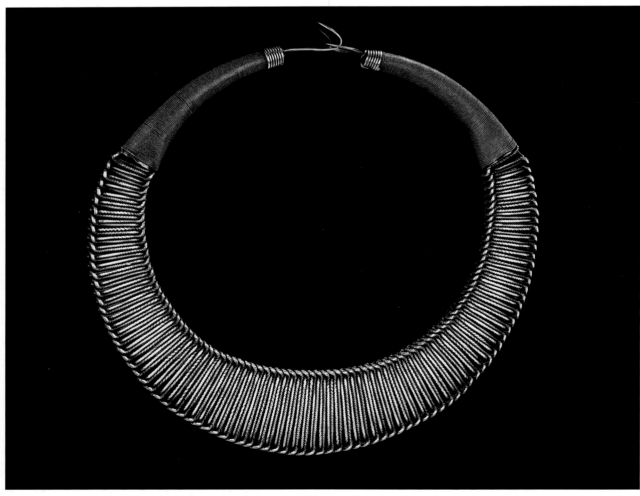

8. *Neckring*
Cu 65%, Zn 11%, Ni 17%
(alpaca alloy), silver-plated
H 26 cm, W 27 cm, largest width
of bottom rim: 5 cm; 579 g
Miao; Guizhou
This neckring has a beautiful well-worn
patina.

9. *Neckrings*
Ag 99%
H 28 cm, W 31 cm, largest width
of bottom rim: 7.5 cm, 475 g
H 40 cm, W 42 cm, largest width
of bottom rim: 8.5 cm, 720 g
H 52 cm, W 56 cm, largest width
of bottom rim: 10 cm, 1060 g
2255 g in total

Miao; Guizhou, Jianhe area
Set of three separate bands with V-shaped
motifs; these are also worn in sets of two;
a top-quality set because of its powerful
and beautiful design.

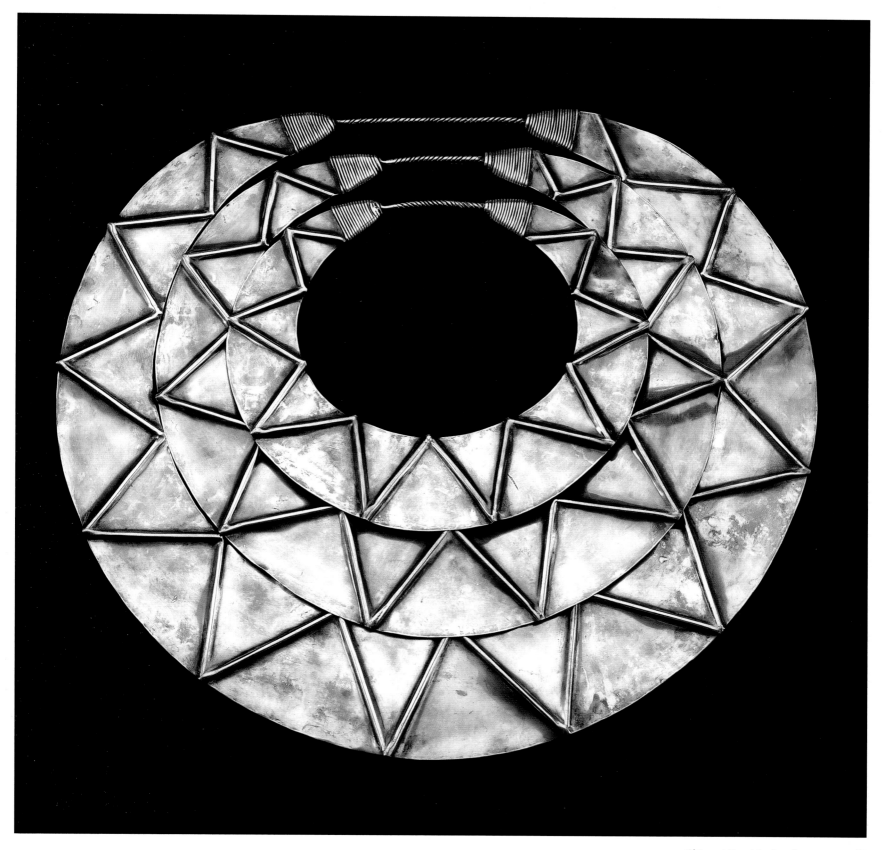

10-11. *Necklace*
Ag 99% (chain included)
H 22 cm, W 37 cm (sizes without
chain), largest width of bottom rim:
6.2 cm; 610 g
Li; Hainan Island
Necklace with chain; necklace in the shape
of a half-moon, both ends in the shape of
a turtle, with engravings of turtles.

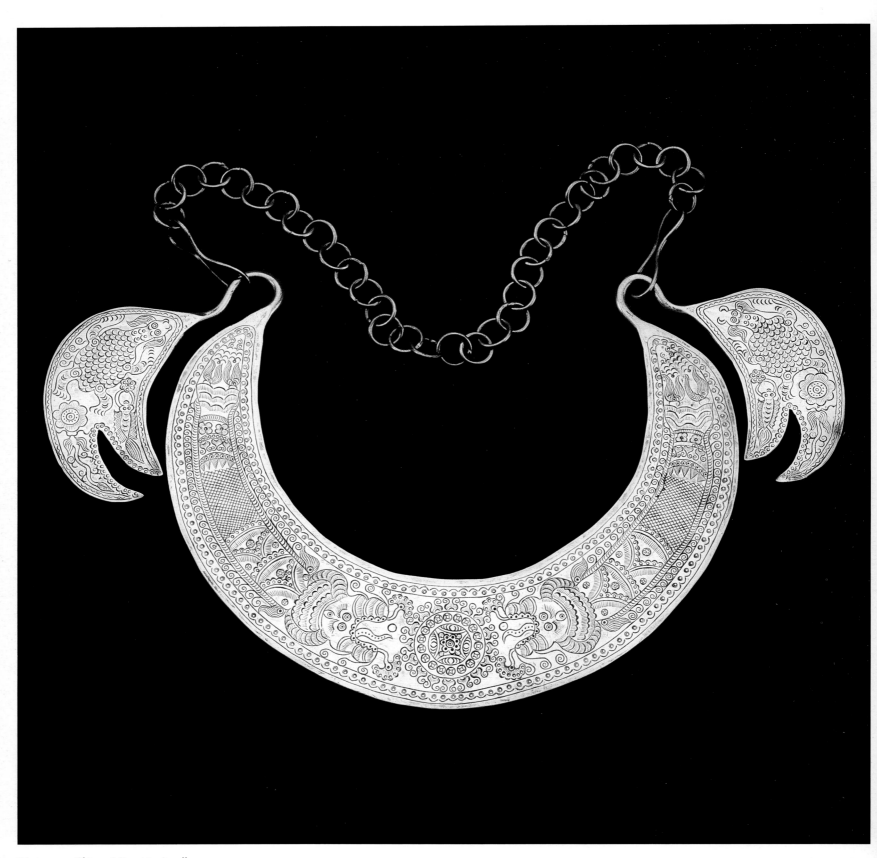

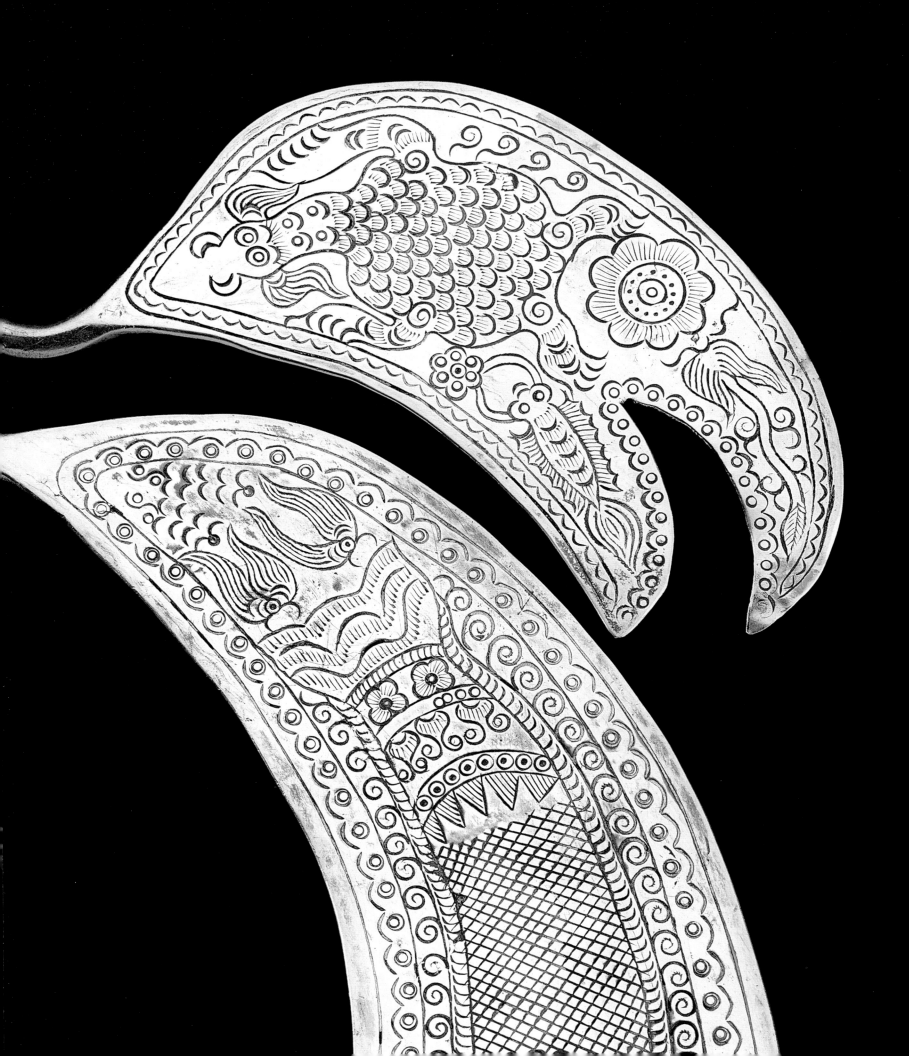

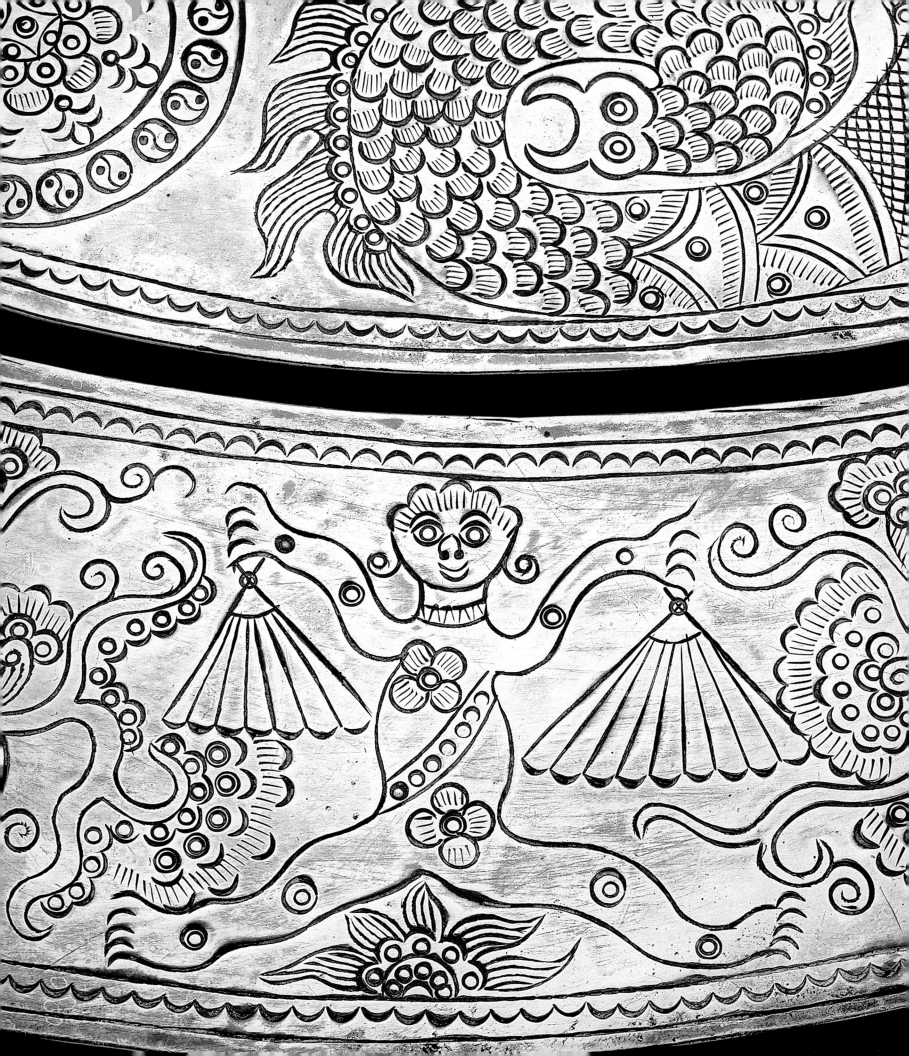

12-13. *Necklace*
Ag 99% (chain included)
H 31 cm, W 37.5 cm (sizes without chain), largest width of bottom rim: 6.2 cm; 976 g
Li; Hainan Island

Three separate necklaces joined by means of a chain; the centre of each necklace is adorned with an image of the sun, which is worshipped by the Li; the sun stands for a good and colourful life.

Upper necklace: engravings of floral motifs. Middle necklace: engravings of dragons and fish. Lower necklace: anthropomorphic figures, floral motifs and two water buffaloes.

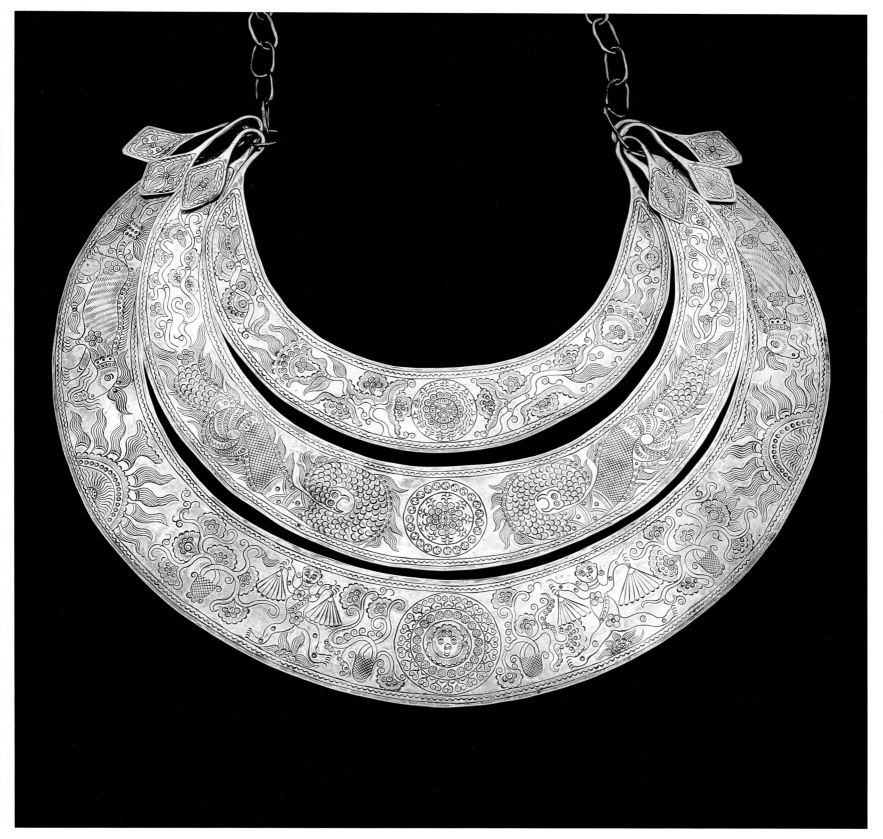

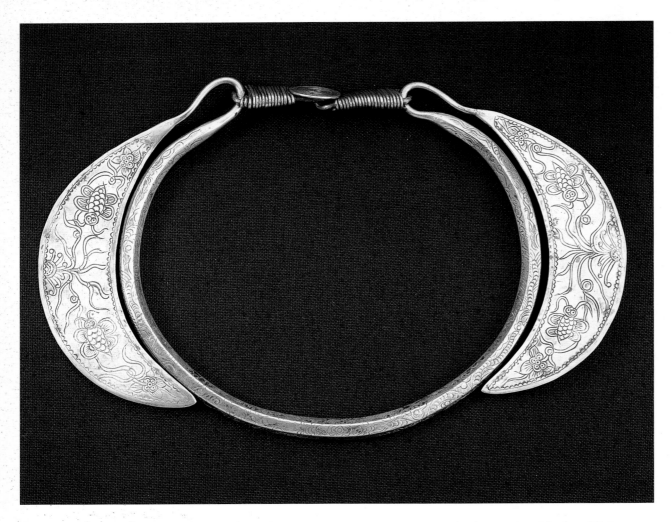

14. *Neckring*
Ag 98%, Cu 2%
H 18 cm, W 28 cm; 537 g
Yi (comparable types are also worn
by the Zhuang people); Yunnan
Neckring with somewhat more primitive
engravings: floral motifs with bees or
butterflies.

15. *Neckring*
Ag 99%
H 37.5 cm, W 20.5 cm; 574 g
Miao; Guizhou
Neckring with two loose pendants.

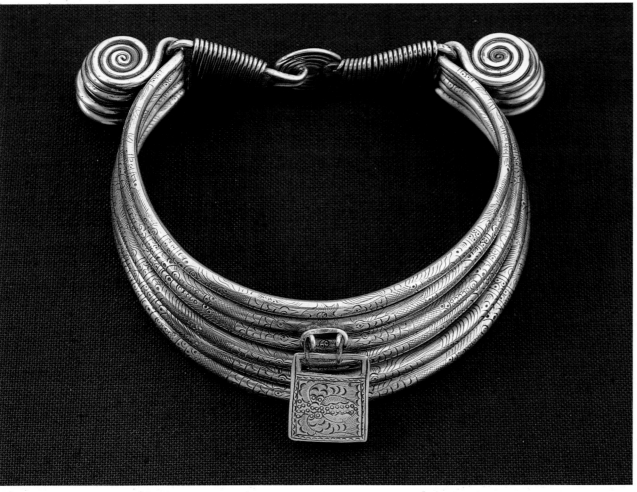

16. *Neckring*
Ag 99%
H 13.5 cm, W 16.5 cm, thickness
4.5 cm; 751 g
Miao and Dong
Guizhou, near Quangxi, Chong Jiang
area
Six superimposed loose rings joined by
the fastener; engravings of a water
buffalo, phoenix, butterflies, and others;
on the front two fish are depicted.

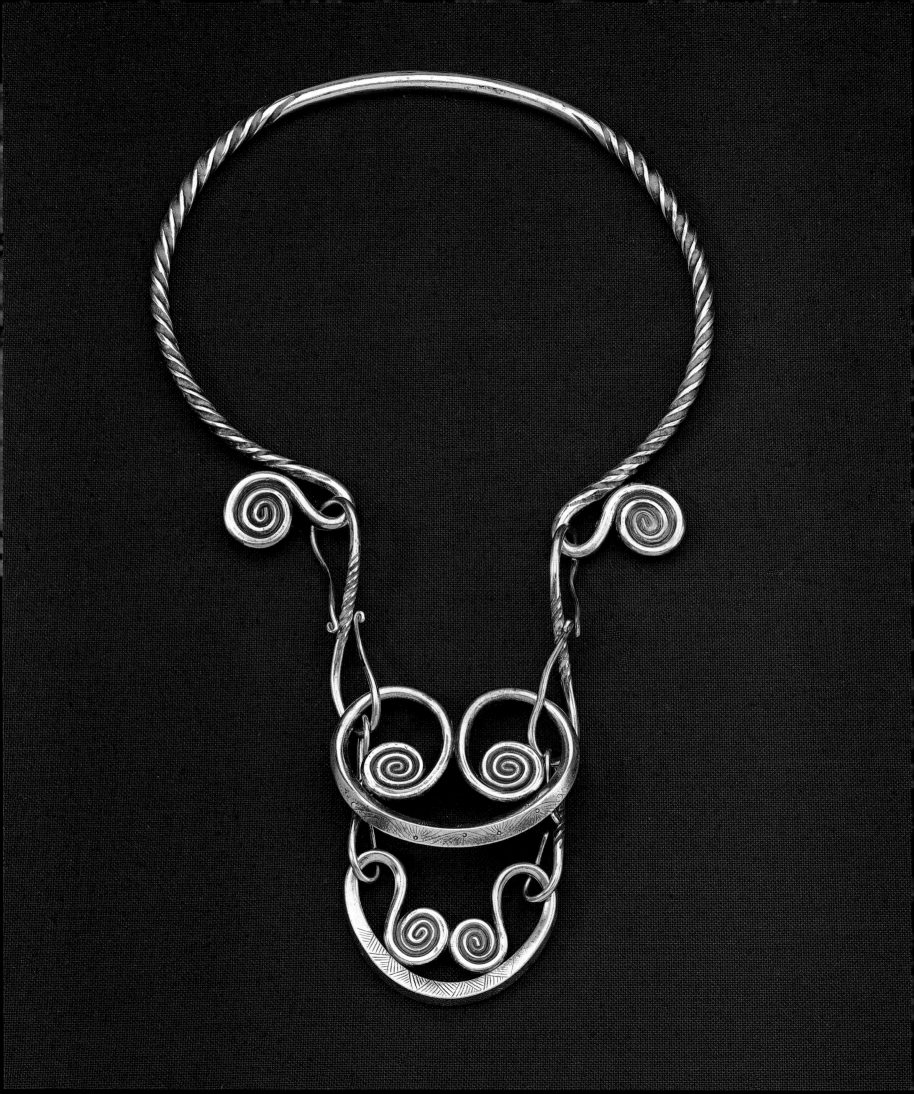

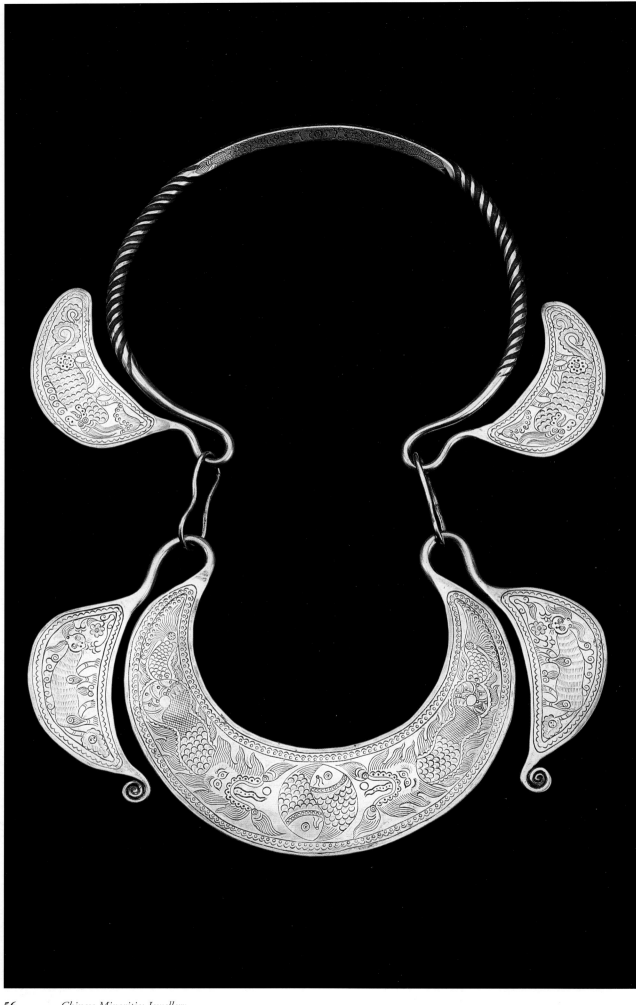

17-18. *Neckring*
Ag 99%
H 39 cm, W 28.5 cm, largest
width of bottom rim 5.2 cm; 790 g
Zhuang; Guizhou
Neckring consisting of two opposing
bands joined by two links, engraved with
dragons, and others; the middle of the
bottom band engraved with two fish in
the form of the Yin–Yang symbol.
Opposite page: detail of two fish in the
form of the Yin–Yang symbol: Yin and
Yang are dependent opposites that must
always be in balance as nothing is either
100% Yin or 100% Yang.

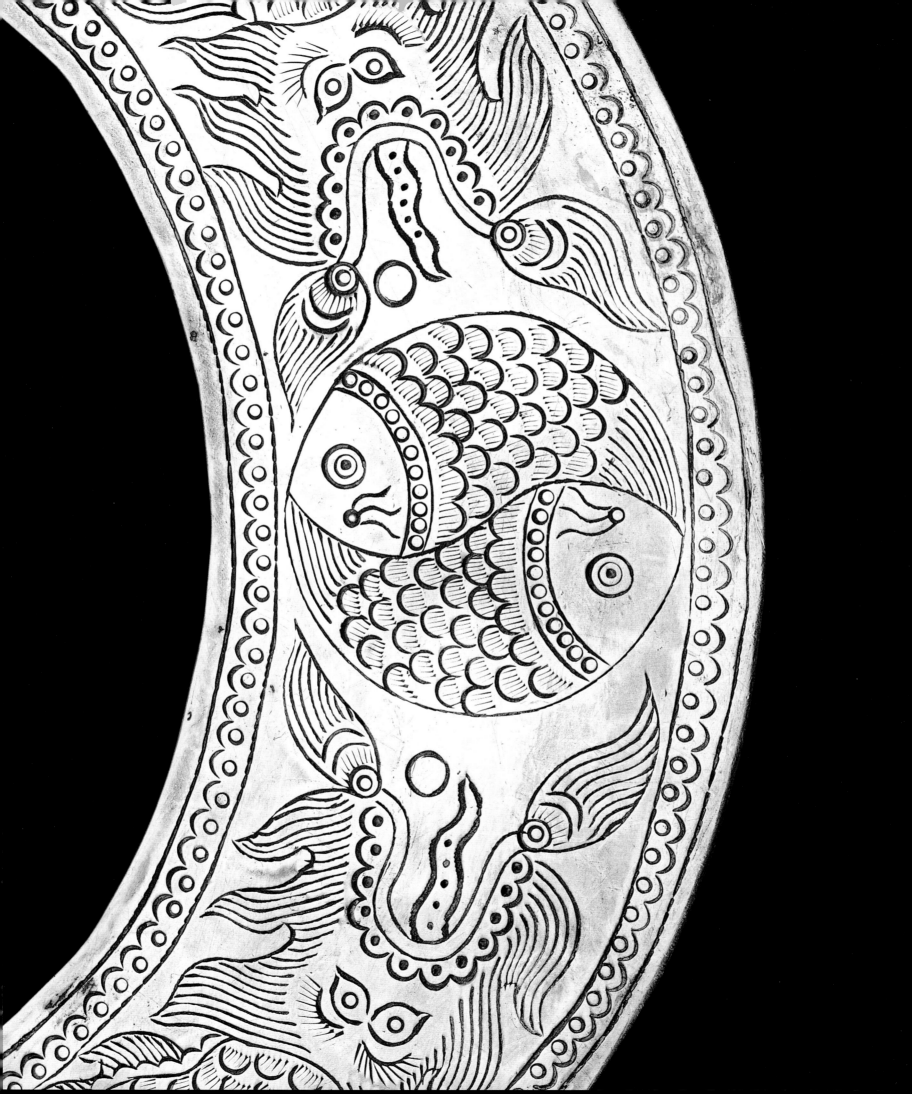

19-20. *Neckring*
Ag 99%
Ø 23.5 cm; 813 g
Zhuang; Yunnan
Two joined bands with fastener;
engravings meeting in the middle
are mirror images of each other.
Opposite page: detail with engraved
catfish with the Yin–Yang motif in its tail.

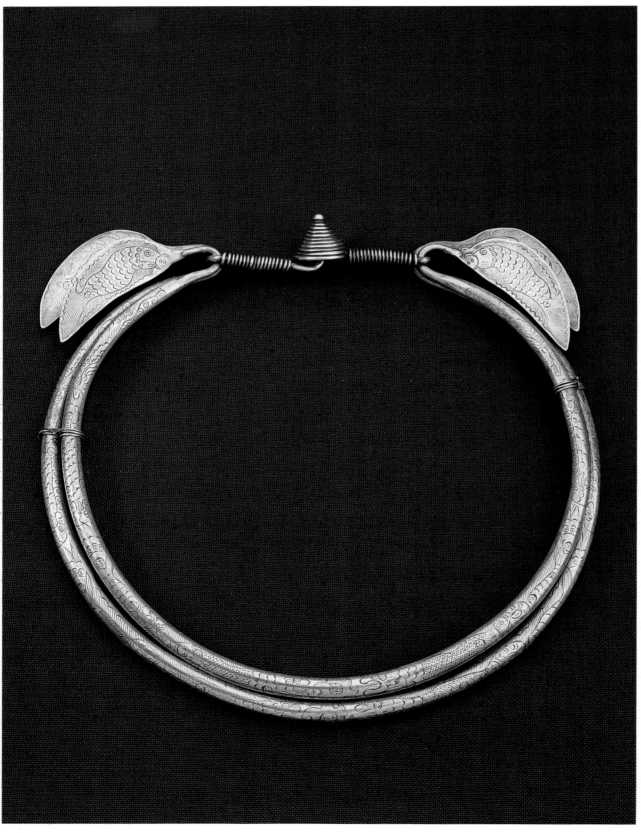

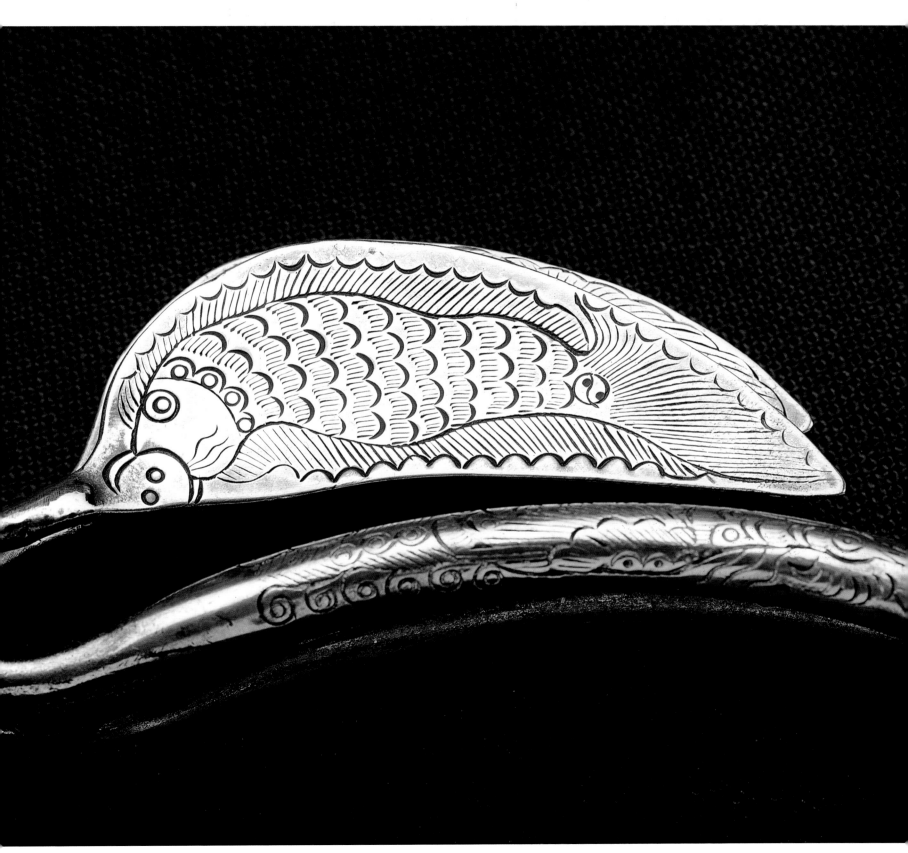

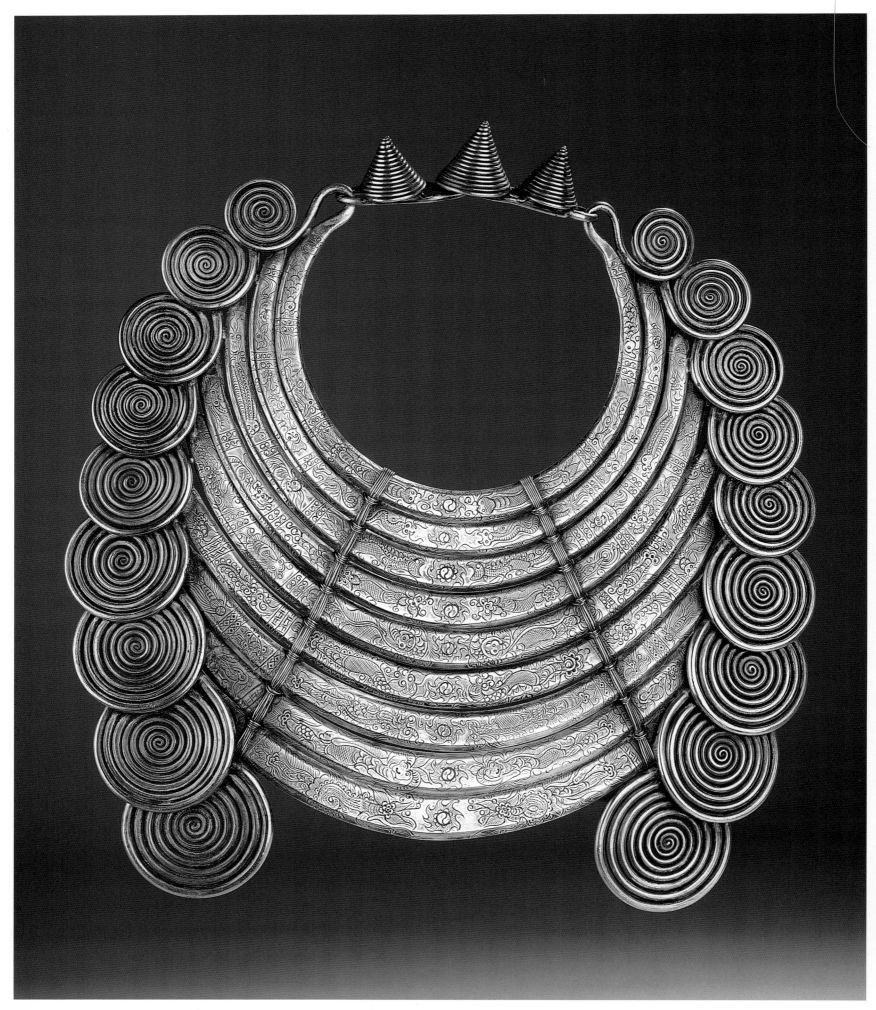

21. *Neckring*
Ag 99%
H 34 cm, W 32.5 cm; 2985 g
Miao; Guangxi. Sanjiang area
Engraved nine-ring band with spiral ends;
the centre of each band is decorated with
the sun, flanked by dragons, fish,
butterflies and phoenixes; fastener with
pyramid-shaped twisted spiral; clear, well-
worn patina near the top-band fastener.

22. *Neckring*
Ag 99%; fastener: Ag 94%, Cu 6%
H 22 cm, W 23 cm; 795 g
Shui; Guizhou, Sandu area
Solid twisted neckring with a fastener at
the top; at the ends two horned dragons'
heads.

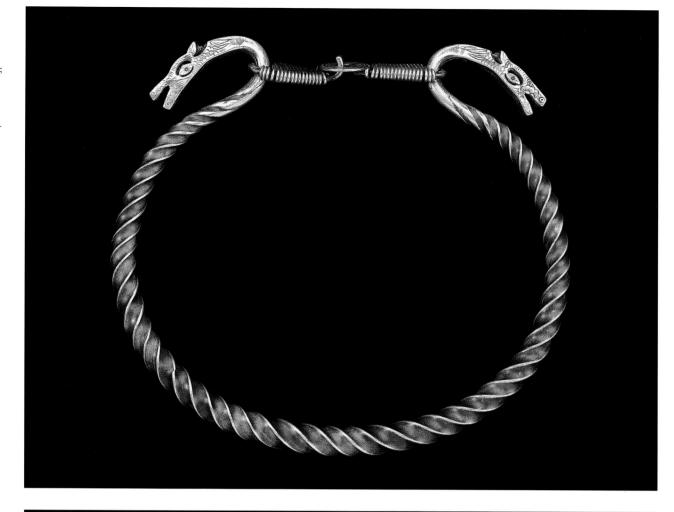

23. *Bracelets* (pair)
Ag 99%, traces of Cd
H 6.5 cm, W 8.2 cm; 260 g the pair
Shui; Guizhou, Sandu area
Solid bracelets (open on one side) with
horned dragons' heads at both ends.

23. *Hairpin*
Ag 99%
L 27.5 cm; 90 g
Shui; Guizhou, Sandu area
At the front a dragon's head with a long
horn.

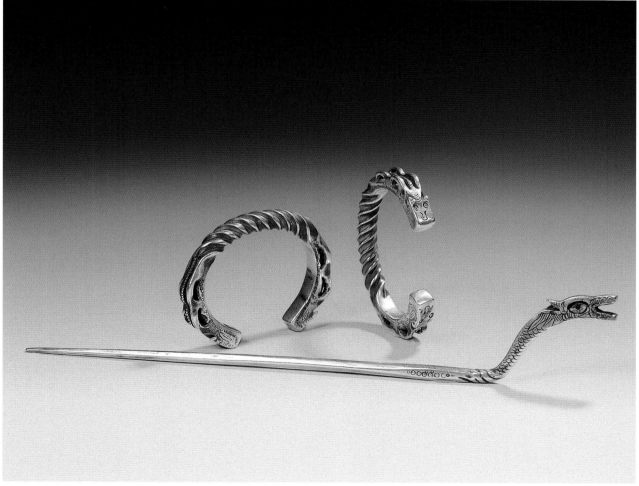

24-25. *Neckrings*
Ag 99%
H 23 cm, W 21 cm, 575 g
H 20 cm, W 18.5 cm, 460 g
H 17.5 cm, W 16.5 cm, 355 g
1390 g together
Shui; Guizhou, Sandu area

Set of three loose-fitting solid twisted bands; the ends consist of dragons' heads with a flattened horn each.
Opposite page: detail of a dragon's head with flattened horn.

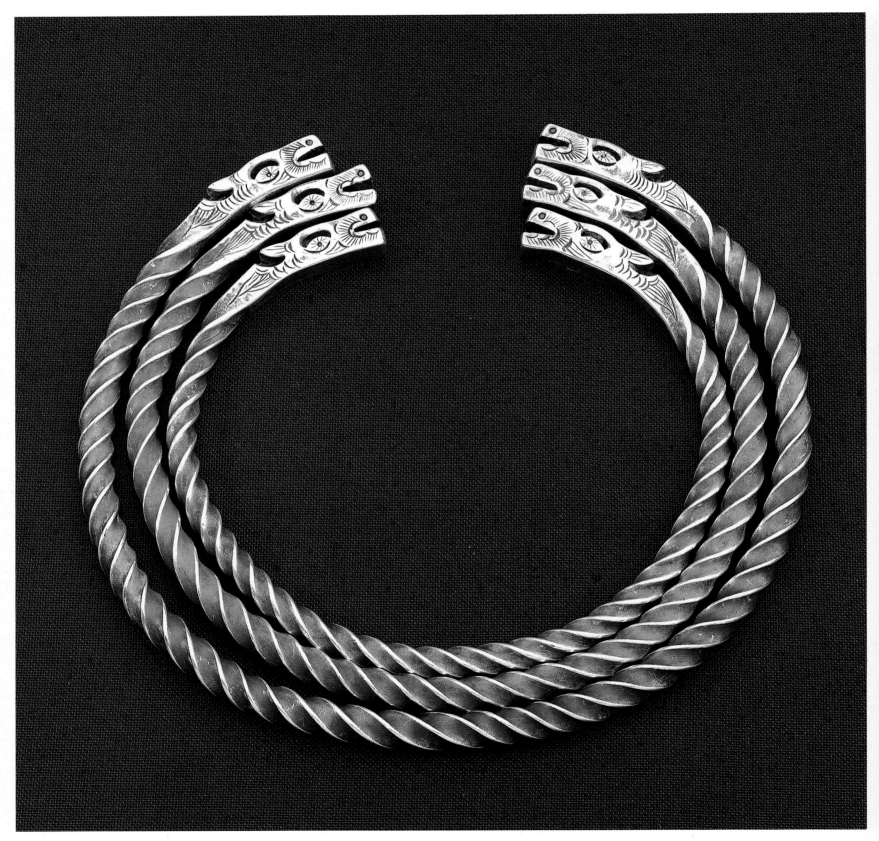

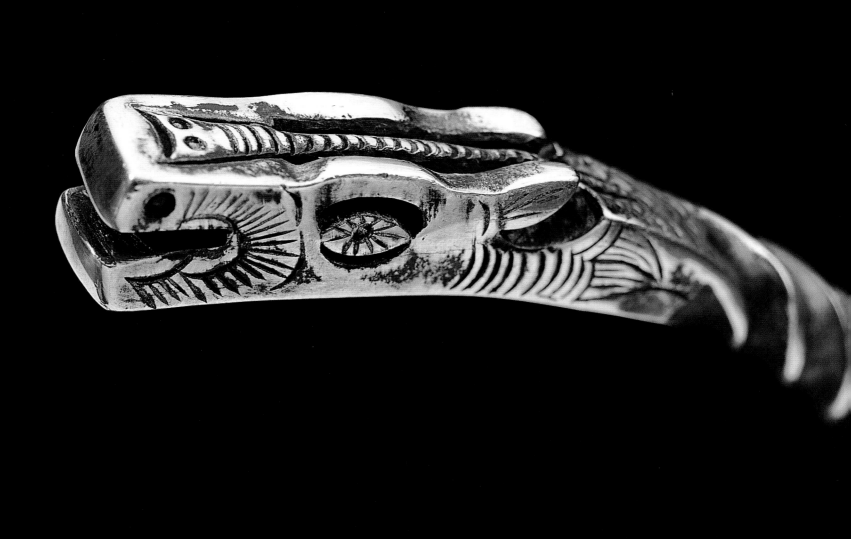

26. *Neckring*
Ag 99%
Ø 27.5 cm; 1460 g
Miao; Guizhou
Four countertwined wires; a particularly
fine and heavy ring of its kind.

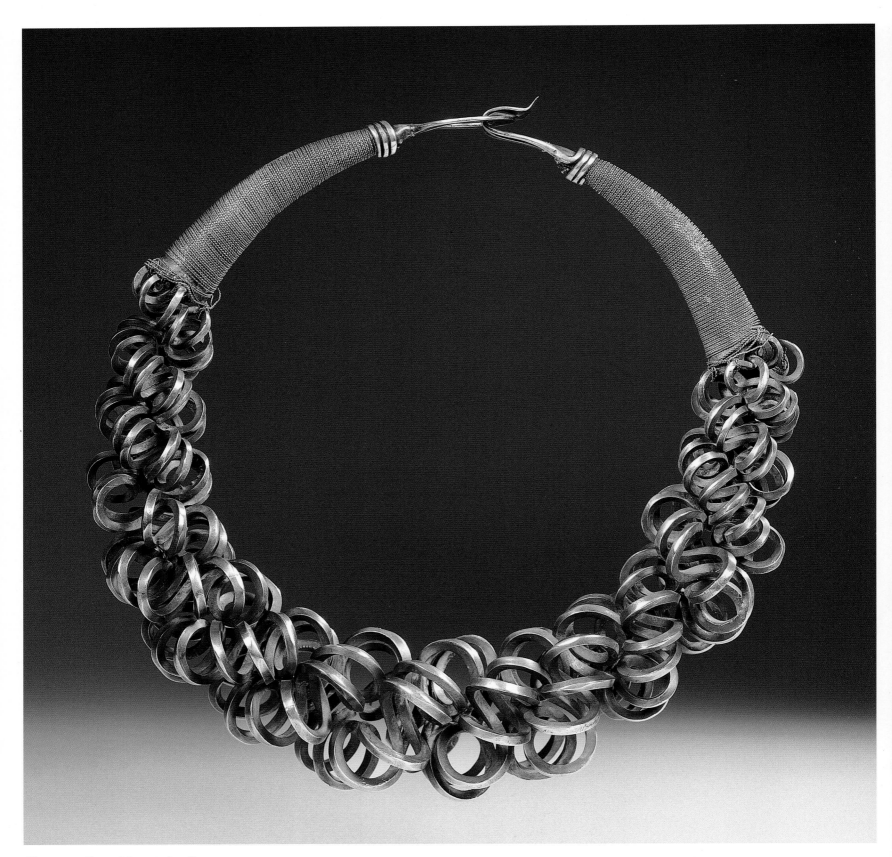

27 (top). *Comb*
Ag 99%
H 20 cm, W 32.8 cm; 740 g
Miao; Guizhou, Bijie area
Comb in the form of buffalo horns,
worn on the back of the head; engraved
with dragons and phoenixes.

27 (bottom). *Comb*
Ag 99%
H 16.3 cm, W 38 cm; 390 g
Miao; Guizhou, Bijie area
Comb in the form of buffalo horns,
worn on the back of the head.

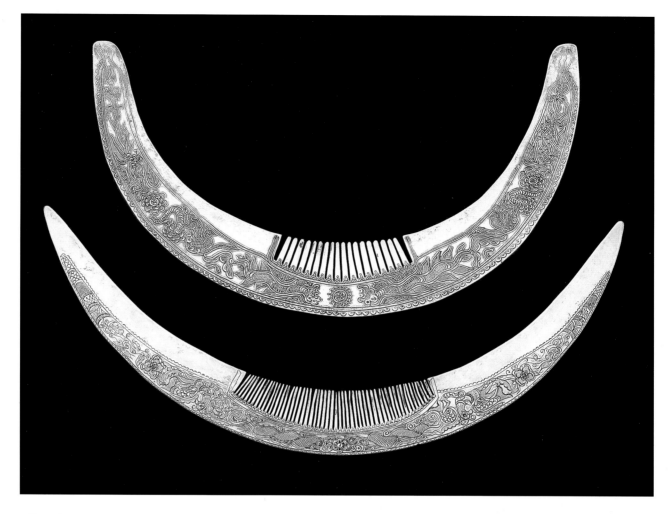

28. *Comb*
Comb: Ag 94%, Cu 6%;
hairpins: Ag 49%, Cu 46% Zn 5%;
inside: wood
H 9.5 cm, L 13 cm,
thickness 1.8 cm; 96 g
Miao; Guizhou
Repoussé work adorned with floral
motifs and a row of spikes on top; on
either side a piece of chain plus pin as
additional fasteners.

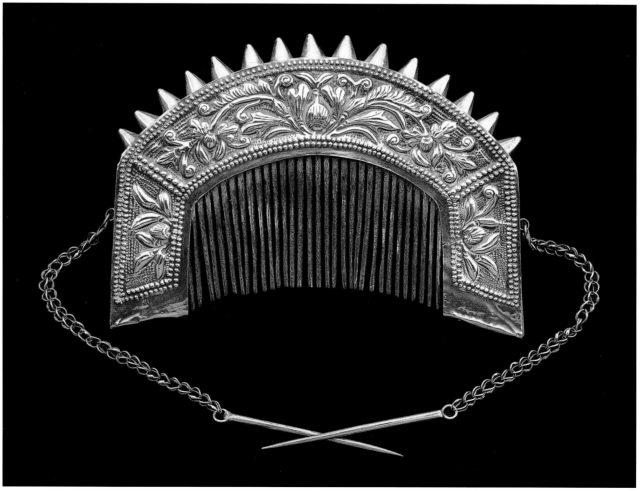

29-30. *Headddress*
Ag 99%
H 42.5 cm (without feathers),
W 58.5 cm; 410 g
Miao (Dandu style); Guizhou,
Jianhe area

Repoussé (hammered) silver headdress,
worn at festivals; adorned with depictions
of anthropomorphic figures, dragons,
fish, phoenixes and frogs; in the centre
depictions of the sun, which is
worshipped and stands for a good and
colourful life.

Opposite page: detail with various
dragons and an anthropomorphic figure;
the dragon on the upper band is a male,
with considerably more beard than his
female partner (on ill. 29 she can be seen
in mirror-image).

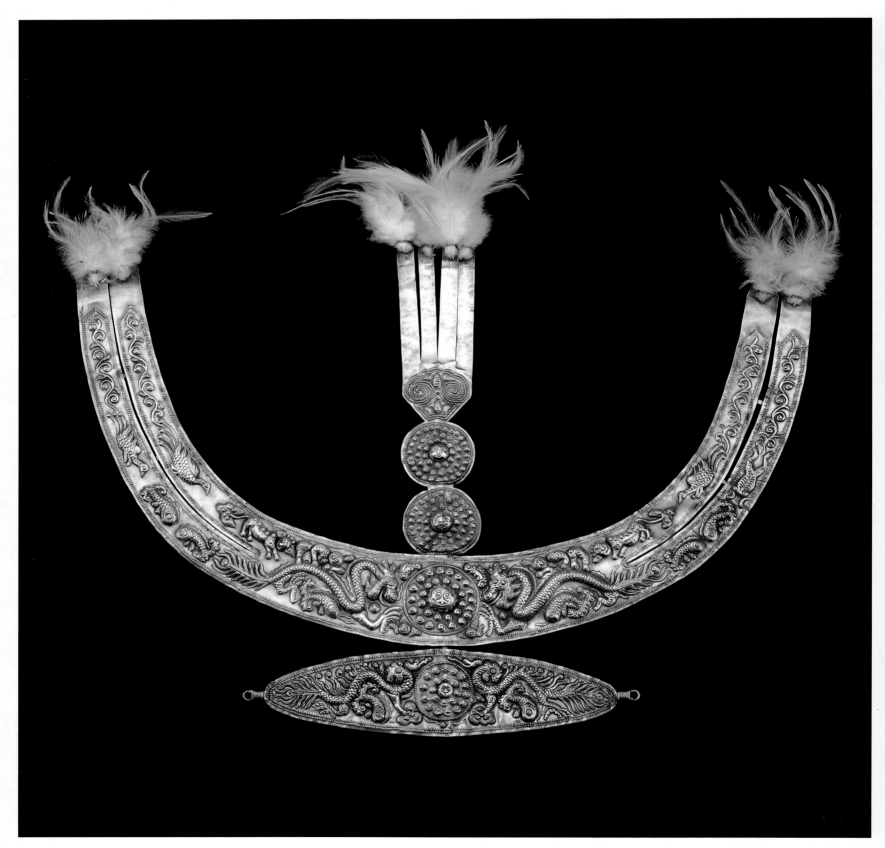

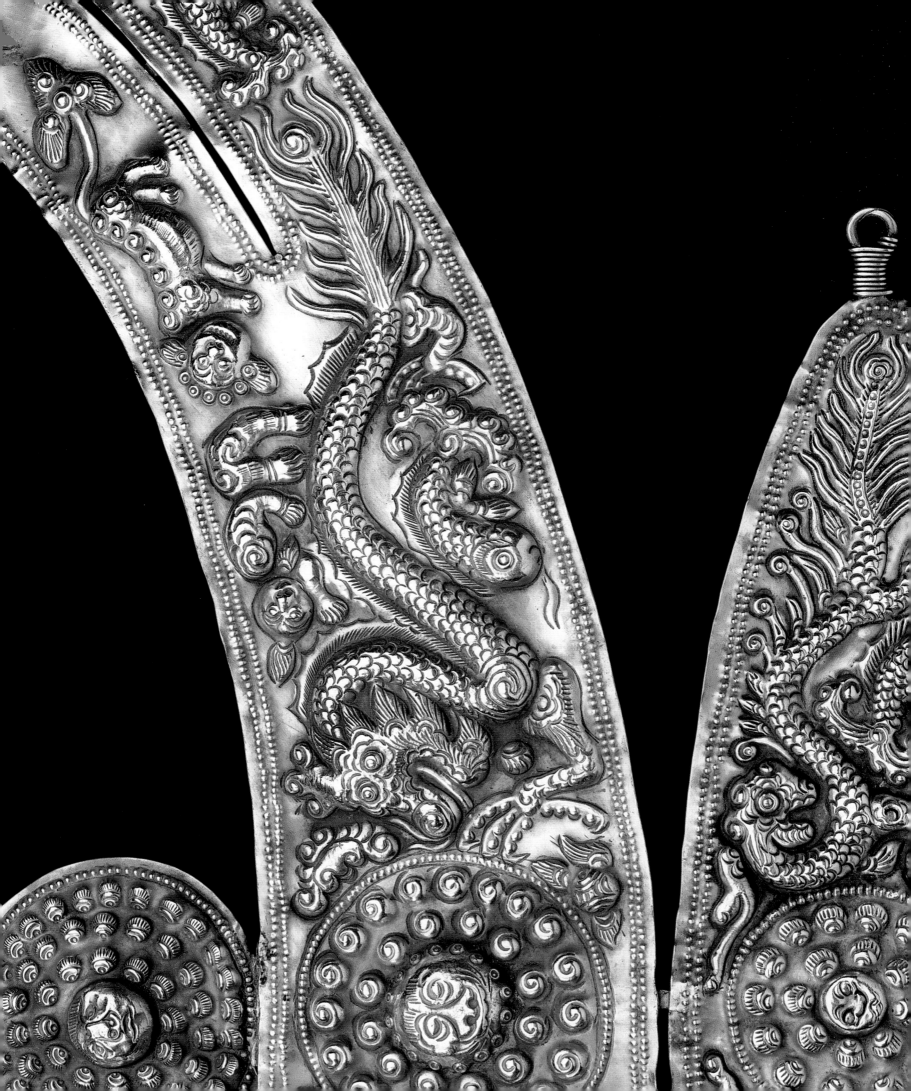

31 (top). *Comb*
Wood and silver (Ag 98%, Cu 2%);
heads: Ag 92%, Zn 5%, Cu 3%
H 3.5 cm, W 7.5 cm, L 12 cm; 77 g
Dong; Guizhou
Both sides of the comb are repoussé work;
the rim is adorned with anthropomorphic
figures.

31 (bottom). *Comb*
Ag 99%
H 4.5 cm, L 12.5 cm; 85 g
Dong; Guizhou, Sandu area.
The top is engraved on either side.

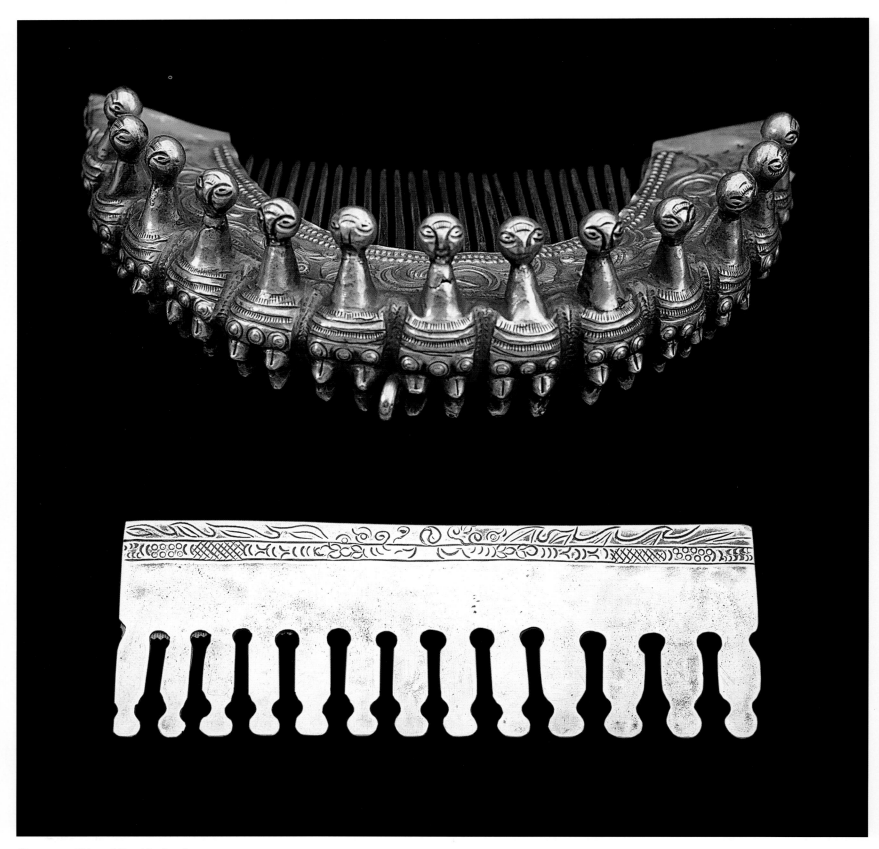

32. *Headdress*
wire: Ag 97%, Cu 3%;
elements: Ag 96%, Cu 4%; cotton,
wool and glass beads
H approx. 29 cm, W 15.5 cm, L 11 cm;
348 g
Yao; Yunnan
Part of the headdress; worn in
combination with bone comb
(see ill. 33-34).

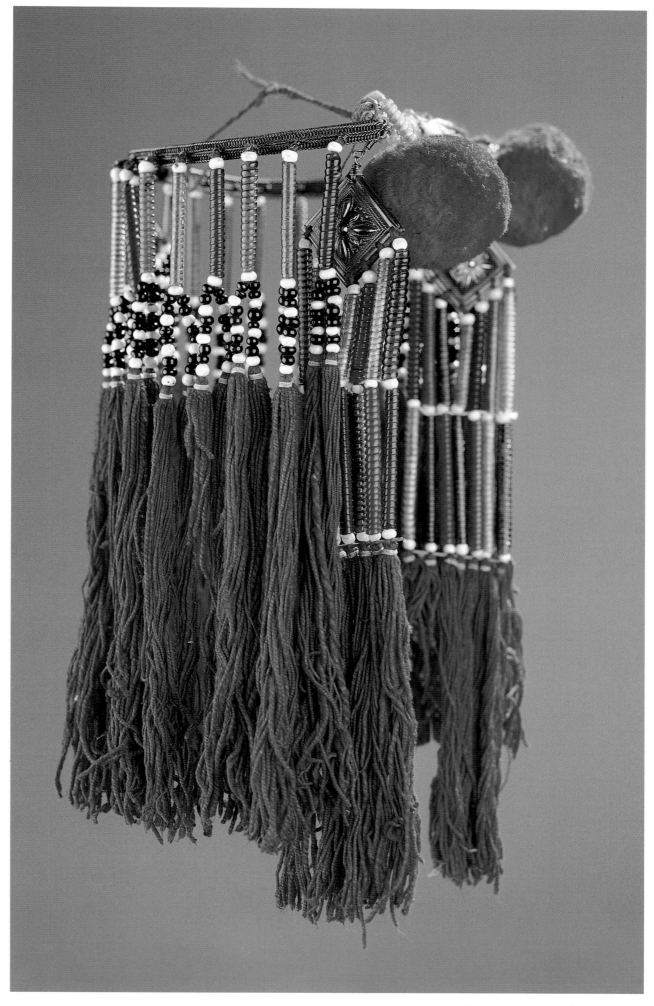

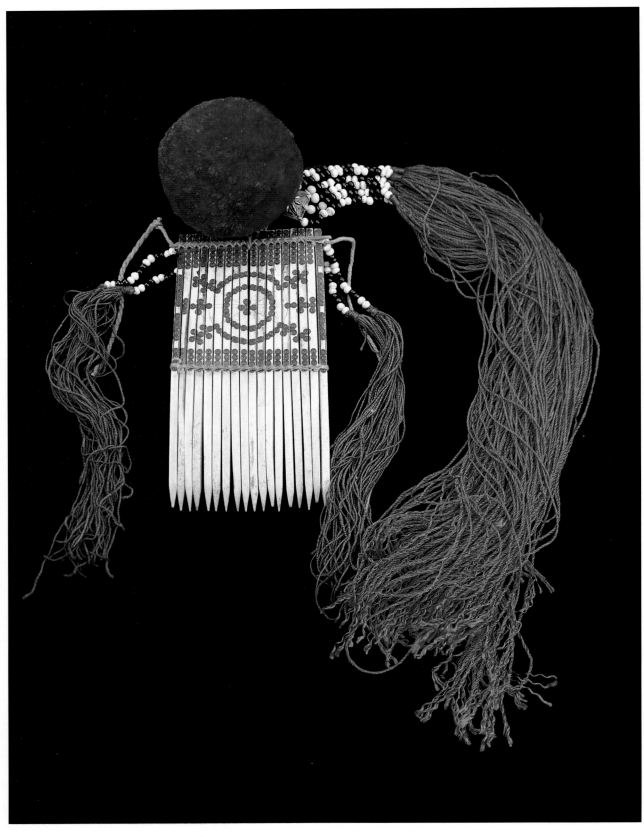

33-34. *Comb*
Bone, cotton, wool and glass beads
H 15 cm, W 8 cm; 154 g
Early 20th century
Yao; Yunnan
This comb – worn in combination with headdress of ill. 32 – consists of eighteen bone segments. Engravings filled with black ink on either side; at the front of the comb a large ball of red wool, at the back (see opposite page) a silver square and glass beads; cotton fringes and glass beads on the sides.

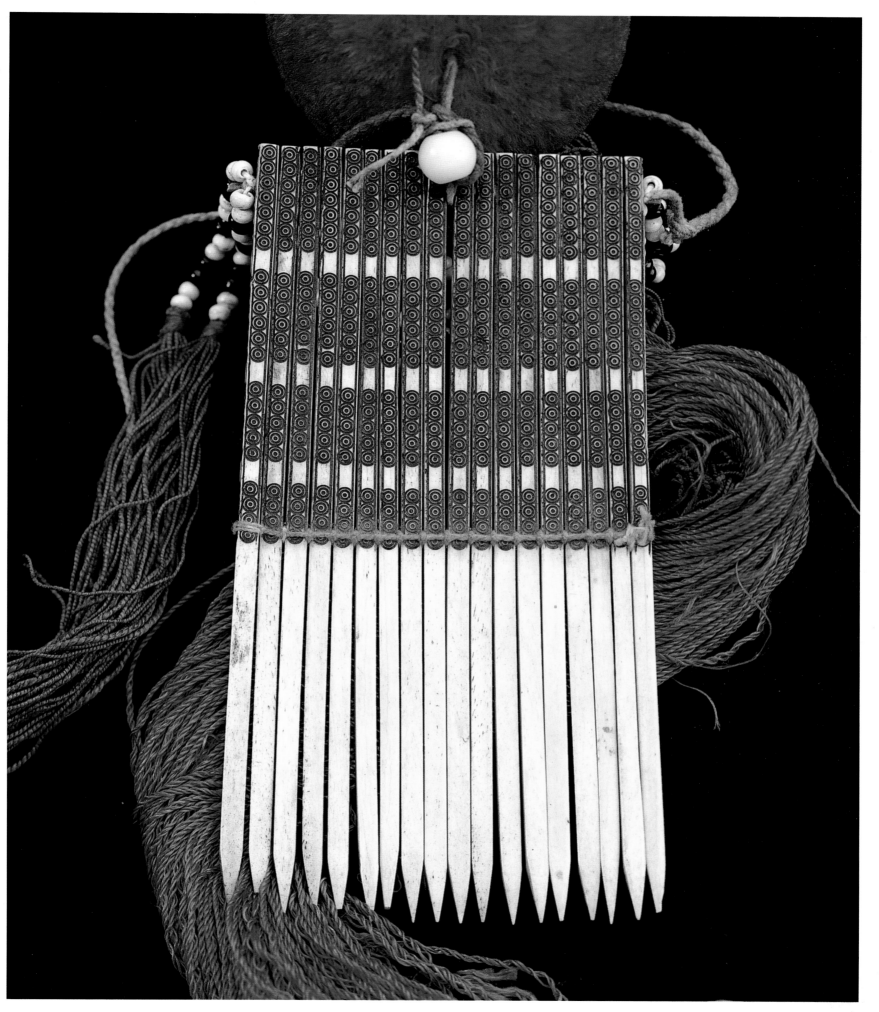

35 (left). *Ring*
Ag 75%, Cu 25%, trace of Zn
H 2.4 cm, W 2 cm; 6.6 g
Dong; Guizhou
Depictions of *shishi* (Chinese lion) front,
butterflies sides.

35 (right). *Ring*
Ag 91%, Cu 8%, Zn 1%
H 2.6 cm, W 2 cm; 6.7 g
Dong; Guizhou
Depictions of *shishi* (Chinese lion) front,
butterflies sides.

37. *Earrings*
Ag 99%, Cu 1%
H 9.6 cm, W 4.6 cm
74 g together
Miao; Yunnan province

38. *Earrings*
Ag 99.7%, Cu 0.3%
H 5.8cm, W 6.,6 cm; 68 g together
Miao; Guizhou and Yunnan province

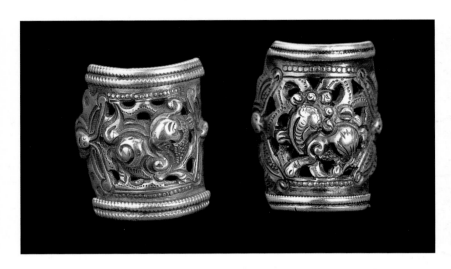

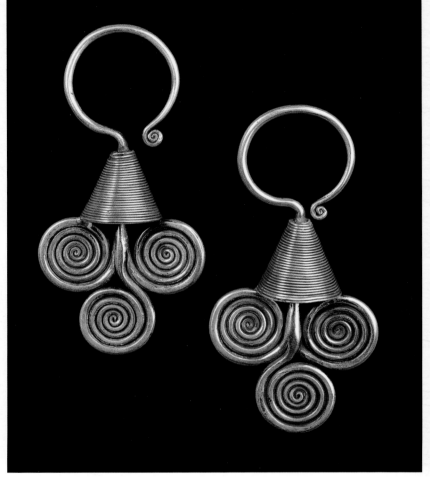

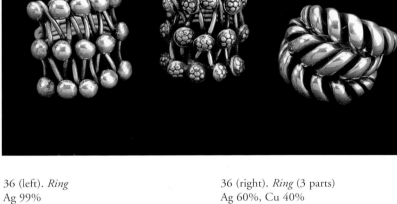

36 (left). *Ring*
Ag 99%
H 2.8 cm W 2.5 cm; 15.9 g
Miao; Guizhou

36 (centre). *Ring*
Ag 98%, Cu 2%
H 2.5 cm W 2.5 cm; 13 g
Miao; Guizhou

36 (right). *Ring* (3 parts)
Ag 60%, Cu 40%
Ø 2.5 cm; 36 g together
Miao; Guizhou
Ring consisting of three separate twisted
parts that form the whole.

39-40. *Earrings*
Ag 72%, Cu 25%, Zn 3%
H 10 cm, W 6.5 cm; 44 g together
Miao; Guizhou
Both sides engraved with floral motifs.

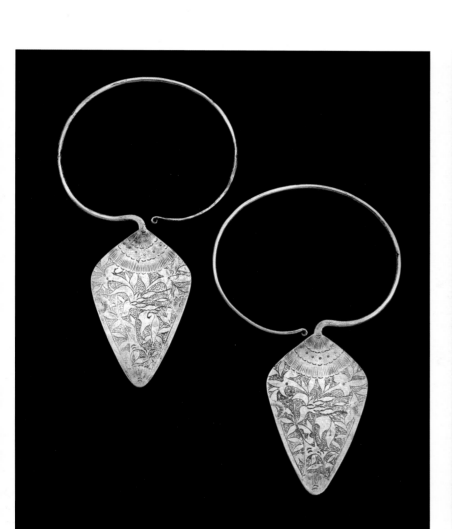

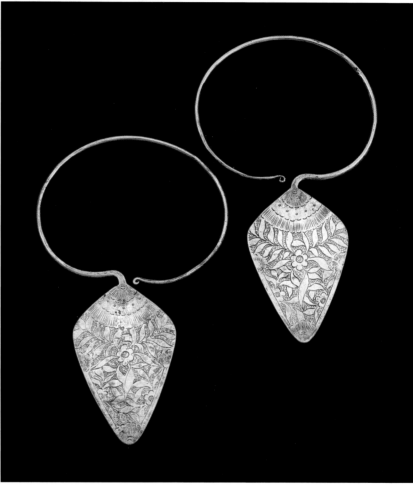

41. *Earrings*
Miao; Guizhou Shidong, Taijang area
The three pairs are of the same type,
with stamps on the side; top: three circles;
bottom: two circles (this type of earring
is depicted on the Chinese 5 jiao
banknote).

top
Ag 93%, Cu 7%
H 2 cm, Ø 4 cm; 186 g together

bottom right
Ag 99%
H 1.5 cm, Ø 2.7 cm; 58 g together
Ears and earrings are often joined by a bit
of string to prevent loss.

left and centre
Ag 96% Cu 4%
H 1.8 cm, Ø 3.7 cm; 110 g together
The stamps on the side give the maker's
name, in this case the father of the
silversmith with whom we were staying;
the earrings are some eighty years old.

42. Detail of earrings top. The maker's
stamp; silversmith's name: Wu Tong Yu.

43. Detail of earrings left and centre.
The maker's stamp; silversmith's name:
Wu Ying Fu.

44. Detail of smallest earring bottom
right.
The maker's stamp; silversmith's name:
Zhang Zheng Hui.

45. *Earrings*
Ag 96%, Cu 4%
H 9.5 cm, W 8.5 cm; 185 g together
Miao ?; Guizhou
The inside of the earring ends
in a dragon's head.

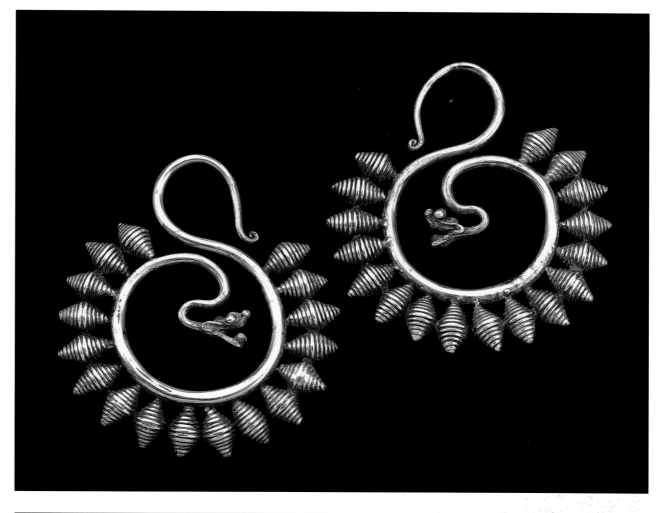

46 (top). *Earrings*
Curl: Ag 75%, Cu 25%;
balls: Ag 45%, Co 54%, Zn 1%
Ø 6 cm; 102 g
Dong; Guizhou

46 (bottom). *Earrings*
Ag 91%, Cu 9%
Ø 6.3 cm; 72 g
Dong; Guizhou
The most characteristic Dong earrings:
depicted on the Chinese 1 yuan
banknote.

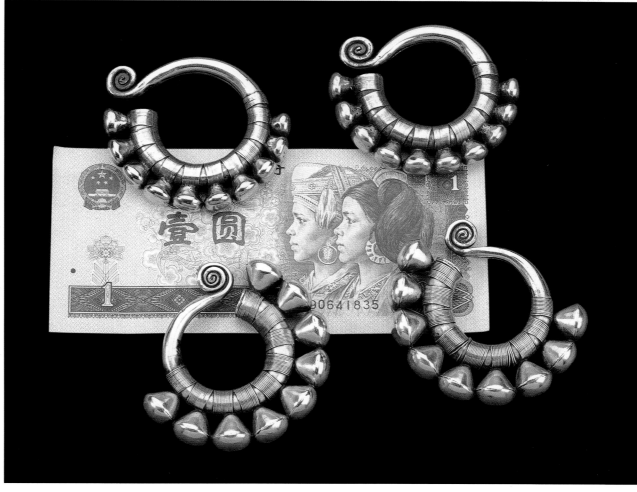

47 (top). *Earrings*
Ag 73%, Cu 26%, trace of Zn
H 5.8 cm, W 5.2 cm; 54 g together
Miao; Guizhou

47 (bottom). *Earrings*
Hook: Ag 62%, Cu 38%;
hanger: Ag 85%, Cu 15%
H 6.7 cm, W 4.5 cm; 43 g together
The hangers show remnants
of green/yellow/blue enamel.

48 (top). *Earrings*
Ag 99%
H 14.5 cm, W 9 cm; 188 g together
Miao; Guizhou, Ludian area
Flat twisted spiral, symbolising the cycle
of life, that has no beginning nor end;
in China a spiral may also indicate
a coiled-up snake.

48 (bottom). *Earrings*
Ag 99%
H 20 cm, W 14.5 cm; 488 g together
Miao; Guizhou, Ludian area
A snake is generally associated with the
fertility of the soil; in spring it rises from
the underworld, like plants rise from the
ground.

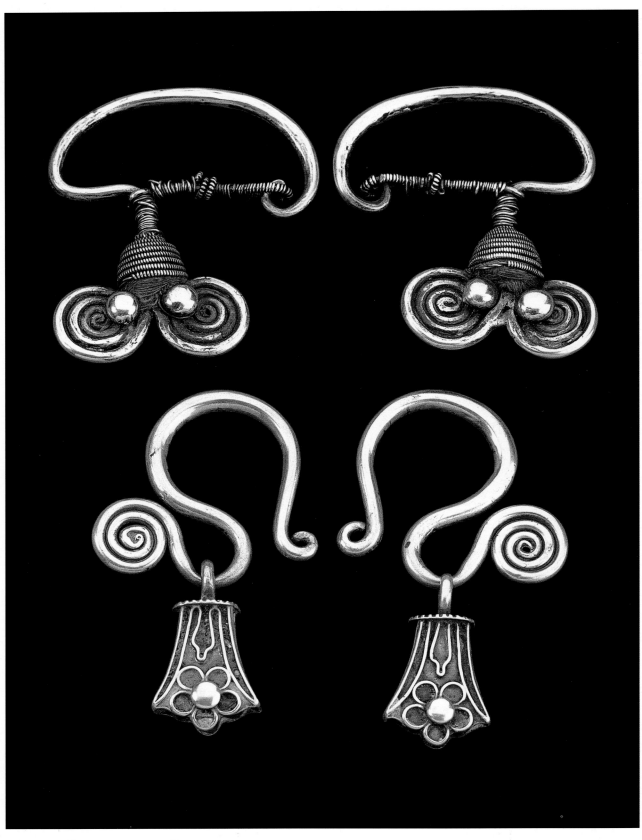

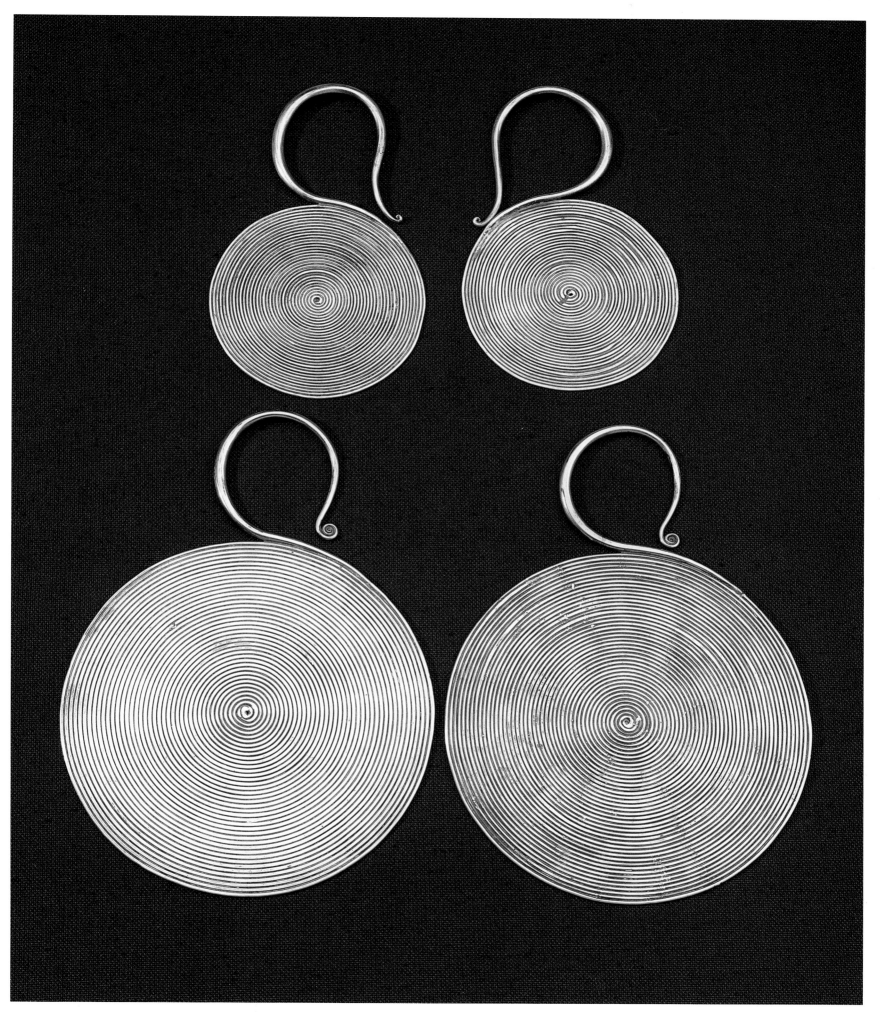

49. *Earrings*
Ag 99%
H 8.5 cm, W 4 cm; 140 g together
Miao; Guizhou

49. *Earrings*
Ag 99%
H 9, W 6.5 cm; 162 g
Miao; Guizhou

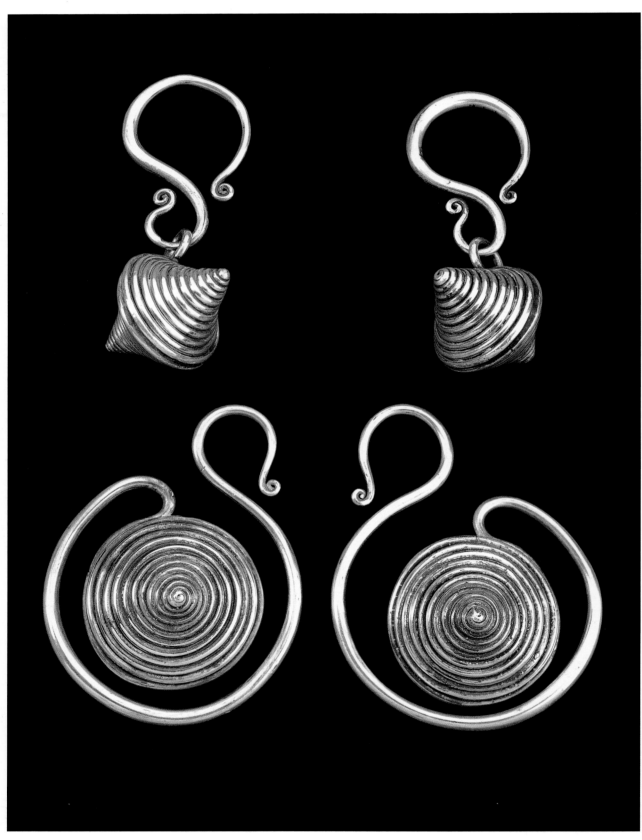

50. *Earrings*
Ag 99%
H 8.3 cm, W 5.5 cm; 80 g together
Yao; Guangdong
This type of earring is depicted on the
Chinese 1 yuan banknote (see ill. 46).

51. *Earrings*
Ag 99%, a trace of Cu
Ø 2.8 cm, thickness 1.2 cm;
28 g together
Dong, but also Miao;
Guizhou, Danzhai area
Very fine filigree work.

52. *Earrings*
Ag 99%
L 13 cm; 60 g together
Yi; Guizhou
Hook form.

53 (top). *Earrings*
Ag 53%, Cu 43%, Zn 2%, Ni 1%
Ø 4.6 cm; 50 g together
Miao ; Guizhou
The front is in the shape of a hand.

53 (bottom). *Earrings*
Ag 91%, Cu 9%
H 4.5 cm, W 3 cm; 12.5 g together
Miao; Hainan Island
Decorative engravings.

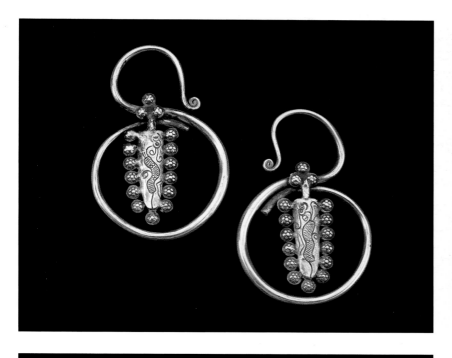

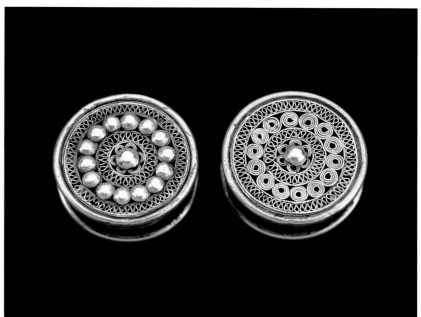

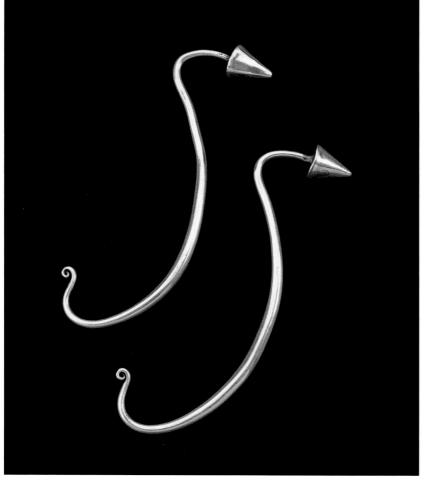

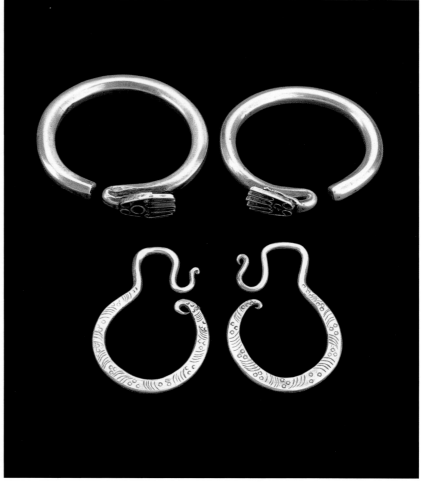

54. *Earrings*
hook: Ag 86%, Cu 14%; hanger:
Ag 93%, Cu 6%
H 8.5 cm, W 5 cm; 74 g together
Dong; Guizhou

55 (top). *Earrings*
Ag 99%
H 6 cm, W 5 cm; 80 g together
Miao; Guizhou

55 (bottom). *Earrings*
Ag 54% Cu 46%
Ø 4.2 cm; 66 g together
Dong and Miao; Guizhou

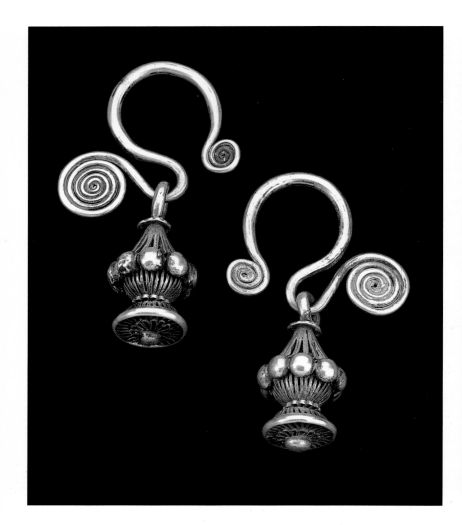

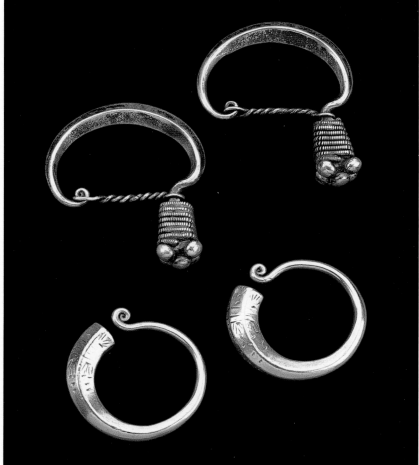

56. *Earrings*
Ag 99%
H 12.8 cm, W 6.2 cm; 136 g together
Miao; Guizhou, Jianhe area

57. *Earrings*
hook: Ag 60%, Cu 40%
bead: Ag 85%, Cu 15%
H 6.5 cm, W 2.7 cm
faceted carnelian and cotton
Where the bead is linked to the hook
the silver is wound with red yarn to
prevent wear.

58. *Earrings*
Ag 99%
Ø 6.2 cm; 142 g together
Miao; Guizhou
The construction with twisted silver wire
is considered old-fashioned nowadays.

59. *Earrings*
Ag 99%
H 6 cm, W 4.8 cm; 41 g together
Miao; Guizhou
Decorative engravings.

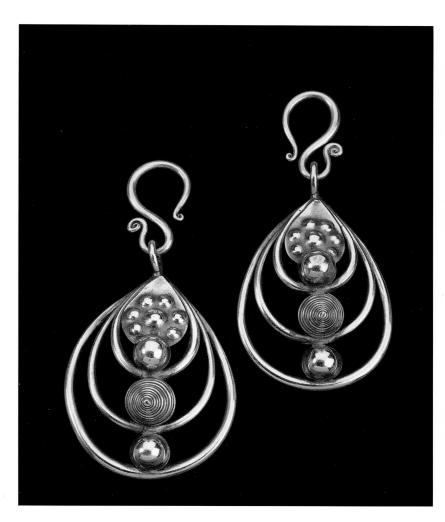

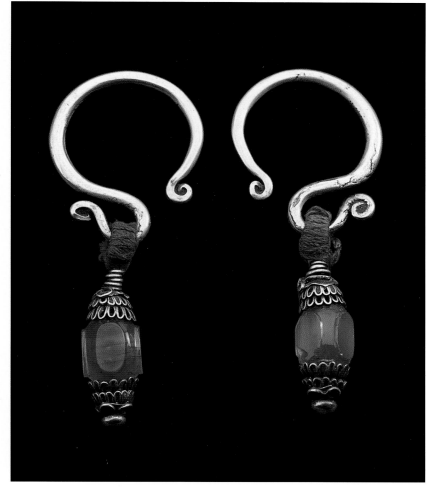

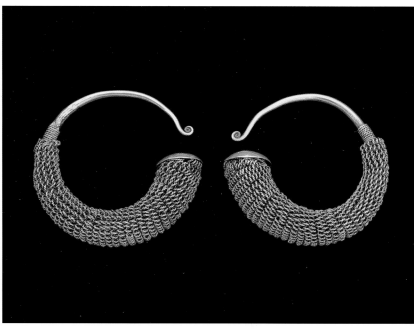

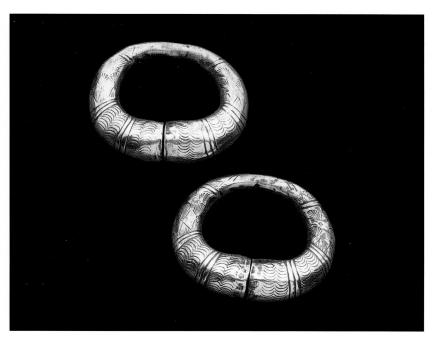

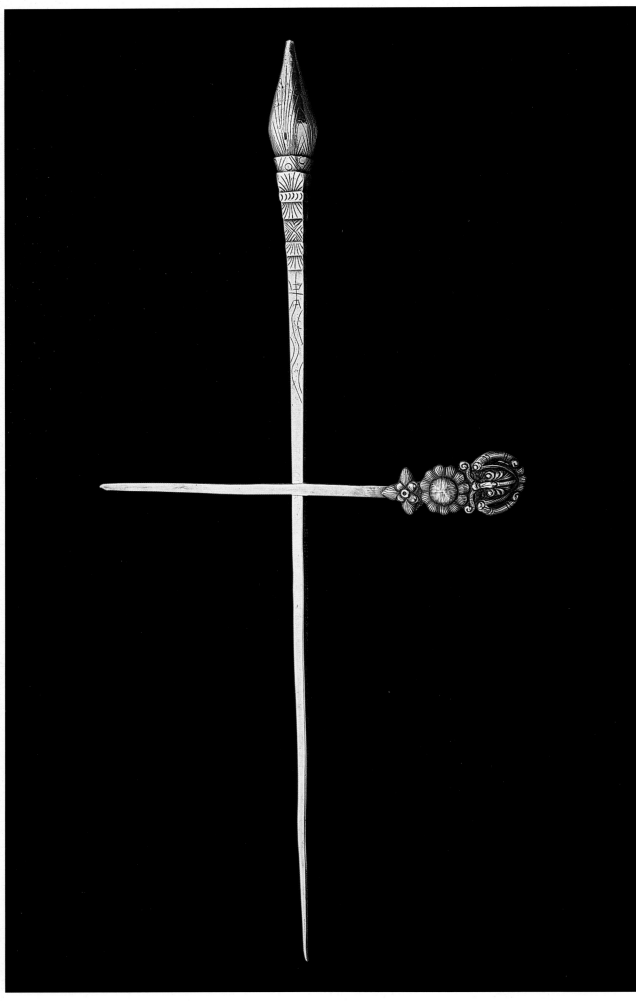

60 (vertical). *Hairpin*
Ag 92%, Cu 8%
L 28.5 cm; 74 g
Miao; Guizhou, Shidong area
The end in the form of a closed bud;
this hairpin is worn together with the
other hairpin in this photograph.

60 (horizontal) and 61.
Hairpin
Ag 92%, Cu 8%
H 13.8 cm; 11 g
Miao; Guizhou, Shidong area
Always worn in combination with the
other hairpin in this photograph.
Opposite page: detail of the top in form
of a flower with bat or butterfly above.

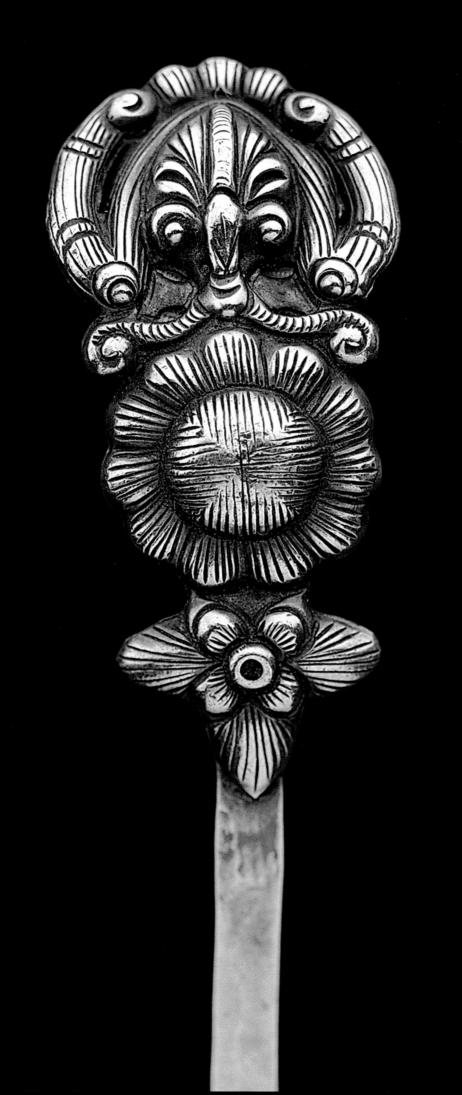

62 (left). *Hairpin*
Bone, cotton, glass beads
L 22 cm; 33 g
Early 20th century
Li; Hainan Island
Engraved bone hairpin; top: human
figure with hat riding a dragon,
geometric motifs; the engravings have
been filled in with black.

62 (centre). *Hairpin*
Bone, cotton, glass beads
L 26.2 cm; 46 g
Early 20th century
Li; Hainan Island
Comparable to the hairpin on the left;
at centre there is also an engraved fish.

62 (right). *Hairpin*
Bone, cotton, glass beads
L 21.8 cm; 34 g
Early 20th century
Li; Hainan Island
See the other two hairpins.

63. Details of the hairpins left and
centre. Li bone hairpins have become
really rare.

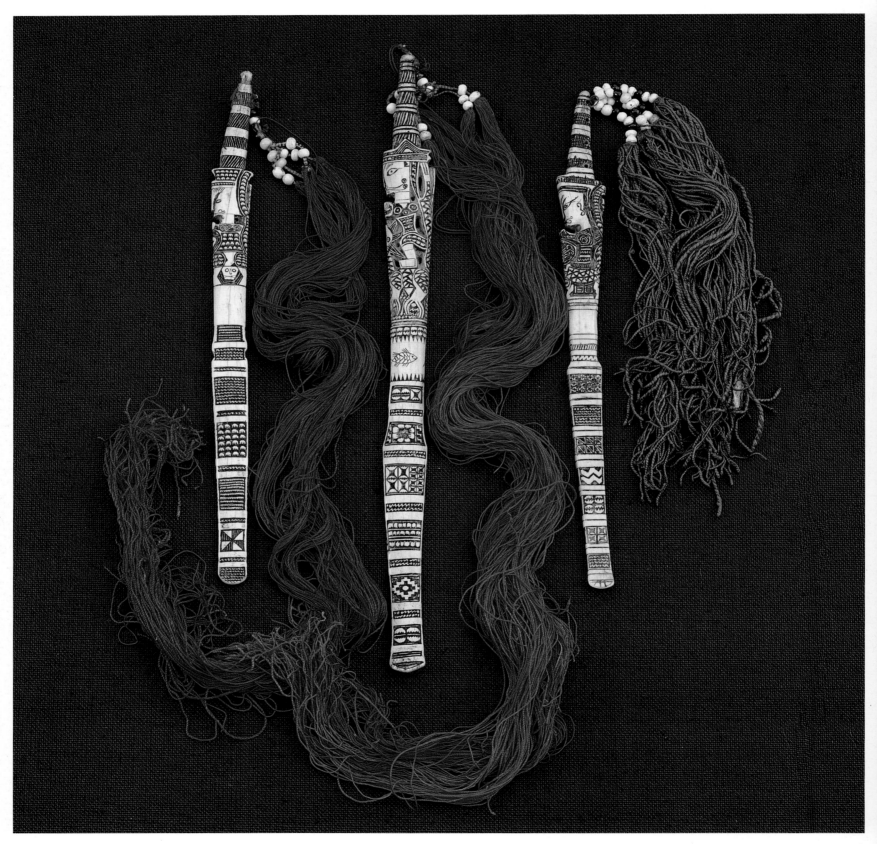

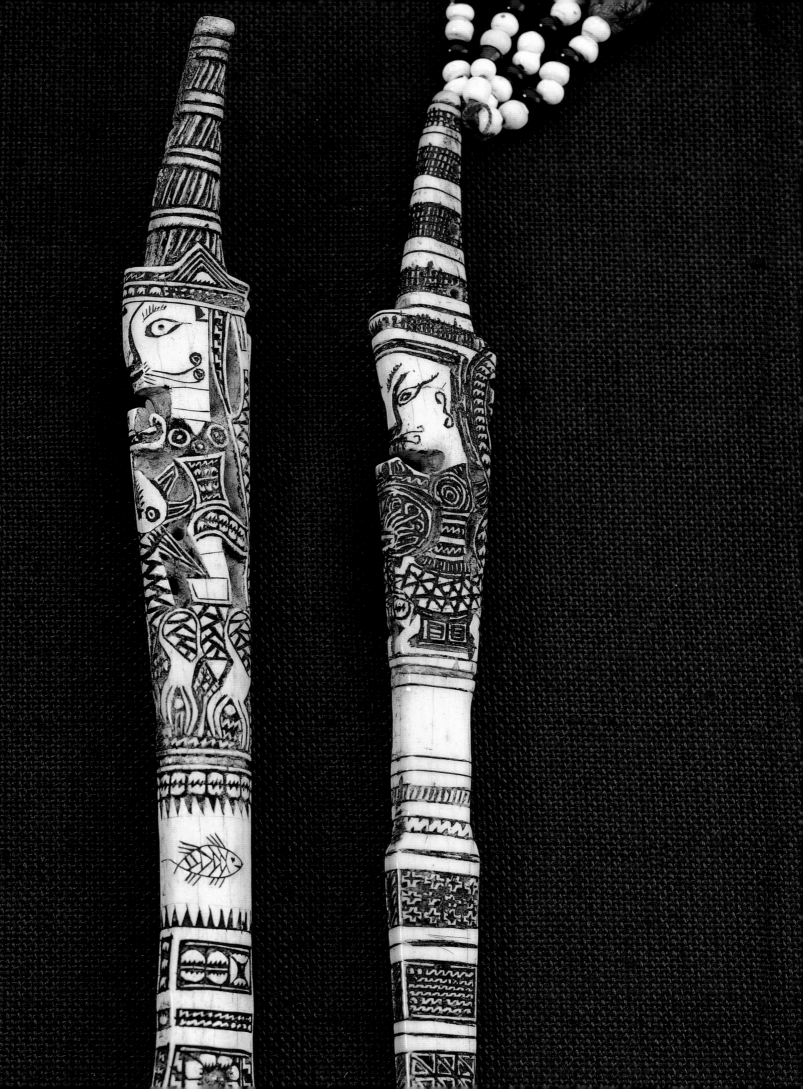

64. *Hairpin*
Ag 99%
L 25 cm, H front (with chain) 10 cm
161 g
Dong; Guizhou, Li Ping area
Knob comparable with Dong back
ornaments; knob engraved with flowers.

65 (left). *Hairpin*
Ag 58%, Cu 42%
L 18.7 cm; 38 g
Dong and Miao; Guizhou and Guangxi,
Sanjiang area

65 (right). *Hairpin*
Pin: Ag 45%, Cu 49%, Zn 4%, Ni 2%;
conical hat: Ag 92%, Cu 8%
L 15.2 cm; 33 g
Miao; Guizhou, Congjiang area

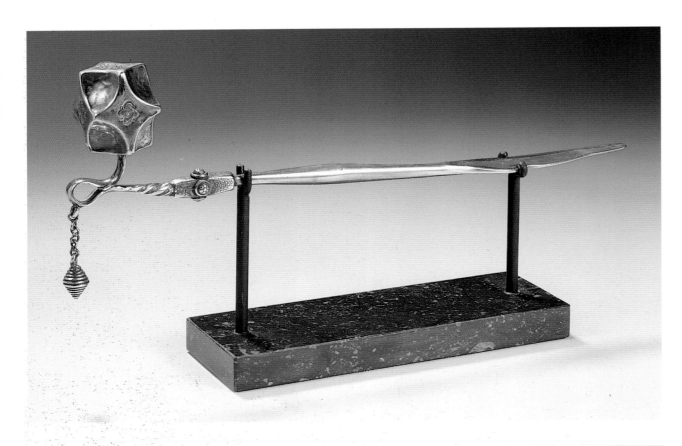

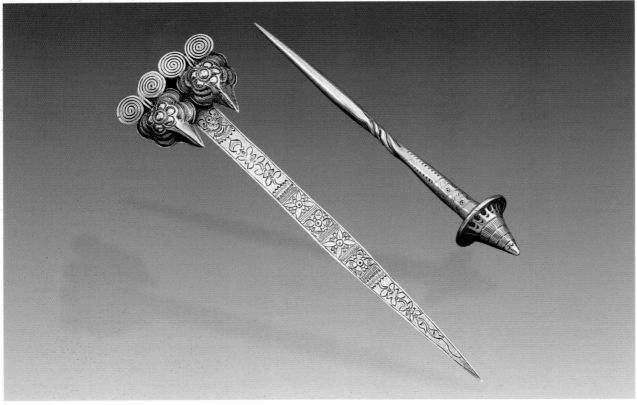

66 (left). *Hairpin*
Ag 99%
L 25.2 cm; 126 g
Li; Hainan Island
Top in the shape of a face with hat;
pin engraved with two human figures.

66 (right). *Hairpin*
Ag 99%
L 23.5 cm; 72 g
Li; Hainan Island
Top in the shape of a face with hat;
engravings.

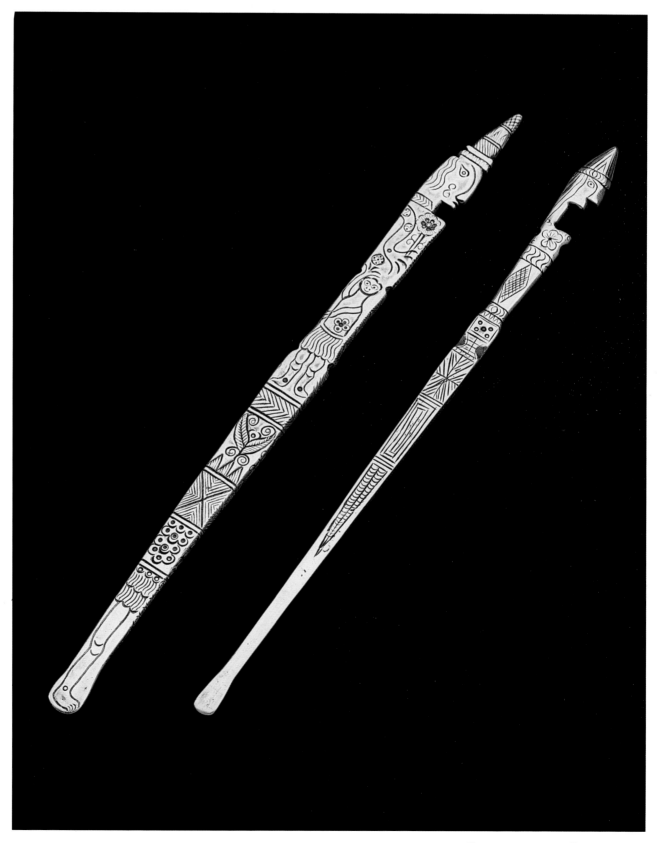

67 (left). *Hairpin*
Ag 69%, Cu 31%
L 16.2 cm; 48 g
Dong; Guizhou
At the end of the pin we see a spoon,
used symbolically to scoop up happiness.

67 (right). *Hairpin*
Ag 99%
L 23.5 cm; 141 g
Miao; Guizhou, Jianhe area
Top consists of a solid knob with three
spiral-shaped ends.

68 (right). *Hairpin*
Ag 60%, Cu 40%
L 9.2 cm; 31 g
Yao; Guizhou
Engraved solid hairpin.

68 (centre). *Hairpin*
Ag 62%, Cu 38%
L 8.5 cm; 37 g
Yao; Guizhou
Engraved solid hairpin.

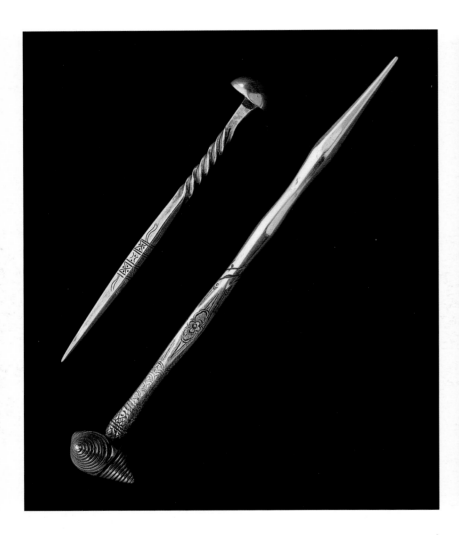

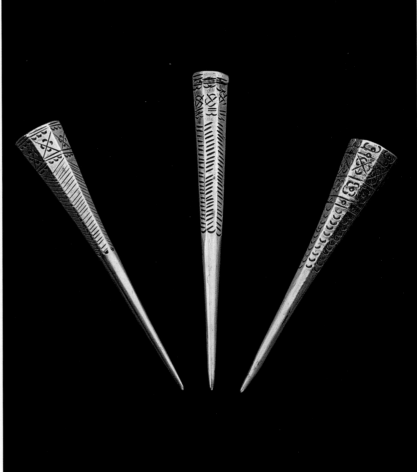

68 (left). *Hairpin*
Ag 56%, Cu 39%, Zn 1%
L 8 cm; 36 g
Yao; Guizhou
Engraved solid hairpin.

69 (left) and 70-71. *Hairpin*
Ag 55%, Cu 44%, Zn 1%
L 26.5 cm, W 6.7 cm; 106 g
Dong; Guizhou
In the front, under the knob, two stamps,
probably the silversmith's (name Xing
Chang; see detail above); on the back, at
the bottom, the owner's name engraved
(Bixiu si, see detail below).

69 (right). *Hairpin*
Alpaca: Zn 14%, Cu 68%, Ni 18%
L 22.8 cm
Dong; Guizhou
Knob with attached balls.

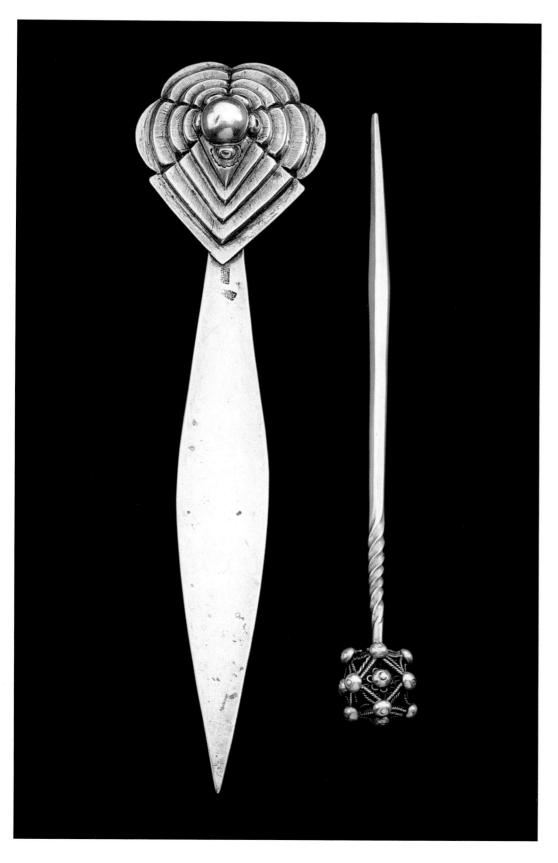

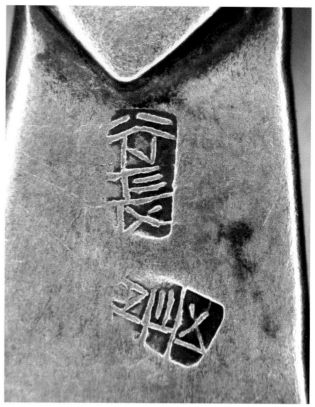

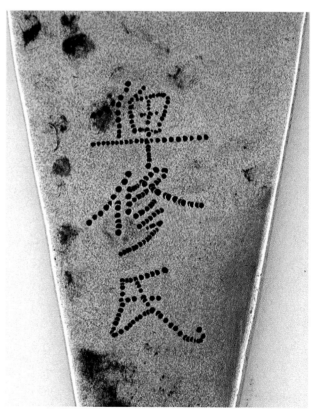

72. *Earrings*
Ag 99%, a trace of Cu
H 16.5 cm, W 10.5 cm; 544 g together
Li; Hainan Island

Earrings consisting of five rings hanging from a hook; the rings are engraved with fish-dragons; in front of the rings a scythe-shaped ornament with two engraved fish holding the Yin–Yang symbols in their mouths; the female dragon is the ruler of the ocean.

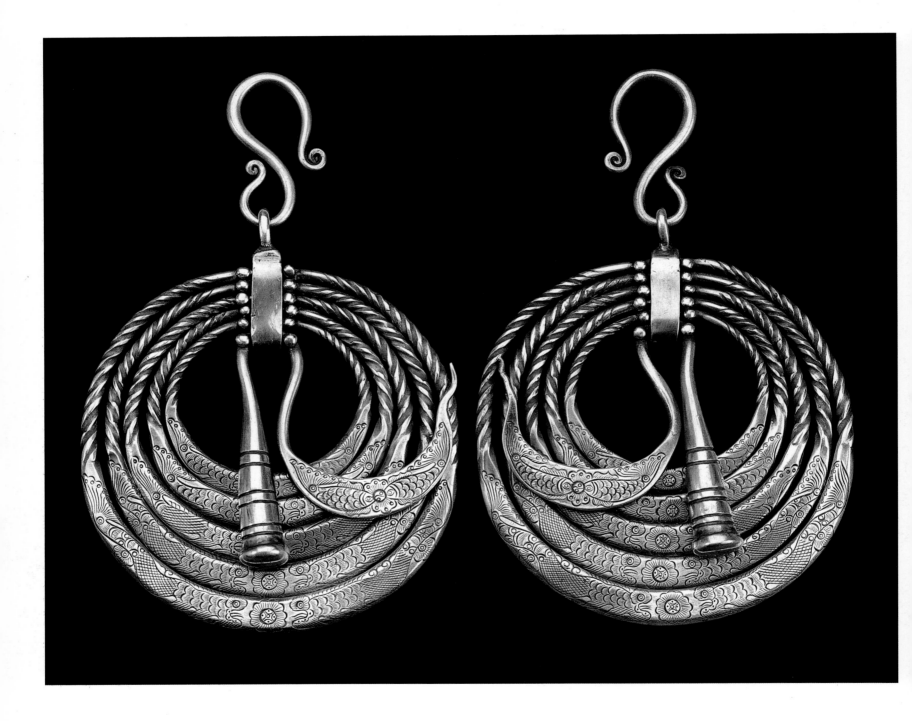

73 (top). *Earrings*
Ag 99%
H 20 cm, W 13.5 cm; 740 g together
Li; Hainan Island
Earrings consisting of eight rings hanging from a hook; the rings are engraved with dragons, two rings showing slight torsion; today this size earring is only worn by old women.
75 (bottom)

73 (bottom). *Earrings*
Ag 99%; H 17.5 cm, W 12 cm
520 g together
Li; Hainan Island
Earrings consisting of six rings hanging from a hook; five rings are engraved with fish-dragons; the outer ring is twisted; in the centre a fish, a symbol of wealth and fertility.

74. *Earrings*
Ag 72%, Cu 26%, Zn 2%
H 6 cm, W 3 cm; 40 g together
Dong; Guizhou
Each earring consists of a butterfly; hanging from it are two blue and yellow glass beads covered with filigree work and dangles.

75. *Earrings*
Ag 74%, Cu 26%, traces of Zn
H 4 cm, W 4.8 cm; 36 g together
Yao; Yunnan
In the centre a triangular element with flowers, comparable with earrings worn by the Hmong in Vietnam and the Golden Triangle.

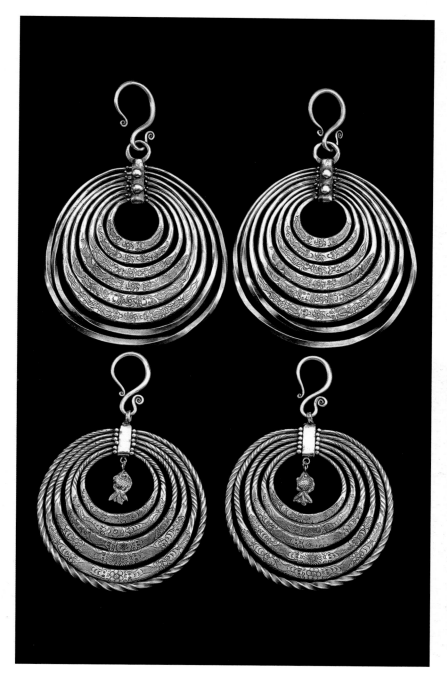

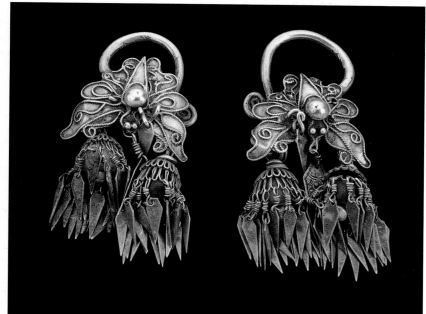

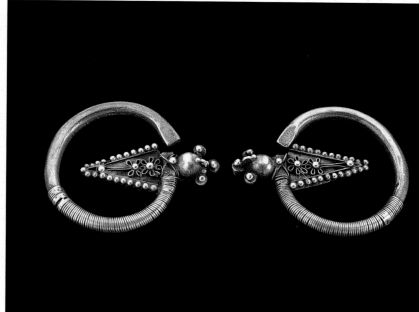

76. *Earrings*
silver-plated alpaca: Zn 10%,
Cu 69%, Ni 20%
H 5.2 cm, W 5.2 cm; 49 g together
Dong; Guizhou
Adorned with flower motifs
(chrysanthemums).

76 (centre). *Earrings*
silver-plated alpaca: Zn 17%,
Cu 67%, Ni 16%
H 5.5 cm, W 6 cm; 54 g together
Dong; Guizhou
Adorned with flower motifs
(chrysanthemums).

77 (hanging). *Earrings*
Ag 99%
H 9.5 cm, W 7 cm; 102 g together
Shui; Guizhou
The Miao have comparable earrings.

77 (flat). *Earrings*
Ag 99%
H 5.8 cm, W 7 cm; 74 g together
Shui; Guizhou

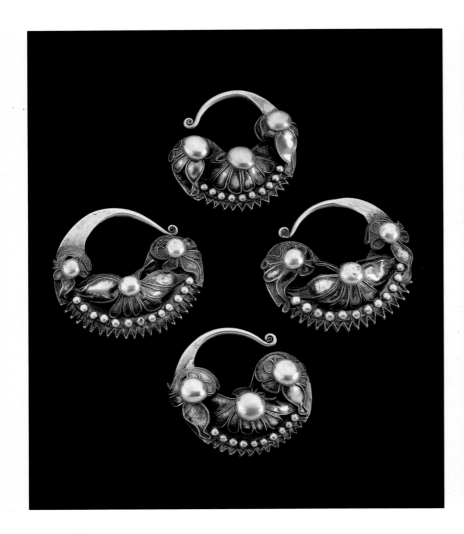

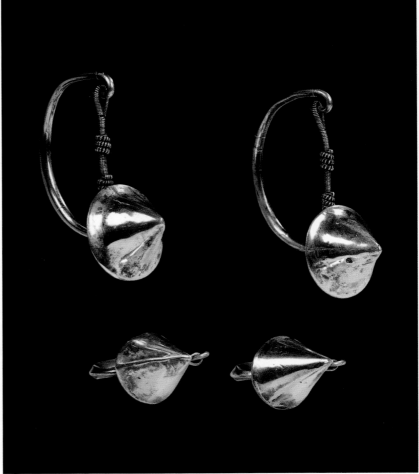

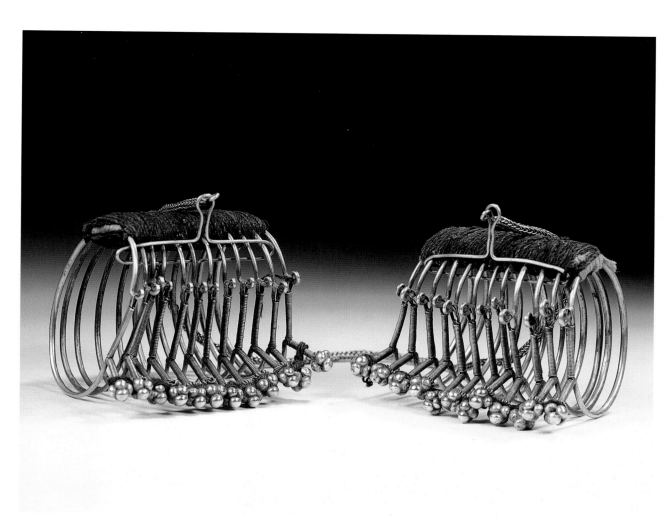

78. *Temple hangers*
Hangers: Ag 59%, Cu 41%, trace of Zn;
chain: Ag 56%, Cu 44%; cotton thread
H approx. 8 cm, L 9 cm, W 8.5 cm
(hangers); chain 29 cm; 456 g together
Yao; Guangxi, Nandan county
Top of the hangers fixed with cotton
thread.

79. *Headband*
Ag 99%, cotton
L 40 cm, H of silver plate: 8 cm; 295 g
Miao; Guizhou, Congjiang area
Headband fastened to cotton cloth.

80. *Tobacco box*
Box: Ag 55%, Cu 43%, Zn 2%;
pendants: Ag 51%, Cu 47%, Zn 2%
Cord with glass bead: H 7.8 cm,
L 3.5 cm, W 2.5 cm; pendants approx.
6 cm; 104 g
Miao; Guizhou
A cord passes through the three sections
of this box, which has the same shape as
a Japanese medicine container (*inro*).

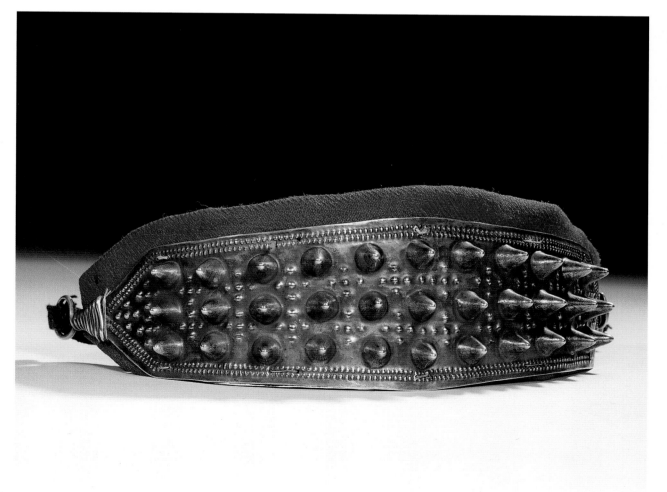

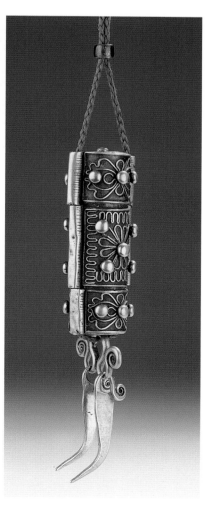

81 (top). *Silver plate*
Ag 99%
H 10.2 cm, W 10.2 cm; 23 g
Miao; Guizhou, Shidong area
These plates are used to decorate
traditional dress at festivals; the plate
shown was made in the mould below.

81 (bottom). *Lead mould*
Pb 84%, Sb 16%
L 9.8 cm, W 9.8 cm, thickness 2.7 cm
2685 g
Miao; Guizhou, Shidong area
This mould consists of two parts; it was
made by the silversmith himself and lasts
some seven years.

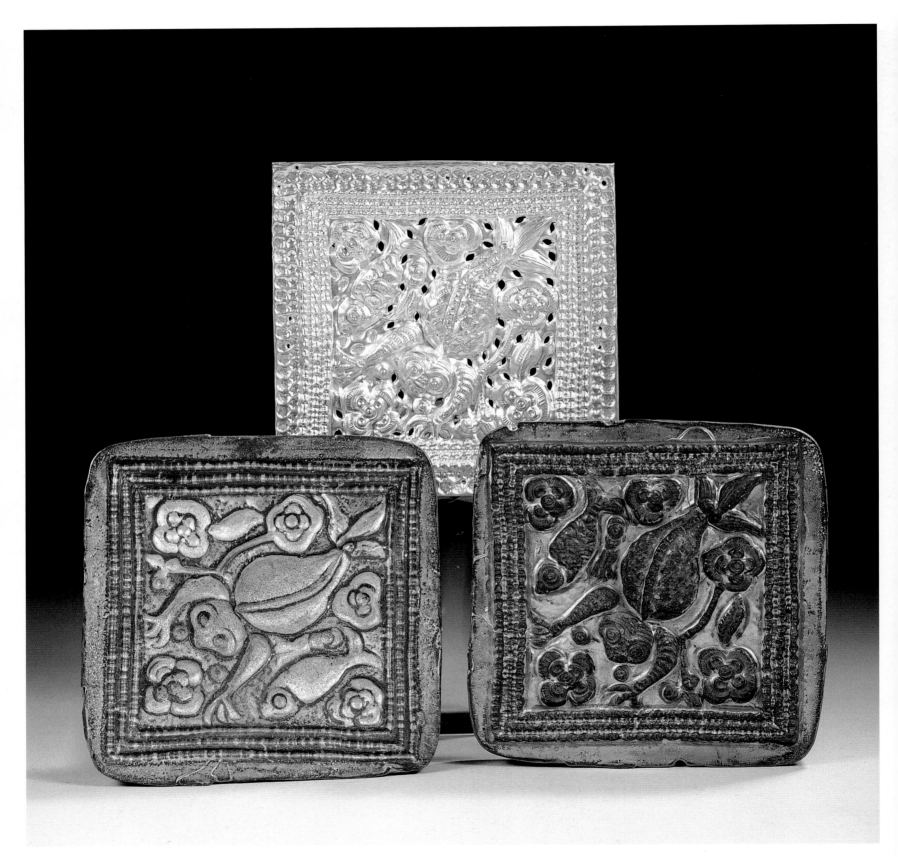

82. *Headdress*
Ag 99%
L 43.5 cm, W 24.5 cm; 1140 g
Yao; Guangxi, Zhuang autonomous region
Three bent silver bars are joined and are attached to the head by means of pieces of fabric.

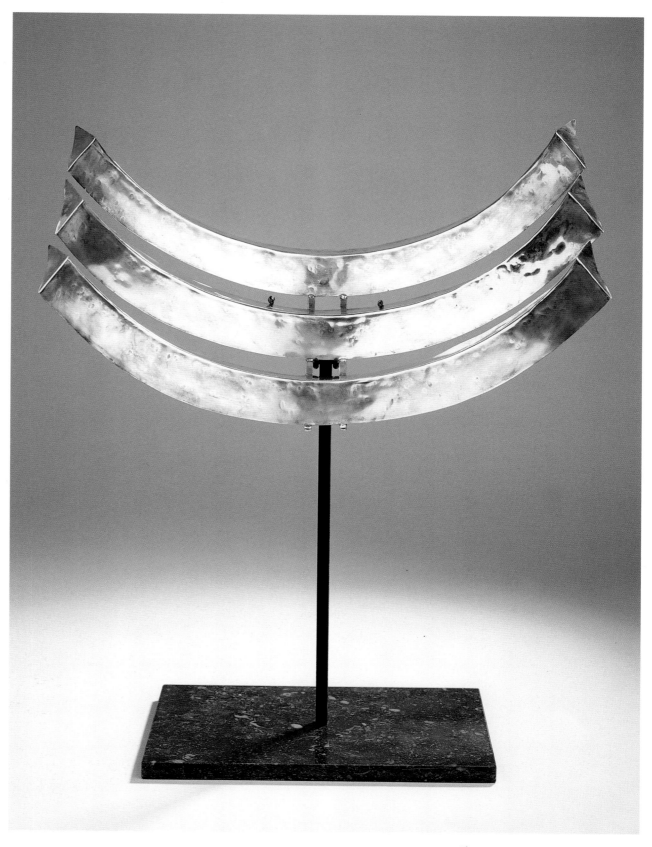

83. *Back ornament*
(set of two)
Ag 81%, Cu 19%; Ag 82%, Cu 18%
L 10 cm, W 10.8 cm, H 8 cm;
L 10.5 cm, W 8.5 cm, H 3 cm
175 g, 119 g; 294 g together
Dong and Miao; Guizhou, Li Pin area
This small set was worn by young girls
during festivals.

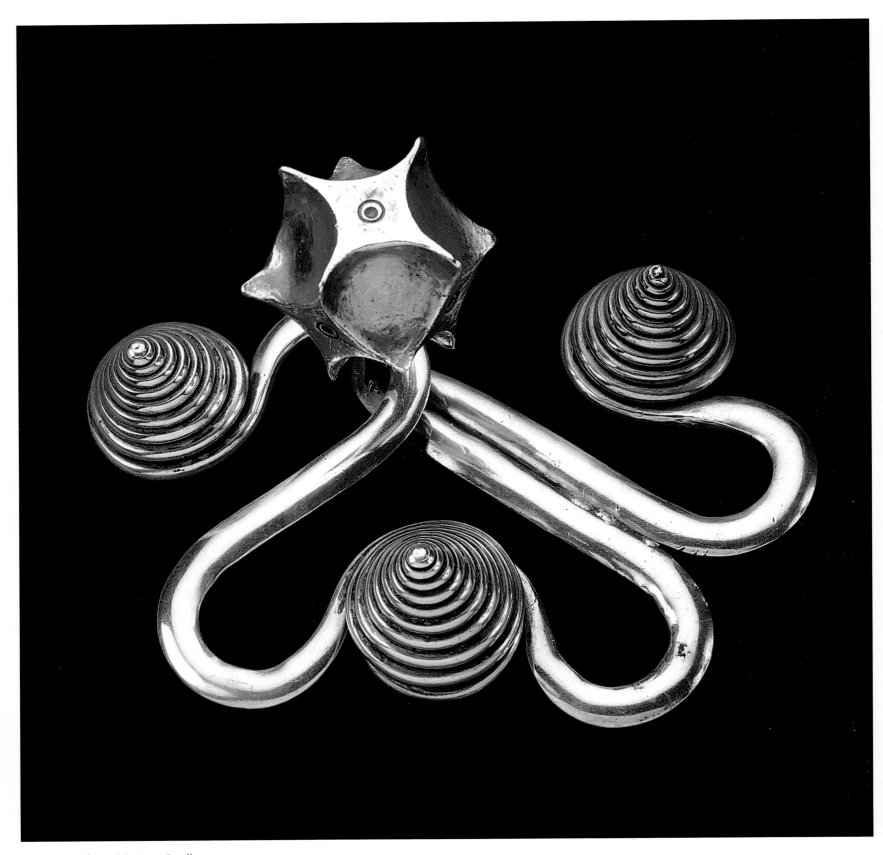

84-85. *Back ornament*
Ag 73.1%, Cu 23.7%, Ni 1.6%,
Zn 1.6%
H 7.5 cm, L 4 cm, W 4 cm; 565 g
Dong; Guizhou

The function of this back ornament is to
counterbalance an apron; cubiform with
flattened corners; eighteen surfaces
(squares and triangles) in total, seven
of which with identical stamps of
silversmith's mark name: Tian He
(see detail).

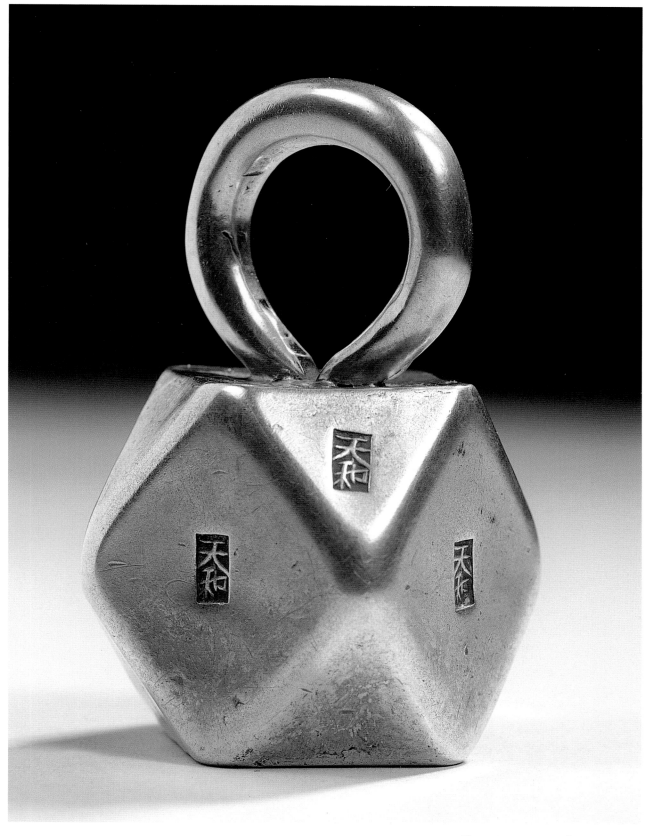

86 (left). *Back ornament*
Ag 99%
L 17.5 cm, W 12 cm, H 5 cm; 526 g
Dong and Miao; Guizhou, Li Pin area

S-shaped back ornament, pyramid-shaped spirals at either end; this ornament is often worn in combination with the ornament on the right; together they form a set, though they are sometimes worn separately.

86 (right)-87
Back ornament
Ag 99%
H 10.5 cm, L 14.5 cm W 17 cm; 745 g
Dong and Miao; Guizhou, Li Pin area

Three-dimensional back ornament, often worn in combination with back ornament on the left; knob with two pyramid-shaped spirals.
Opposite page: detail of engravings with the Yin– Yang symbol in the centre.

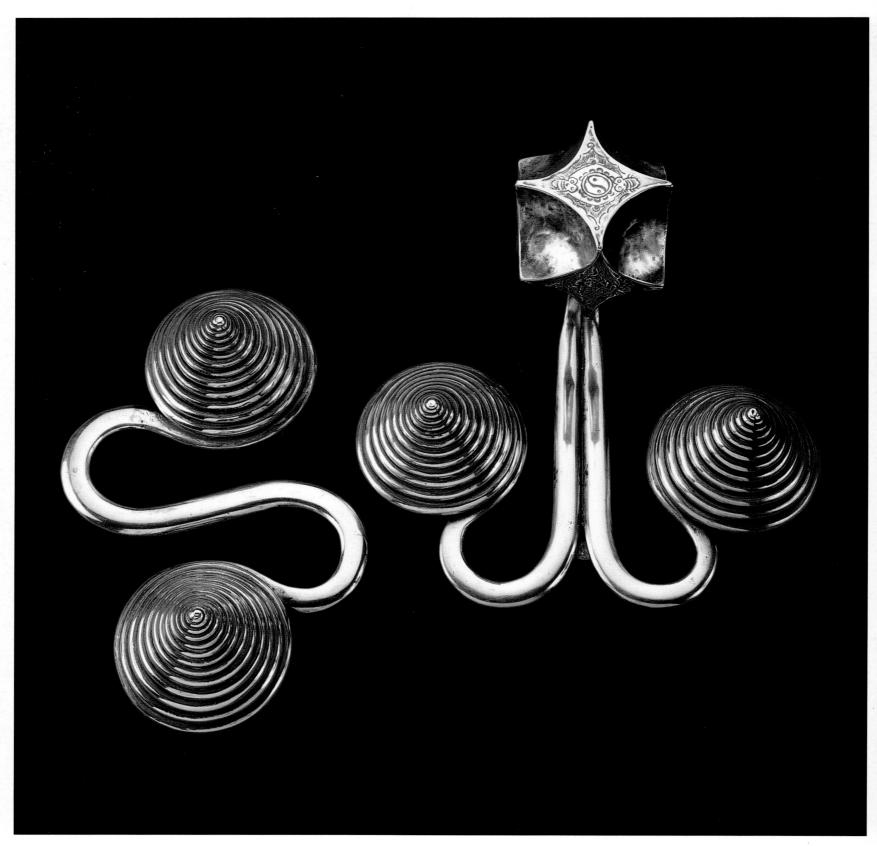

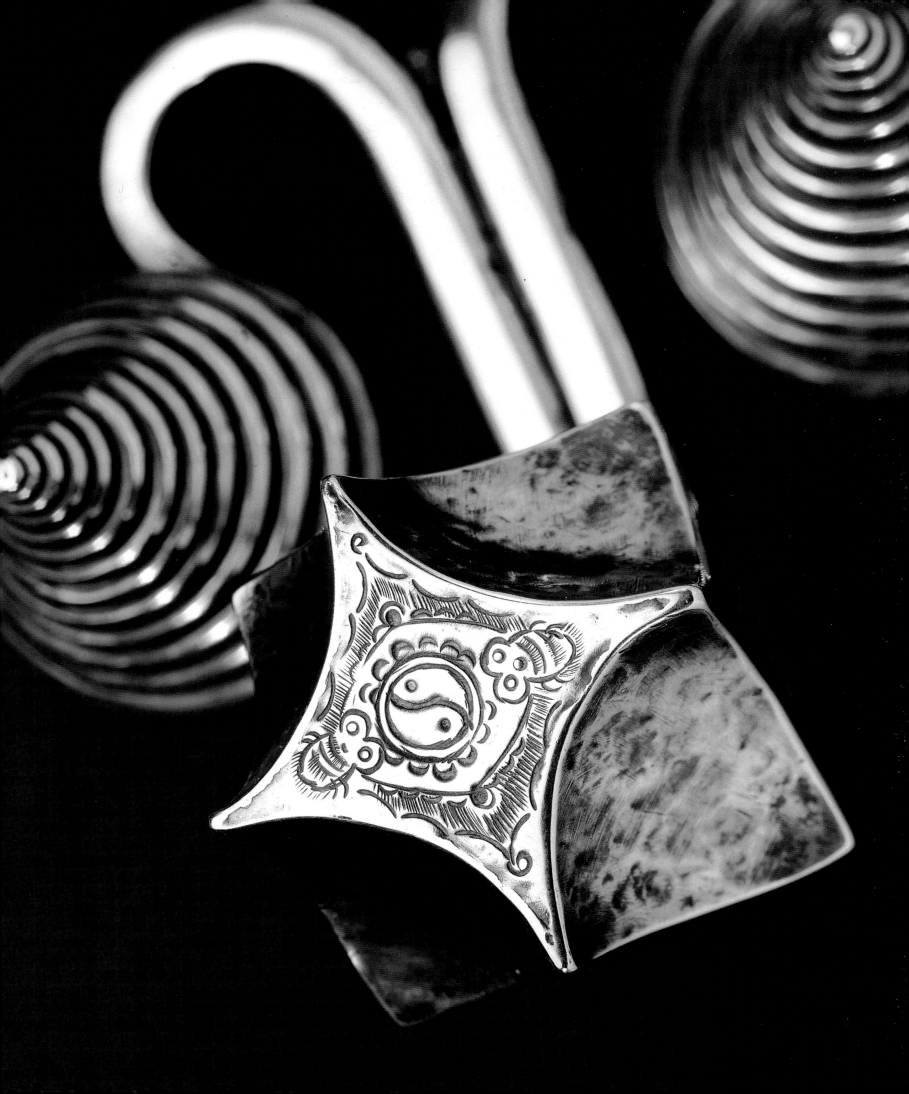

88 (top right) and 89. *Back ornament*
Ag 61%, Cu 38%, Zn 1%
H 10 cm, W 7.4 cm; 100 g
Dong and Miao; Guizhou, Zhaoxing area
In many cultures a spiral symbolises the
never-ending cycle of life, that has neither
beginning nor end.

88 (bottom right). *Back ornament*
Ag 51%, Cu 48%, Zn 1%
H 10.5 cm, W 8.5 cm; 145 g
Dong and Miao; Guizhou, Zhaoxing area

88 (left). *Back ornament*
Ag 62%, Cu 38%
H 15.5 cm, W 13 cm; 198 g
Dong and Miao; Guizhou, Zhaoxing area

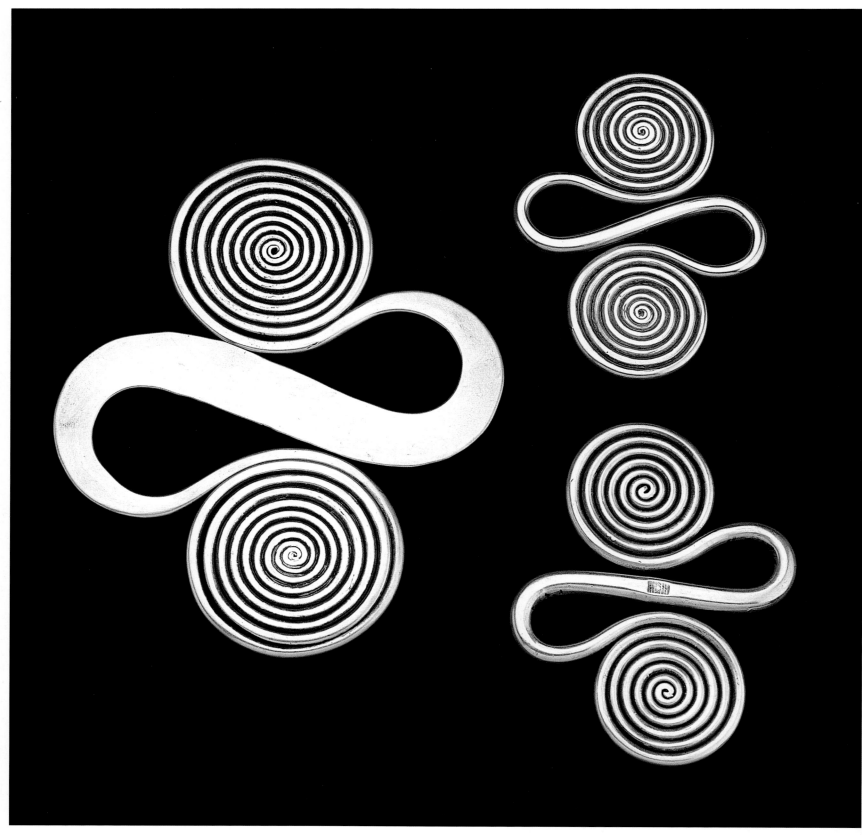

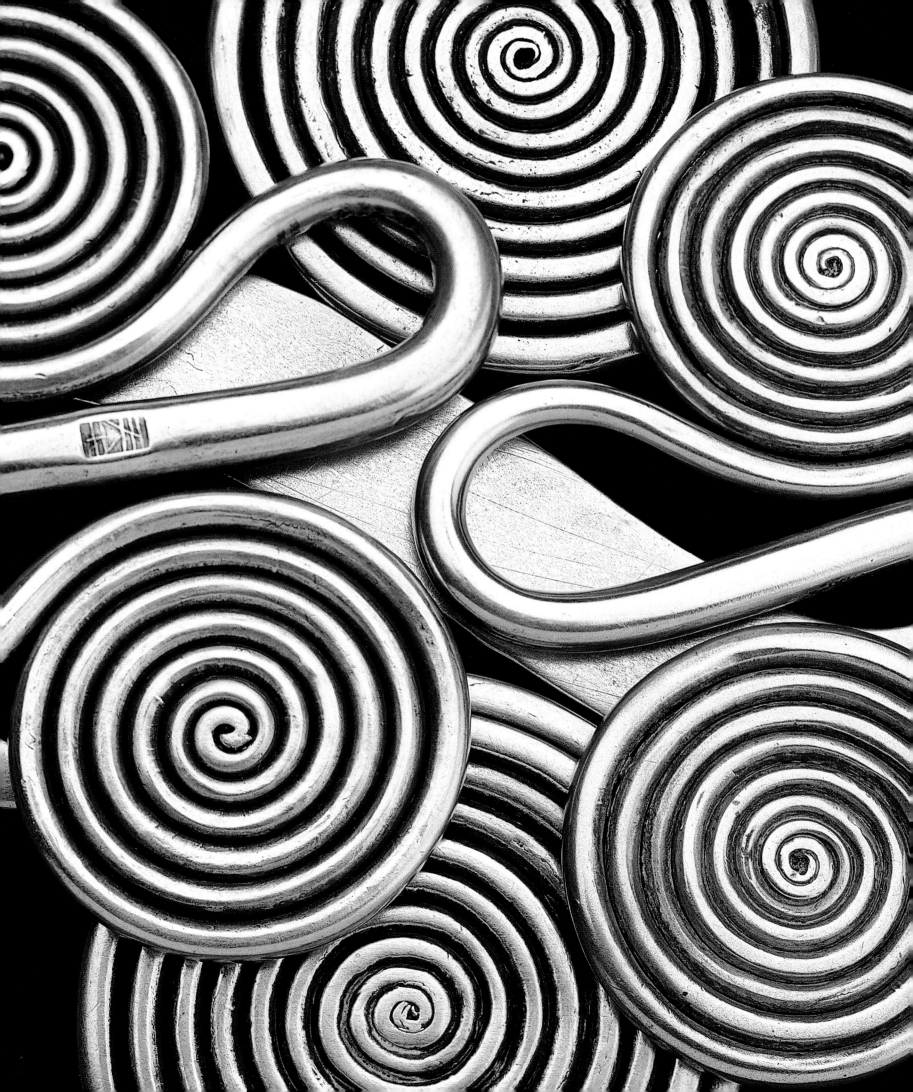

90. *Back ornament*
Ag 99%
L 21 cm, W 14.3 cm; 505 g
Dong; Guizhou, Congjiang area
Double spiral, middle part engraved with
two dragons; in many cultures a spiral
symbolizses the cycle of life, that has
neither beginning nor end.

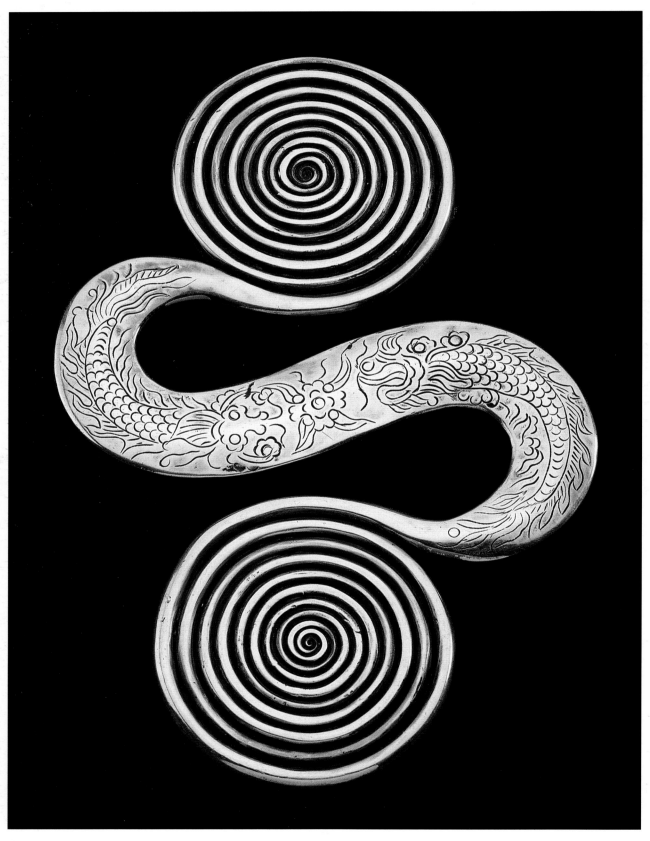

91. *Bridal collar*
Ag 99% plus cloth; Chinese 20-cent
coins from Kwang Tung province
Ø 83 cm; 1940 g
Yi; Yunnan, Yuanyang area
Bridal collar on cloth, consisting of
six plates of silver, each provided with
three different ornaments and four oval
platelets with dangles.

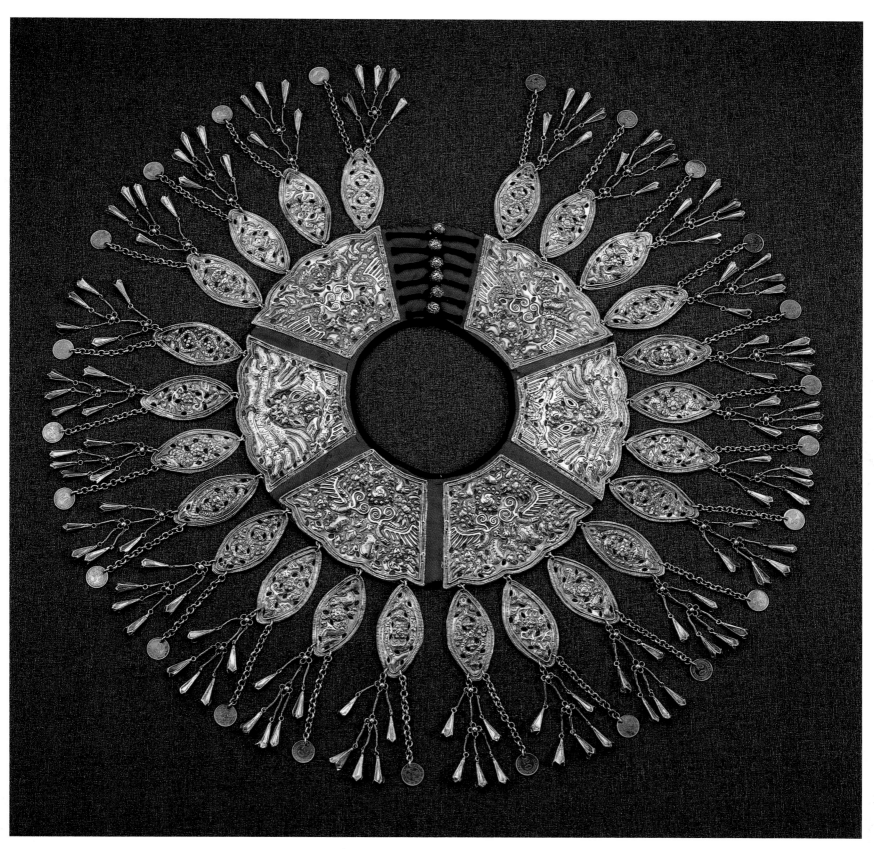

92-93. *Neckring*
Ag 99%
H 21.2 cm, W 25.8 cm; 477 g
Zhuang or Yi; Guizhou
Adorned with engravings of dragons,
and others.
Opposite page: detail of a bird,
a butterfly and floral motifs.

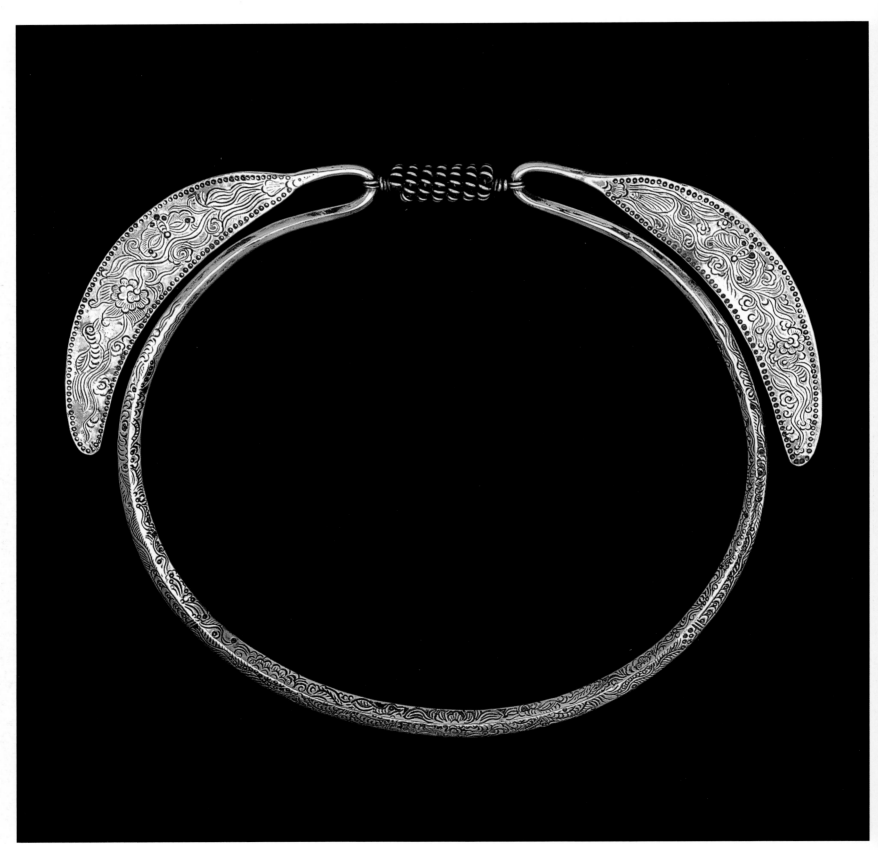

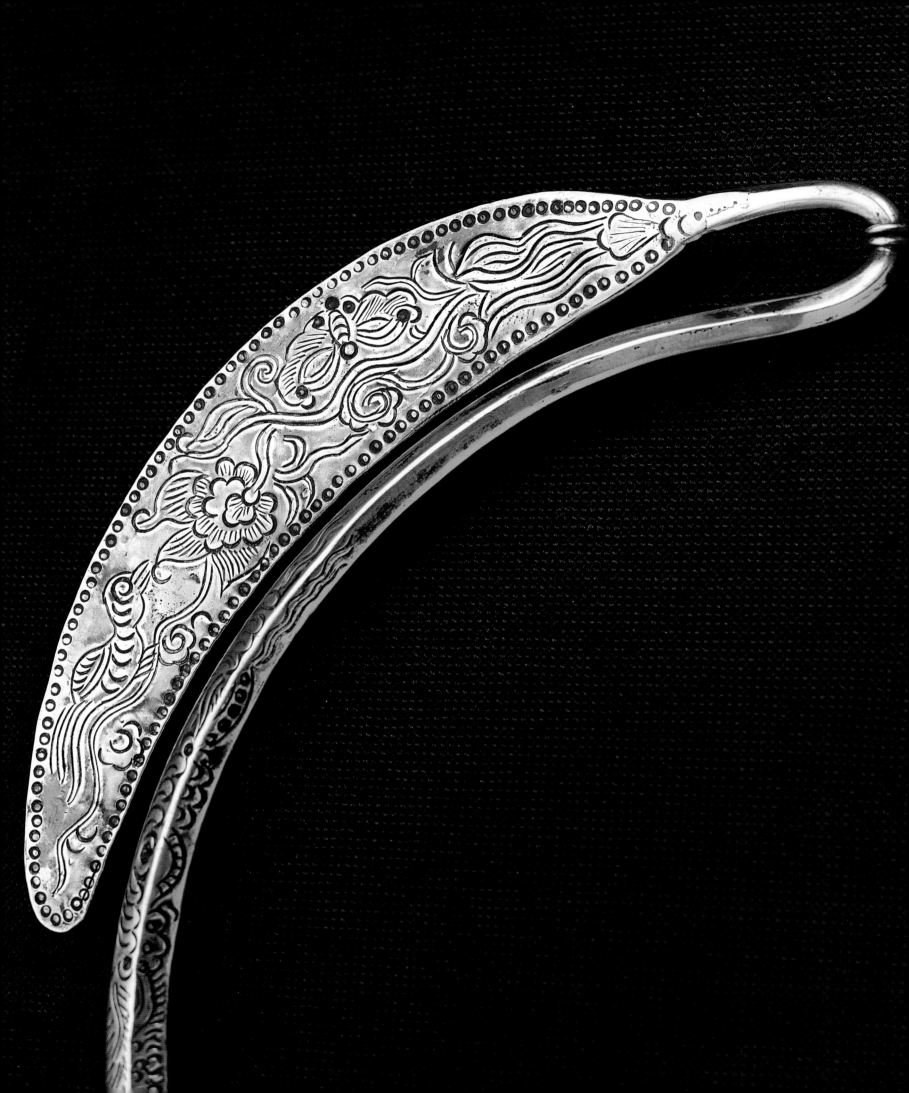

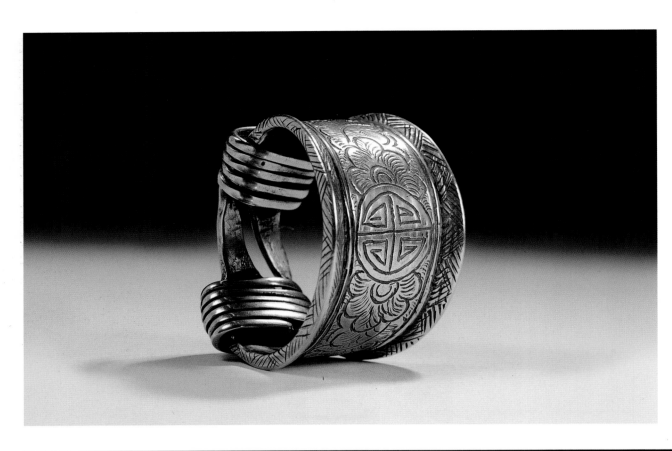

94. *Bracelet*
Ag 60%, Cu 35%, Zn 3%, Cd 2%
H 4.5 cm, Ø 6.5 cm; 170 g
Miao; Guizhou
Engraved with, among others, the Shou
ideogram, which embodies a wish for
a long life.

95. *Bracelets*
Ag 99%
H 5.5 cm, W 7.2 cm; 215 g together
Miao; Guizhou, Gejia area
Openwork part in the centre consisting
of slightly twisted bands; engravings with
butterflies, and others, on either side.

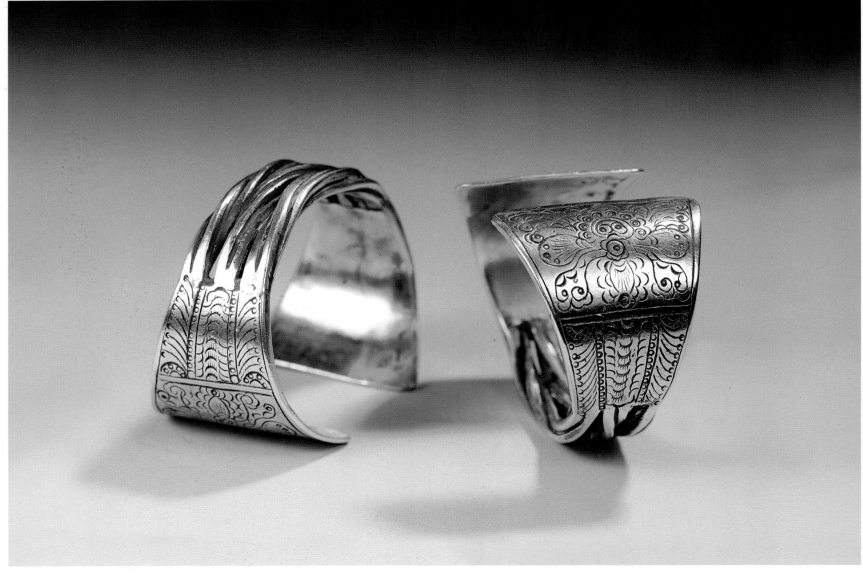

96. *Bracelets*
silver-plated alpaca: Cu 72%,
Ni 3%, Zn 23%
H 7.5 cm, W 8 cm; 218 g together
Miao; Guizhou
Nicely faceted.

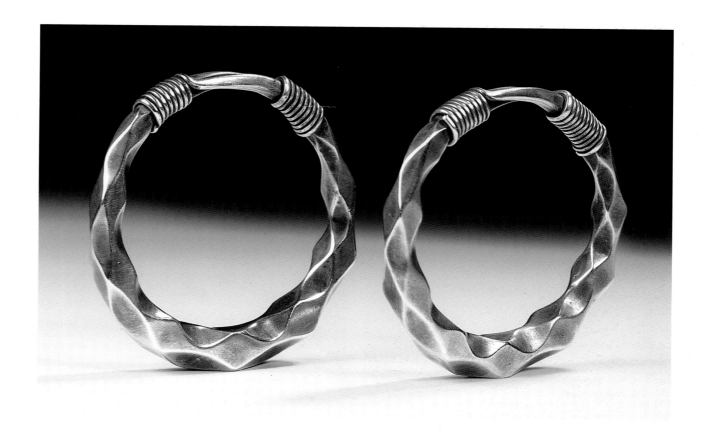

97-98. *Bracelets*
Ag 95%, Cu 3%, Zn 2%
Ø 9.5 cm; 358 g together
Miao; Guizhou, Shidong area
Each bracelet consists of 7 metres of
drawn and twisted silver wire; the
manufacture of each bracelet took a full
week. The top of the bracelet has a
stamp, in this case the owner's name
(see detail below), Zhang Zheng Hua,
the silversmith's wife in Shidong, who
was our hostess. This pair was made on
the occasion of their thirtieth wedding
anniversary in 1998.

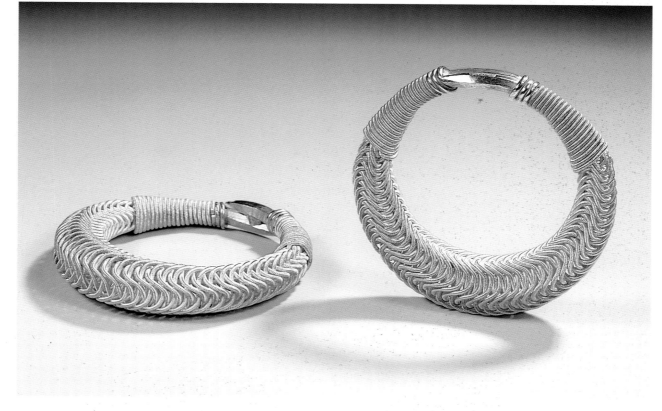

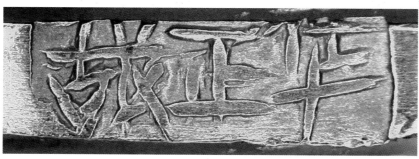

99. *Bracelets*
Ag 97%, Zn 3%
H 7.8 cm, W 8.7 cm; 298 g together
Miao; Guizhou
Company name on the inside of both
bracelets; flower ornaments; very good
quality – rare.

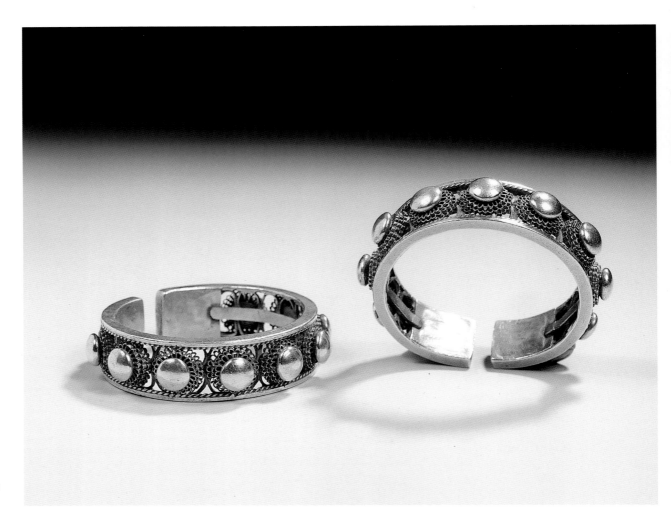

100 (right). *Bracelets*
Ag 88%, Cu 6%,Zn 6%
H 7.6 cm, W 8.8 cm; 138 g together
Miao; Guizhou
Silver bracelet filled with resin; these
bracelets represent caterpillars (animals
that have the power to turn into dragons!)

100 (left and upright). *Bracelets*
Ag 98%, Cu 2%
H 7.8 cm, W 8.8 cm; 180 g together
Miao; Guizhou
Stylized dragons with the Yin–Yang
symbols above the face; on the back these
symbols as well, together with four fish.

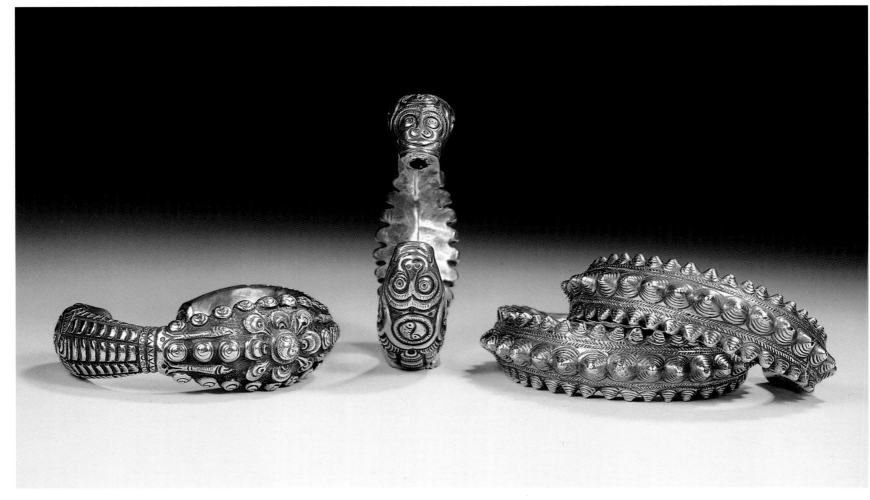

101. *Neckring*
Ag 99%; fastener: Ag 98%, Cu 2%
H 22.5 cm, W 33.5 cm, maximum
thickness 4.5 cm; 1265 g
Miao; Guizhou, Pin Ba area
Tapered neckring consisting of eight
bands with intermediate open spaces; the
ends of the bands ending in small spirals.

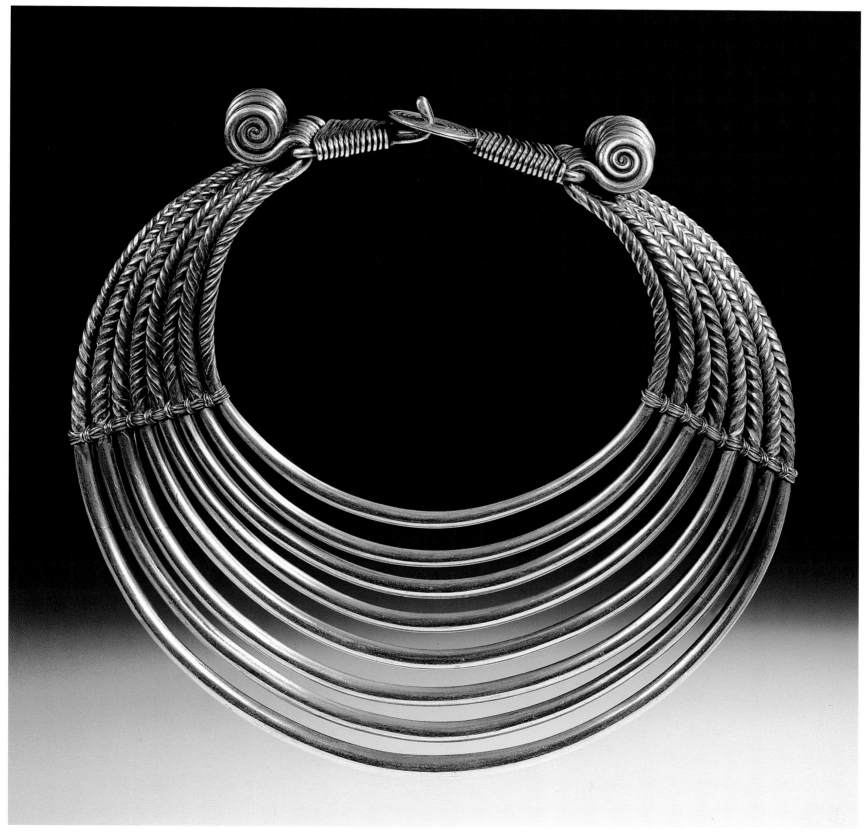

102-103. *Neckring*
Ag 98%, Cu 2%
H 19 cm, W 29.4 cm; 1545 g
Miao; Guangxi, Sanjiang area

Engraved ring consisting of five bands;
in the middle of each band a flower
containing the Yin–Yang symbol; very
fine engravings of dragons, butterflies,
and others.
Opposite page: all engravings are each
other's mirror image, starting from the
flower in the centre.

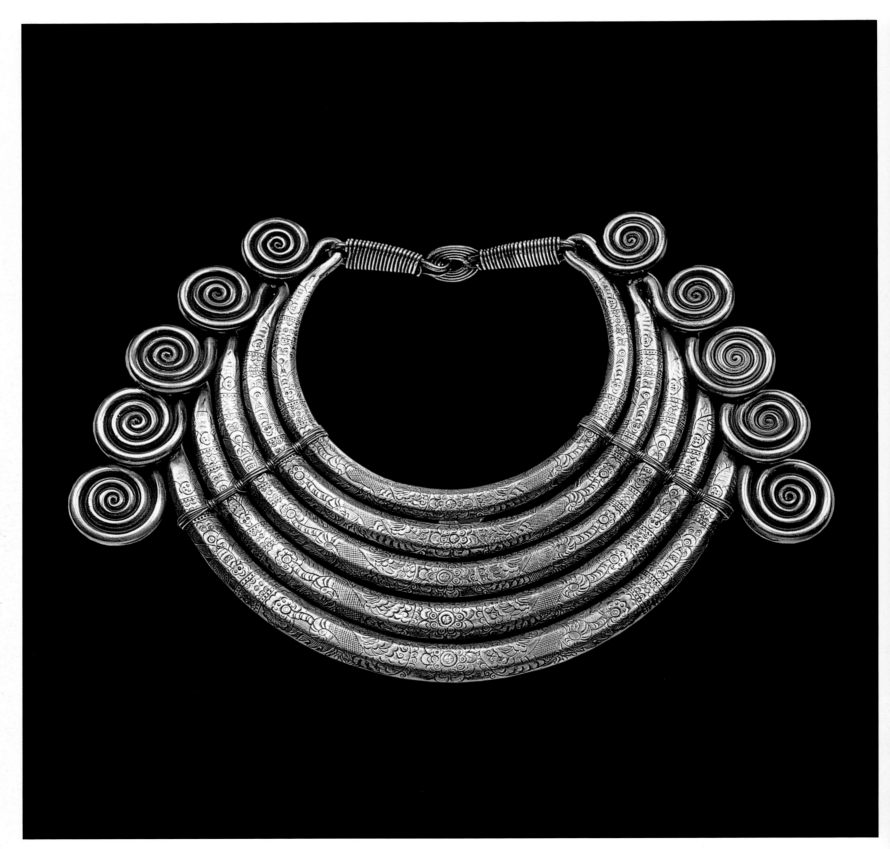

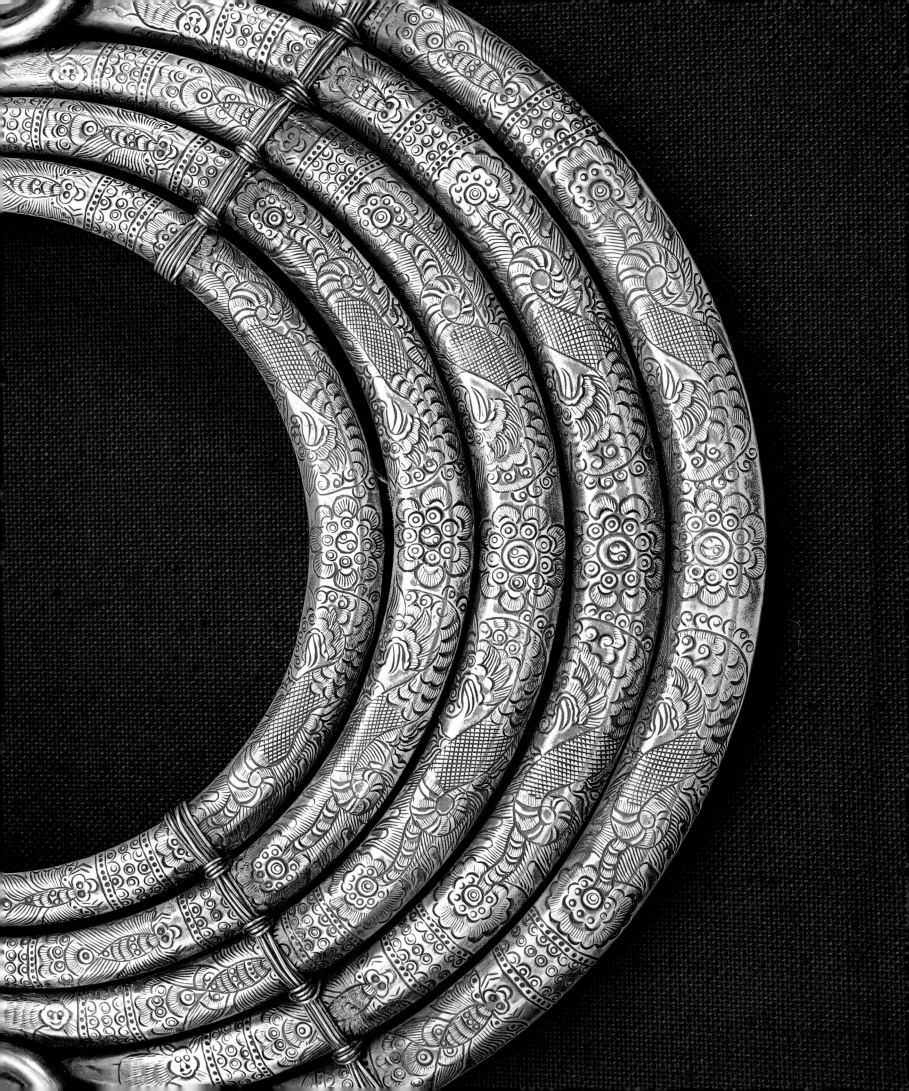

104-105. *Neckring*
Ag 98%, Cu 2%
Ø 29 cm, maximum thickness 4.5 cm
2610 g
Miao; Guizhou, Huangping area
Six engraved bands, ending in a spiral
and joined by silver wire.

Opposite page: engravings of water
buffaloes, phoenixes, frogs, fish,
butterflies, and others.

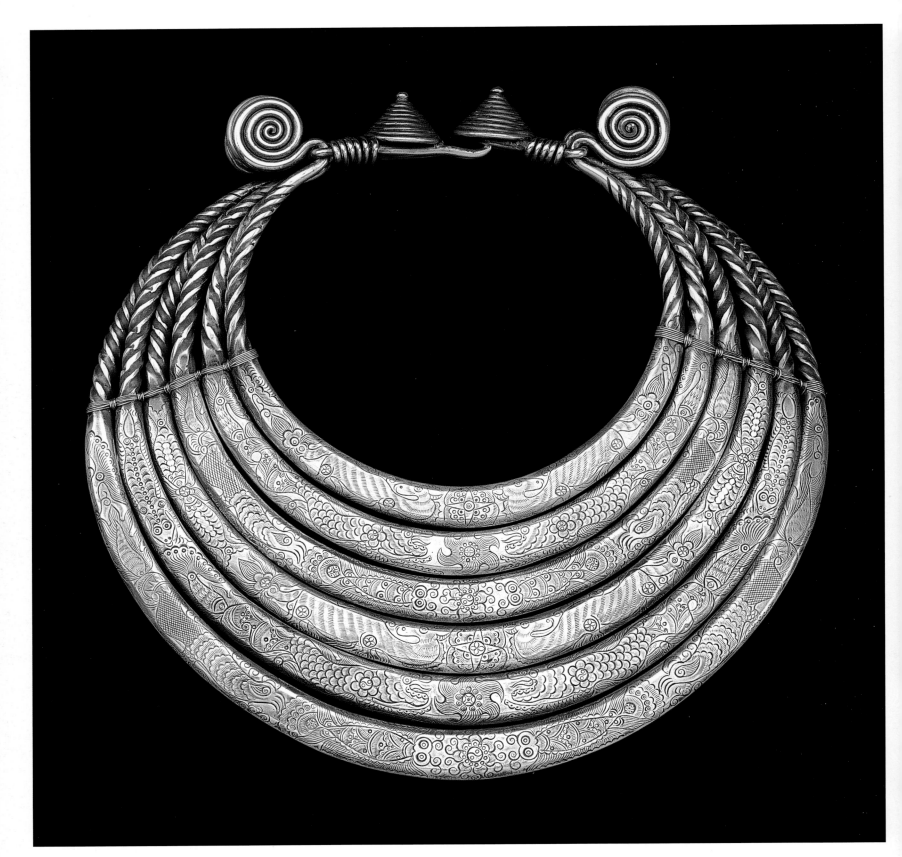

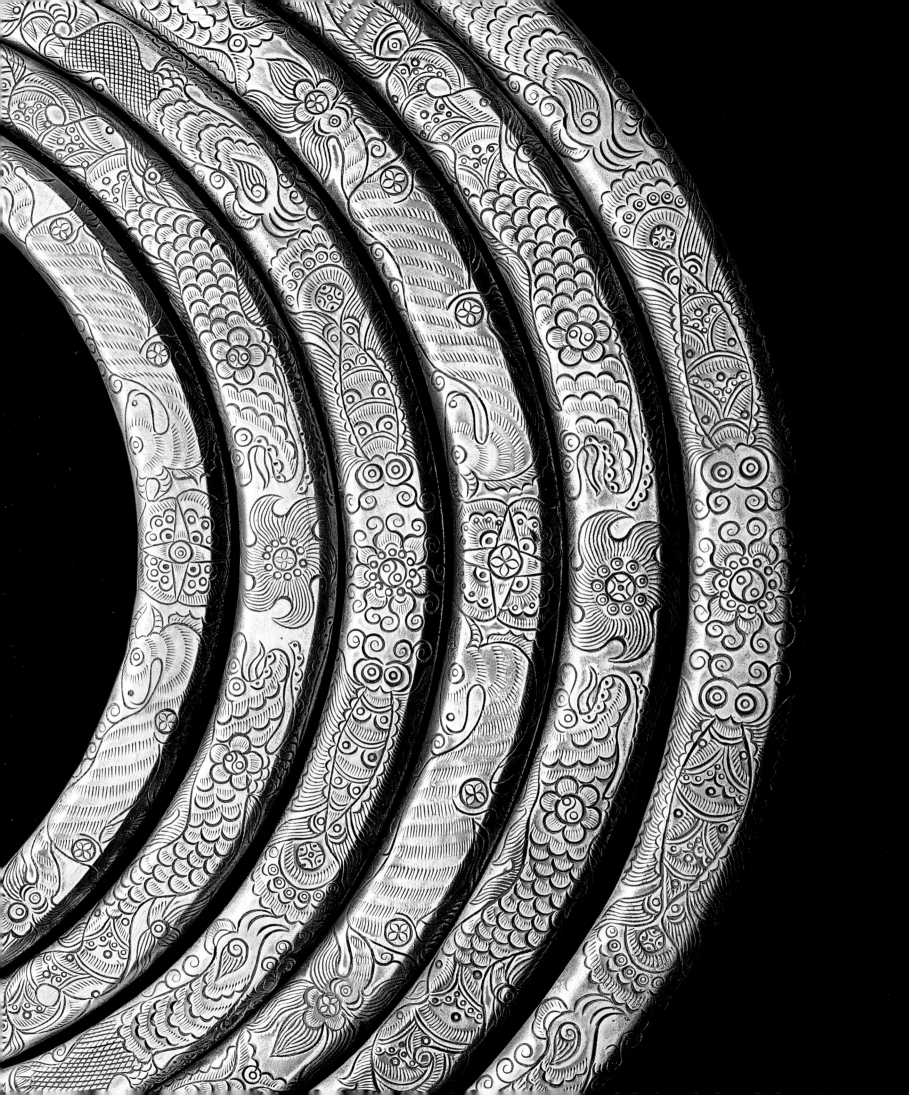

106. *Neckrings*
(set of two)
Ag 99%
Ø 19.5 cm and Ø 16.5 cm; 680 g
and 560 g
Miao; Guizhou

Set of two separate neckrings; fasteners at
the top. Both neckrings are of braided
silver; because of their high silver content
they open and shut easily in spite of their
thickness.

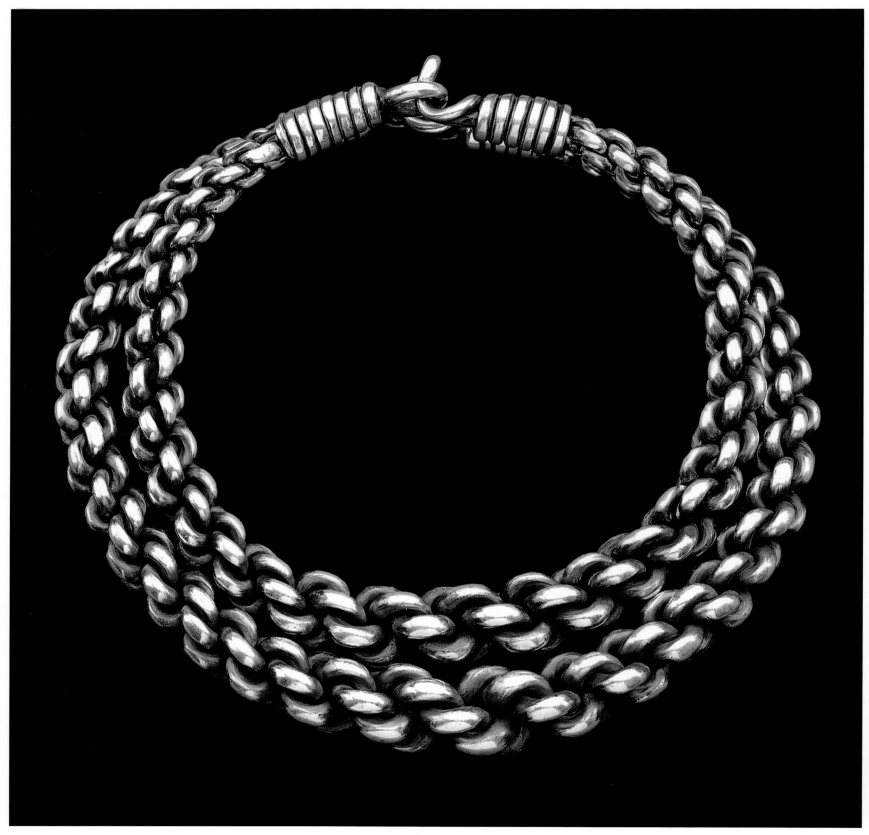

107. *Neckring*
Ag 99%
H 34.5 cm, W 44.5 cm; 2830 g
Miao; Guangxi, Sanjiang area
Neckring consisting of five smooth plain bands; each band has three surfaces and ends in a spiral at both ends.

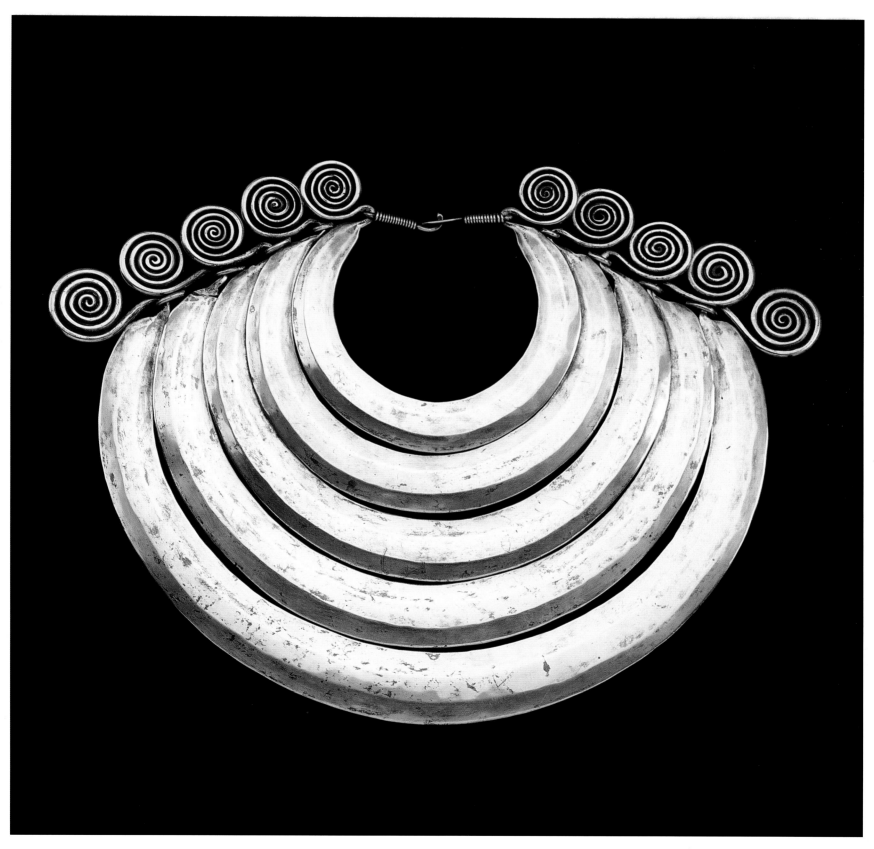

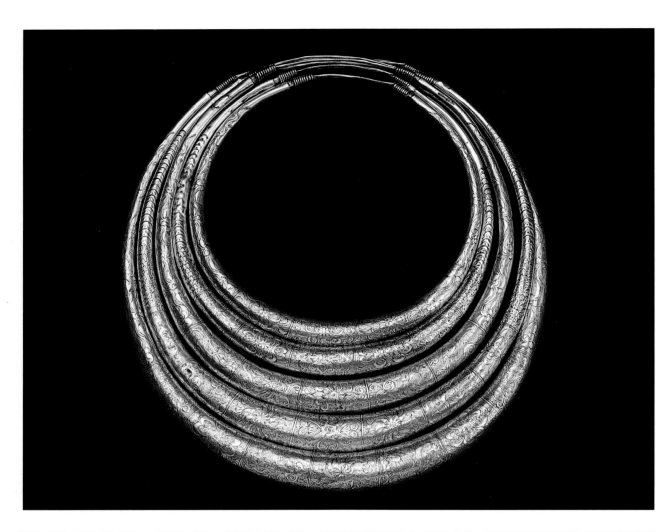

108. *Neckrings*
(set of five)
Ag 96%, Cu 4%
Ø 22.5--35 cm; 712 g together
Miao; Guizhou, Gejia area
Set of five hollow closed
neckrings, adorned with engraved floral
motifs; the bottom ring also has a
phoenix and a dragon.

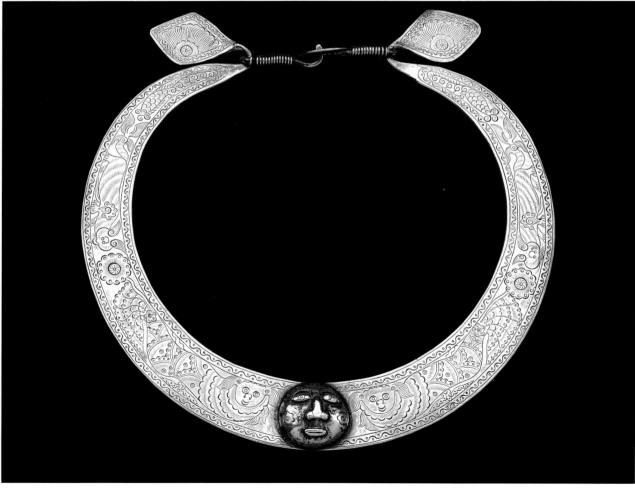

109. *Neckring*
Ag 99%
H 24.8 cm, W 23.2 cm; 610 g
Yi; Sichuan
A face in the centre, with engravings of a
dragon with a face, and others, on either
end. The face in the centre is soldered on
the silver band; the story behind it is the
one of the old man who was going to
change into a dragon after his death.
There is a story Miao people believe that
good people can turn into a dragon when
they die. An old man was told by a
fortune-teller that he would turn into a
dragon. After he died his family buried
him exactly where he had wanted. They
were so curious that they dug him up
after a couple of days. But too soon,
when the opened the coffin they saw a
dragon with an old man's head. They
should have waited a bit longer. This
dragon remained in the pictures or on
jewellery with the human head.

110. *Neckring*
Ag 99%
H 31 cm, W 36.5 cm; 2925 g
Miao; Guangxi, Sanjiang area
Engraved nine-band neckring; three groups of three similar bands; pyramid-shaped torsades at the ends; a flower engraved in the middle of each band divides engravings of phoenixes, dragons, fish, and others.

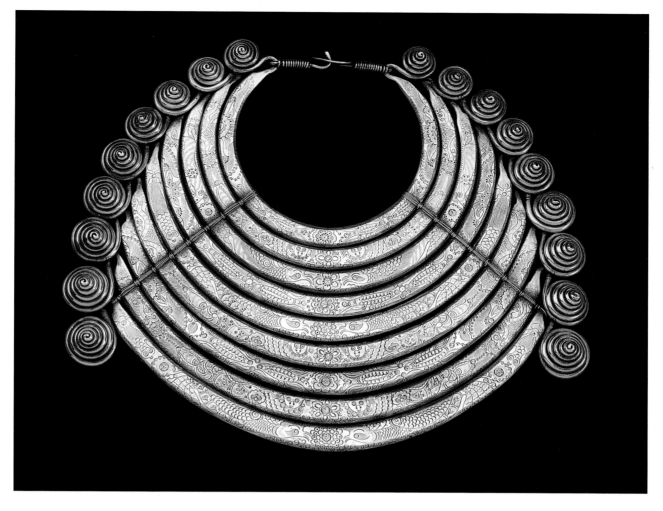

111. *Neckrings*
(set of five)
Ag 98% Cu 2%
Ø 19–-29.5 cm; 2845 g together
Miao; Guizhou, Gejia area
Set of five separate solid neckrings; floral motifs have been applied by means of chasing, a technique of detailing the front surface of a metal article with various hammer-struck punches; four neckrings are closed, the smallest opens at the top.

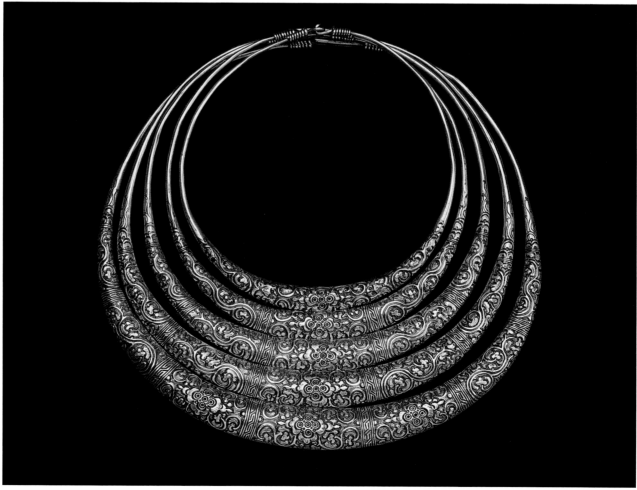

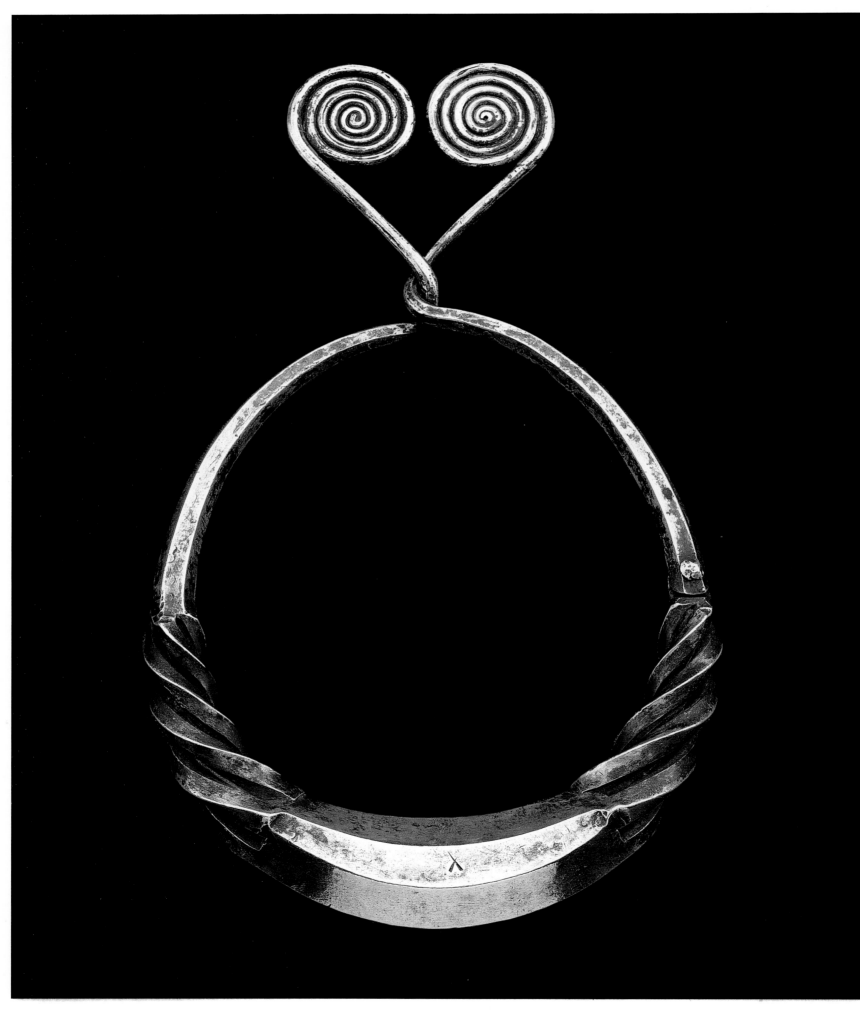

112. *Neckring*
Ag 75%, Cu 25%
H 21.5 cm, W 12.5 cm; 452 g
Dong; Guizhou
This neckring has one hinged arm that serves as an opening.

113. *Necklace with breast ornament*
Ag 99% (plate), Ag 98% (chain)
H 72 cm, W 19 cm; 470 g
Yi; Sichuan
Punched openwork breast- plate with six dangles hanging from a chain with S-shaped spirals, and others.

114. *Breast ornament and chain*
Alpaca: Cu 68%, Ni 21%, Zn 10%
H 5.2 cm, W 13.8 cm (plate), 28 cm (chain); total height with attachments approx. 45 cm; 140 g
Dong; Guizhou
Breastplate hanging from chain depicting two *shishi* (Chinese lions) with moving heads; in the centre a rotating ball.

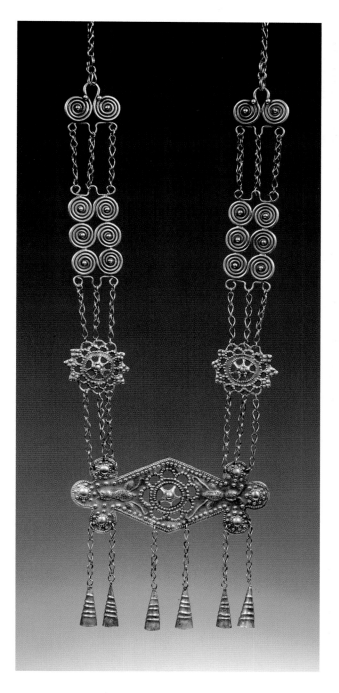

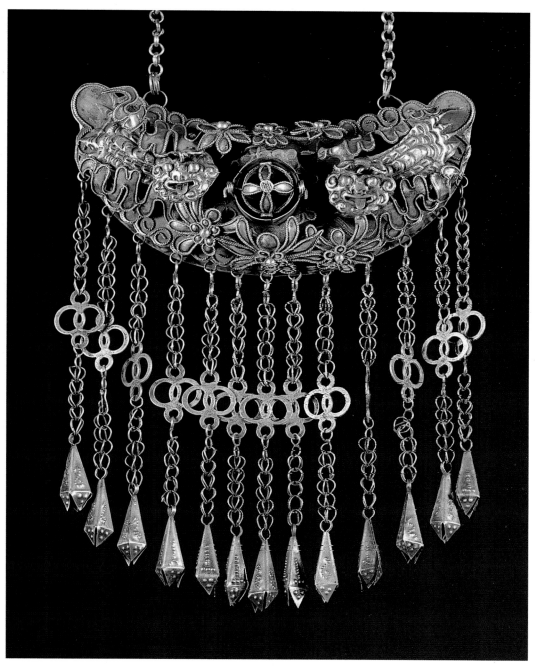

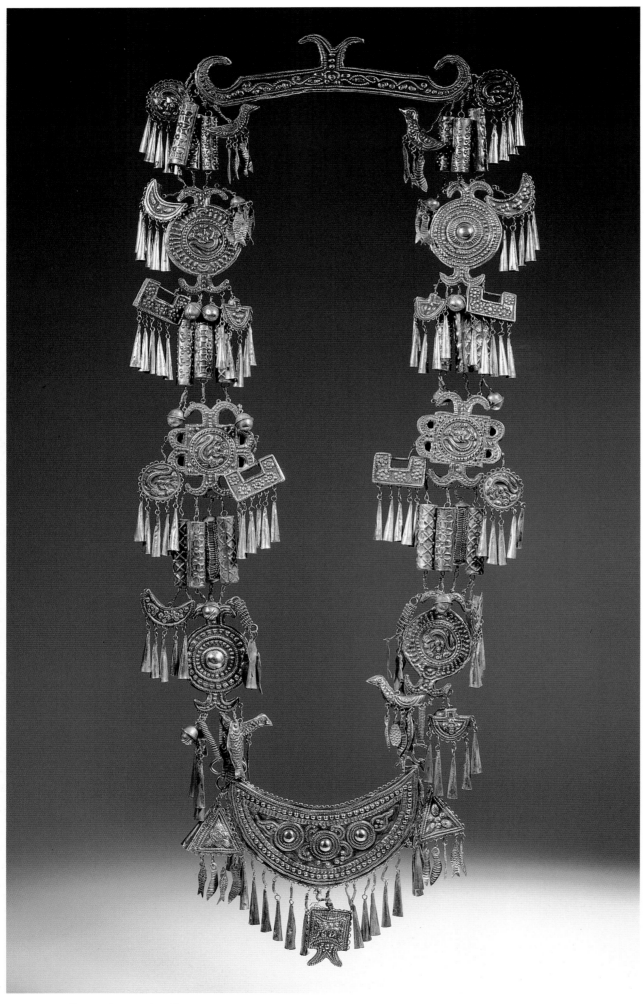

115-116. *Bridal necklace*
Ag 99%
H 84 cm, W approx. 43 cm; thickness
of boxes 0.7 cm; 2020 g
Yi; Sichuan
Bridal necklace consisting of a breast-
plate and differently decorated boxes;
depicted are mainly symbols of wealth
and happiness, such as birds and fish.
Opposite page: detail with catfish-like
creatures, flowers and butterflies; on the
right a lock, which symbolically retains
happiness.

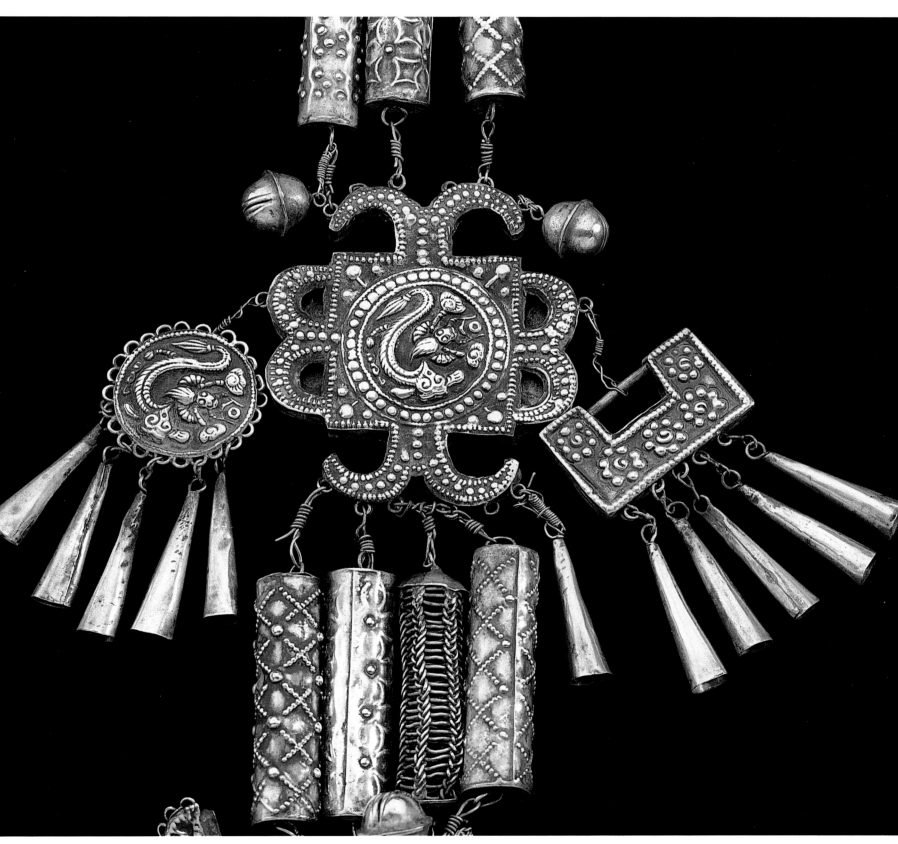

117. *Necklace with a carp*
Alpaca: Cu 70%, Ni 17%, Zn 11%
fish: L 9 cm, H 6 cm (without chain)
42 g
Dong; Guizhou
A fish represents a good life; a carp also symbolises strength; this necklace is worn by boys between six and ten years old.

118 (top). *Hairpin*
Ag 43%, Cu 52%, Zn 5%
L approx. 12 cm, W 6 cm; 48 g
Bai; Yunnan
Worn at the back of the hair; repoussé work (hammered from the back), sides engraved.

118 (bottom). *Hairpin*
Ag 44%, Cu 51%, Zn 5%
L approx. 12 cm, W 6 cm; 58 g
Bai; Yunnan
Worn at the back of the hair; repoussé work (hammered from the back); depictions of butterflies (seen as the reincarnations of the souls of the ancestors).

119. *Chatelaine*
Butterfly: Ag 68%, Cu 32%; enamel
Instruments: Ag 76%, Cu 24%
H 16 cm, W 6 cm; 70 g
Dong; Guizhou
Set for personal care with five attached instruments.

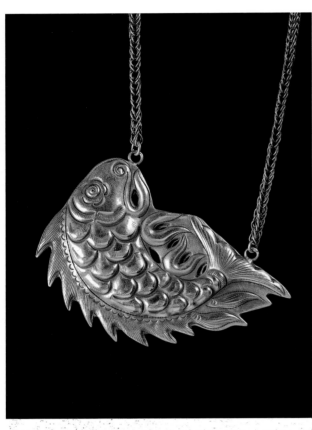

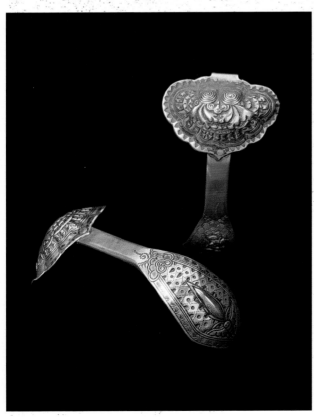

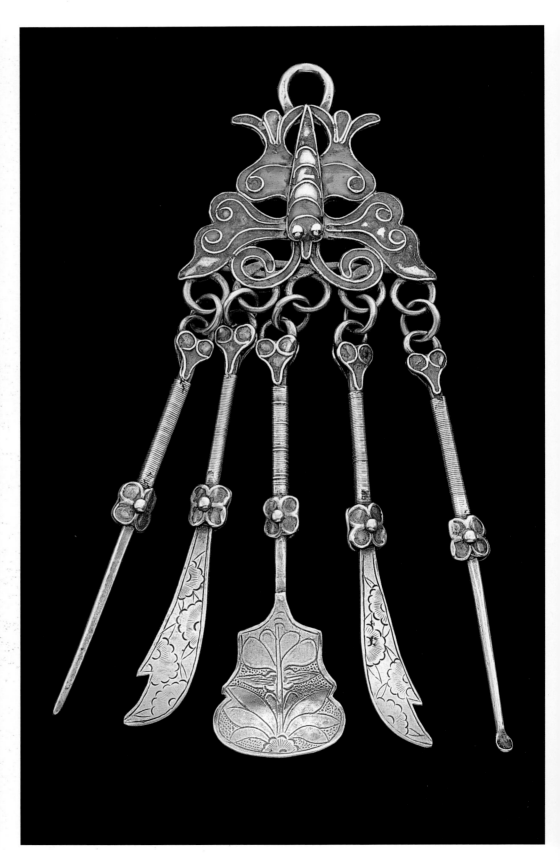

120 (right) *Linked chain*
Ag 60%, Cu 39%, Zn 1%
H 33 cm, W 18 cm; 387 g
Dong and Miao; Guizhou
Chain made of eight-shaped links, thirty-
one in all; this type of chain is very
common.

120 (left). *Necklace*
Ag 68%, Cu 32%, (chain); Ag 55%,
Cu 44%, Zn 1% (pendant)
H 36 cm, W 18 cm; 559 g
Dong; Guizhou
Pendant engraved with floral motifs.

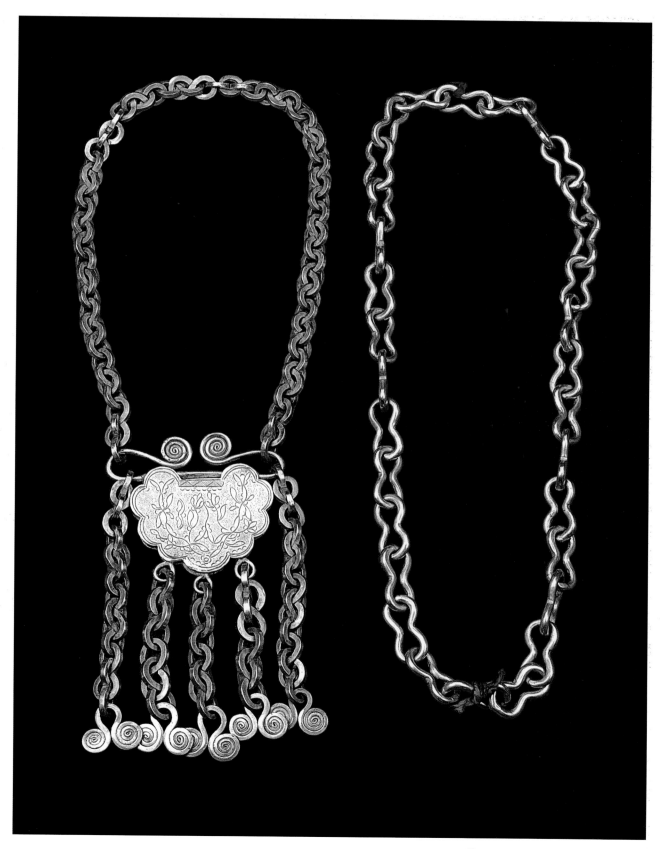

121. *Earrings*
Hook backside: Ag 86 %, Cu 14%
Top earrings: Ag 89%, Cu 11%
Bottom: Ag 86%, Cu 14%
H 19 cm, W 5.5 cm; 150 g together
Tu; Qinghai province

The Tu area is located in the northeast of the Qinghai – Tibet plateau.
On the upper part of the earrings is an engraved lotus flower signifying purity; the circle below is decorated with a bat, a symbol of prosperity and happiness.

122. *Earrings*
Ag 98%, Cu 2%
H 10 cm; 70 g together
Miao; Guizhou
In the centre of either earring an engraved fish, a symbol of wealth and fertility; above the fish the Shou ideogram, which embodies a wish for a long life.

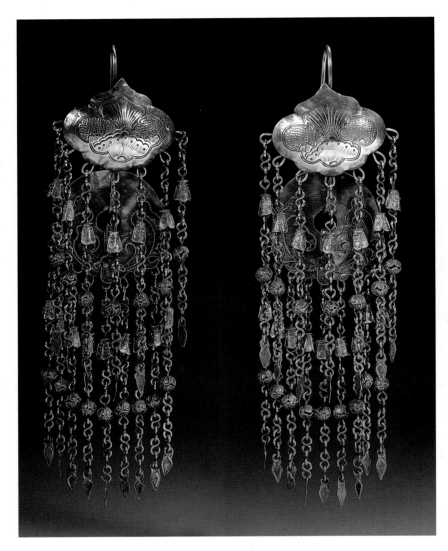

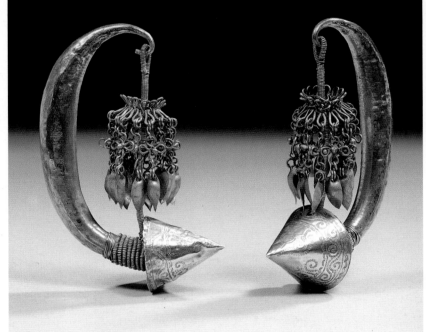

123-125. *Neckring*

Ag 87%, Cu 13% (neckring); Ag 92%,
Cu 8% (dragon)
H 32 cm, W 13.2 cm (H without
attachments: 14.5 cm); 206 g
Miao; Guizhou

Two stamps on the upper part of the
necklace, one stamp on the back of the
dragon; attachments show remnants of
enamel. A male dragon, as shown here, is
the symbol of the upper world; he
represents divine activity and symbolises
thunder. A female dragon is the symbol
of the underworld and the ruler of the
oceans; together these dragons form the
Yin–Yang symbol.
Below: detail of the maker's stamp
(dragon pendant, back): Wu Ji.
Bottom: detail of the two maker's marks
name: Heng Xing.

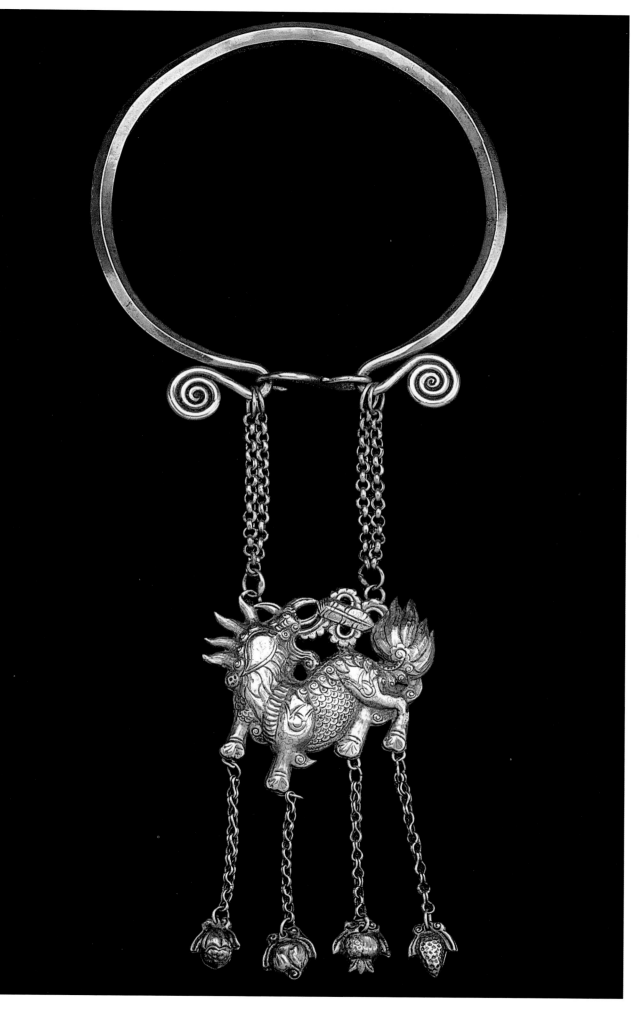

126-130. *Neckring*
Ag 99% (plus fastener)
H 22.5 cm, greatest width 37 cm
2150 g
Miao; Guangxi, Sanjiang area
Seven joined bands, each ending in a
spiral at either end; engravings (each a
mirror image starting from the centre) of
butterflies, fish, phoenixes, lion-dragons,
and others.

Opposite page: details with lion-dragons
(mostly seen as benevolent gods);
phoenixes (a phoenix is a bird that rises
from its ashes.); fish (symbols of fertility,
strength and a good life);flowers flanked
by butterflies; in the heart of the flowers
the Yin–Yang symbol.

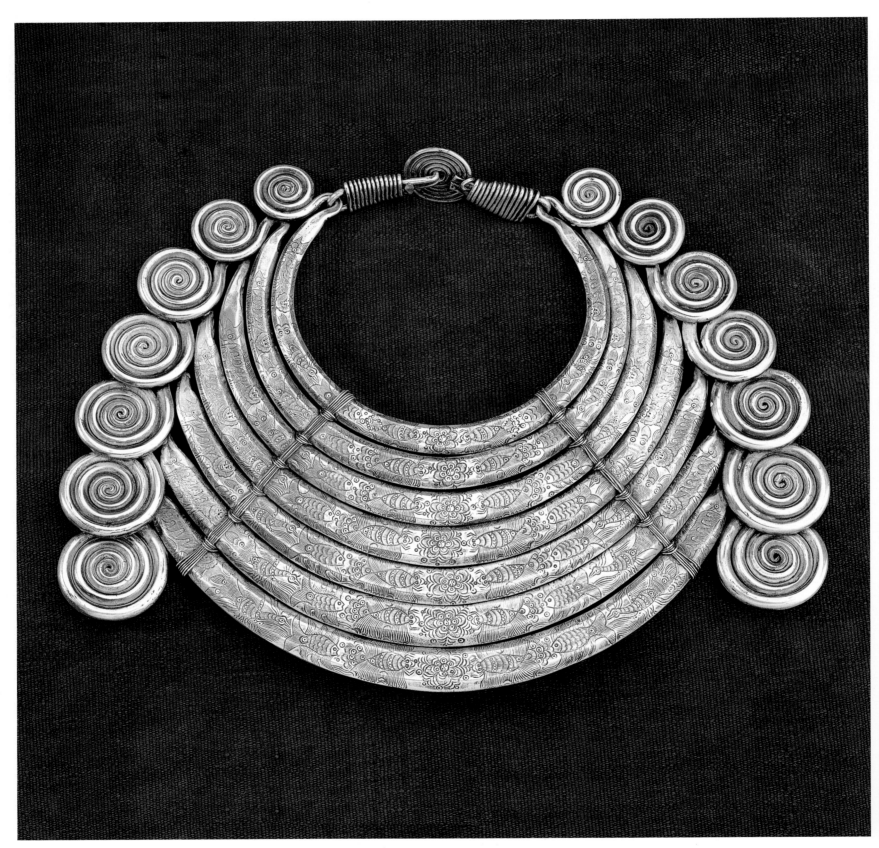

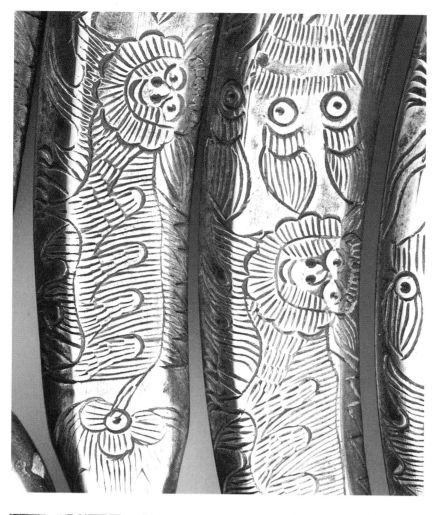

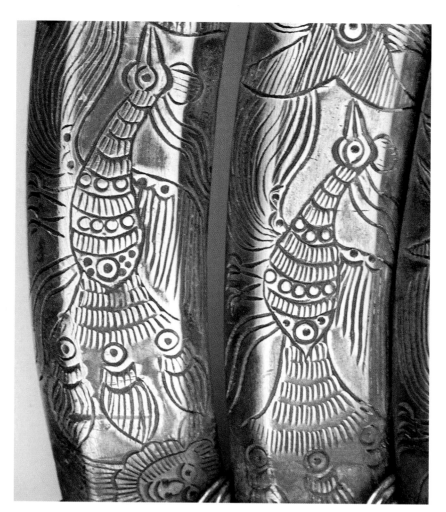

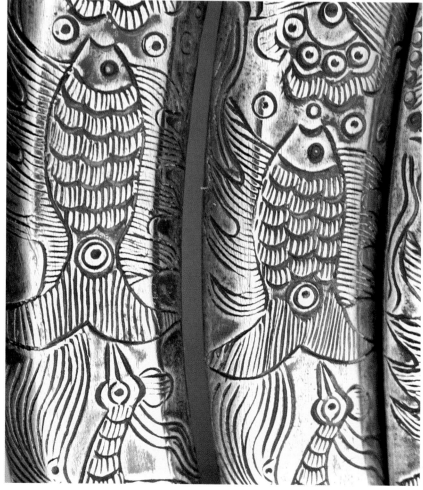

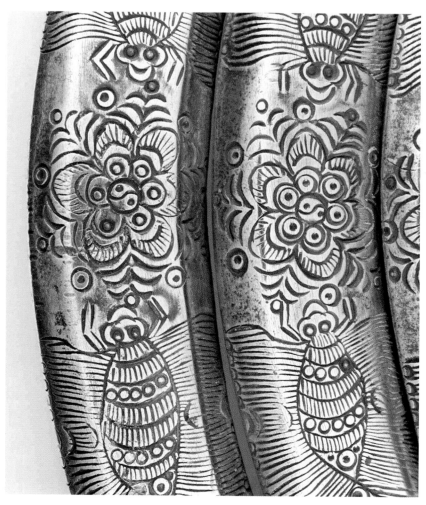

131. *Neckring*
Ag 60%, Cu 40%
H 17 cm, W 15 cm; 360 g
Miao; Guizhou
Opens at the top, hinge on one side,
flat bottom.

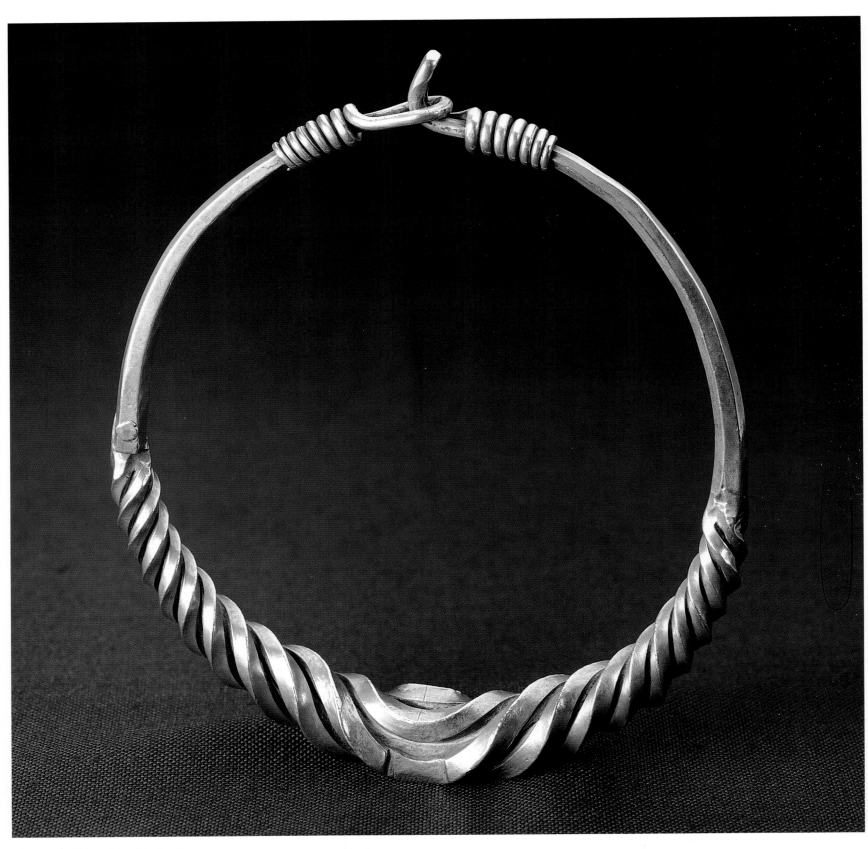

132. *Neckring*
Ag 71%, Cu 29% (plus fastener)
H 16 cm, W 19 cm; 458 g
Shui; Guizhou
Plain silver solid neckring; opens at the
top, twisted chain fastener.

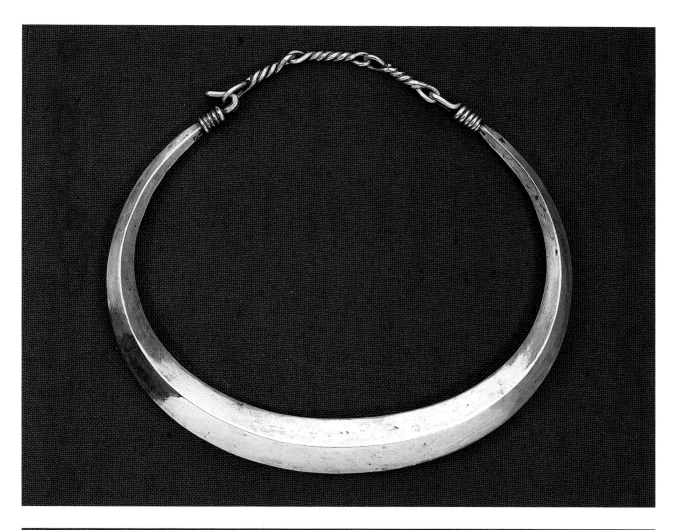

133. *Neckring*
Ag 83%, Cu 16%, Zn 1%
H 17.5 cm, W 17 cm; 352 g
Miao; Guizhou
Hook opening at the bottom; short spiral
on either side of the hook; slight torsion.

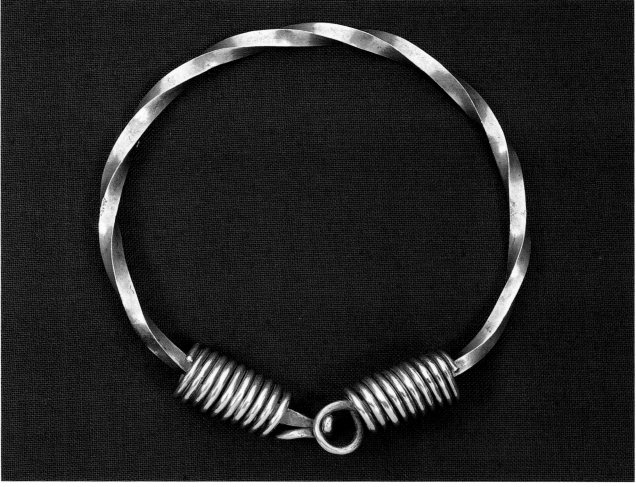

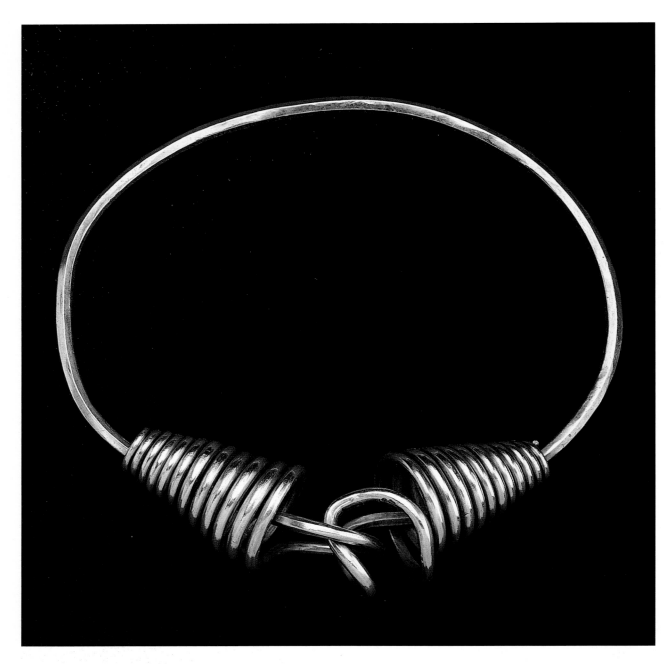

134. *Neckring*
Ag 99%, a trace of Cu
Ø 21.5 cm; 663 g
Miao; Guizhou, Gejia area

135. *Bracelets*
Ag 96%, Cu 4%
Ø 8 cm; 353 g together
Miao; Guizhou, Gejia area
Bracelets matching the necklace.

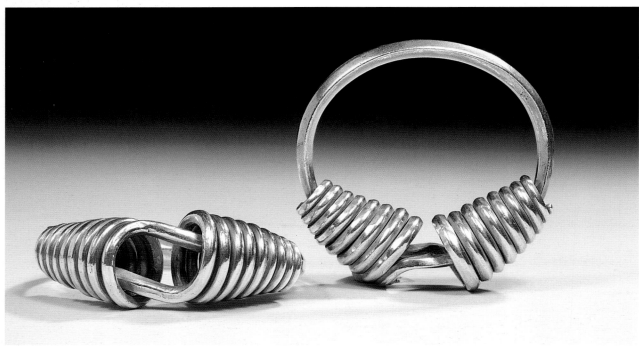

136 (bottom). *Bracelets* (pair)
Ag 42%, Cu 52%, Zn 6%
Ø 8 cm; 197 g together
Miao; Guizhou
Partly braided.

136 (top). *Bracelets* (pair)
Ag 44%, Cu 48%, Zn 8%
Ø 7.5 cm; 198 g together
Miao; Guizhou
Slightly twisted spirals.

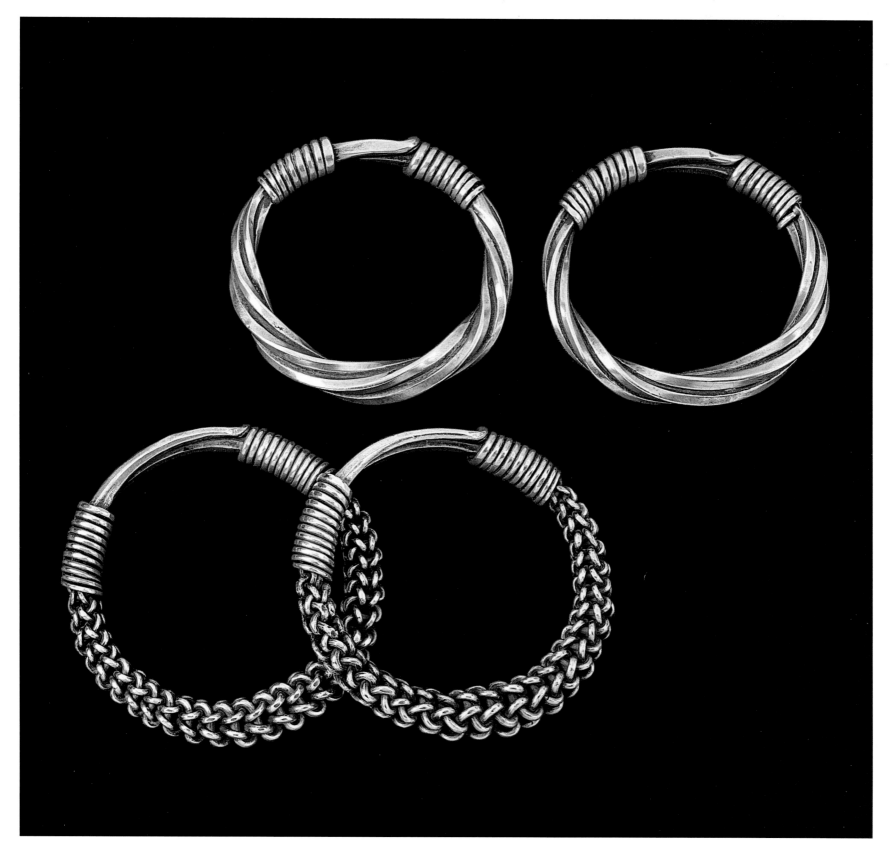

137 (right). *Bracelet*
Ag 95%, Cu 5%
Ø 7 cm; 228 g
Miao; Guizhou
Floral and geometric engravings on the side.

137 (left). *Bracelet*
Ag 96% Cu 4%
Ø 8 cm; 376 g
Miao; Guizhou
Floral and geometric engravings on the side

138. *Bracelet*
Ag 74%, Cu 26%
L 10.2 cm, W 7.8 cm, H 4.9 cm
160 g
Miao; Guizhou
Repoussé work: ornamentation of metal in relief by pressing or hammering on the reverse side.

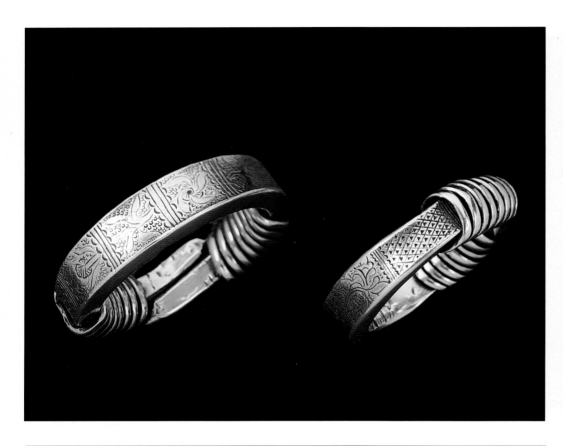

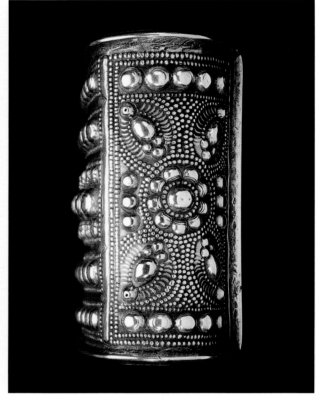

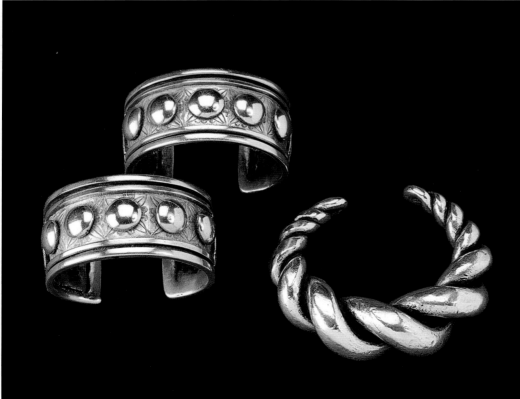

139 (left). *Bracelets* (pair)
Ag 65%, Cu 43%, Zn 2%
H 5 cm, W 6 cm; 164 g together
Miao; Guizhou

139 (right). *Bracelet*
Ag 98%, Cu 2%
H 7 cm, W 8 cm; 300 g
Miao; Guizhou
Two countertwined silver bands.

140 (left). *Bracelets* (pair)
Ag 43% Cu 57%, trace of Zn
Ø 6.8 cm; 292 g together
Miao; Guizhou
Engravings.

140 (right). *Bracelets* (pair)
Ag 58%, Cu 36%, Cd 3%, Zn 2%,
Ni 1%
Ø 7 cm; 417 g together
Miao; Guizhou
Engravings.

141. *Bracelet*
Ag 44%, Cu 53%, Zn 3%
H 6.8 cm, W 9.5 cm; 278 g
Miao; Yunnan
Man's solid bracelet; two dragons' heads
with curled horns, a ball in either mouth.

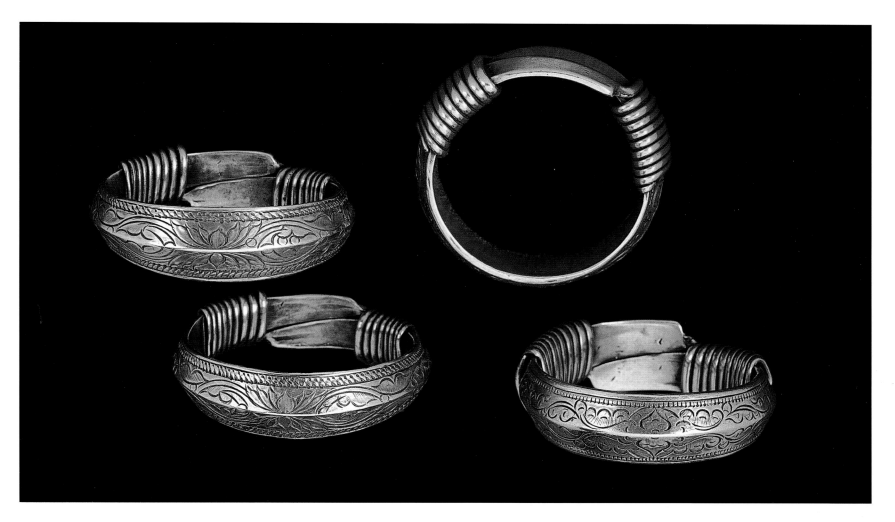

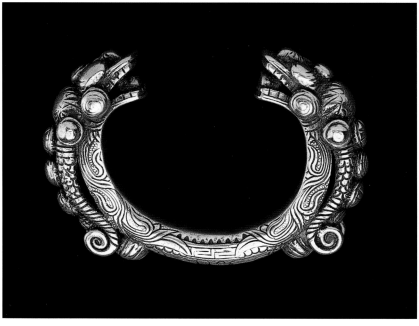

142-143. *Ornaments of a child's bonnet*
Ag 94%, Cu 6% (platelets); Ag 97%,
Cu 3% (wire); worn gold-plating
H 3.5 cm, W 1.6 cm per platelet
Shui (comparable ornaments are found
among the Miao and Dong)
Guizhou

Each of the eight silver platelets shows
one of the eight Taoist immortals (Ba
Xian), with Buddha Hva Shang at centre;
some of the immortals show remnants of
gold-plating.

Opposite page: detail of Buddha Hva
Shang, the children's fat-bellied buddha;
a snake is also depicted.
H 4 cm W approx. 3.7 cm

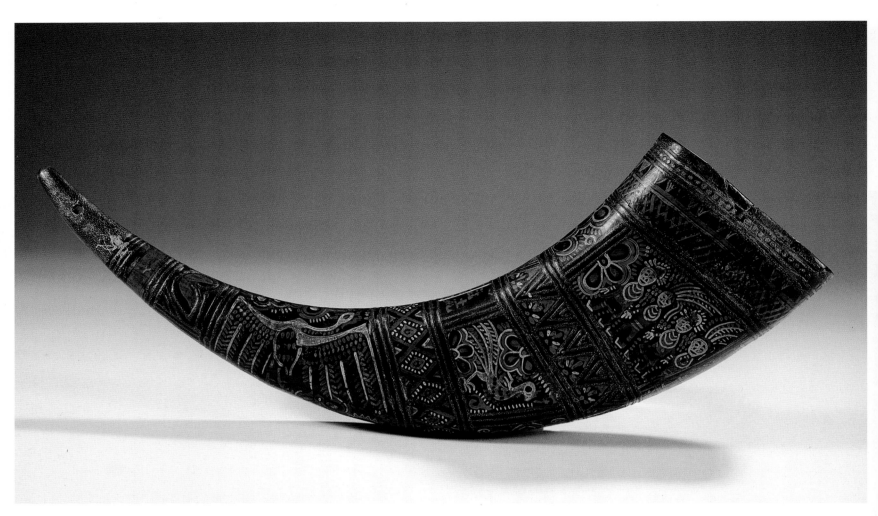

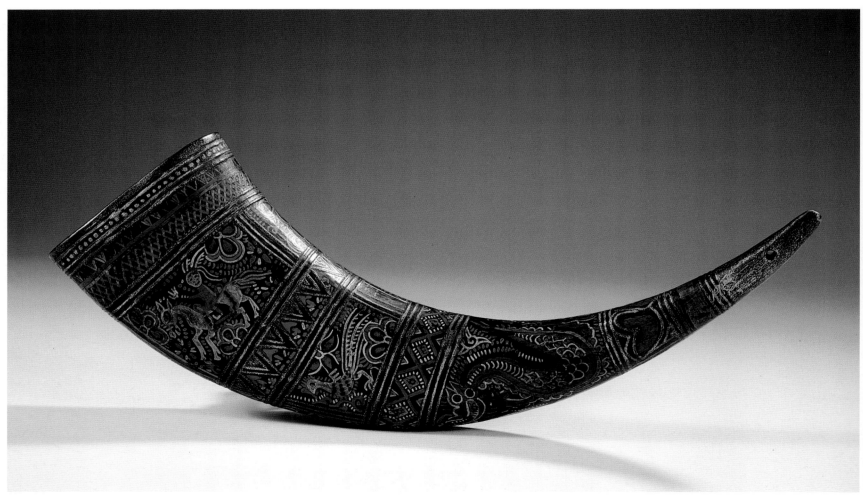

144-146. *Drinking-horn for wine used by men at festivals and weddings.*
Buffalo horn, lacquer and silver powder
L 36 cm, largest opening 10 × 6 cm
Miao; late 19th – early 20th century

Buffalo horn painted with red, yellow and black lacquer, some ports sprinkled with silver powder; both sides show different paintings, human figures with neckrings, phoenixes, and others.
On the reverse side, a man on horseback, dragon, and others.

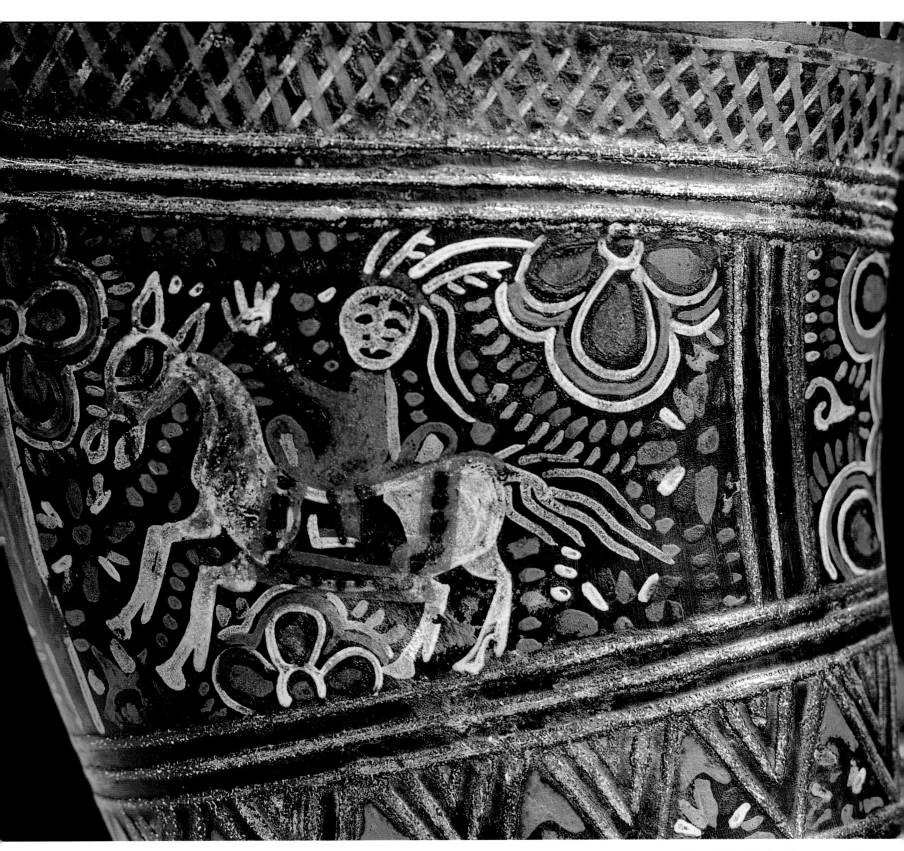

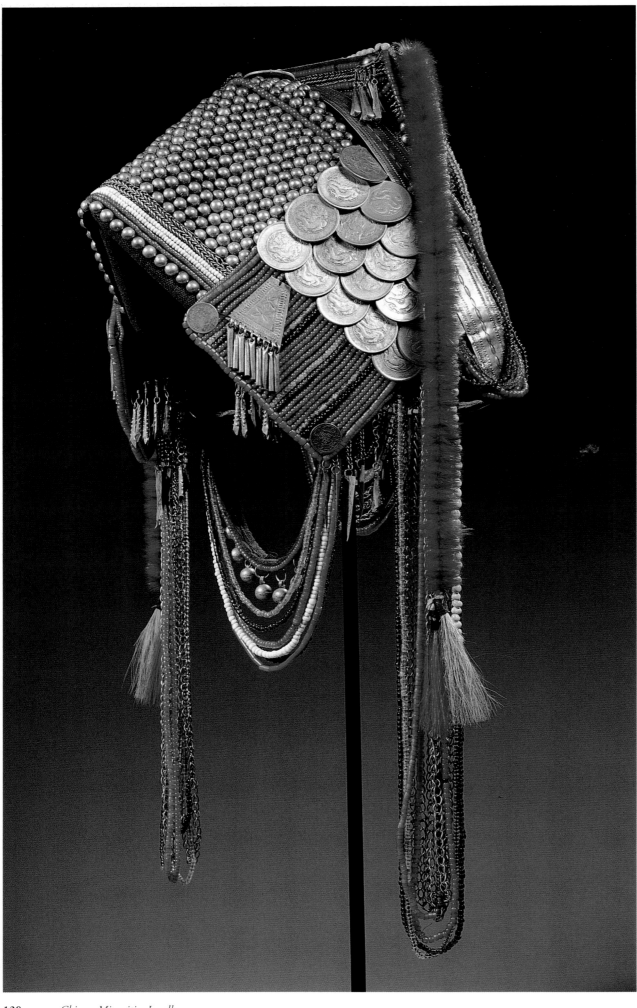

147-148. *Woman's headdress*
Shaped somewhat like a helmet, is constructed on a bamboo frame with an indigo cotton collar; entirely encrusted with silver buttons, coins (mostly Chinese with a few Indian rupees), glass beads and two tassels made of coloured chicken feathers with some goat hair and Job's tear seeds.
Silver buttons: Ag 92%, Cu 8%
Hat rim: Ag 89%, Cu 11%
Chinese coins: Ag 48%, Cu 52%
Linked chains: Ag 58%, Cu 42%
H (without chains) 23 cm, H (with chains) 58 cm; W 30 cm; 2535 g
Hani; Yunnan province, Menghai area
In Thailand and Myanmar this headdress is used to be worn by the Phami-Akha. The red and orange glass beads are double-layered with a white core, called "pound beads", since these mostly nineteenth-century European glass beads were sold by the pound.

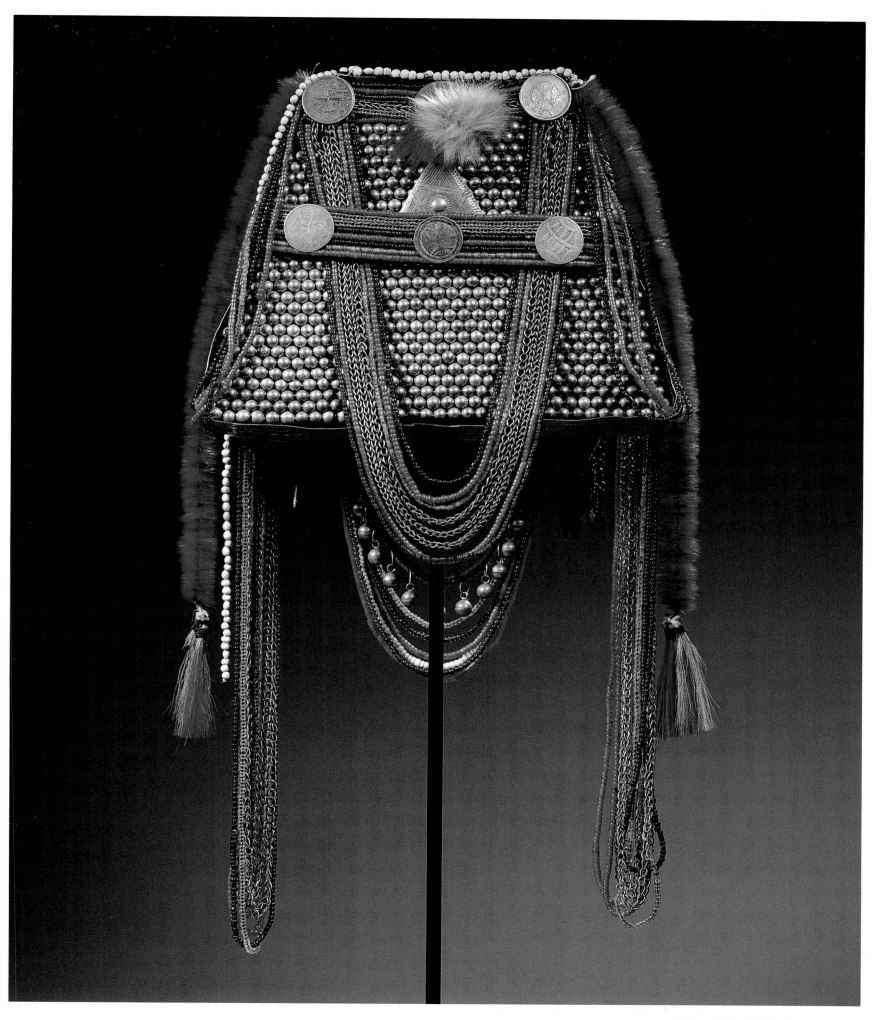

Golden Triangle
Jewellery

149. *Neckring* (inside)
Ag 99%
H 15.5 cm, W 14 cm; 308 g
Hmong, Yao; Golden Triangle:
Thailand, Myanmar, Laos
Thick hollow faceted ring; sometimes
worn singly, sometimes with other rings.

149. *Neckring* (outside)
Ag 99%
H 20 cm, W 19 cm; 364 g
Hmong, Yao; Golden Triangle:
Thailand, Myanmar, Laos
Thick hollow faceted ring; sometimes
worn singly, sometimes with other rings.

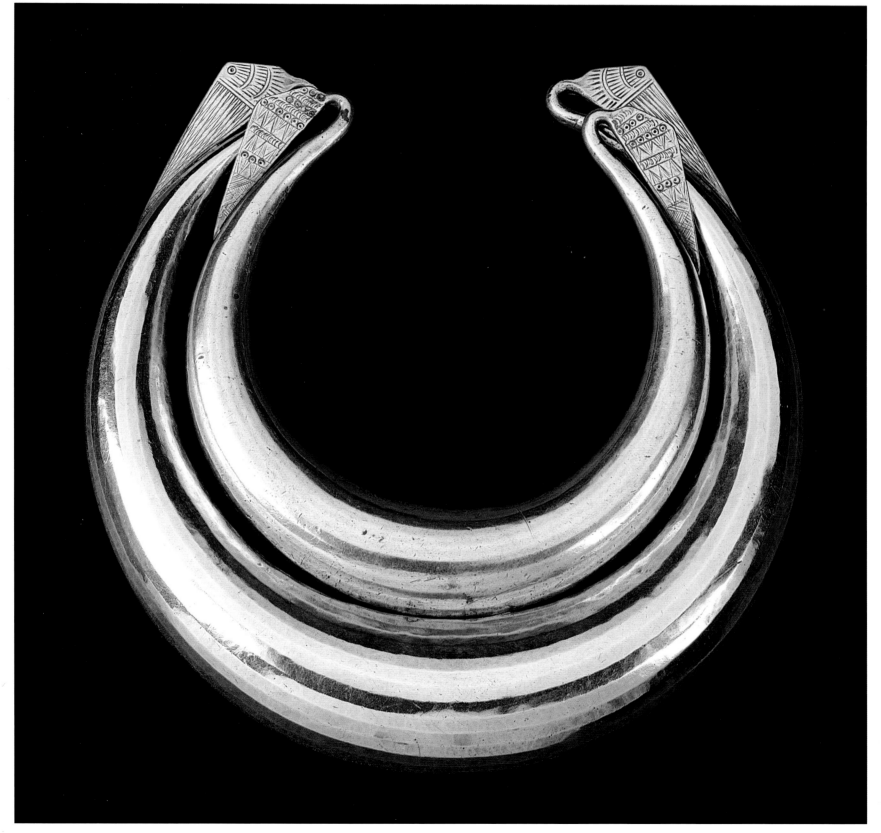

150. *Neckring*
Ag 72%, Cu 28%
Ø 19.5 cm; 242 g
Akha; Golden Triangle: Thailand,
Myanmar, Laos
Chased plain silver.

151. *Neckring*
Ag 90%, Cu 10%
H 21 cm, W 23 cm; 768 g
Hmong, Yao, Lahu; Golden Triangle:
Thailand, Myanmar, Laos
Solid closed faceted silver ring with
widely outspread wings.

152. *Necklace*
Ag 97%, Cu 3%
H 35 cm, W 19 cm; 169 g
Karen; Golden Triangle: Thailand,
Myanmar, Laos
Necklace consisting of silver beads
with a wooden core.

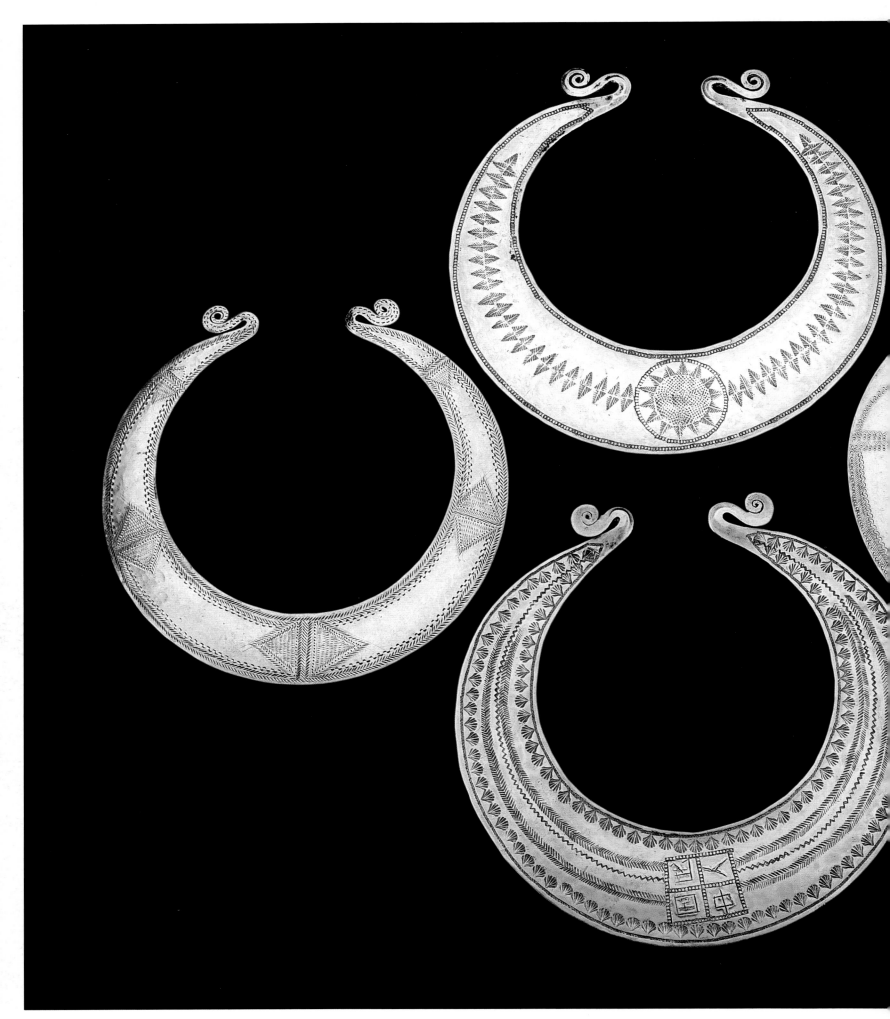

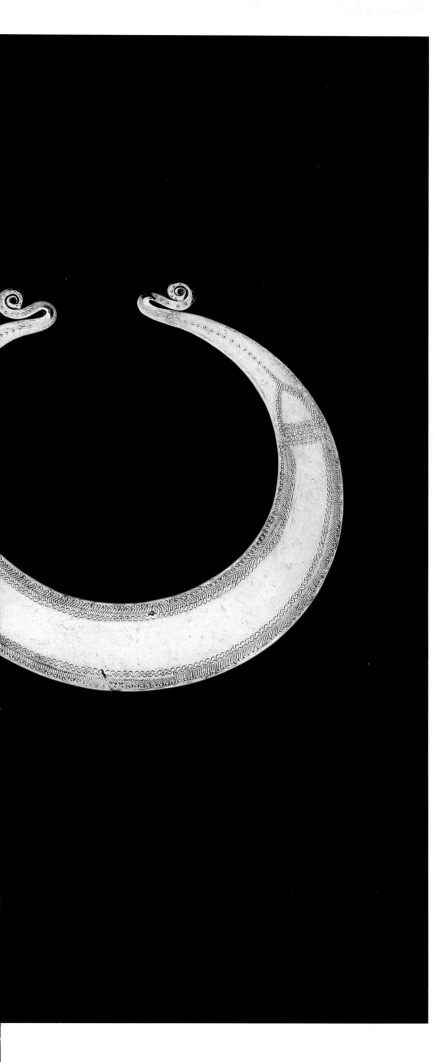

153 (top). *Neckring*
Ag 90%, Cu 10%
H 20.5 cm, W 20 cm; 400 g
Akha; Golden Triangle: Thailand,
Myanmar, Laos
In the middle of the engravings, a sun.

153 (bottom). *Neckring*
Ag 90%, Cu 10%
Ø 20 cm; 341 g
Akha; Golden Triangle: Thailand,
Myanmar, Laos
In the middle of the engravings, four
Chinese characters.

153 (right). *Neckring*
Ag 91%, Cu 9%
Ø 20 cm; 265 g
Akha; Golden Triangle: Thailand,
Myanmar, Laos
With engravings.

153 (left). *Neckring*
Ag 98%, Cu 2%
H 18.5 cm, W 18 cm; 251 g
Akha; Golden Triangle: Thailand,
Myanmar, Laos
With engravings.

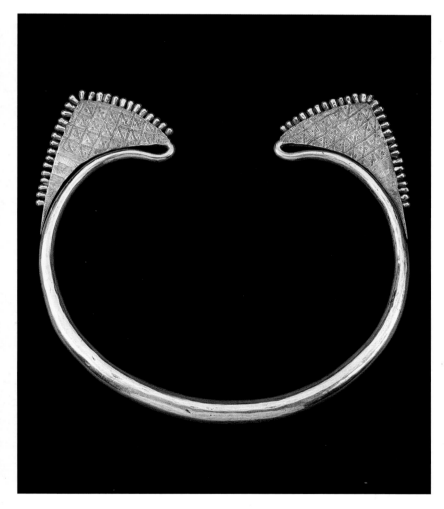

154. *Neckring*
Ag 90%, Cu 10%
H 22.5 cm, W 24.5 cm; 822 g
Hmong, Yao, Lahu; Golden Triangle:
Thailand, Myanmar, Laos
Wings engraved with geometrical motifs
and fitted with silver studs.

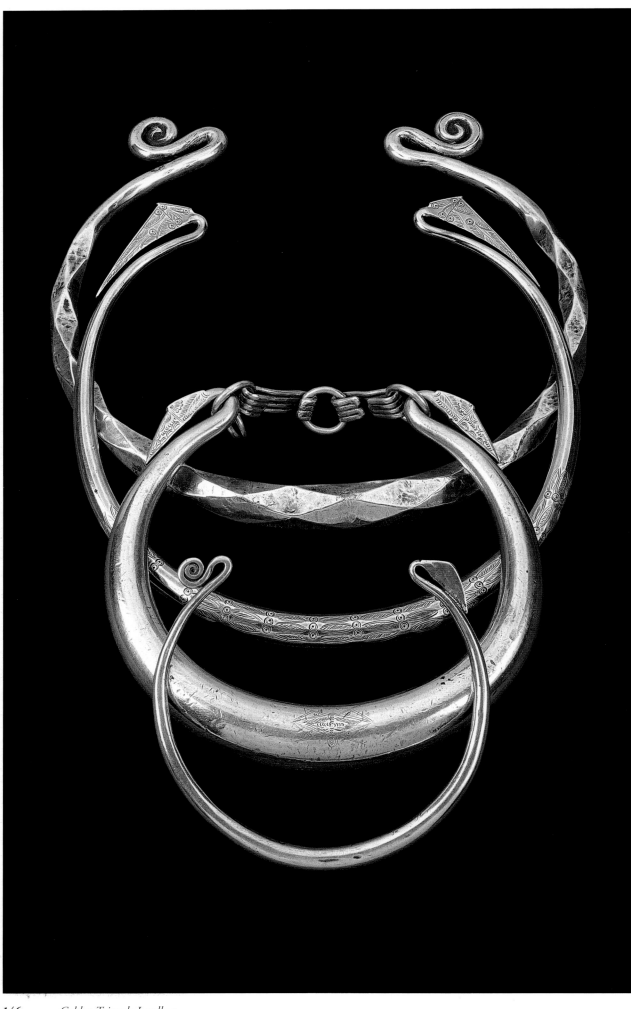

155 (top). *Neckring*
Ag 70%, Cu 30%
H 20 cm, W 19 cm; 490 g
Hmong, Yao, Lahu; Golden Triangle:
Thailand, Myanmar, Laos
Solid faceted band with curled ends.

155 (second from top)
Neckring
Ag 93%, Cu 7%
H 18.5 cm, W 17 cm; 326 g
Hmong, Yao, Lahu; Golden Triangle:
Thailand, Myanmar, Laos
Engraved band; finely faceted
silver.

155 (third from top). *Neckring*
Ag 98%, Cu 2%
H 13 cm, W 14 cm; 719 g
Hmong, Yao, Lahu; Golden Triangle:
Thailand, Myanmar, Laos
Solid band; front with engravings – back
with three Chinese characters, probably
the owner's or maker's name.

155 (bottom). *Neckring*
Ag 83%, Cu 17%
H 10 cm, W 10.5 cm; 67 g
Hmong, Yao; Golden Triangle:
Thailand, Myanmar, Laos
Small specimen worn by an adult
woman; two different ends, which is
quite exceptional.

156. *Neckring*
Ag 98%, Cu 2%
Ø 16.5 cm; 725 g
Hmong, Yao; Golden Triangle:
Thailand, Myanmar, Laos
Multi-tiered plain hollow rings; the five
rings are connected.

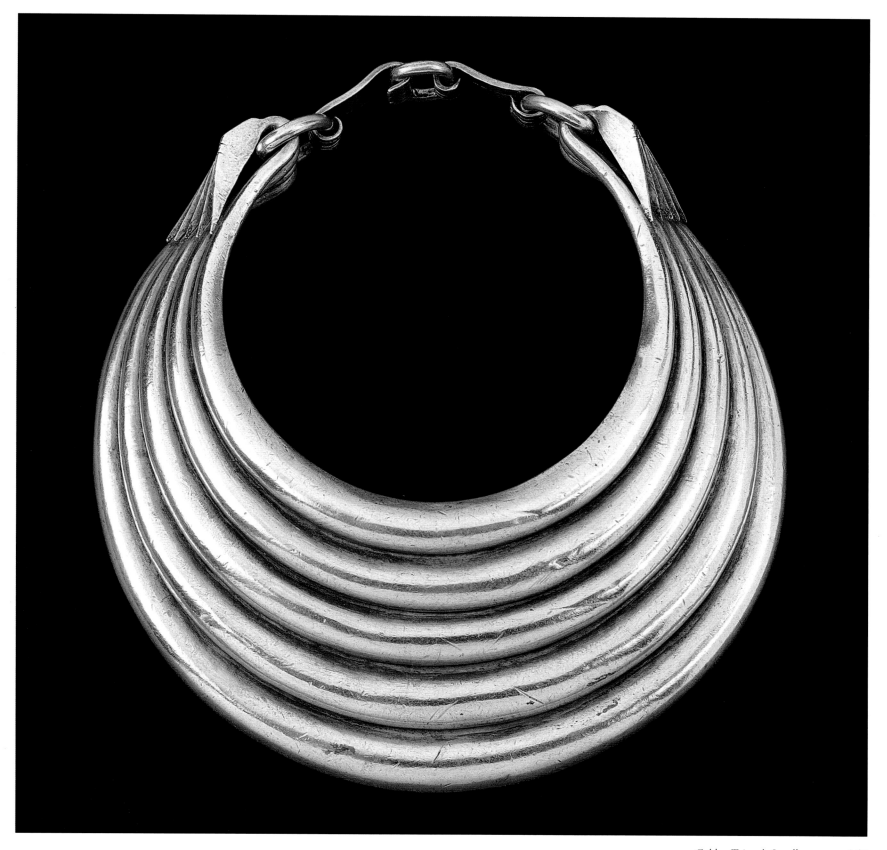

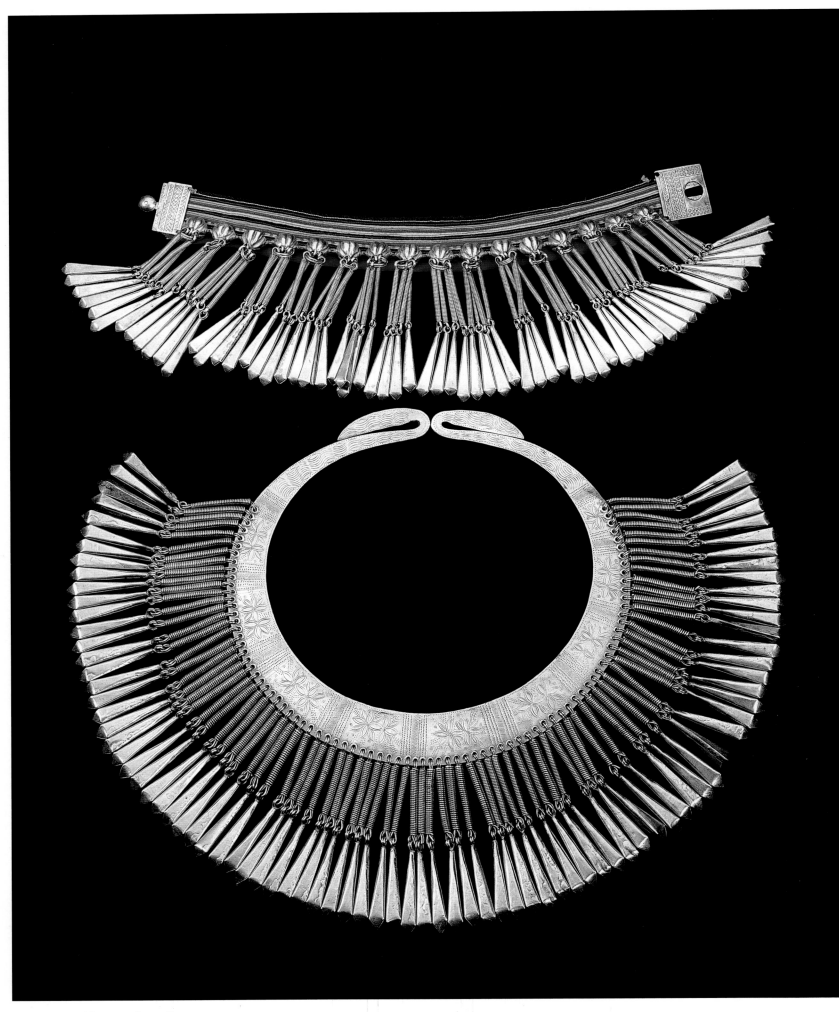

157 (top). *Necklace*
Ag 94%, Cu 6% (rosettes)
Ag 88%, Cu 11%, Zn 1% (wire)
Ag 96%, Cu 4% (dangles)
L 32 cm, H 11 cm
400 g
Lisu; Golden Triangle: Thailand,
Myanmar, Laos
Different layers of cotton band stitched
on top of each other; sixty-four dangles.

157 (bottom). *Neckring*
Ag 92%, Cu 8%; wire: Ag 93%
H 28 cm, W 37 cm; 874 g
Lisu; Golden Triangle: Thailand,
Myanmar, Laos
Forms one set with the other naklace;
ring with engravings and eighty-seven
dangles.

158. *Neckring*
Ag 99% (band plus dangles)
H 41.5 cm, W 19 cm; 763 g
Hmong; Golden Triangle: Thailand,
Myanmar, Laos
Twisted neckring with long wings; many
dangles, among which two "soul lockers"
(these keep the soul inside the body
during illnesses).

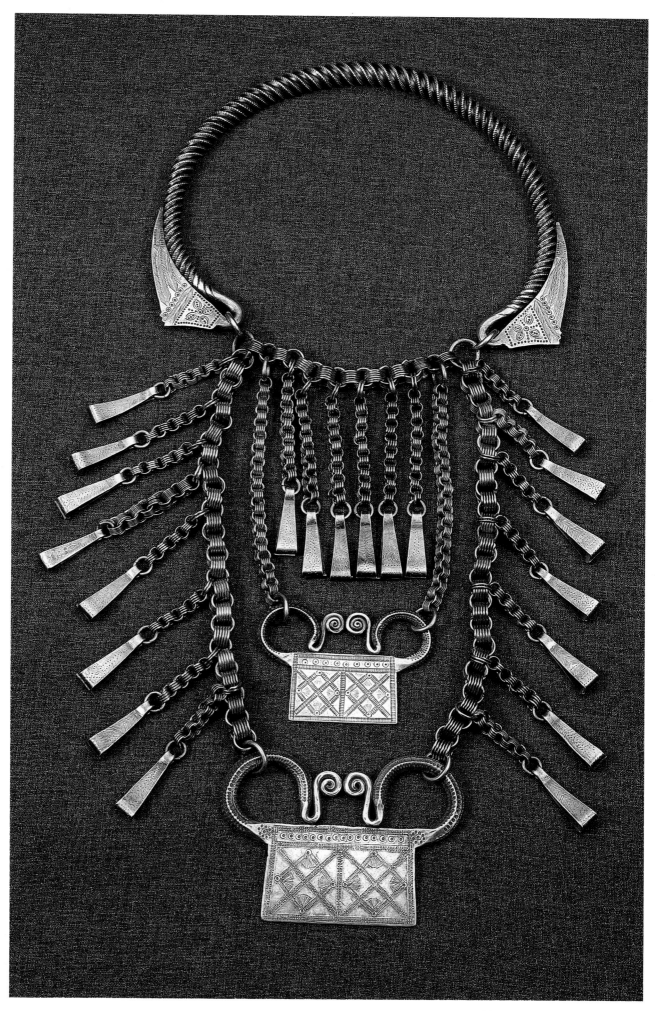

159. *Chatelaine*
Ag 95%, Cu 5% (chain)
Ag 97%, Cu 3% (pendant)
Ag 88%, Cu 12% (instruments)
L (with chain) 45.5 cm; L (without
chain) 19.5 cm; W 5 cm; 163 g
Golden Triangle: Thailand, Myanmar,
Laos
Chatelaine with five attached instruments
for personal care.

160. *Soul lockers*
H 4.5–6.5 cm, W 6.3–9.7 cm
(sizes of all seven lockers)
Hmong; Golden Triangle: Thailand,
Myanmar, Laos
All seven lock-shaped pendants are
engraved and are originally part of
a neckring; soul lockers protect against
illnesses and keep the soul inside the
body.

top right
Ag 81%, Cu 19%
72 g

bottom right
Ag 92% Cu 8%
71 g

top centre
Ag 92%, Cu 8%
62 g

centre
Ag 81%, Cu 19%
36 g

bottom centre
Ag 76%, Cu 24%, trace of Zn
89 g

top left
Ag 99%
76 g

bottom left
Ag 92%, Cu 8%
80 g

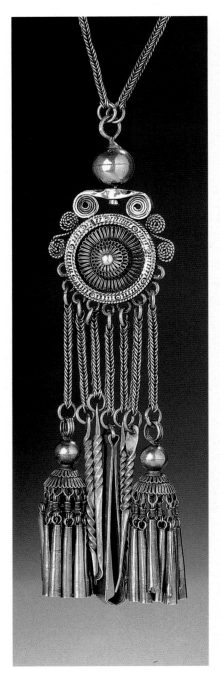

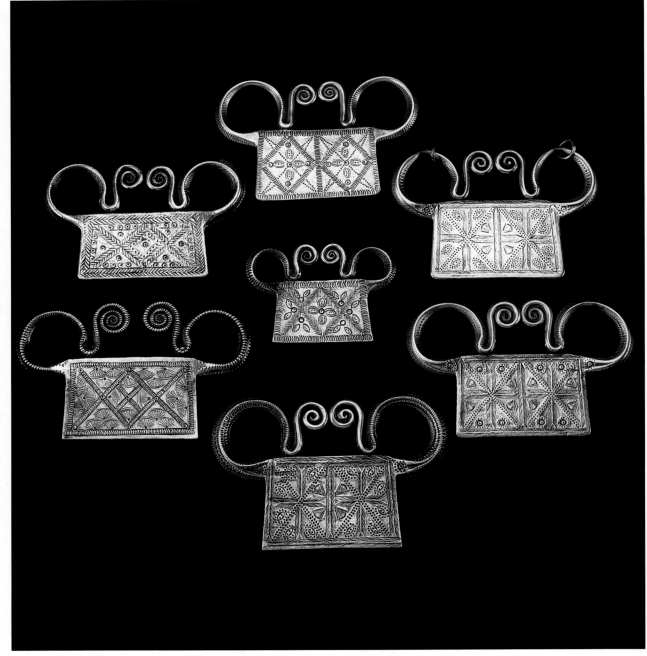

161-162. *Earrings* (pair)
Ag 80%, Cu 20%
H 23.5 cm, W 8.5 cm; 82 g together
Hmong; Golden Triangle: Thailand,
Myanmar, Laos
Engravings on both sides; knobs made
of French coins, dated 1923 and 1925
(see detail).

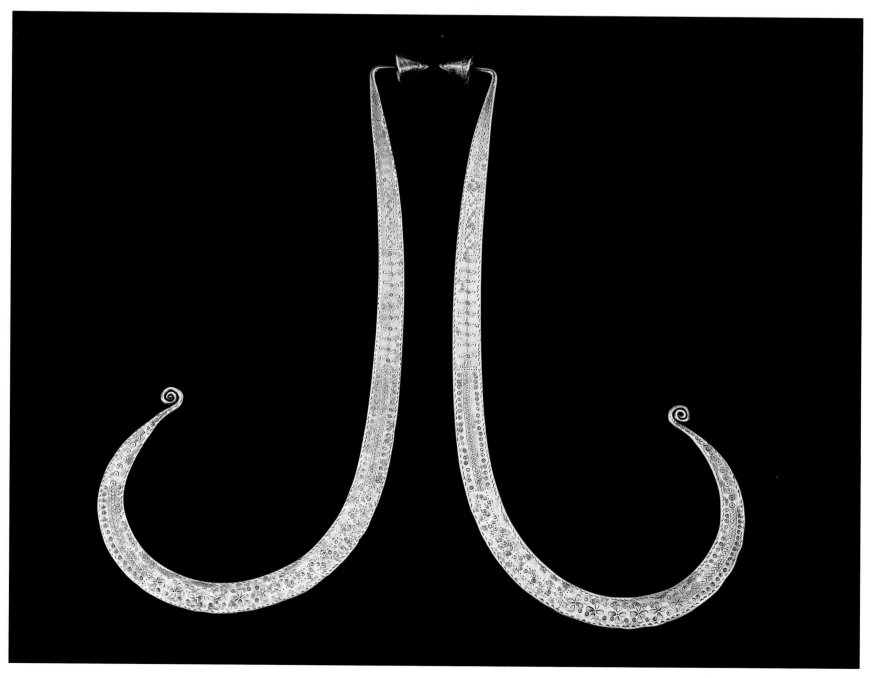

163 (left). *Hairpin*
Ag 89%, Cu 11% (same for lid)
L 30.5 cm; lid: 3.5x3.5 cm; 129 g
Laos, Vietnam
Hollow hairpin; the lid can open – used
to store small objects, e.g. amulets.

163 (right). *Hairpin*
Ag 97%, Cu 3%; lid: Ag 95%, Cu 5%
L 31.2 cm; lid: 3.7x3.7 cm; 102 g
Laos, Vietnam
Hollow hairpin; the lid can open – used
to store small objects, e.g. amulets.

164 (top). *Button*
Ag 84%, Cu 16%;
wire: Ag 98%, Cu 2%
Ø 10 cm; 65 g
Akha, Lahu; Golden Triangle: Thailand,
Myanmar, Laos
Engraved floriform button.

164 (bottom). *Button*
Ag 91%, Cu 9%; wire: Ag 97%, Cu 3%
Ø 15.5 cm; 275 g
Akha, Lahu; Golden Triangle: Thailand,
Myanmar, Laos
Disc-shaped button with silver engravings,
to be fastened to clothing; consisting of flat
disc, round button and silver extension.

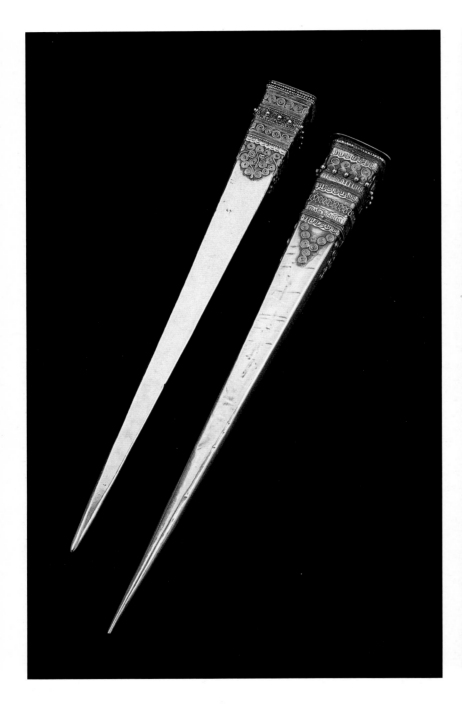

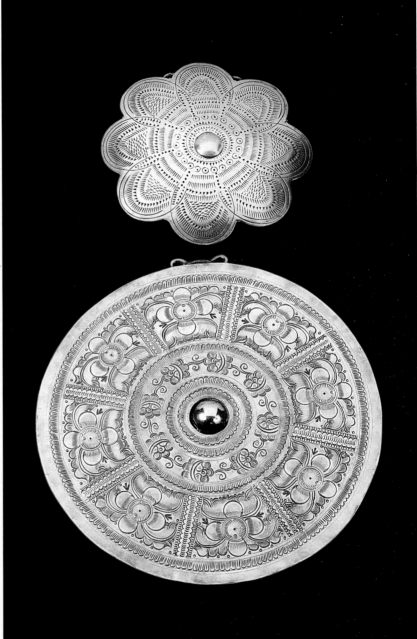

165. *Earrings*
Elephant ivory
Ø 5.6 cm, H 3 cm; 232 g together
Karen, Laowe; Golden Triangle:
Myanmar, Laos
Late 19th century

166 (vertical). *Earrings*
Elephant ivory
L 5.9 cm, W 2.1 cm; 26 g
Karen; Golden Triangle: Thailand,
Myanmar, Laos
Late 19th century

166 (horizontal). *Earrings*
Elephant ivory
L 7 cm, W 2.3 cm; 31 g together
Karen; Golden Triangle: Thailand,
Myanmar, Laos
late 19th century

167 (top) and 168. *Betel box*
Ag 86%, Cu 14%
H 7.3 cm, Ø 11 cm; 313 g
Shan; Myanmar
Repoussé work; animal motifs on sides;
bottom engraved with geometrical patterns.
Opposite page: detail with three animal
figures, horse, elephant, bird, and others.

167 (bottom). *Pipe*
Ag 95%, Cu 5% (plus wood)
L 32 cm; 172 g
Golden Triangle: Thailand, Myanmar,
Laos
Pipe consists of three sections;
mouthpiece section entirely of silver.

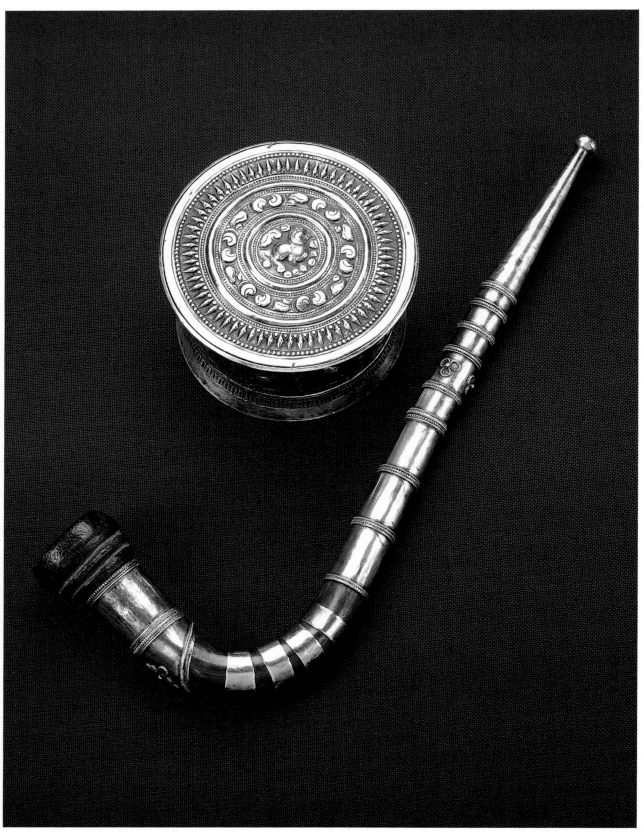

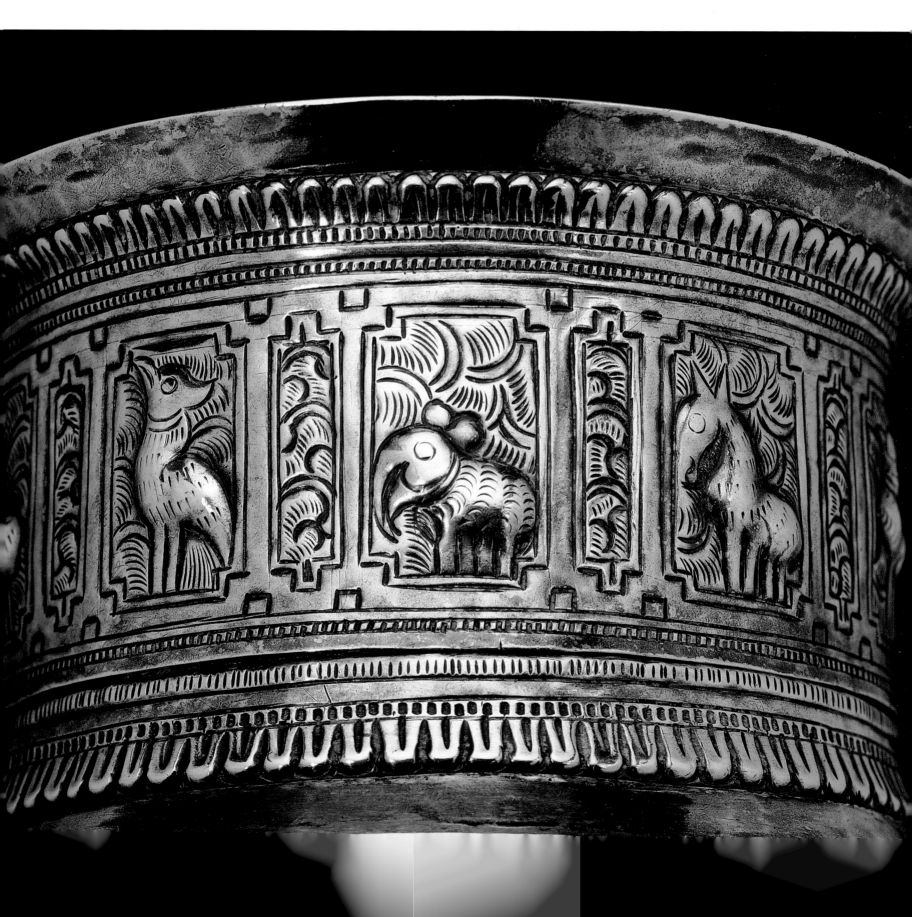

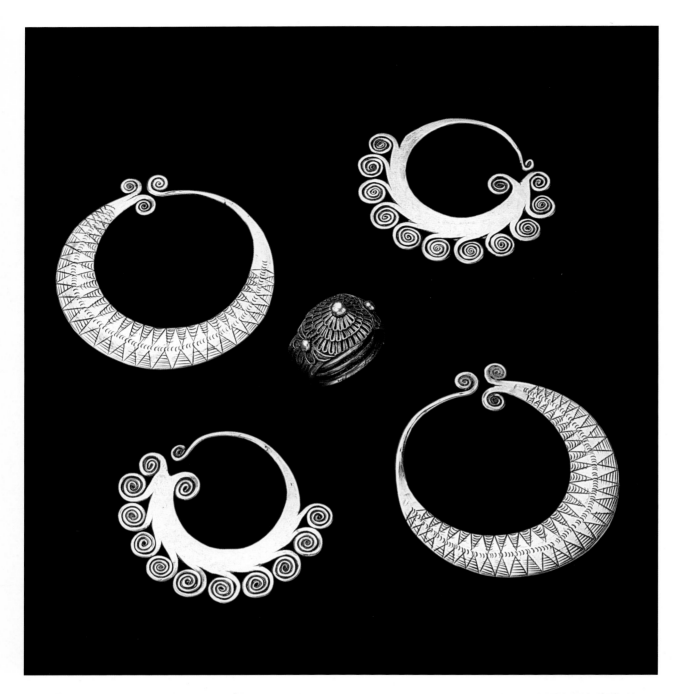

169 (top right). *Earrings*
Ag 93%, Cu 7%
H 5 cm, W 5.5 cm; 19.7 g together
Hmong; Golden Triangle: Thailand,
Myanmar, Laos
Curled sides bottom.

169 (bottom left). *Earrings*
Ag 93%, Cu 7%
H 6.2 cm, W 5.8 cm; 23.2 g together
Hmong; Golden Triangle: Thailand,
Myanmar, Laos (also Vietnam)
Smooth round bottom.

169 (centre). *Ring*
Ag 92%, Cu 8%
H 3.5 cm, W 2.2 cm; 21 g
Akha; Golden Triangle: Thailand,
Myanmar, Laos
Man's ring.

170. *Earrings*
Ag 92%, Cu 8%; wire: Ag 94%, Cu 6%
H 6 cm, W 9 cm; 42 g together
Lahu; Golden Triangle: Thailand,
Myanmar, Laos
Two rows of dangles hanging from
twisted wires.

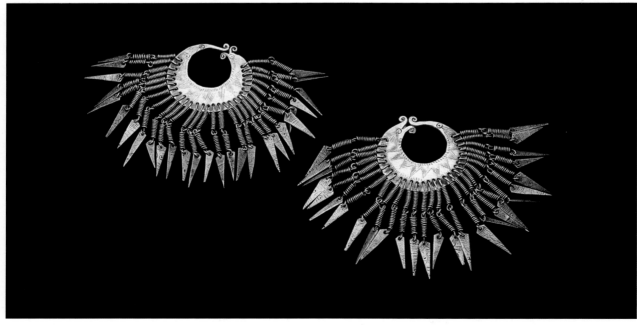

171. *Bracelets* (pair)
Ag 92%, Cu 8%
H 7.5 cm, Ø 7.2 cm; 627 g together
Wa and Lawa; Laos
Slightly expanded spirals.

172 (top right). *Bracelet*
Ag 95%, Cu 5%
Ø 8.5 cm; 206 g
Wa and Lawa; Myanmar, Laos

172 (top left). *Bracelet*
Ag 90%, Cu 10%
Ø 8.7 cm; 205 g
Wa and Lawa; Myanmar, Laos

172 (bottom right). *Bracelet*
Ag 94%, Cu 4%, Pb 2%
Ø 8.2 cm; 240 g
Wa and Lawa; Myanmar, Laos

172 (bottom centre). *Bracelet*
Ag 67%, Cu 33%, trace of Zn
Ø 7.8 cm; 120 g
Wa and Lawa; Myanmar, Laos

172 (bottom left). *Bracelet*
Ag 80%, Cu 20%
Ø 7.2 cm; 116 g
Wa and Lawa; Myanmar, Laos

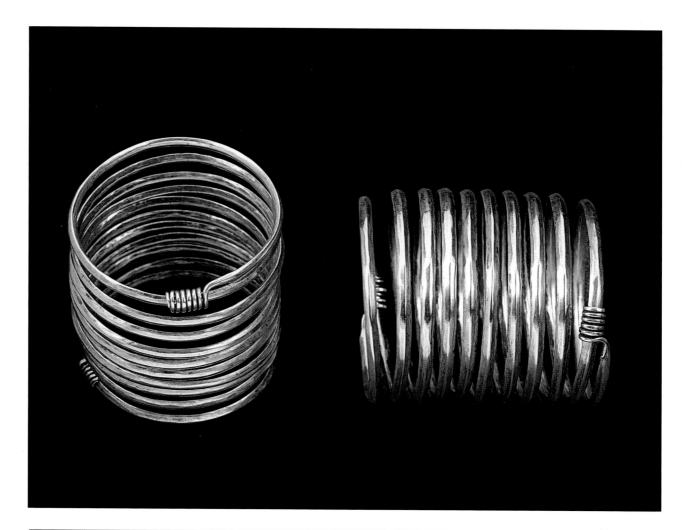

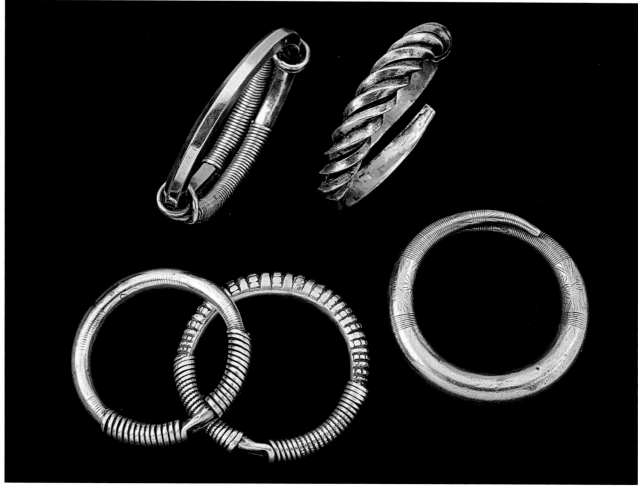

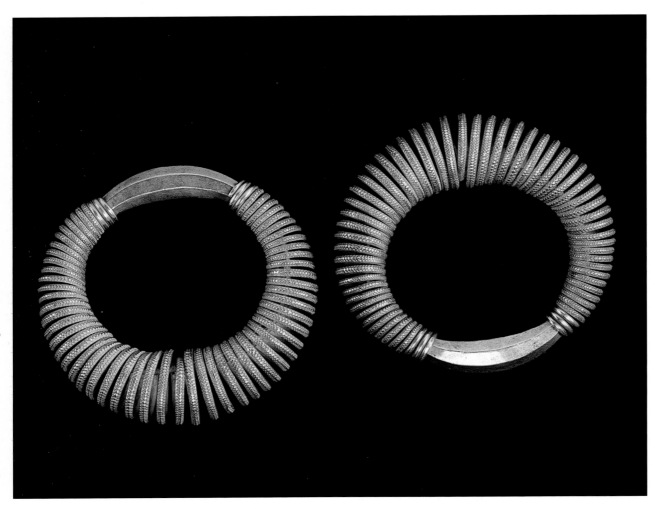

173. *Bracelets* (pair)
Ag 92%, Cu 8%
Ø 7.5 cm; 271 g together
Wa and Lawa; Myanmar, Laos
Closed round bracelets with plain middle sections; each spirals the other's mirror image.

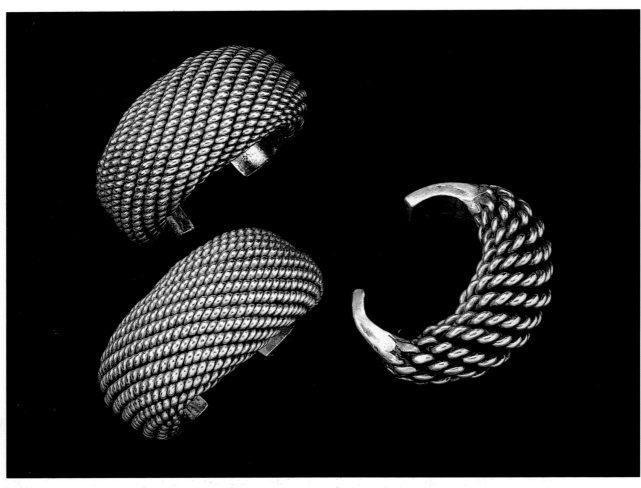

174 (right). *Bracelet*
Ag 95%, Cu 5%
H 5.5 cm, W 7.5 cm; 170 g
Various Thailand tribes,
mainly Phami and Akha.

174 (left). *Bracelets* (pair)
Ag 96%, Cu 4%
H 6.5 cm, W 7.5 cm; 629 g together
Various Thailand tribes, mainly
Phami Akha
Bracelets are each other's mirror image,
including the spirals.

175 (top right). *Bracelet*
Ag 58%, Cu 42%
H 4.6 cm, W 5.5 cm,
thickness 2.2 cm; 58 g
Lahu, Akha, Lisu; Golden Triangle:
Thailand, Myanmar, Laos
Woman's bracelet with engravings.

175 (top left). *Bracelet*
Ag 95%, Cu 5%
H 5.5 cm, W 7.2 cm; 160 g
Hmong, Yao; Golden Triangle:
Thailand, Myanmar, Laos
Man's solid bracelet with engravings.

175 (centre). *Bracelet*
Ag 91%, Cu 9%
H 4.5 cm, W 6.6 cm; 92 g
Hmong, Yao; Golden Triangle:
Thailand, Myanmar, Laos
Man's solid bracelet with engravings.

175 (bottom). *Bracelet*
Ag 94%, Cu 6%
H 4.2 cm, W 6.2 cm; 87 g
Hmong, Yao; Golden Triangle:
Thailand, Myanmar, Laos
Man's solid bracelet with engravings.

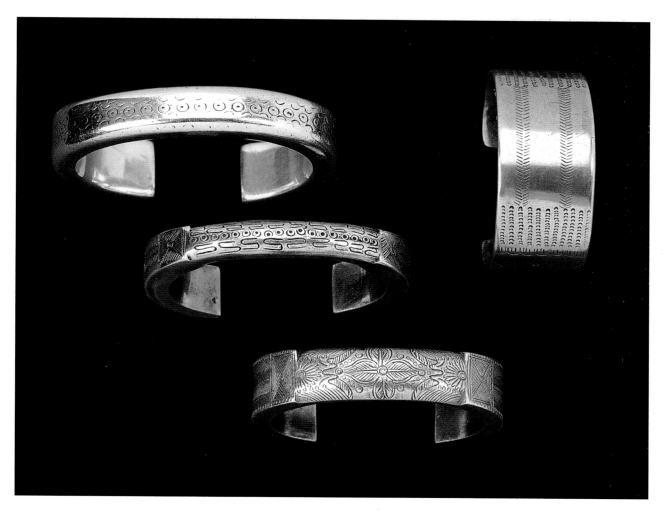

176 (top left). *Bracelet*
Ag 69%, Cu 31%
Ø 6.2 cm; 83 g
Lawa; Laos
Bracelet consisting of a spiral
narrowing towards the ends.

176 (bottom left). *Bracelet*
Ag 58%, Cu 42%, trace of Zn
Ø 7.7 cm; 93 g
Lawa; Laos
Bracelet consisting of a spiral
narrowing towards the ends.

176 (right). *Bracelets* (pair)
Ag 83%, Cu 16% Pb 1%
H 8 cm, W 7.5 cm; 348 g together
Wa and Lawa; Laos
Woman's solid bracelets,
also suitable for self-defence.

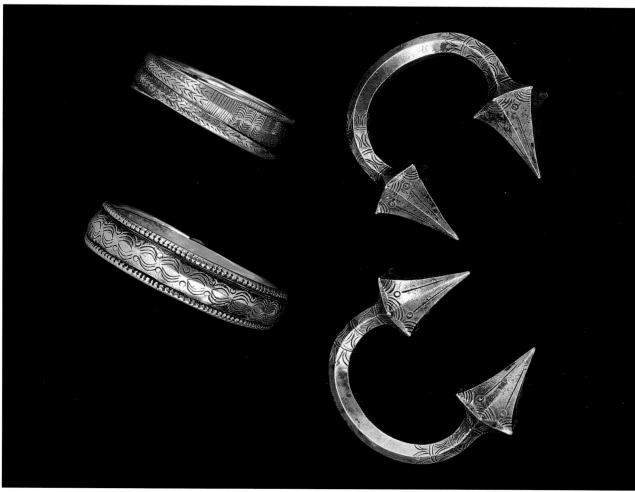

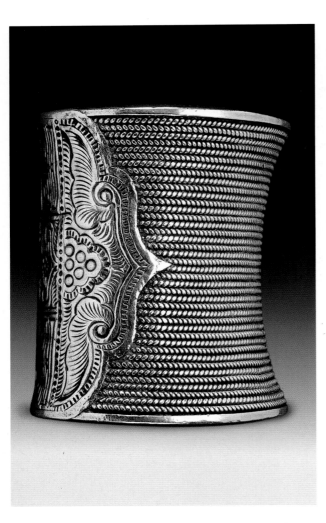

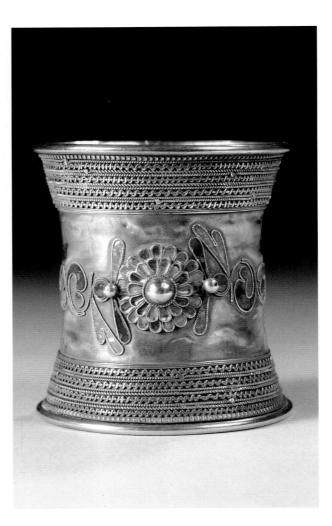

177. *Bracelet*
Ag 97%, Cu 3%
H 5.5 cm, L 7.3 cm; 278 g
Shan; Myanmar
Cuff has braided wires and applied
elements; decorated with repoussé work.

178. *Bracelet*
Ag 91%, Cu 9%
H 8.2 cm, W 7.6 cm; 115 g
Jinghpaw; Myanmar, Kachin state
Middle part decorated with floral motifs;
enamelled red, yellow, green and blue.

179. *Bracelets* (pair)
Ag 99%; wire: Ag 97%, Cu 3%
H 10 cm, W 7 cm
Shan; Myanmar
Closed tubular bracelets, adorned with
floral motifs; bracelets as fine as these are
very rare.

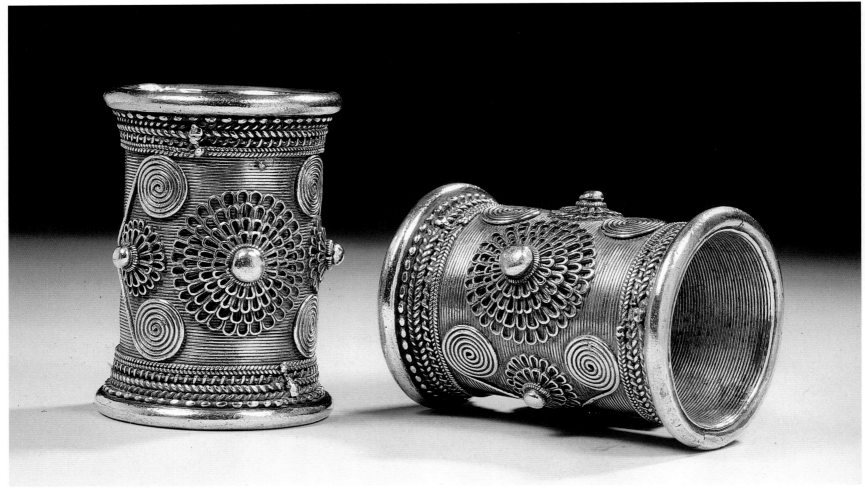

180. *Pipe*
Ag 61%, Cu 39%
H 16.5 cm; 74 g
Hmong; Laos

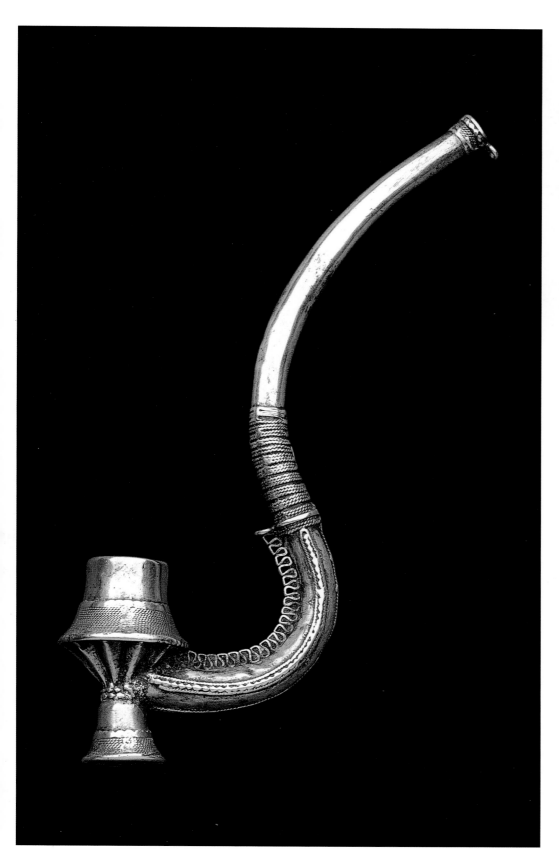

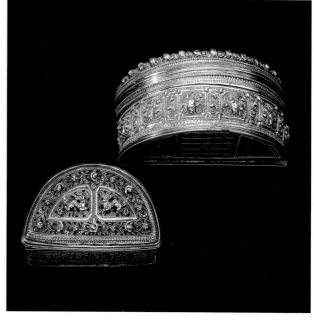

181 (top). *Tobacco box*
Ag 98%, Cu 2%
L 10 cm, H 4 cm, D 4.5 cm; 142 g
Shan; Myanmar/Laos
Repoussé work; magic diagram
engraved on bottom.

181 (bottom). *Tobacco box
or lime container*
Ag 98%, Cu 2% (ornaments and lid)
Ag 97%, Cu 3% plate
L 7cm, H 3.5cm, D 4cm; 80 g
Shan; Myanmar
Extremely fine repoussé work probably
the property of a tribal chief. Two
appliqué cast lions soldered on top.

Textiles

182. *Wrap-around skirt*
Cotton
Ø 102 cm, H 56 cm
Hmong; Thailand, Laos
Pleated wrap-around skirt (*phaa sin*); blue
indigo batik with patchwork and
embroidery.

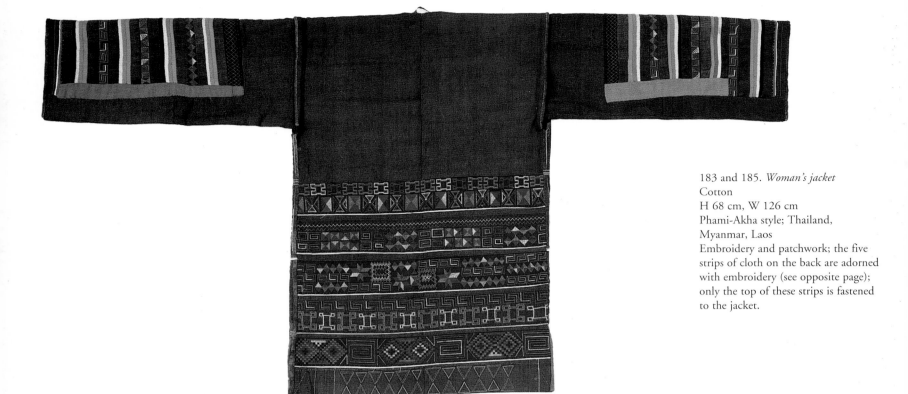

183 and 185. *Woman's jacket*
Cotton
H 68 cm, W 126 cm
Phami-Akha style; Thailand,
Myanmar, Laos
Embroidery and patchwork; the five
strips of cloth on the back are adorned
with embroidery (see opposite page);
only the top of these strips is fastened
to the jacket.

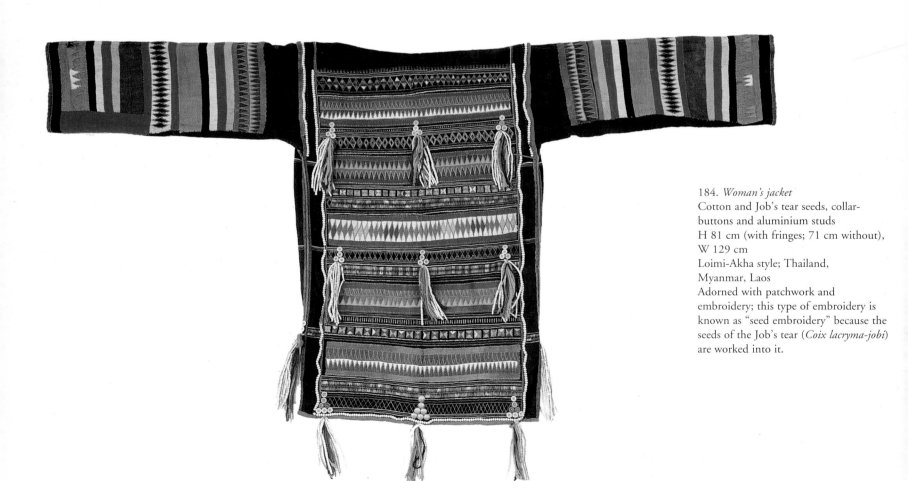

184. *Woman's jacket*
Cotton and Job's tear seeds, collar-
buttons and aluminium studs
H 81 cm (with fringes; 71 cm without),
W 129 cm
Loimi-Akha style; Thailand,
Myanmar, Laos
Adorned with patchwork and
embroidery; this type of embroidery is
known as "seed embroidery" because the
seeds of the Job's tear (*Coix lacryma-jobi*)
are worked into it.

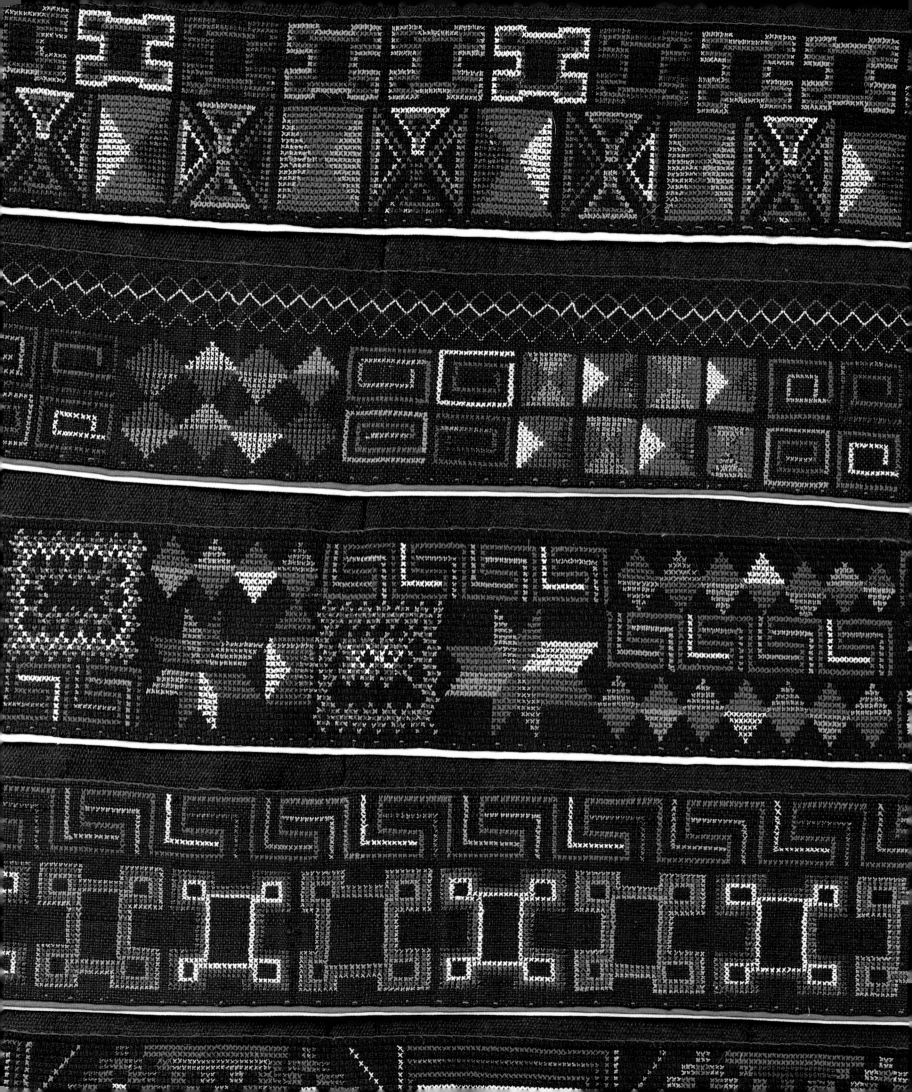

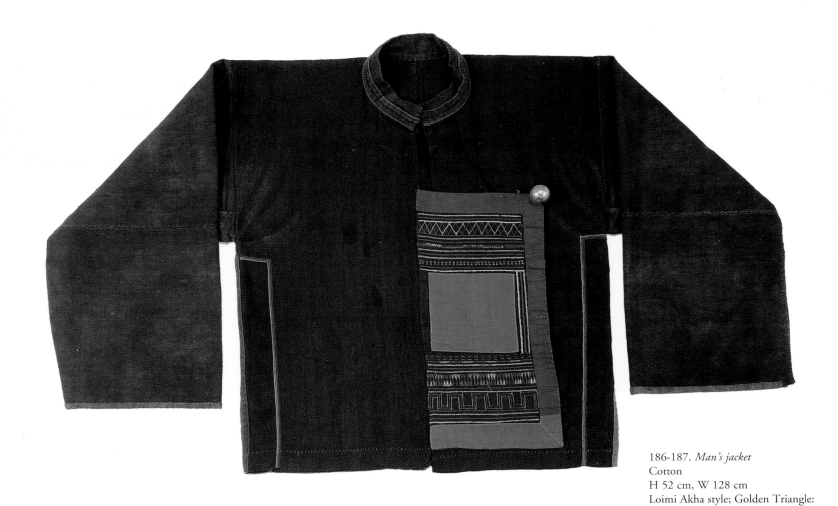

186-187. *Man's jacket*
Cotton
H 52 cm, W 128 cm
Loimi Akha style; Golden Triangle:
Thailand, Myanmar, Laos
Adorned with patchwork; a silver button
at the front.

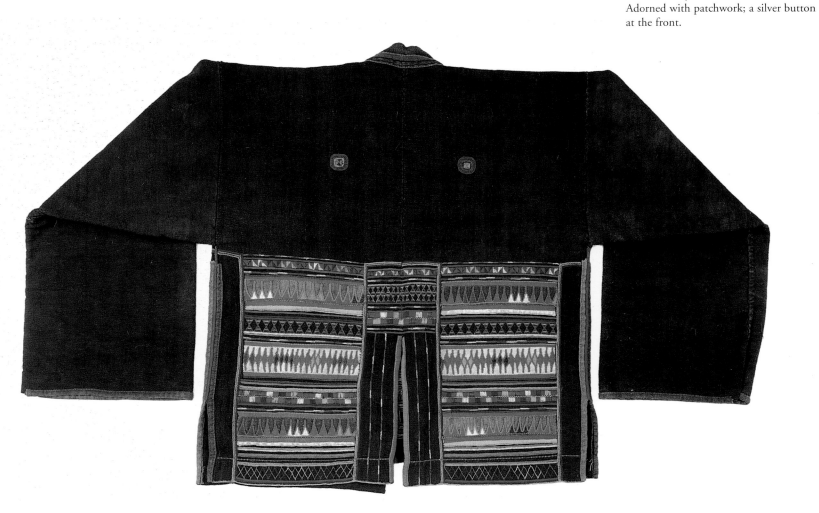

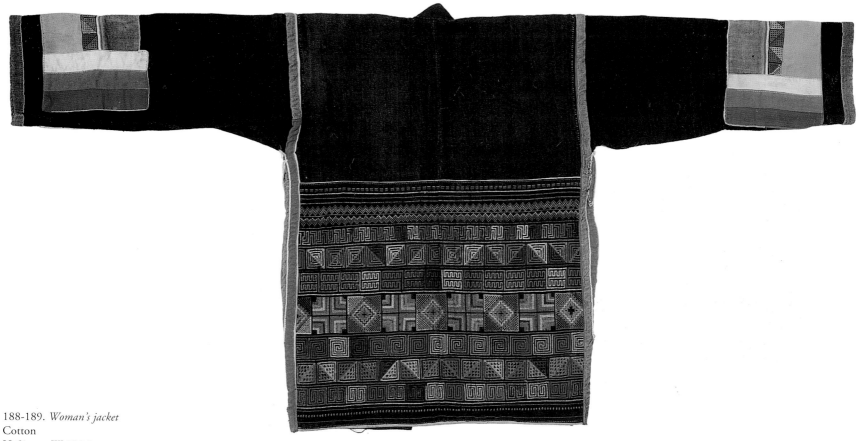

188-189. *Woman's jacket*
Cotton
H 61 cm, W 123.5 cm
Phami-Akha style; Golden Triangle:
Thailand, Myanmar, Laos
Patchwork on the sleeves; the back of the
jacket is adorned with embroidery.

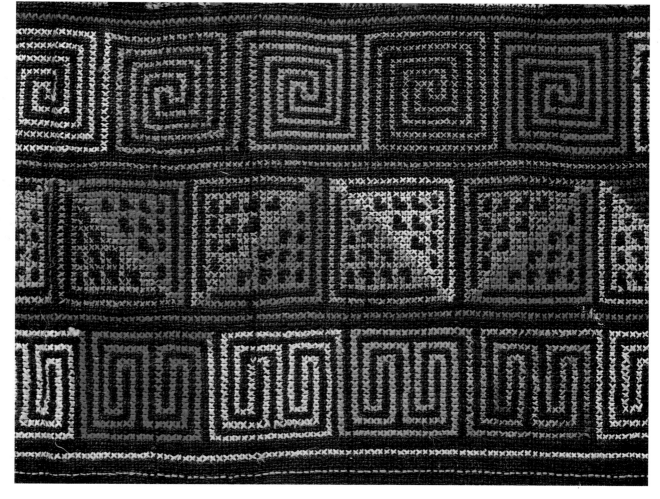

190. *Over-blouse for married women*
Cotton and Job's tear seeds
H 65 cm, W 55 cm
Pwo Karen (valley dwellers); Thailand, Myanmar
Red and yellow embroidered blouse adorned with white seeds; a sarong is worn under the blouse.

191. *Over-blouse for married women*
Cotton and Job's tear seeds
H 61 cm, W 67 cm
Sgaw Karen (mountain dwellers); Thailand, Myanmar
Embroidered blouse adorned with seeds.

192-193. *Woman's trousers*
Cotton
L 90 cm, W 56.5 cm
(measured at the waist)
Yao; Thailand, Laos
Colourful and fine embroidery.

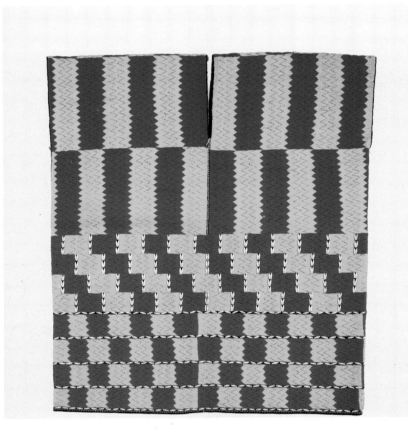

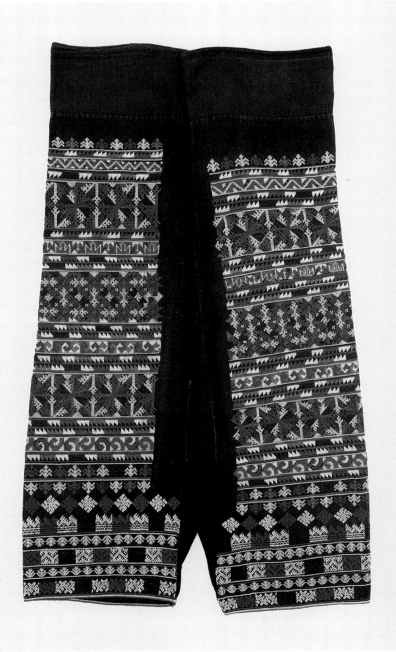

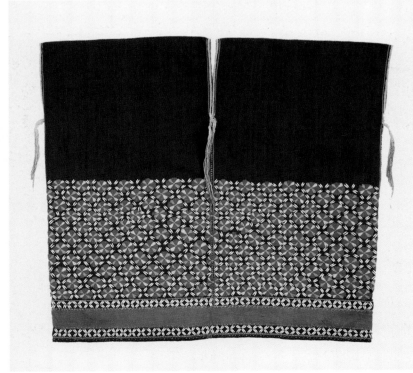

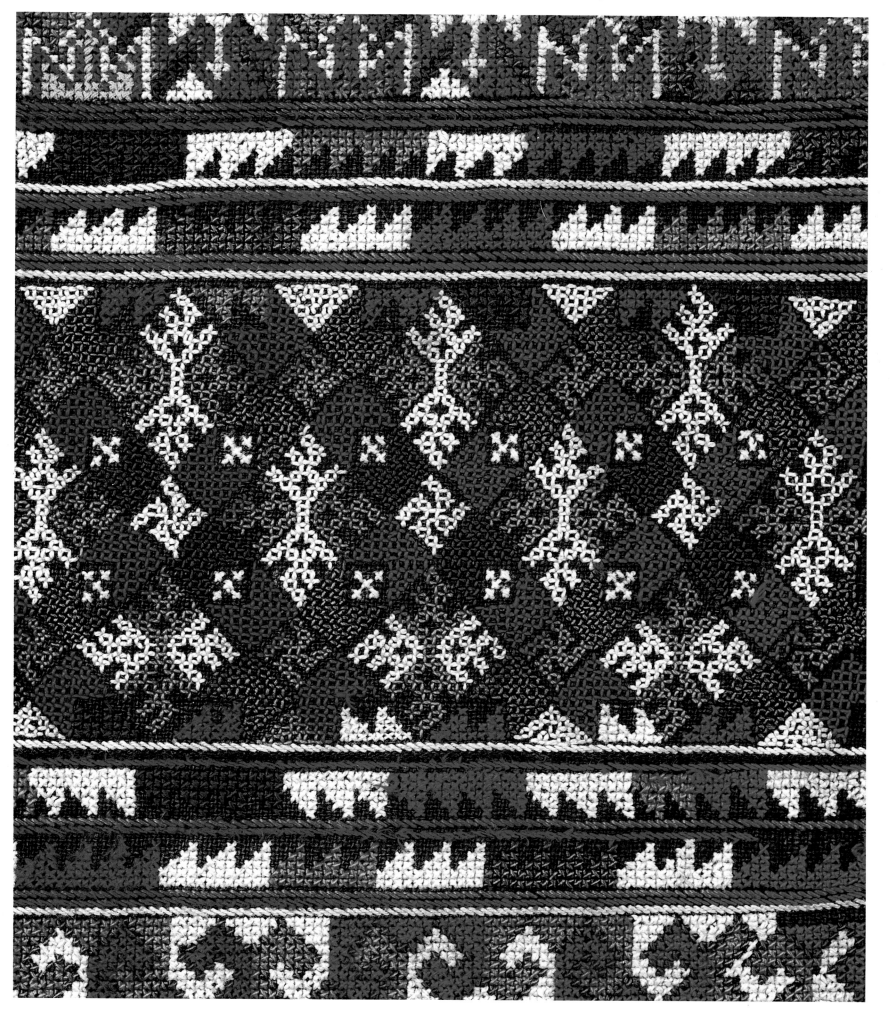

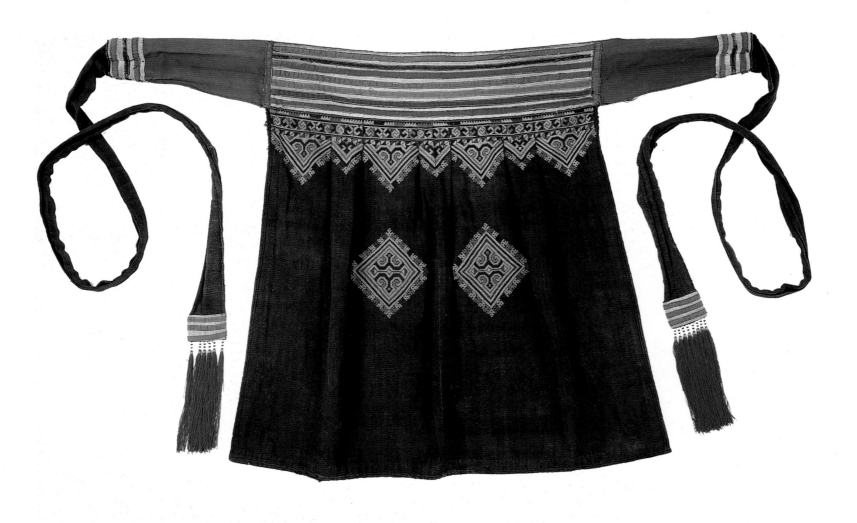

194 and 196. *Apron/cape*
(also used as baby-carrying cloth)
Cotton and glass beads
H 68 cm, W 100 cm (at the top);
tassels: 2 x approx. 148 cm
Yao; Laos, China (Yunnan province)
Worn on special occasions (including
weddings), both as apron and as cape;
adorned with patchwork, embroidery
(see opposite page) and two long tassels.

195. *Man's jacket*
Cotton
H 80 cm, W 142 cm
Yao; China (Yunnan province)
Blue 100% indigo jacket with two rows
of white metal buttons.

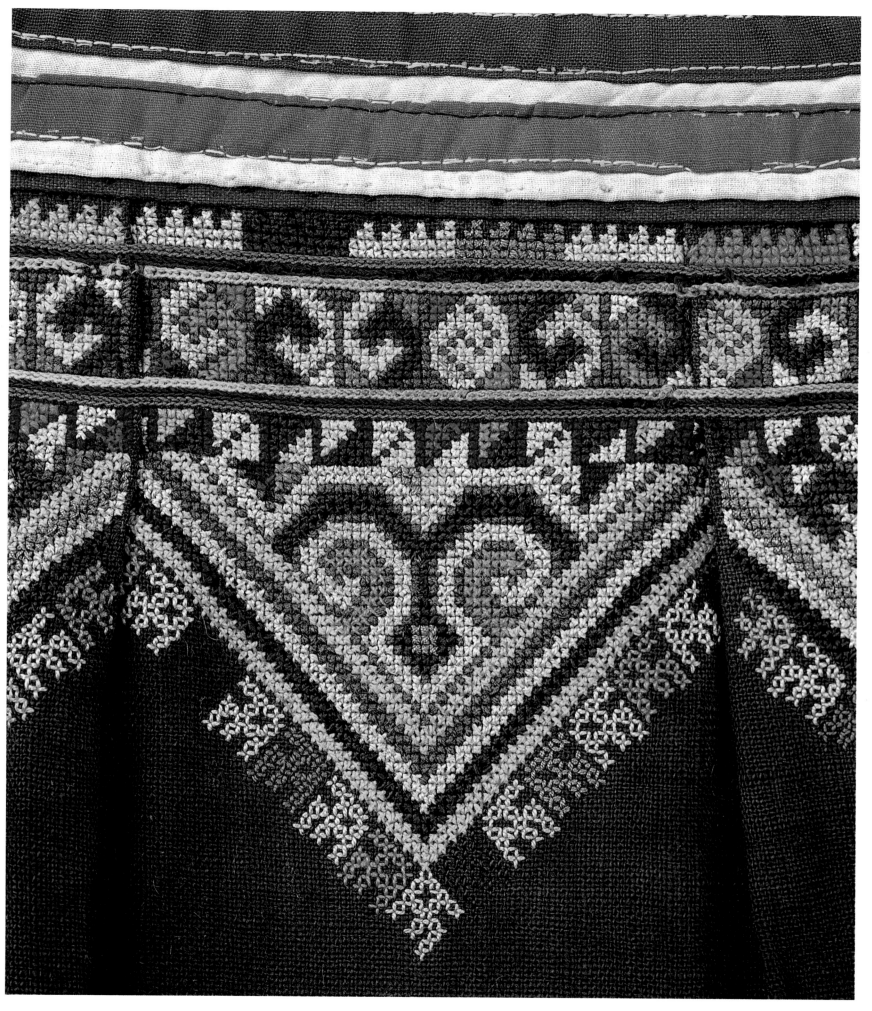

197. *Woman's jacket with matching pleated skirt*
Cotton, silver
H 55 cm, W 123.5 cm (jacket)
H 82 cm, W (at top) 71 cm (skirt)
Zhuang; Yunnan, Wen Shan area
Dark indigo blue jacket and skirt, adorned with embroidery; jacket is adorned with silver discs and triangles.

198-199. *Man's jacket*
Cotton, metal buttons
H 76 cm, W 139 cm
Yi; Yunnan and Guangxi
(Wenxi style)
Indigo-dyed cotton batik jacket consisting of two (mostly three) separate jackets that form the whole; buttons are non-functional, lengths of patchwork.

These batik jackets are mainly worn at festivals; they mostly consist of three separate jackets with the sleeves getting progressively shorter and broader; both front and back are of angular shape with a cross-stitched broad waistband tied over the jacket; these jackets are dyed and made by the bride for her groom, and are her wedding present for him.

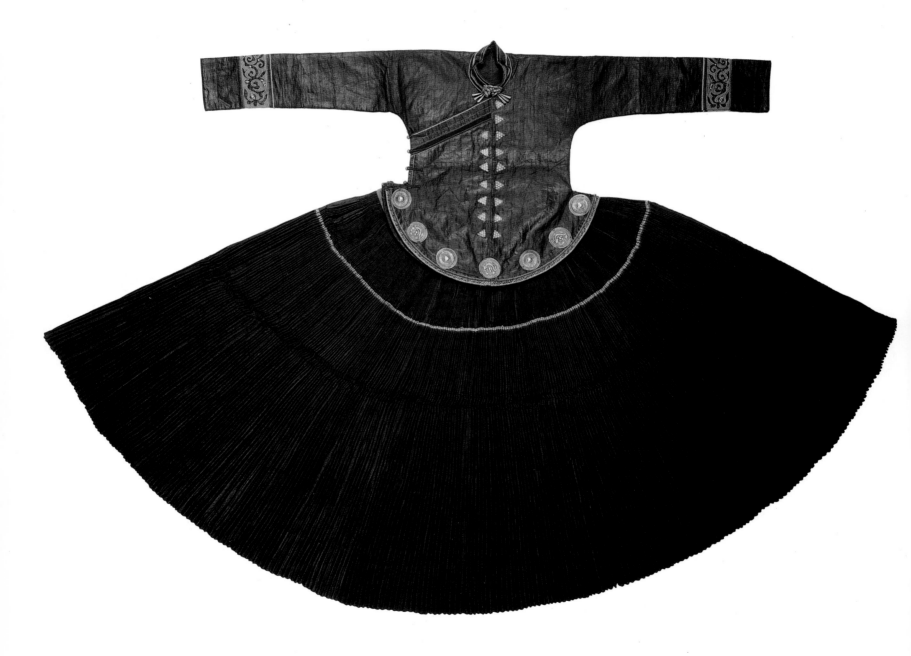

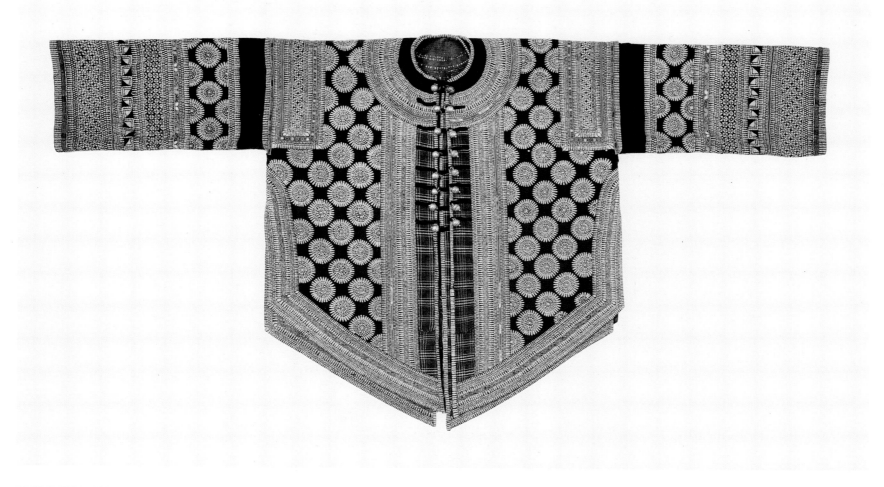

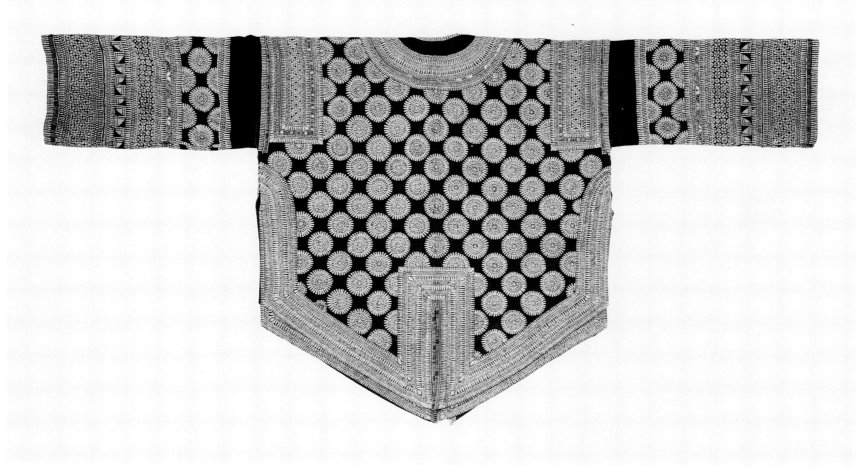

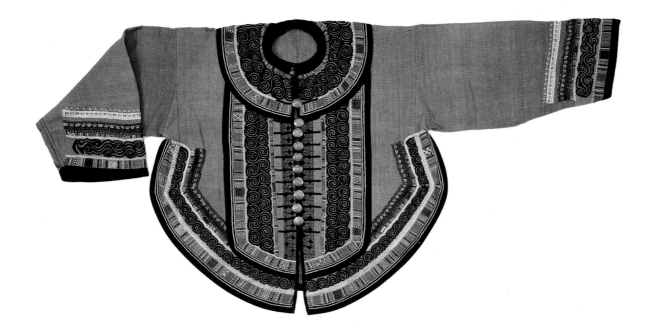

200. *Woman's jacket*
Indigo-dyed cotton and non-functional
silver ornamental buttons.
H 68 cm, W 146 cm
Yi; Yunnan and Guangxi (Wenxi style)
With appliqué work and batik.

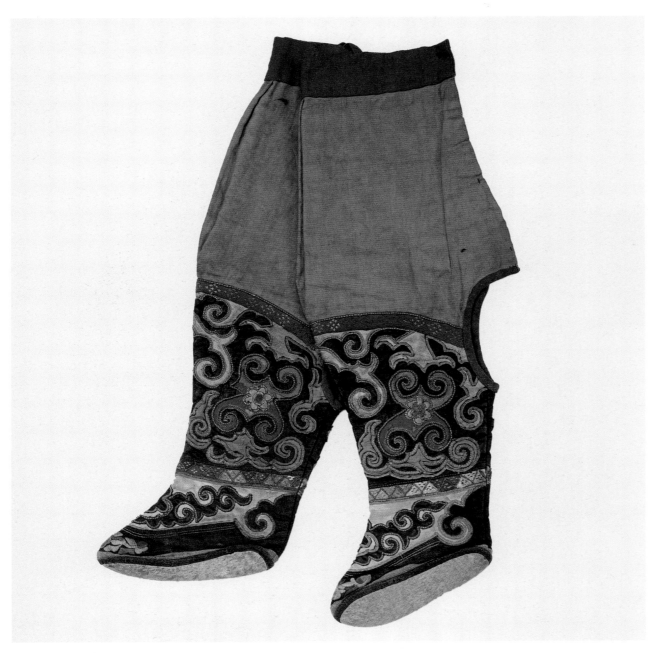

201. *Boy's trousers*
(for boys of 0–4 years)
Indigo-dyed cotton
H 40 cm, W 23 cm (top)
Yi; Yunnan
Appliqué work adornment; the back and
bottom are open to enable the boy to
answer the calls of nature.

202. *Woman's jacket with matching skirt*
Indigo-dyed cotton; jacket with white
ornamental buttons.
H 66 cm, W 147.5 cm (jacket)
H 85 cm, W (at top of skirt) 2 x 48 cm
Yi; Yunnan (Wenxi style), Malipo village
Homewoven cloth with hidden stripes
forms the basis of the jacket; batik cotton
prints line the shoulders, front openings,
sleeve-cuffs and lower hem.
The skirt (with supplementary weft) is
adorned with embroidery and is also
inlaid with triangular pieces of cloth in
various colours.

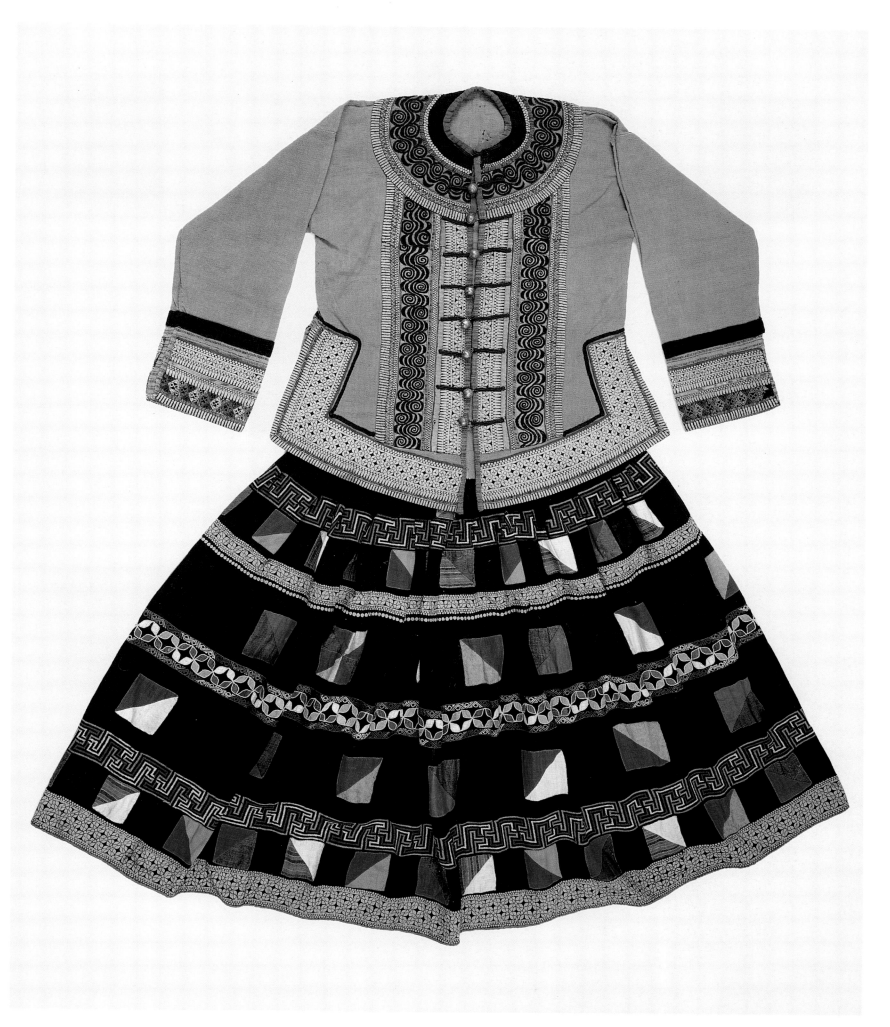

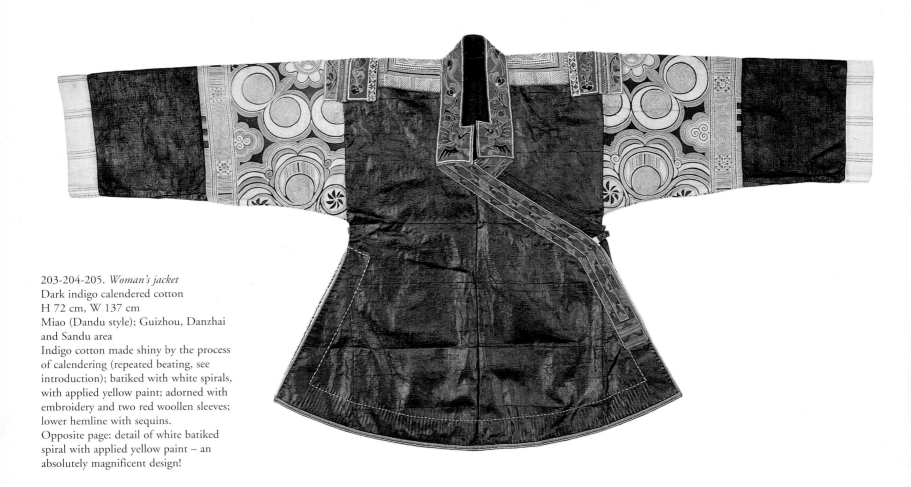

203-204-205. *Woman's jacket*
Dark indigo calendered cotton
H 72 cm, W 137 cm
Miao (Dandu style); Guizhou, Danzhai
and Sandu area
Indigo cotton made shiny by the process
of calendering (repeated beating, see
introduction); batiked with white spirals,
with applied yellow paint; adorned with
embroidery and two red woollen sleeves;
lower hemline with sequins.
Opposite page: detail of white batiked
spiral with applied yellow paint – an
absolutely magnificent design!

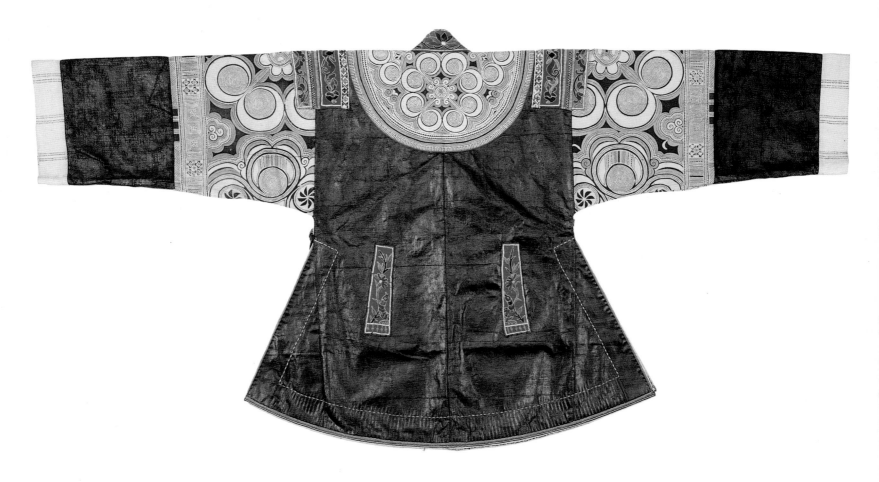

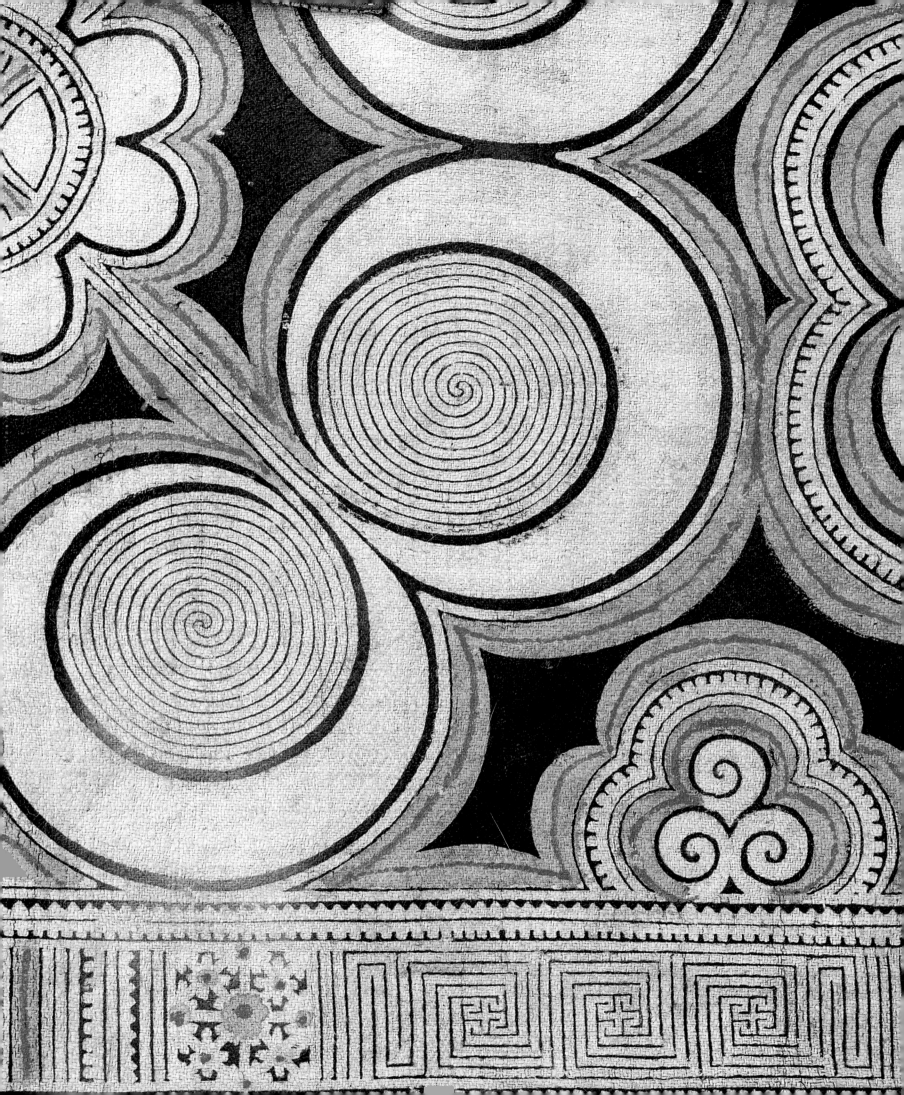

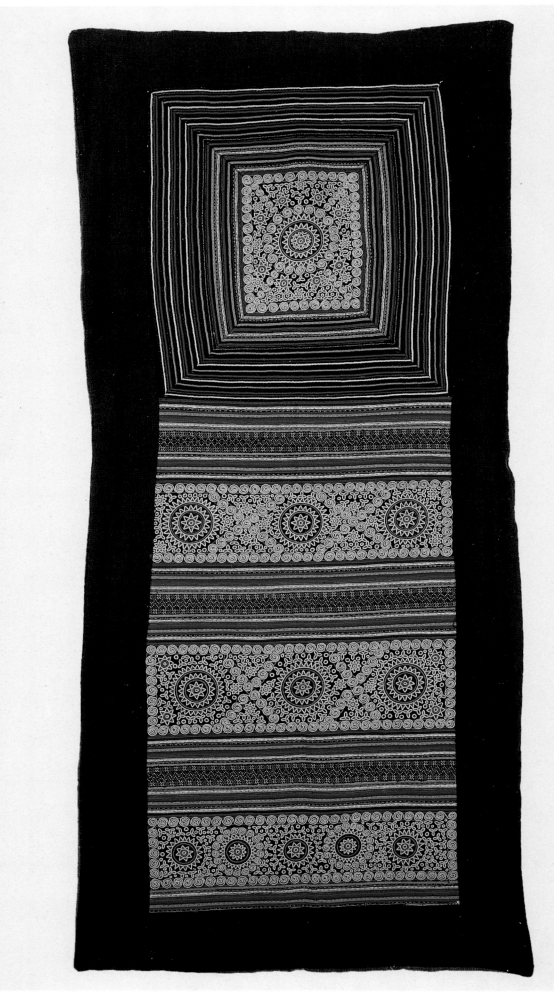

206-207. *Baby-carrier (back)*
Indigo-dyed, handspun cotton,
embroidery
H 104 cm, W 47 cm
Miao; Guizhou
Patchwork and extremely fine embroidery
(see opposite page).

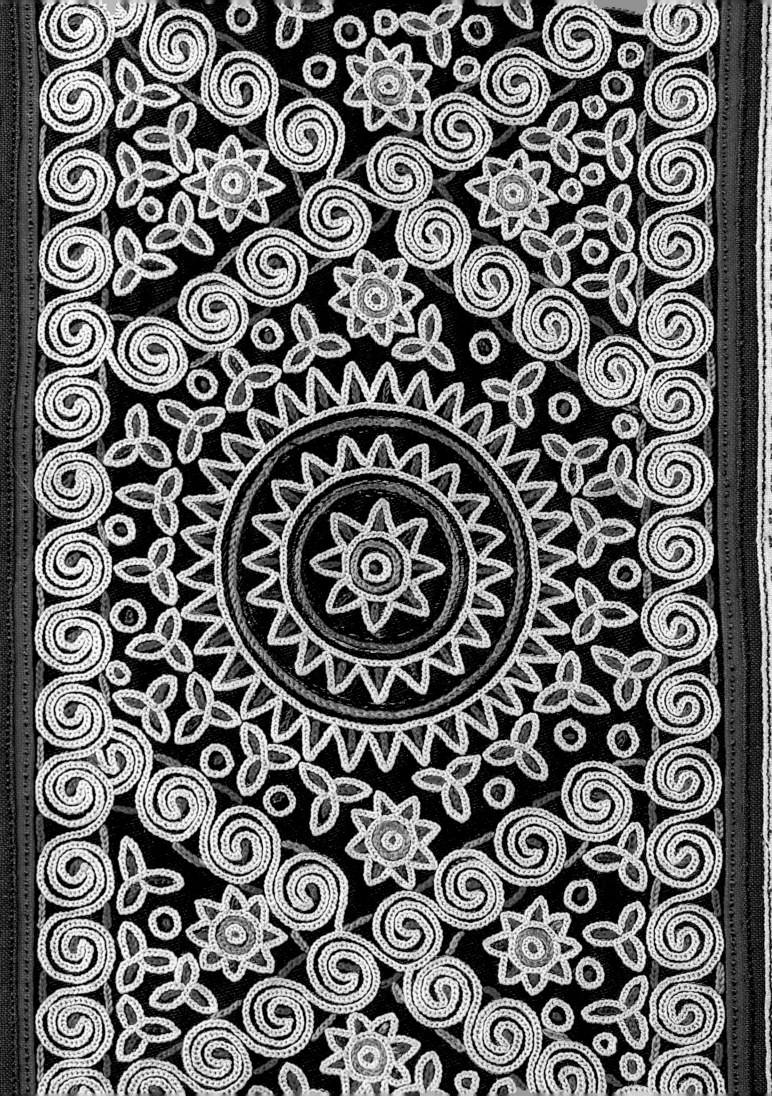

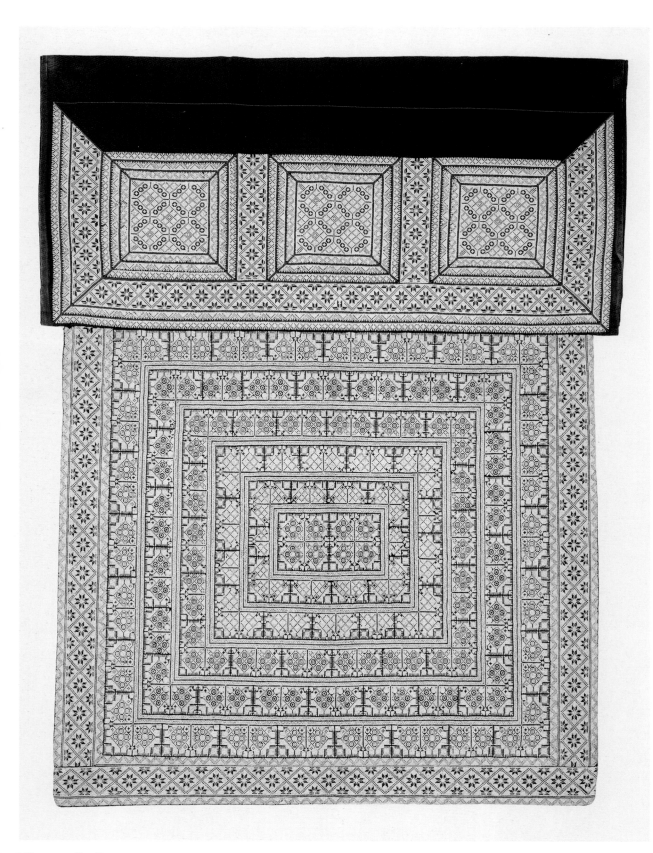

208-209. *Baby-carrier (back)*
Dark indigo-dyed cotton, white
embroidery
H 66 cm, W 51 cm
Miao; Guizhou
Extremely fine embroidery (see opposite
page); for three years every spare hour
was spent on this baby-carrier (which
consists of two parts).

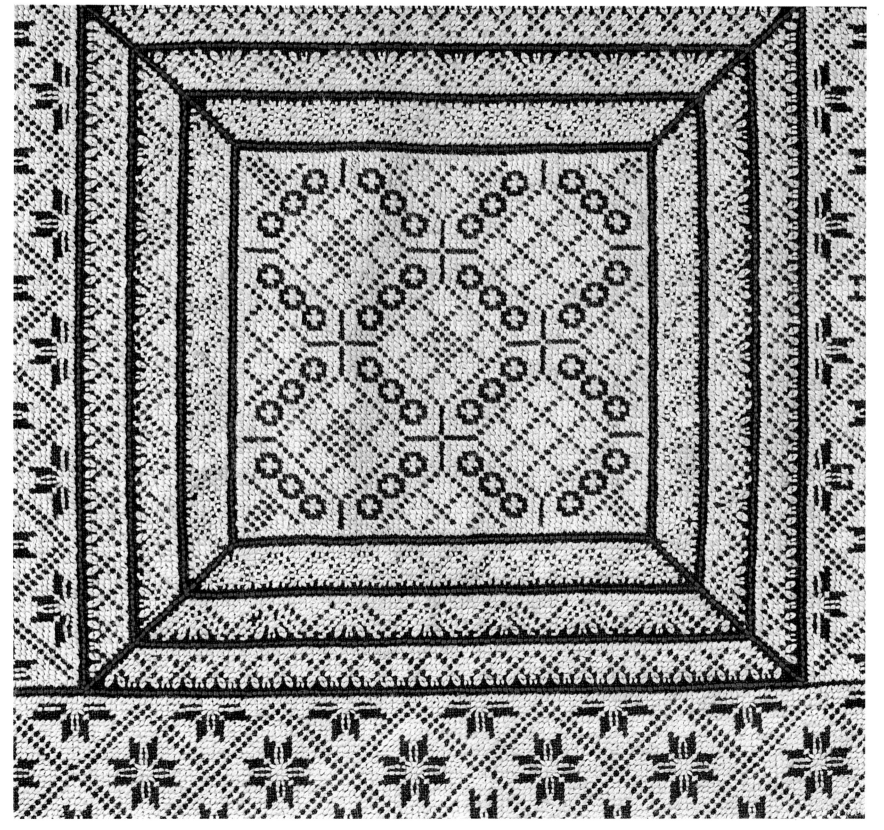

210-211. *Woman's jacket*
dark indigo-dyed cotton base with silk embroidery; hand-made copper sequins and pewter bendable appliqué
H 83 cm, W 110 cm
Miao (Taijang style); Guizhou, Shidong area
The jacket is calendered and twill-woven; the embroidered parts can be removed when the cotton basis has become threadbare and they can then be reused on a new jacket; a coat like this is three years in the making and is worn by young adult women on special occasions such as festivals and weddings; women over forty-five no longer wear this type of jacket, but wear dark colours; this jacket is some seventy years old.

Embroidery from Shidong is some of the most highly appreciated; it is characterised by the use of loose, coloured floss silk. Ornamental patterns are made by means of flat stitching, weaving and padding figured designs. Flat embroidery is mostly used to adorn jackets: the floss silk is first split into a number of thin strands, which results in very exquisite and refined embroidery. The colours used by the Miao are mainly red and blue; designs are pictorial and narrative as a rule.
Opposite page: embroideries of cats, birds, fish, butterflies, and others.

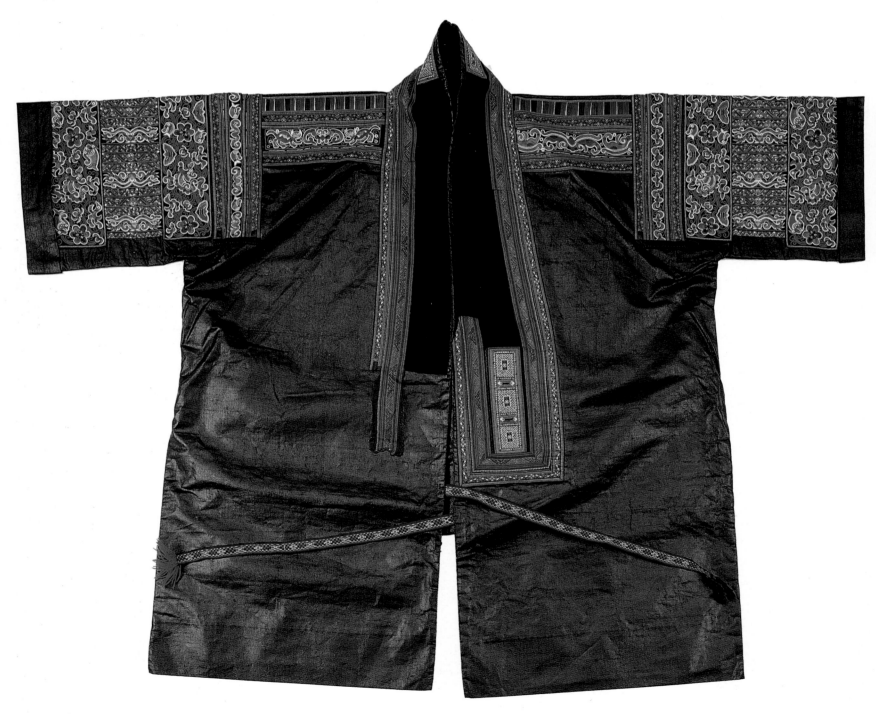

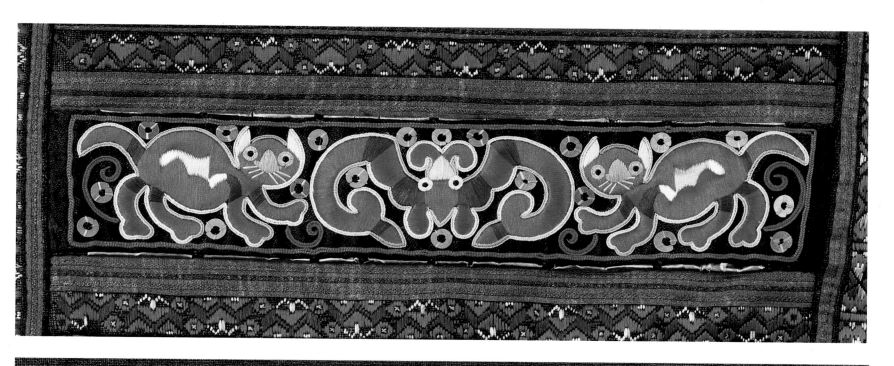

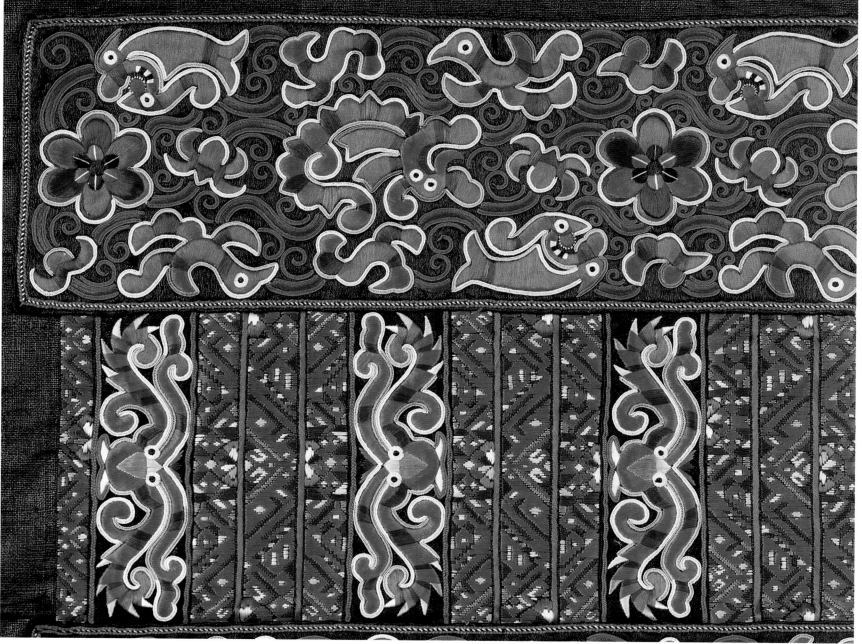

212. *Man's long robe with cape*
Cotton and linen
H 107 cm, W 77 cm
(cape and robe together)
Miao (Bijie style); Guizhou
Embroidery and appliqué work.
Man's traditional costume consists of a
long linen robe with cape; the robe is
without buttons or collar and opens in
the middle; long-legged trousers are also
worn; women wear comparable clothes,
but with a skirt underneath.

213-214. *Jacket and apron*
(bridal apron)
Silk felt appliqué
Cotton inside and out; pewter buttons;
lower hem of dyed-silk felt with
pewter straps
H 62 cm, W 110 cm (jacket)
H 45 cm, W 58 cm (apron)
Miao (Leigong Shan style)
Guizhou, Shiqing area
Embroidered silk felt appliqué, a
technique handed down from mother to
daughter.

Silk felt is made by some Miao in east
Guizhou by not allowing a silkworm to
wrap the silk fibre around itself but
rather by keeping it on a flat board;
hundreds of silkworms deposit layers of
silk on suchlike boards; successive layers
of silk build up and eventually create silk
felt which is very precious.

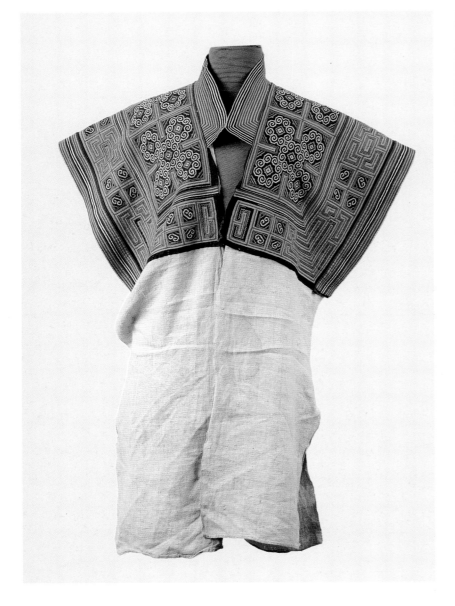

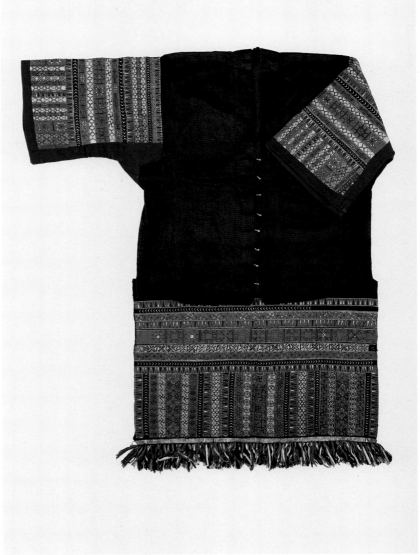

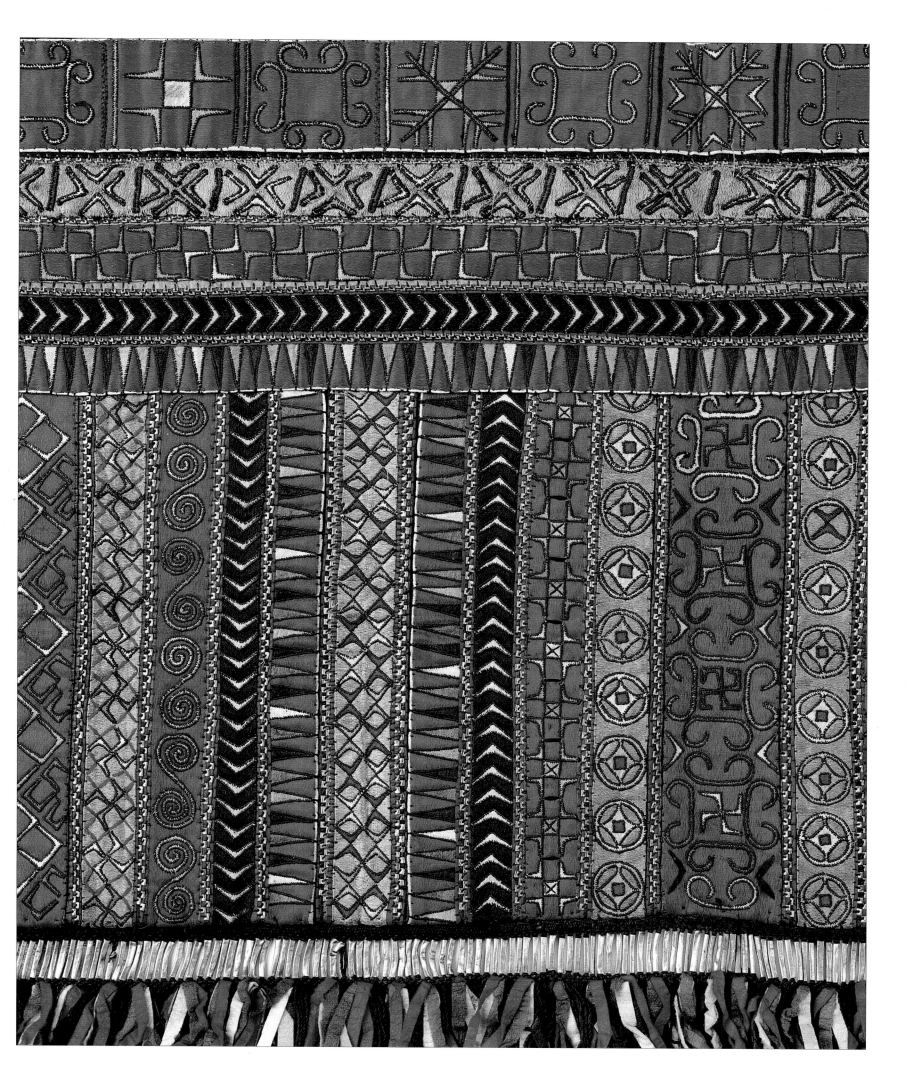

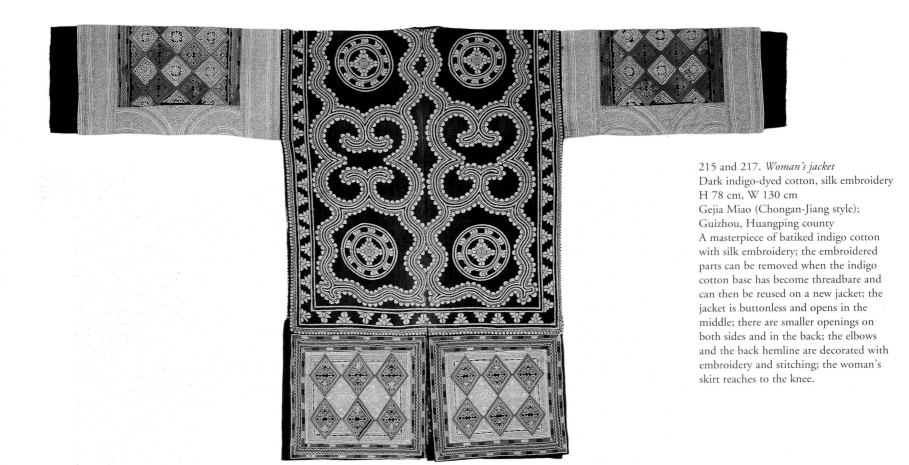

215 and 217. *Woman's jacket*
Dark indigo-dyed cotton, silk embroidery
H 78 cm, W 130 cm
Gejia Miao (Chongan-Jiang style);
Guizhou, Huangping county
A masterpiece of batiked indigo cotton
with silk embroidery; the embroidered
parts can be removed when the indigo
cotton base has become threadbare and
can then be reused on a new jacket; the
jacket is buttonless and opens in the
middle; there are smaller openings on
both sides and in the back; the elbows
and the back hemline are decorated with
embroidery and stitching; the woman's
skirt reaches to the knee.

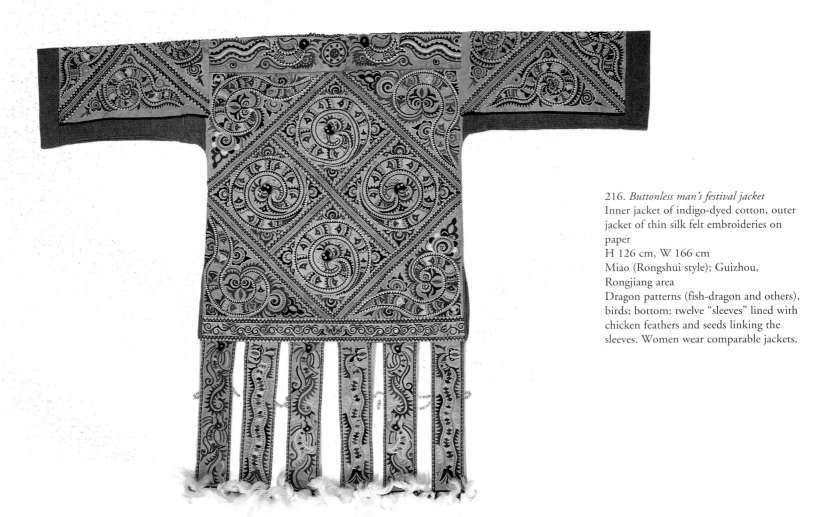

216. *Buttonless man's festival jacket*
Inner jacket of indigo-dyed cotton, outer
jacket of thin silk felt embroideries on
paper
H 126 cm, W 166 cm
Miao (Rongshui style); Guizhou,
Rongjiang area
Dragon patterns (fish-dragon and others),
birds; bottom: twelve "sleeves" lined with
chicken feathers and seeds linking the
sleeves. Women wear comparable jackets.

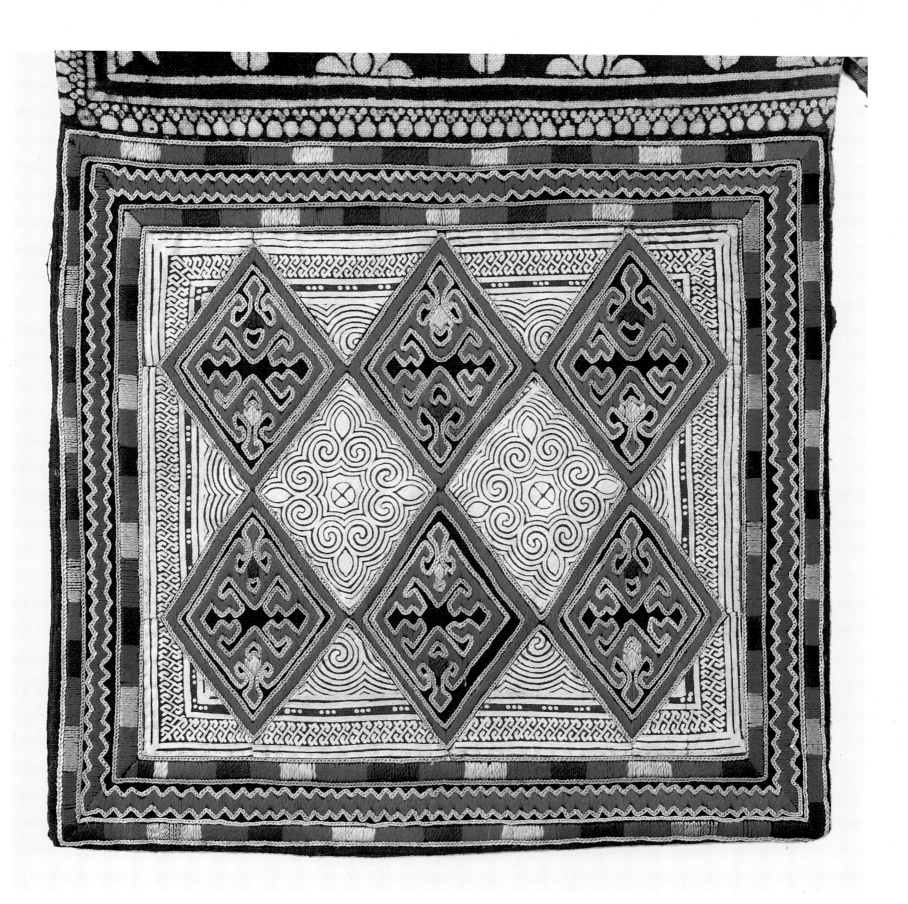

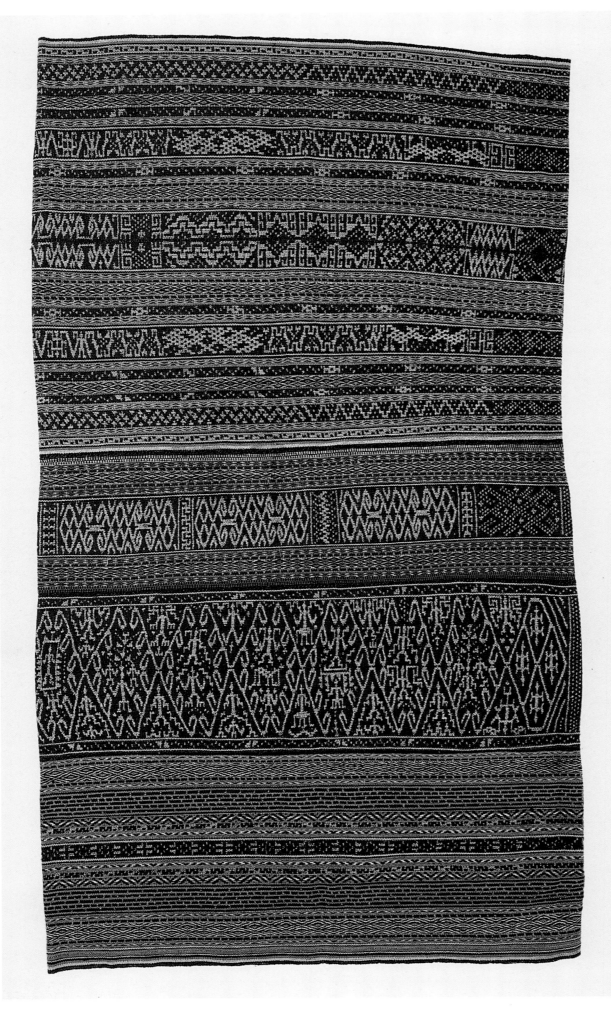

218-219. *Woman's skirt*
Cotton
H 100 cm, W 2x56 cm
Li; Hainan Island
pencil skirt consisting of five lengths;
well-defined*ikat* (see opposite page)
with supplementary weft showing human
figures and horsemen.
This skirt shows clear similarities with
textiles from Flores and Savu, islands in
East Indonesia.

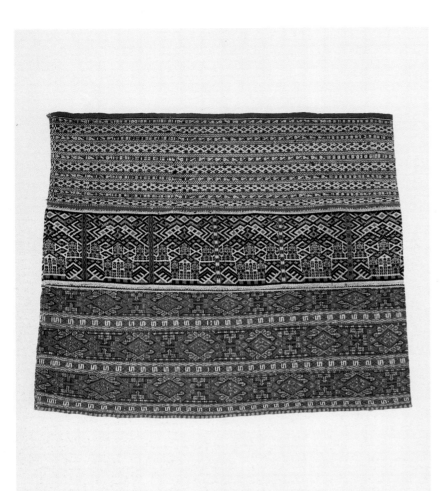

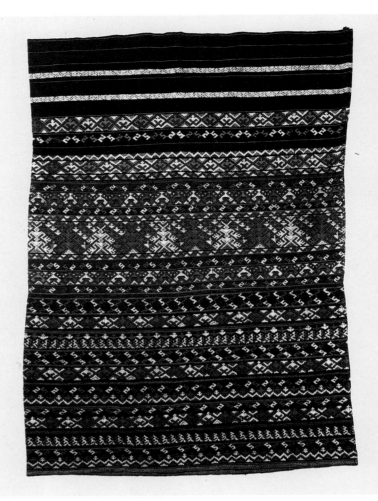

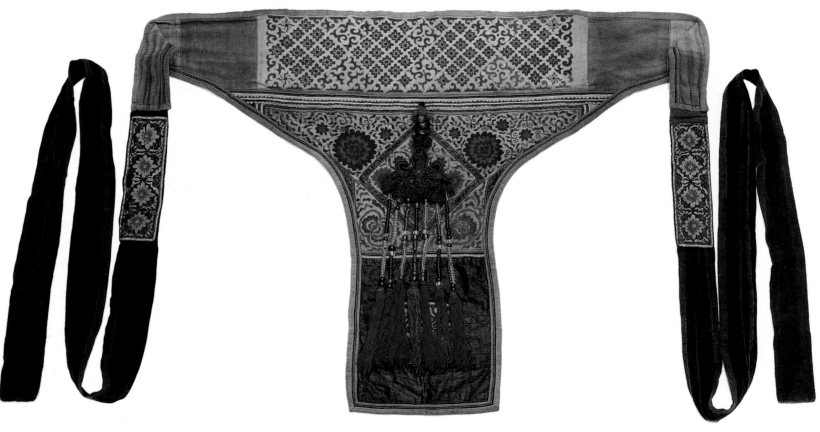

220. *Woman's skirt*
Cotton
H 32.5 cm, W 2x35.5 cm (top),
2 x 38 cm (bottom)
Li; Hainan Island, Baisha county
The skirt (supplementary weft) consists of
three lengths; middle length with
anthropomorphic figures.

221. *Woman's skirt*
indigo-dyed cotton with natural pigments
H 80 cm, W 57 cm
Li; Hainan Island, Dongfang area
Embroidered pencil skirt (supplementary
weft) consisting of three lengths;
anthropomorphic figures.
The red pigment is madder (*rubia
tinctorum*), of which the root is used; on
the back much yellow ochre pigment; the
central length with anthropomorphic
figures is red on one side and yellow on
the other.

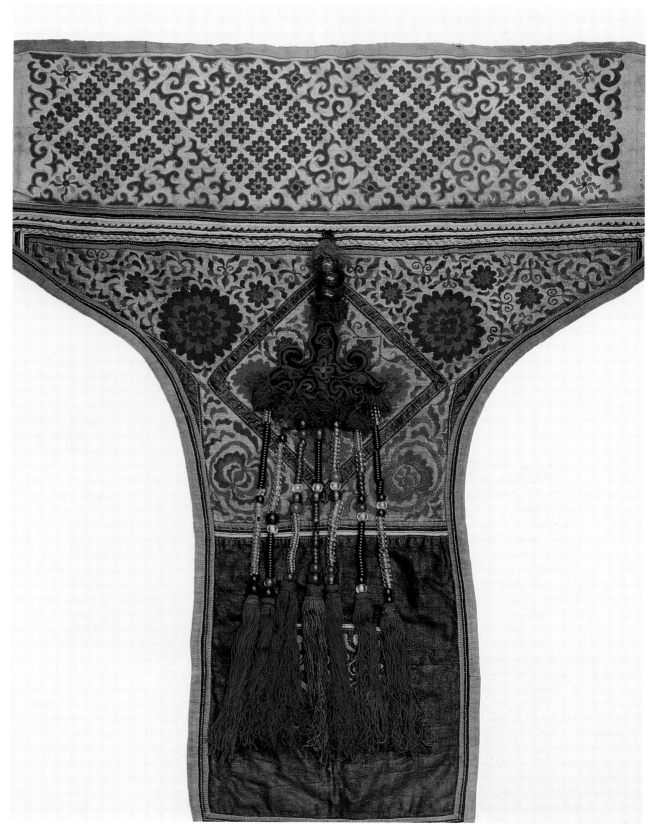

222-223. *Lao Jia baby-carrier*
Silk embroidery on cotton; padded tassels
with glass beads
H 90 cm, W 72.5 cm excluding straps
Miao; early 20th century
This well-constructed and beautiful baby-
carrier includes indigo-dyed cotton and
the prized calendered "black shiny cloth";
the shaped padded tassel is a nice detail;
the tassel even covers an additional small
embroidery panel; there are borders of
minutely folded silk triangles below the
top panel.
Baby-carriers of this type in such fine
condition are very rare nowadays.

224-225. *Woman's skirt*
and matching jacket
Skirt: H 29 cm, W 2x33.5 cm (top),
2x38 cm (bottom)
jacket: H 52 cm, W 116 cm
Li; Hainan Island, Baisha county

The skirt (supplementary weft) consists
of three lengths with geometric and
anthropomorphic figures; the jacket is
embroidered with large human figures
and with dragons in the lower hemline.
Opposit page: large stylised
anthropomorphic figure including smaller
human-like figures in its head, trunk,
arms, legs and armpits; very refined work.

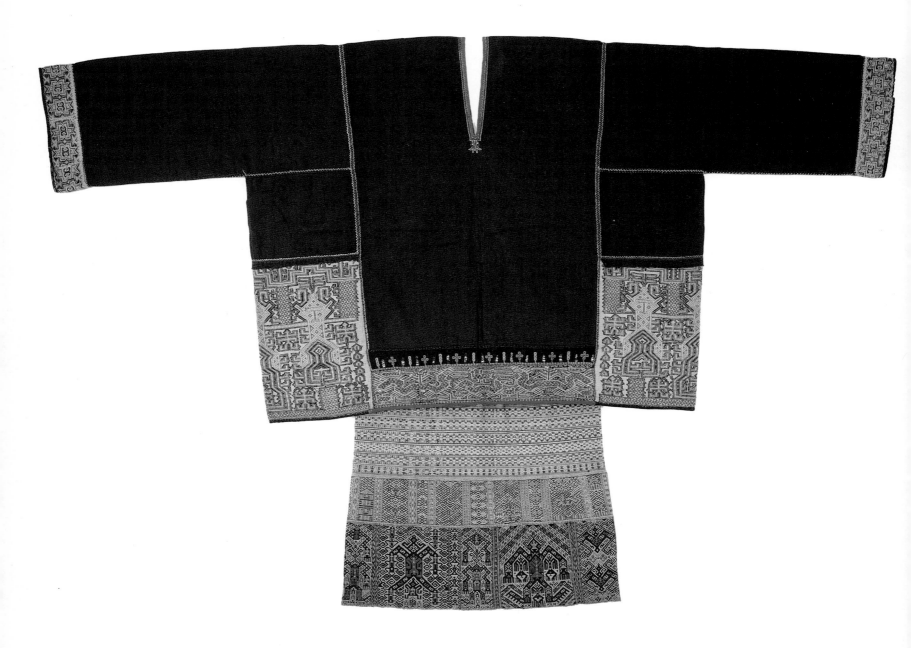

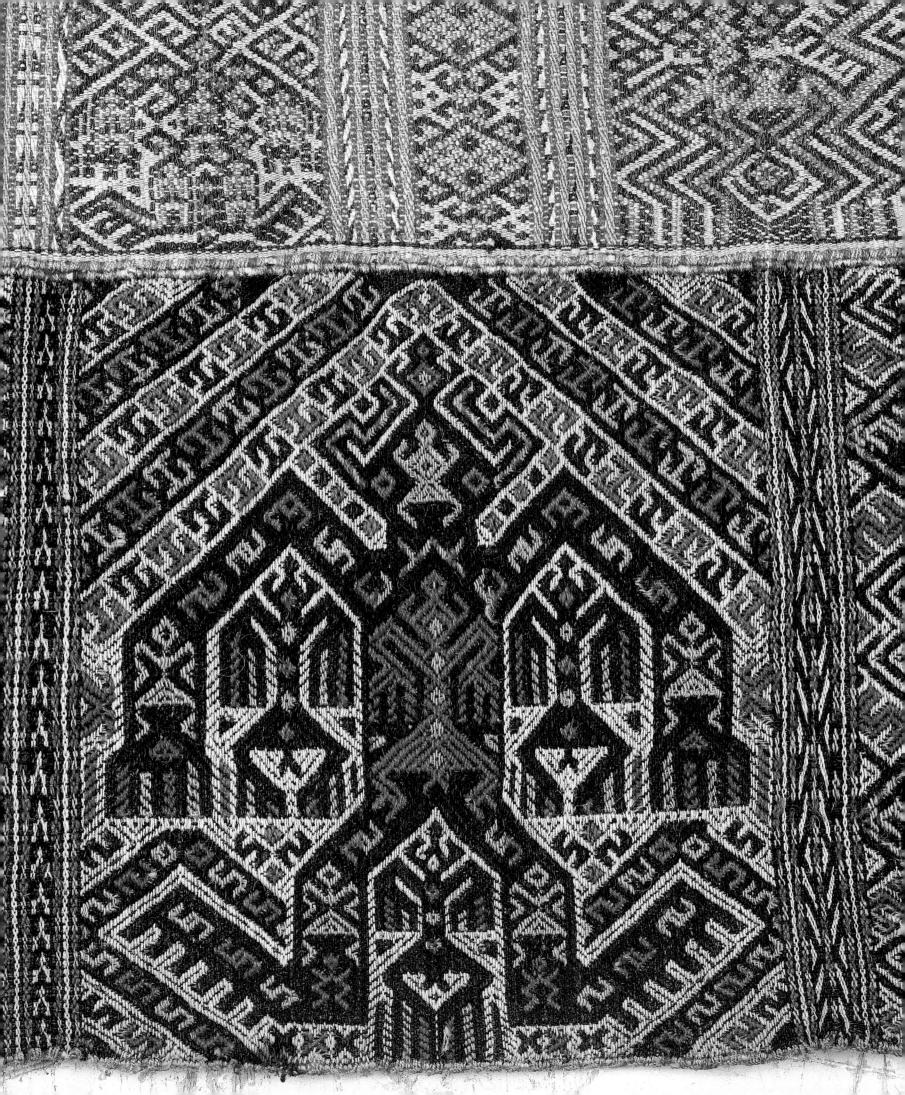

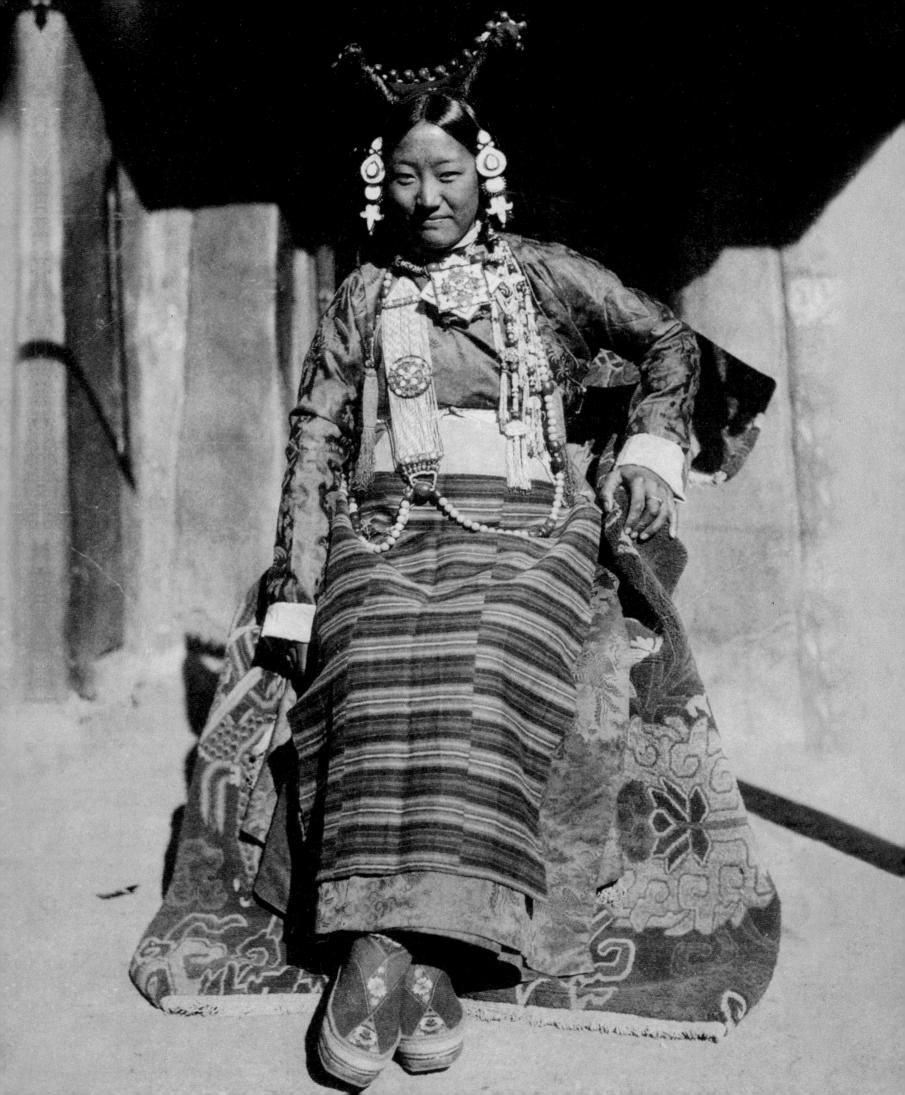

Hugo E. Kreijger

Nomadic Jewellery from Mongolia

L et's face it, the Mongols have never had a positive reputation, especially in the West. The name is associated with rapacious plunderers who made life miserable from the twelfth to fourteenth centuries for the peoples living in the Eurasian grasslands from Hungary to Korea. Nonetheless, their first leader Genghis Khan (*ca.* 1167–1227) founded the largest empire in the history of the world. Some historians believe now that the Mongol hordes were less destructive than previously thought. It is interesting to note that the term *horde* is the only Mongolian loanword to have entered Western idioms and now stands for troop or army (Berger 1995, 9). Most of our scarce knowledge about this period and the Mongolian tribes in general come from friends or conquered tribes of the Mongols and are therefore not so reliable. Just a few Mongol inscriptions in stone and chronicles have survived to give limited, but valuable, information from a Mongolian perspective. Being nomads on the vast steppes, it is understandable that they did not leave a sedentary culture.

History

The enormous extended grasslands, from the Siberian *taiga* and Lake Baikal in the north to the Gobi Desert in the south, were inhabited by nomadic tribes of diverse ethnic and linguistic origins. The first traces of nomadic life, of a mainly Iranian origin, in this vast area date from the second millennium BC. Most of our knowledge about these early tribes stems from Chinese annals and are inevitably one-sided. The first tribes encountered in the annals are the Xiongnu, often identified as the Huns. They inhabited present day Mongolia during the Han dynasty (206 BC–220 AD) but were followed by many waves of different no-

madic tribes. Those living closest to the Chinese border were the first to be influenced by Han–Chinese culture. These tribes regularly conquered territory from their Chinese neighbours but settled, thus weakening their interest in their ancestral homelands, but these gaps were quickly filled by other tribes that gradually descended from the Siberian taiga. In the course of the following centuries this repeated process had a large impact on both the nomadic tribes and their Chinese neighbours.

A few centuries later, during the Tang dynasty (618–907), the Chinese expanded their influence over larger parts of Central Asia and encountered the Mongols for the first time. The latter shared the steppes with a large number of different Turco-Mongol and Tungusic tribes. Some inscribed stone pillars which have been found scattered throughout these extensive grasslands. They were carved in an old Turkic language suggesting a strong Turco-Mongol kinship (Fontein 1999, 14). During the chaotic period that followed the fall of the Tang dynasty, the Mongols rose spectacularly to power. Consisting of various tribes and speaking different languages that often were not even related, the Mongols shared the nomadic life-style that was imposed on them by geographical and climatic conditions. These constant migrations limited the number of people in a unit of any particular tribe to probably just a few thousands. This mobility also limited their ability to carry much around in case of emergency: thus they needed to buy or barter goods from neighbouring civilisations. If denied trade, tribes united temporarily under a strong leader and raided these sedentary civilisations.

Genghis Khan was a suprarenal leader of this

Tibetan lady with jewellery, early 20th century.

195

kind. After several years of power, he united most of the tribes and founded the Mongol state in 1206 (Berger 1995, 9), following which, during a four-year campaign, he conquered the Eurasian steppes. One of his sons almost reached the gates of Vienna but the death of another son obliged the army to return to Mongolia in order to choose a successor and, luckily for Europe, they did not return.

In fact, the excesses of the Mongol hordes under Genghis Khan and his descendants have been overstated. Genghis Khan recruited foreigners as advisers, interpreters and officials, and even foreign craftsmen were valued as the Mongols' nomadic life style prevented the development of an artisan class capable of creating secular and religious buildings. The willingness to borrow from foreign artistic traditions remained till the early twentieth century as is evident from the jewellery and ornaments presented in this book. Genghis Khan's grandson Kublai Khan (1216–94) not only brought Tibet under Mongol jurisdiction in 1252, but he also conquered the Chinese empire, upon which he founded the Yuan dynasty (1279–1368) (Berger 1995, 29). Kublai Khan followed in the footsteps of his grandfather and strongly supported foreign cultural assets. He ordered a Tibetan monk to develop a new quadratic script, known as Phagpa script, though in the end it did not replace the many written languages in the Mongolian dominated lands. His court also adopted the Tibetan form of Buddhism, though it was interwoven with shamanistic elements. Foreign artists were invited to build monasteries and to decorate them with sculptures and paintings. Sadly, hardly any religious works of art have survived the ravages of time. The Italian merchant Marco Polo spent approximately nineteen years in China and wrote highly of the court of Kublai Khan but, by the end of the emperor's reign, the court's financial condition had worsened due to the many military campaigns and the luxury of court life. Forced to struggle for internal power, his successors were not of Kublai's calibre and political and financial problems hastened the collapse of the Yuan dynasty.

The end of the Yuan marked the start of a few centuries in which we have an almost total lack of knowledge about the whereabouts of the Mongols. Annals from the subsequent Chinese Ming dynasty (1368–1644) related that they had returned to their old grazing grounds and picked up their traditional nomadic life. A few archaeological finds are evidence of some Buddhism among the Mongol nobility during the late thirteenth and fourteenth centuries (Fontein 1999, 17) and ambitious successors occasionally dreamed of recreating the world empire of Genghis and Kublai Khan.

One of them, Altan Khan (1543–82) of the east Mongolian Khalka tribe, partly succeeded. He united various Mongolian tribes and reintroduced or reactivated Buddhism in Mongolia. He later bestowed the title of Dalai Lama on the patriarch of the Tibetan Gelugpa (Yellow Cap) sect, the religious master Sonam Gyatso, who visited Mongolia in 1578 (Kreijger 2001, 15). The Mongolian term *dalai* means "ocean", better interpreted as Ocean of Wisdom, while *lama* stands for religious teacher. In return Altan Khan was recognised by the Tibetan leaders as the reincarnation of Kublai Khan. This renewed patron-priest relationship between Mongolia and Tibet was intended to give Altan Khan a kind of legitimacy over the various Mongolian tribes.

In the seventeenth century it was the turn of the Manchus from the north to become the masters over large parts of the vast steppes and conquered Chinese territory. In 1644 they established the Qing dynasty which was to last till 1911. The Manchus adopted a policy of divide and conquer and thus gradually expanded their influence over the Mongols, who were finally obliged to accept Chinese suzerainty. The Manchus also forced Tibet to become a vassal state, though they adopted Tibetan Buddhism as the state religion to keep the Mongols and Tibetans under control. The Mongolian recon version to the Tibetan form of Buddhism spread the way to a cultural renaissance in a region of inner Asia that included Mongolia, Tibet and Manchu-ruled China.

However, during the same period the independence of the Mongolian tribes was threatened on the western side by the Russian advance into Siberia, meaning that they were squeezed by two major powers. In 1727 a treaty was signed between China and Russia which established the borders between both empires (Fontein 1999, 19): in 1911 the steppes that the Mongols used to roam were divided into an Outer and Inner Mongolia, the first dependent on Russia, the second part of China. Later Inner Mongolia, like Tibet, became an autonomous republic within the People's Republic of China and, in 1930, Outer Mongolia became a vassal state of the Soviet Union. Subsequently, Soviet leaders ordered most of its monasteries to be burned down and the innumerable monks to be either executed or forced to return to a secular life; it was only in 1990 that Outer Mongolia once more became independent of the Soviet Union. The names Inner and Outer Mongolia only make sense from a Chinese perspective. Both states were

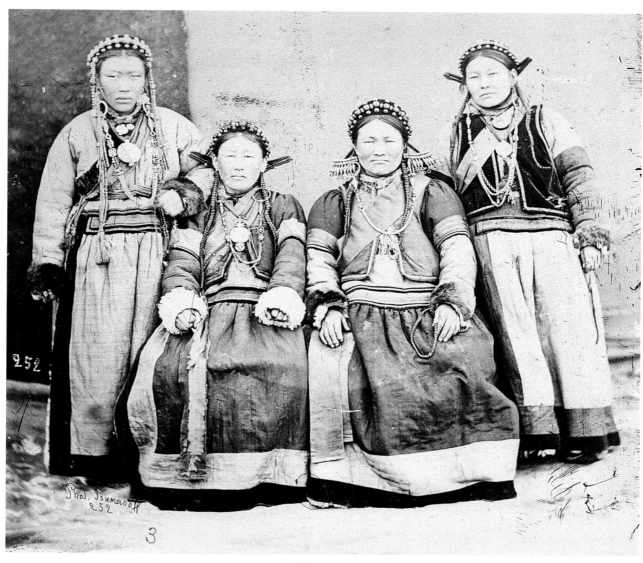

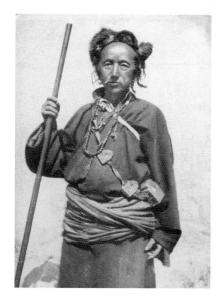

Tibetan man with three gau *and a* mala *(Buddhist rosary), early 20th century.*

gradually settled with large numbers of ethnic Han-Chinese and Russians in order to turn the native inhabitants into minorities. On the other hand, larger numbers of Mongols now live in Russia and China than in their own states.

The extensive grasslands of present Outer Mongolia can be considered as the heartland of the Mongolian sedentary renaissance from the late sixteenth century onwards. It was in this vast area where monasteries, lamas and khans promoted the material culture created by local and especially foreign artists which on it's turn stimulated the nomadic material culture.

Nomadic Jewellery

The nomadic life of the Mongol tribes was an old social and economic system in which small groups moved along set yearly paths. Even today many Mongols still live as pastoral nomads. Over the past millennium they had little choice as the steppes and deserts do not provide the possibility of a sedentary agriculture. This way of life had an immense impact on their art as the difficulty of transporting baggage from one encampment to anoth-

er meant their belonging had to be limited. Consequently, their artistic expression found its outlet in ornamentation, refinement and a high regard for detail, as can be seen in the artefacts in this book. Utilitarian objects like saddles, elaborate head ornaments, chopsticks, pipes, tobacco pouches and jewellery became the personal wealth of a family, giving them status and often fulfilling the role of tribe affiliation.

The jewellery and implements presented here are evidence that the Mongolians were and are an artistic race. Old photographs also show that they tend to decorate every section of their body and even the trappings of their animals. They distinguished themselves by their costume, in particular, the women's ornamentation. The importance of jewellery in Mongolian nomadic life is underlined by the fact that over one hundred types of headdress are known (Tsultem, 1987, 1 English text). The most commonly used materials – silver, turquoise and coral – were exploited by all tribes, however, each created its own distinctive features. The headdresses, earrings and necklaces published here once belonged to mainly married women and were giv-

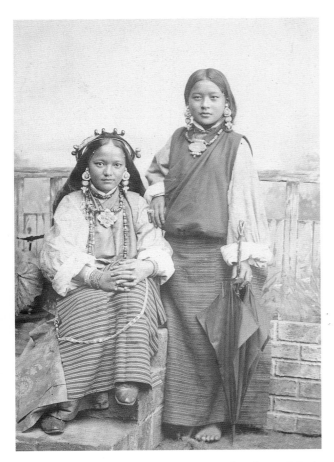

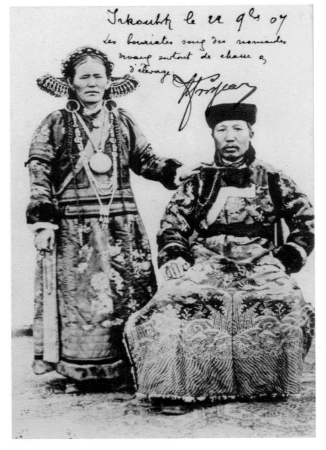

en as a dowry by their parents on the day of their daughter's wedding. The pipes, flint pouches and eating sets were part of the men's regalia. Finely-worked drinking bowls were used by both sexes.

In general a traditional Mongolian costume consists of a rope-like garment without pockets. These embroidered, appliqué and stitched costumes were made by women and are held together by a thin, often silk, sash wound around the waist. Attached to the sash are their eating set, tinder pouch, snuff-bottles, tobacco pipes (see ill. 32) and pouches. The often wonderfully designed eating sets (see ill. 6-7) may incorporate a knife, chopsticks, tooth pick, ear pick and sometimes even tweezers. Some sets are made of precious metals and adorned with semi-precious stones. Tinder pouches consist of a small leather pouch with a strip of steel attached to the lower edge and are often beautifully decorated (see ill. 10, 33). To protect themselves against bad omens or to facilitate a prosperous and auspicious journey, Buddhist amulet boxes and shrines of various forms and sizes were worn. Some are lavishly inlaid with coral and turquoise stones (see ill. 5) while others contain small painted images on linen of Buddhist deities (see ill. 35-36). Turquoise is supposed to alleviate poisoning and red coral to alleviate fever of the liver and the blood vessels, thus both are appropriate when travelling (Casey Singer 1996, 33). According to Mongolian tradition, all stones have a power of medicinal healing.

Many items of jewellery and objects are made with iron and copper as these are basic materials. They are sometimes embellished with gold, but more generally silver is hammered with intricate ornamental designs. The technique of silver filigree is very popular and has a long tradition; its finesse depends on the thickness of the wire. Filigree work is often just a part of the complete ornament as it provides the craftsman with the basis to add other techniques, such as enamelling. Semi-precious stones are kept in place with melted wax with the result that they often fall out and their cavities left empty. It almost seems that no flat surface remains undecorated.

Metal ornamentation is the work of smiths known as *darkhan* (Tsultem 1987, 1 English text) who were and still are highly esteemed in Mongolian society. Their profession was hereditary and handed down from father to son. These artisans also worked with other materials, such as leather, which they embellished with silver ornamentation and useful items like chopsticks and pipes. Although *darkhans* used a small number of rather primitive tools, as they too lived a nomadic life like their patrons, the results were astonishing. Many wandered from one tent to another, from one tribe to the next, offering their highly-valued services. The *darkhans* got their silver ingots from abroad, usually China, as it is hardly mined in Mongolia itself. Semi-precious stones like coral were traded

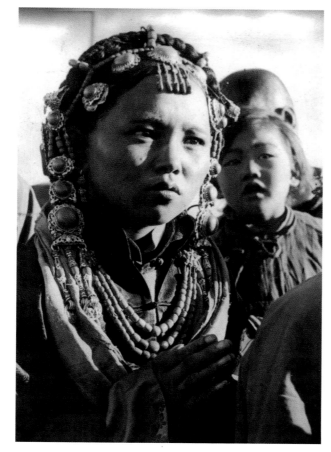

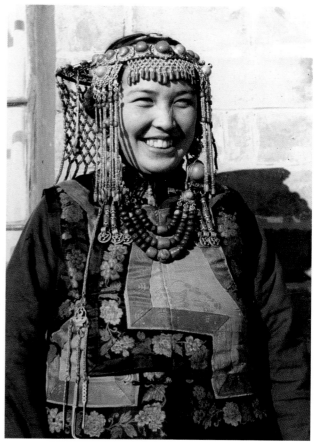

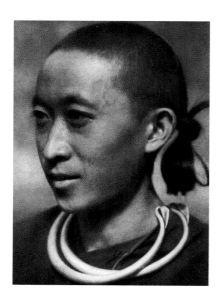

from China though the ones from the Mediterranean were the most sought after (Boyer 1995, 212). Mediterranean beads are slightly lighter in colour and were preferred by the Mongols. The other widely used stone, turquoise, came from Iran, other areas in Central Asia, Tibet or China.

The craftsmen mainly used two patterns: the *khee* (ornament), "which creates the rhythm", and the *ugalz* (scrolls), "which emphasises the form" (Berger 1995, 86). The combination of the two creates aesthetic harmony. Logically, the motifs are generally characteristic of nomadic life and nature. On one hand, there are zoomorphic motifs such as animals and hornlike scrolls and, on the other, clouds, mountains, flames and wave motifs. Aside from these one can find geometrical patterns and rhombic forms. Buddhist motifs like the Eight Auspicious Symbols (*ashtamangala*), the Seven Jewels of the Monarch (*saptaratna*) and the Three Jewels (*triratna*) were incorporated too. Interesting to note is that all these Buddhist symbols are considered as jewels, thereby underlining the importance of jewellery. Even the emblems of the Chinese Eight Daoist Immortals found their way into Mongolian ornamentation (Boyer 1995, 226–27). Thus a general Mongolian design can show Mongolian scrolls and volutes encompassing Tibetan Buddhist auspicious symbols and longevity characters, dragons, bats and other motifs from the Chinese realm.

Although sparsely included in this exhibition, Mongolian religious art used by the nomads during their long travels was based on the designs, motifs, iconography and iconology of Buddhist Tibet. For instance the painting in the shrine shown follows the Tibetan tradition (see ill. 35-36.) but details in the execution of the painting reveal its Mongolian origin, like the specific use of the colour green and the use of stones on the silver box itself.

Tibetan Jewellery

As several Tibetan ornaments and jewels are illustrated in this publication, a few words will be devoted to its art and craftsmen. Most Tibetan art is religious and includes characteristic two- and three-dimensional subjects like male and female deities, lamas, historical figures, buildings and ritual objects. A few examples of the myriad ritual and symbolic objects are included in this exhibition. Talismanic silver amulet boxes inlaid with coral and turquoise were used by men and women alike to ward off evil and protect their owner on dangerous paths during their travels (see ill. 13-18). Some of these smaller amulet boxes were braided into the hair of both men and women. Most striking is both the Tibetan and Mongolian love for silver, coral and turquoise as materials, whereas the Chinese hardly used turquoise. The Tibetans had a preference for the deeper red coral compared to the Mongolians,

who were fond of the lighter coloured ones.

In certain Tibetan Buddhist rituals, human bones played an important role. This collection shows one very nice bone ornament that was once part of a skirt made by a Newari craftsman of the Kathmandu Valley in Nepal (see ill. above). These aprons were worn by terrifying deities and Tantric priests during the performance of certain esoteric rituals. A human cranium used as a skull cup set on a silver base and decorated with miniature skulls is another example of the importance the Tibetans attest to bone (see ill. above). Bowls made of human skulls and lined with silver served as emblems of terrifying deities and are of fundamental importance in Tantric rituals. Priests drink consecrated liquor or beer from these bowls during certain esoteric ceremonies. Other ritual implements were and still are used in temples by initiated lamas who alone have the right and duty to perform the various rites.

Like the Mongols, the Tibetans were and still are fond of jewellery as it symbolises social status, political authority and wealth. They were not on-

ly worn by nomadic compatriots but also by men and women living in the towns. Tibetan jewellery differs from region to region and varies with status and government rank. Like Mongolian jewellery, it is not always known what their function or their significance is.

Some of our information is only derived from early Western travellers to Mongolia and Tibet over the last few centuries as neither people wrote anything down. Some Western travellers remarked that Tibetan society, foremost in towns, was highly hierarchic and that jewellery not only reflected one's social position but also the owner's precise social and political status. Tibetan noblewomen were obliged to wear the jewellery that reflected their husbands' government rank, and a promotion in rank brought with it a promotion in expensive jewellery (Harrer 1953, 121). Tibetan government officials also wore jewellery and ornaments fitting their rank, however, it was generally the Tibetan noblewomen who were adorned with the costly jewellery, as photographs from the early part of the twentieth century nicely show. The fascination of

Tibetans for jewellery drove many Tibetan families into poverty and debt. This was noted around 1929 by the thirteenth Dalai Lama who decreed that women were no longer allowed to wear such an abundance of precious jewellery. After the thirteenth Dalai Lama passed away in 1933 the tendency to acquire elaborate jewellery revived among the ladies of the nobility and other classes (Asian Art Museum of San Francisco 1992, 20).

Many of the Tibetan craftsmen who created these splendid, elaborate jewels and ritual objects wandered around the highlands of Tibet from one patron to the other, like their Mongolian counterparts. Only in the towns could one find established workshops that worked for the local nobility and anyone else who could afford expensive jewellery. Whether their profession was hereditary is not really known, though it seems highly probable. It is only known that artists in the towns were organised in guilds or workshops. Among these artists were many Newaris from the Kathmandu Valley in Nepal who had settled in the various Tibetan towns. They were famous for their ability to create magnificent jewellery and ritual implements, as well as superb bronze Buddhist sculptures.

Conclusion

This brief survey of Mongolian and Tibetan jewellery has shown this art was strongly developed and omnipresent under the nomads and the nobility in the towns. Symbolic of wealth, social and political status and, especially in Mongolia, tribal affiliation, examples became more and more elaborate. Using precious metals like silver studded with semi-precious stones such as coral and turquoise, they formed a family's capital. If it became necessary, these highly esteemed jewels could be traded or sold but generally they were handed down to the next generation. Nevertheless it seems that most surviving jewellery is not so old, hardly more than a few generations. Perhaps this suggests that fashions developed and "old" pieces were no longer valued by a younger generation. Semi-precious stones were removed from their cavities, if they had not already been lost during their years of use, and the silver settings or frames were melted down to create new, more highly-regarded jewels that conformed with contemporary fashion.

Selected Bibliography

Asian Art Museum of San Francisco, *Beauty, Wealth and Power: Jewels and Ornaments of Asia*, University of Washington, Seattle and London 1992.

G. Beguin, *Trésors de Mongolie, XVII-XIX siecles*, Editions de la Reunion des musees nationaux, Paris 1993.

P. Berger and T.T. Bartholomew, *Mongolia: The Legacy of Cingghis Khan*, Thames and Hudson, London 1995.

M. Boyer, *Mongol Jewellery*, Thames and Hudson, London 1995.

J. Casey Singer, *Gold Jewellery from Tibet and Nepal*, Thames and Hudson Ltd, London 1996.

J. Fontein, *The Dancing Demons of Mongolia*, V and K Publishing, Blaricum 1999.

H. Harrer, *Seven Years in Tibet*, Rupert Hart-Davis, London 1953.

W. Heissig and C.C. Muller, *Die Mongolen*, 2 vols., Pinguin-Verlag, Innsbruck 1989.

H. E. Kreijger, *Tibetan Painting*, Serindia Publications, London 2001.

B. Lipton, *Treasures of Tibetan Art*, Oxford University Press, Oxford and New York 1996.

C.C. Muller and W. Raunig, *Der Weg zum Dach der Welt*, Pinguin-Verlag, Innsbruck 1983.

N. Tsultem, *Mongolian Arts and Crafts*, State Publishing House, Ulan-Bator 1987.

H. Weihreter, *Schmuck aus dem Himalaja*, Akademische Druck und Verlaganstalt, Graz 1988.

Tibet and Mongolia

1. *Bone plate from the girdle of a dance skirt*
Human bone
H 16.9 cm, W 4.2 cm
17th century
Tibet
Three faces of the twelve-armed Yidam Chakrasamvara, sitting in the centre on a lotus in Alidha posture, trampling two Hindu deities.
Chakrasamvara has four heads (three are visible here), each looking into one of the quarters of the compass as a sign of his universality; he is also holding the *vajra* and bell (*ghanta*). See also details like the earrings he is wearing and the bone dance-skirt this plate is part of. The upper part of the bone plate showing Buddha Aksobhya surrounded by finely incised tendrils in a niche.

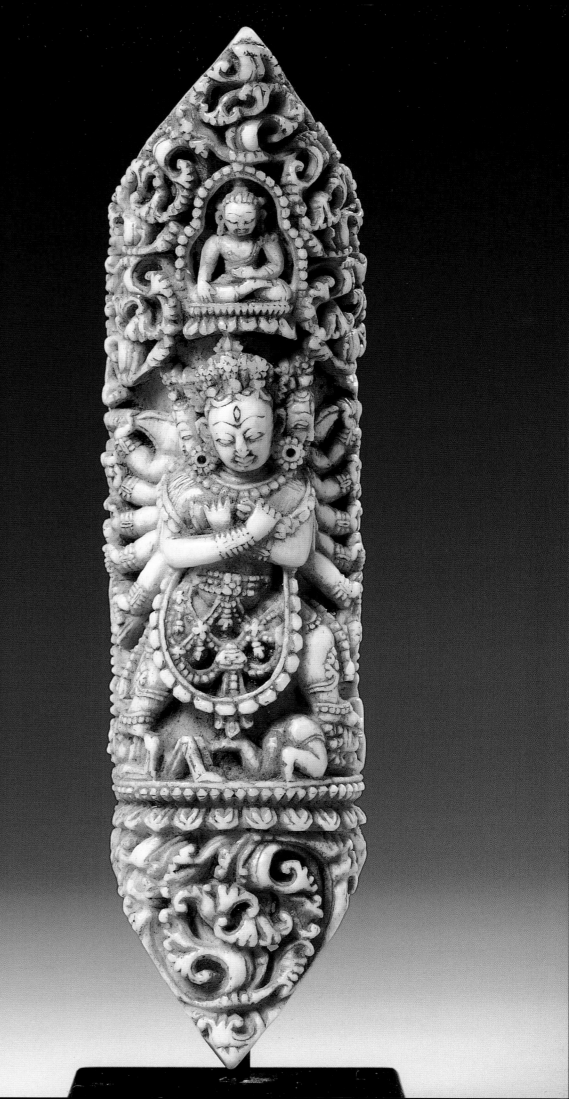

2. *Complete set of skull drinking-bowl and stand*
Partly gold-plated silver
Ag 98%, Cu 2% (stand)
H of stand 10.5 cm, W of stand
(triangle) 17.5 cm
570 g (stand).

The stand is in the shape of a triangular, three dimensional *yantra* (mystic diagram) or mandala (magic diagram) symbolizing the transformation from mortality to immortality or enlightening. The flames on the stand symbolize spiritual purification.

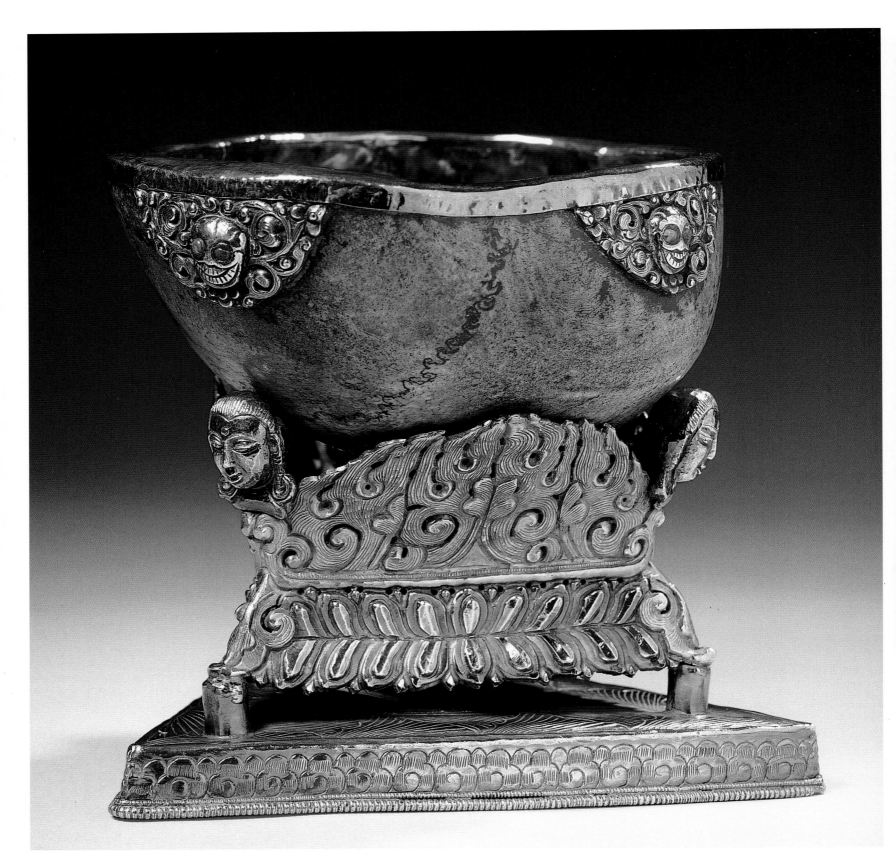

3. *Skull drinking bowl*
name: Kapala
Ag 98%, Cu 2%, human skull
L approx. 18 cm, W approx. 14.5 cm,
H approx. 8.2 cm; 412 g
18th century
Tibet

Skull drinking-bowls made of a human cranium and lined with silver served as emblems of terrifying deities and were essential objects during Tantric rituals. Upper part of a human skull (dark brown patina); silver rim with three miniature skulls with turquoise eyes surrounded by silver tendrils; at the centre a silver flower with dark red coral.

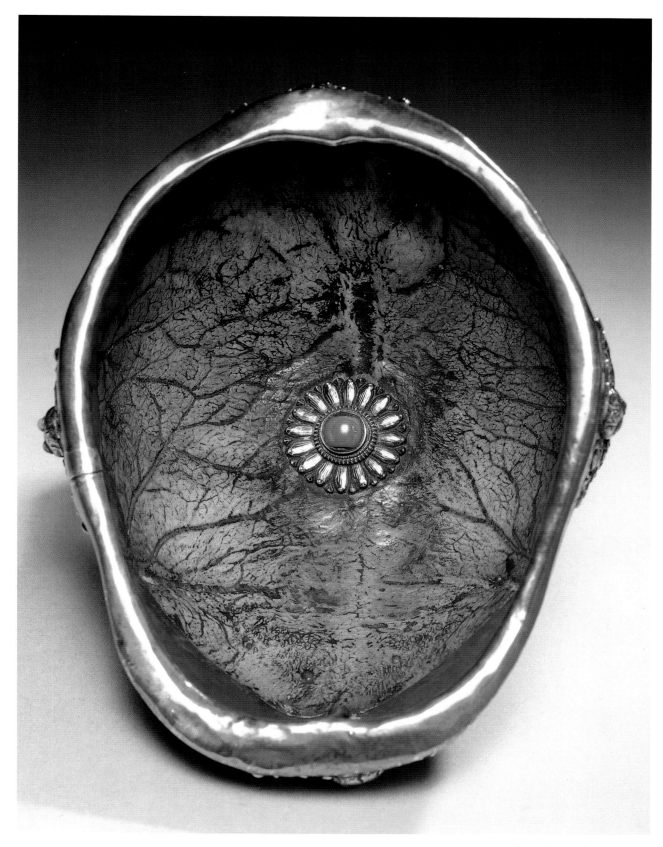

4 (outer necklace). *String of beads Carnelian*
Ø approx. 31 cm; 962 g
18th century, Tibet
Necklace consisting of forty-seven melon seed beads.

4 (inner necklace). *Buddhist rosary* (mala)
Red coral, turquoise, silver, eye agates
H approx. 30 cm, W 16 cm; 58 g
Tibet
One hundred and eight beads in all.

5. *Amulet box* (gau)
Silver, gilded, turquoise and red coral
Box: Ag 98%, Cu 2%
Filigree work: heavily gilded silver
L 9.4 cm, W 9.4 cm, H 1.5 cm; 129 g
Tibet

The box is in a double ogival form gilded filigree plate and stamped units, turquoise stones, red coral. In the middle of the filigree one of the eight symbols of Buddhism: the standard (banner), erected on the summit of Mount Meru, the centre of the Buddhist universe.

6-7. Travelling cutlery set
Leather, coral, wood, bone, turquoise
Spoon: Ag 97% Cu 3%
Sheath: Ag 95% Cu 5%
Pommel: Ag 96% Cu 4%
Steel blade: Fe 82% Mn 15% Co 3%
L 31 cm; 290 g
Tibet
Knife with bone handle and a double
spoon in a wooden leather-covered case;
the case is adorned with red coral,
turquoise and silver, and it hangs from
a girdle.

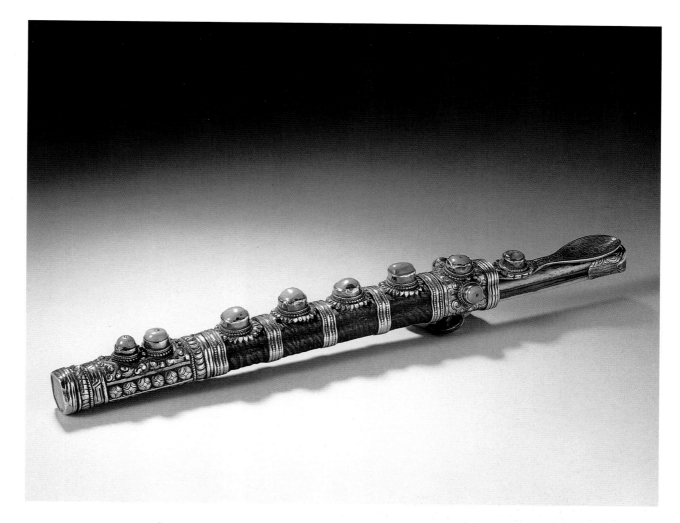

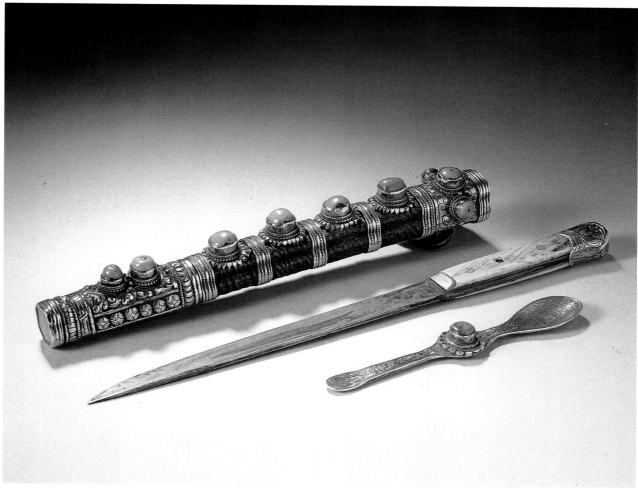

8-9. *Purse*
Leather, turquoise, brass, silver
alloy (Ag 55%, Cu 40% Zn 5%)
H 12 cm (without leather strap),
W 13 cm; 306 g
Tibet
Floral motifs, dragons, waves, birds.
Brass and silver alloy on a leather ground;
worn suspended from a girdle.

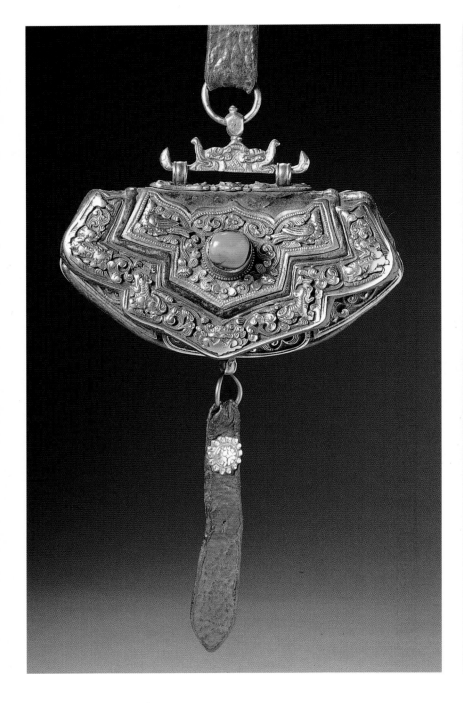
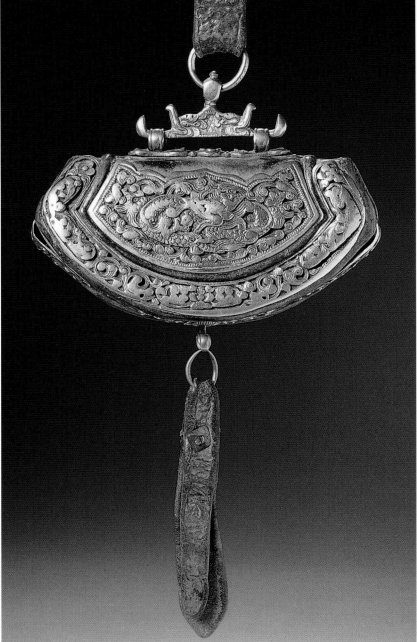

10 *Tinderbox*
Leather, brass, red coral, turquoise,
white metal, steel
Cu 66%, Ni 24%, Zn 7%
(all metal except the bottom)
Fe 81%, Mn 16%, Co 3%
(the steel bottom)
H 9.5 cm, W 13.5 cm; 215 g
Tibet
Worn suspended from a girdle.

11. *Man's hair ornament*
Silver alloy, gold, turquoise, red coral
Box: Ag 63%, Cu 44%, Zn 3%
Gold appliqué platelet: Au 77%,
Ag 16%, Co 7%
L 8cm, W 5 cm, H 1.3 cm; 63 g
Tibet

Front: gold filigree plate and stamped
units, turquoise stones and red coral; this
hair ornament was worn by government
officials of the fourth rank and above as
an indication of their rank and
distinction; it was fixed in their plaited
topknot.

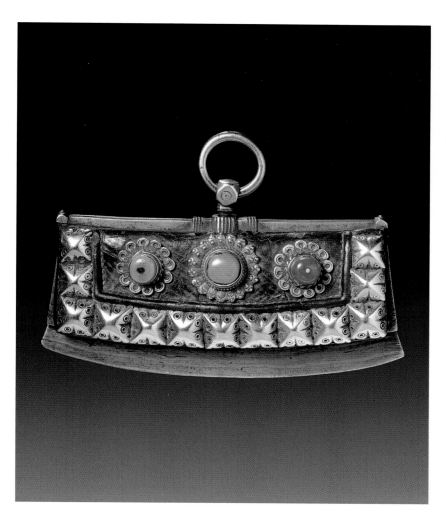

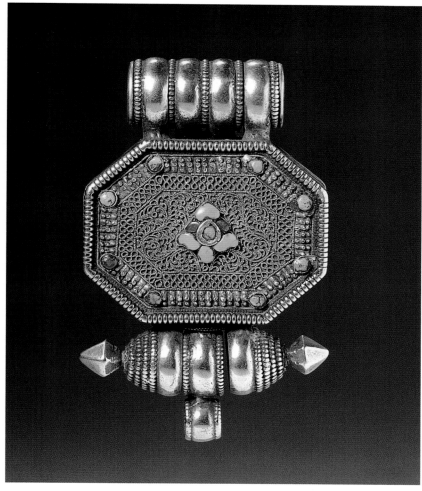

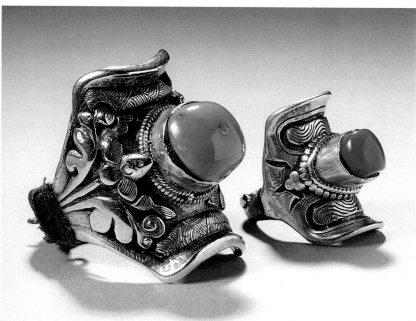

12 (left). *Man's hair ring*
Coral and silver
Ag 88%, Cu 12%
L 4.2 cm, H 4.2 cm, W 3 cm; 30.1 g
Tibet
The bottom is wound with red cloth.

12 (right). *Man's finger ring*
Red coral and silver
Ag 84%, Cu 16%
H 3.5 cm, L 2.9 cm, W 2 cm; 15.6 g
Tibet
Ring in the form of a saddle; brass
restoration work on the bottom.

13. *Amulet box (gau) in red cloth carrier bag*
Ag 74%, Cu 24%, Zn 2% (front and 1/4 of side); Cu (rest)
L 12.3 cm, W 9.2 cm, H 4.6 cm; 426 g
Tibet
In the middle a glass window behind which can be seen a Buddha surrounded by the eight glorious emblems of Buddhism; below the Buddha the demon Kirtimukha, "mooneater".

The eight glorious emblems are: 1) the white parasol, keeping away the heat of evil desires; 2) two fishes, symbolising happiness and utility; 3) the seashell, symbolising the blessedness of turning to the right; 4) the lotus, the pledge of salvation and the symbol of divine origin; 5) the vase, treasury of all desires; 6) the standard (banner), erected on the summit of Mount Meru, the centre of the

Buddhist universe; 7) the wheel, leading to perfection, its eight spokes symbolising the eight-fold path; 8) the endless knot, the mystic symbol of the endless cycle of rebirths.

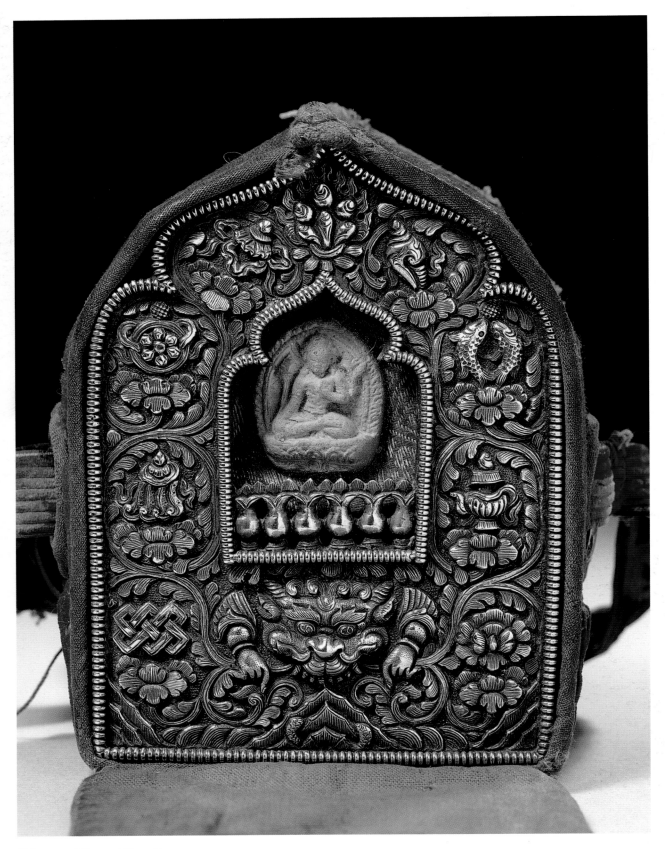

14. *Amulet box* (gau)
Ag 52%, Co 48%, trace of Zn; Cu (back)
L 7.7 cm, W 7.7 cm, H 3 cm; 200 g
Tibet
Front shows the calendar with symbols
for the days of the week, the twelve
animals of the zodiac, weather symbols
and a magical quadrant; underneath, an
inverted turtle pierced by an arrow,
surrounded by the symbols of water and
mountain, the magical wand (*khatvanga*),
the sword and two Apsaras (heavenly
nymphs).

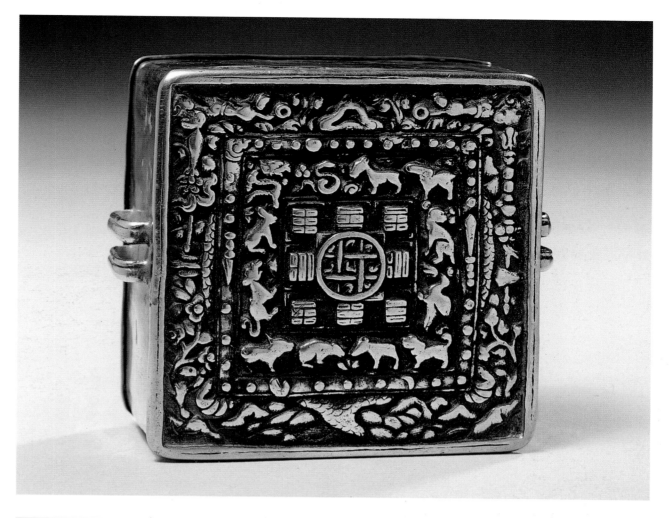

15. *Amulet box* (gau)
Ag 73%, Co 27%; Cu (back)
Ø 6.8 cm, H 2.8 cm; 85 g
Tibet
Round box with a central hole that leaves
room for a painted Buddha; floral motifs
and a monkey, bird, elephant and hare.

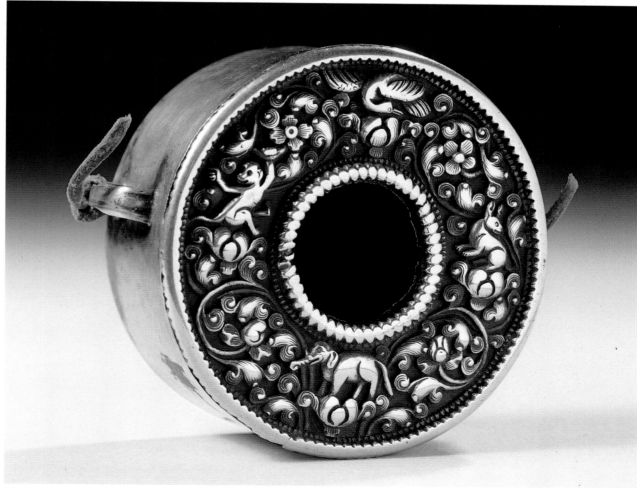

16. *Amulet box* (gau)
Silver alloy (Ag 45%, Cu 49%, Zn 6%),
copper, brass, turquoise and red coral
H 14.5 cm, W 10.5 cm; 302 g
Tibet
The middle part is in the shape of a lotus
flower.

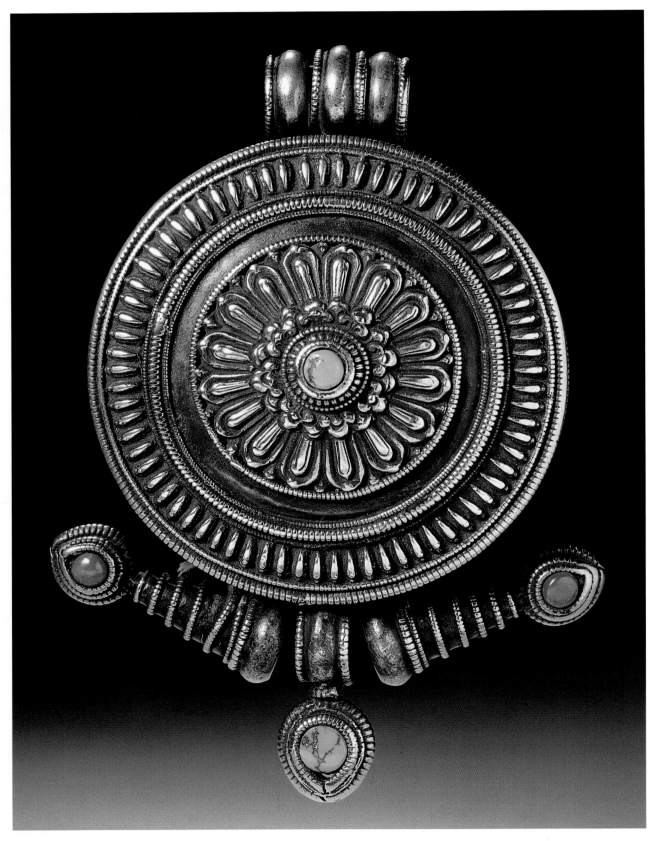

17. *Amulet box (gau)*
Ag 97%, Cu 3%; Cu (back), turquoise
H 11 cm, W 11 cm; 96 g
Tibet
The box is in the shape of a *yantra*, a
mystical diagram attributed with occult
powers and which protects the wearer.

18. *Amulet box (gau)*
Ag 95%, Cu 5%, turquoise; steel back:
Fe 83%, Mn 14%, Co 3%
H 11.5 cm, W 11.5 cm; 91 g
Tibet
The box is in the shape of a *yantra*, a
mystical diagram attributed with occult
powers and which protects the wearer.

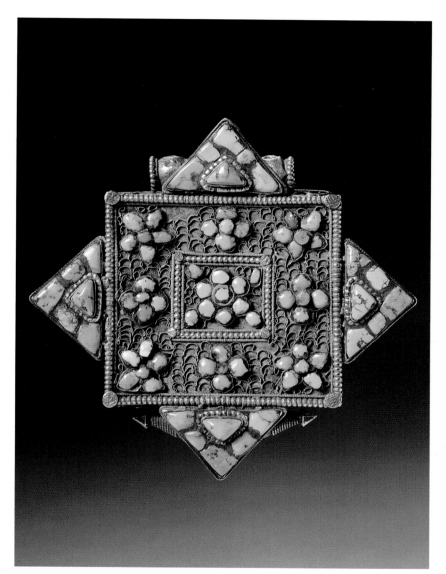

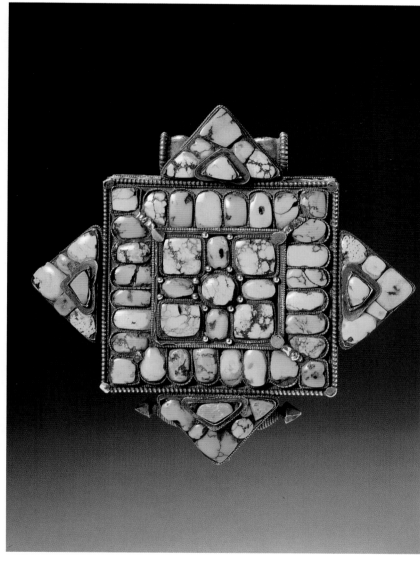

19-20 *Two breast ornaments*
(weight and counterweight – not a pair)
Both ornaments made from gold filled
with lacquer and encrusted with
turquoise, lapis lazuli and rubies.

Ornament on the left:
Au 82%, Ag 16%, Cu 2%
H 11.5 cm, W 5 cm, D 6.5 cm; 217 g
Tibet
Ornaments for high governments officials
worn until the late 1940s; Kirtimukha
("face of glory") is called "moon eater" in
Nepal and Tibet. A comparable ornament
is in the Musée Guimet in Paris.

Ornament on the right:
Au 92%, Ag 17%, Cu 1%
Silver peg: Ag 96%, Cu 4%
H 10.2 cm, W 6 cm, D 4.5 cm. (silver
peg 1.5 cm); 197 g
peg at the back.
The lower part is a round medallion in
the form of a double lotus.
On the back the eight glorious emblems
of Buddhism (see opposite page, left).

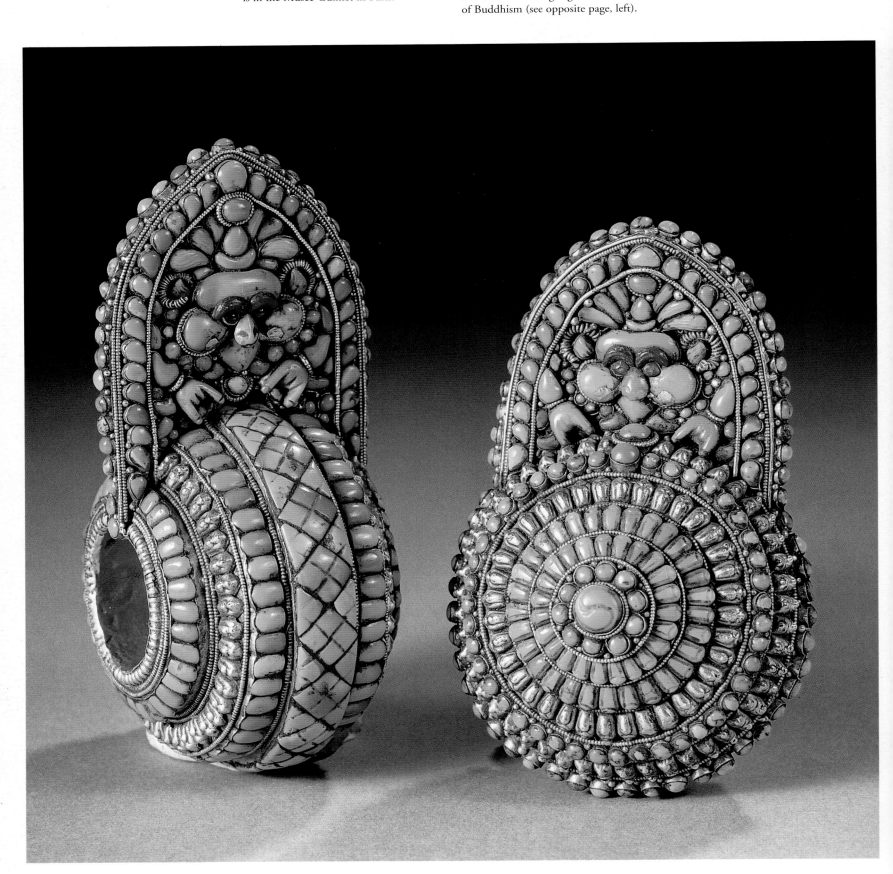

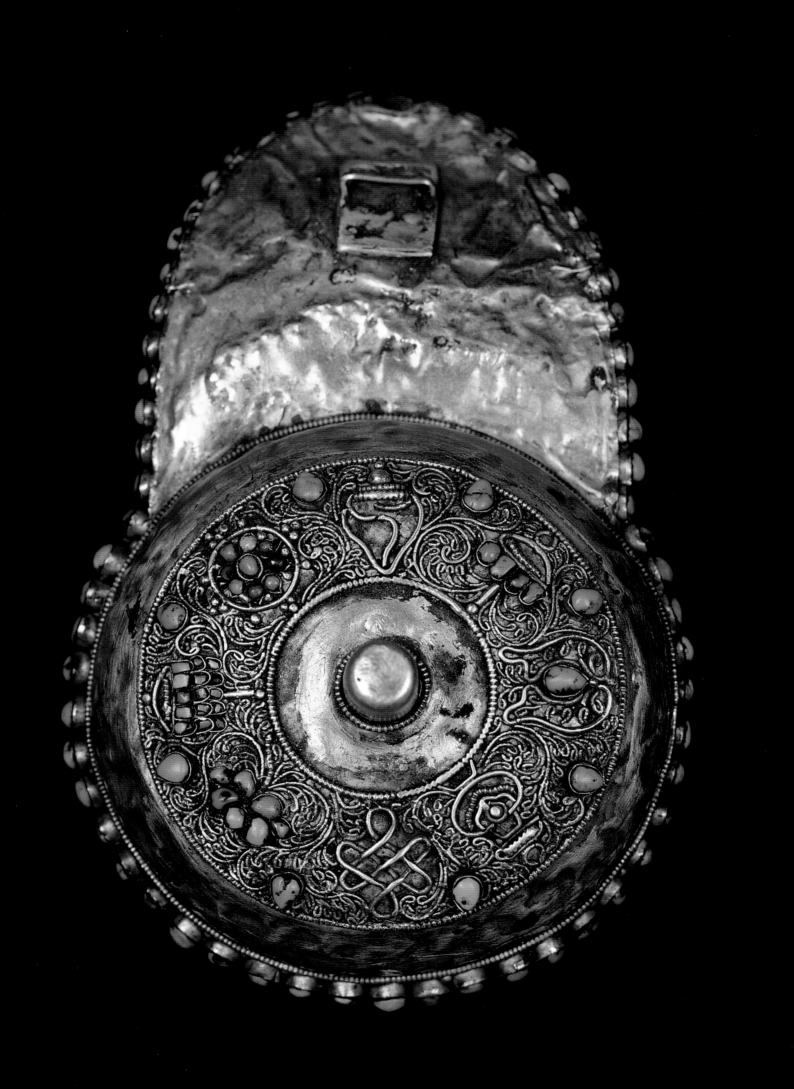

21. *Earrings* (pair)
Turquoise, silver and alpaca
Top: Ag 99%, Cu 1%
Bottom: Ag 91%, Cu 9% ; hook at the
Back: Zn 82%, Cu 12%, Ni 6%
H 13.2 cm, W 4 cm; 128 g together
Tibet
These earrings are worn at festivals
and are fastened to the hair.

22. *Earrings* (pair)
Ag 96%, Cu 4%, turquoise
H 13 cm, W 3.8 cm;132 g together
Tibet
These earrings are worn at festivals and
are fastened to the hair.

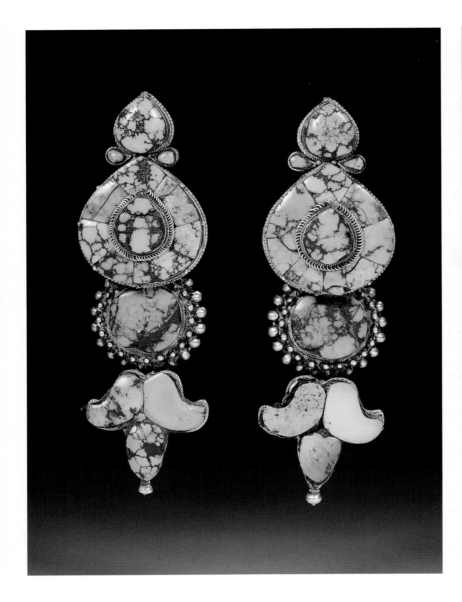

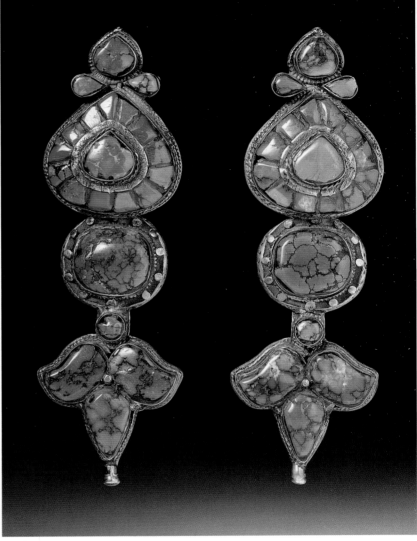

23. *Bone tobacco-container*
Ag 90%, Cu 10%, red coral, turquoise
H 21 cm, W 13 cm; 391 g
19th century
Tibet
Probably a horse's bone; a stopper at the top.

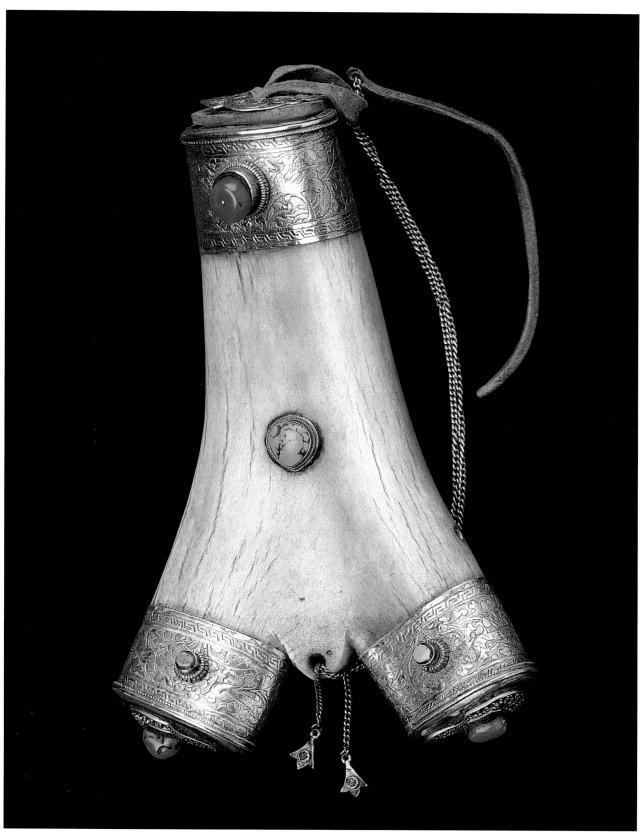

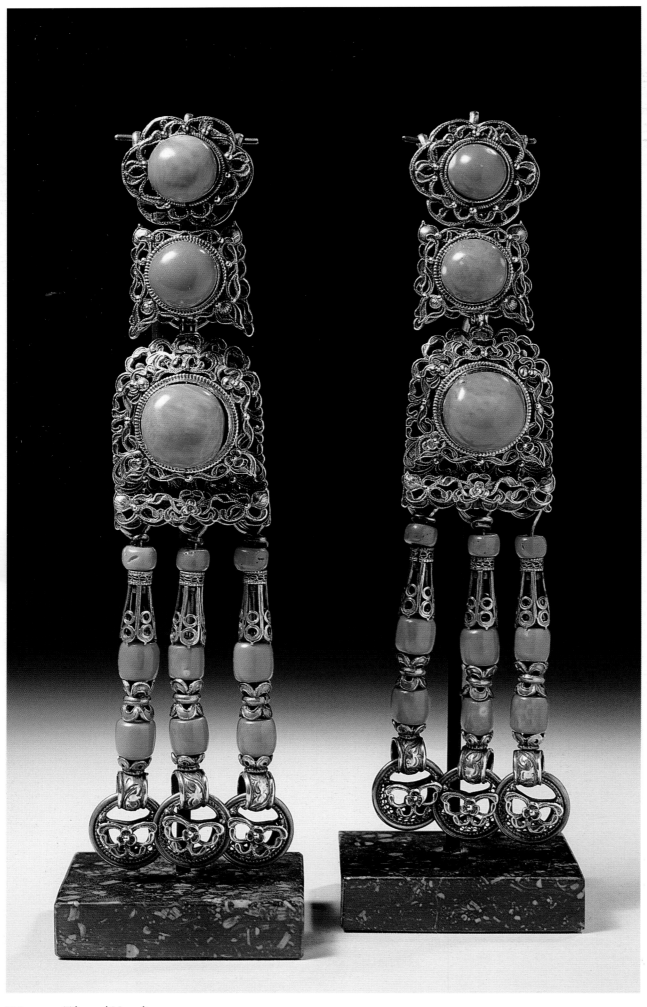

24. *Ear pendants*
Gold-plated silver: Ag 96%, Cu 4%,
red coral
H 21 cm, W 4 cm; 297 g together
Early 20th century
Mongolia, Chahar province (Central
Inner Mongolia)
This type of pendant is worn by married
women as part of their headdress; red
coral symbolises life; three butterflies
depicted in the silver on the bottom.

25. *Ear rings/ear pendants*
Ag 85%, Cu 15%, trace of Zn
L 27.5cm, W (hook) 6.2 cm
Enamel, green glass bead, red coral
175 g together
Early 20th century
Mongolia
The hooks are attached to the hair; the
silver connecting pieces consist of very
fine filigree work; the glass bead is very
old, possibly imported via the Silk Road.

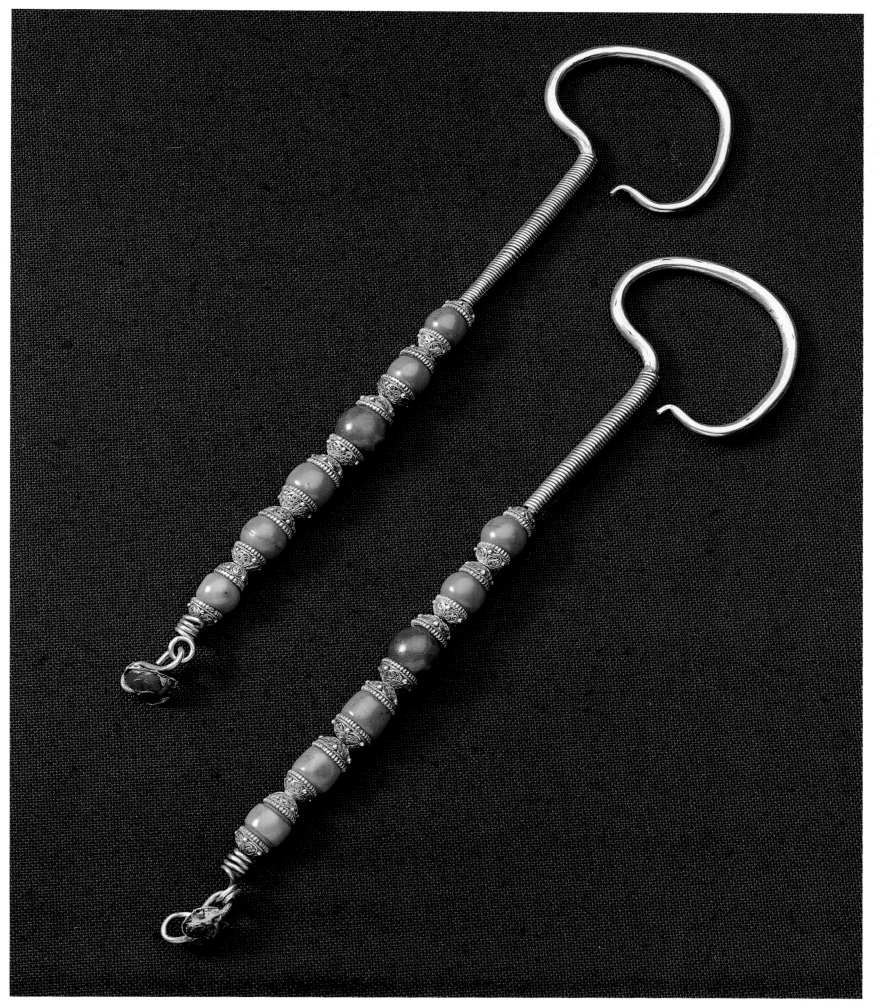

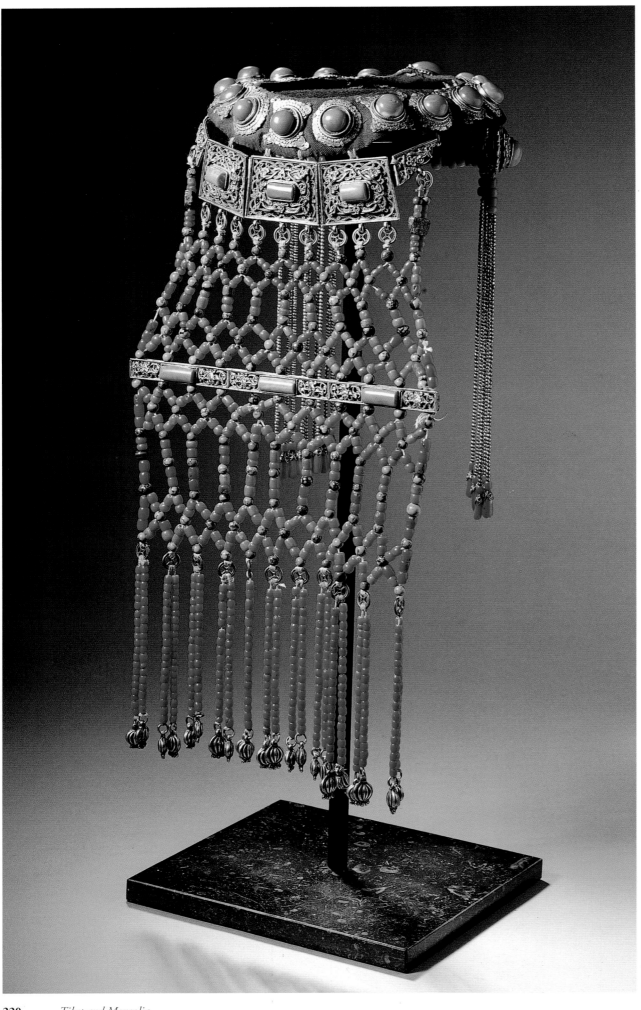

26-27. *Headdress*
Ag 91%, Cu 9% (rosettes)
Ag 96%, Cu 4% (plates backside)
Ag 98%, Cu 1%, Zn 1% (beads)
The silver has been tested at various places
H 57.5 cm, W 21.5 cm (middle of web)
1055 g
Early 20th century
Mongolia, Aduchin, Chahar province (Central Inner Mongolia)
Very rare and superb Mongolian headdress with eighteen large red corals mounted in silver on a cloth band; the back is a criss-cross pattern of red corals and turquoise beads; in the middle a silver band encrusted with three pieces of red coral, the silver with six depictions of butterflies; silver fruits (symbols of a long life) hang from the bottom of the web; twelve strings of small silver beads finished with a piece of red coral hang from the sides.

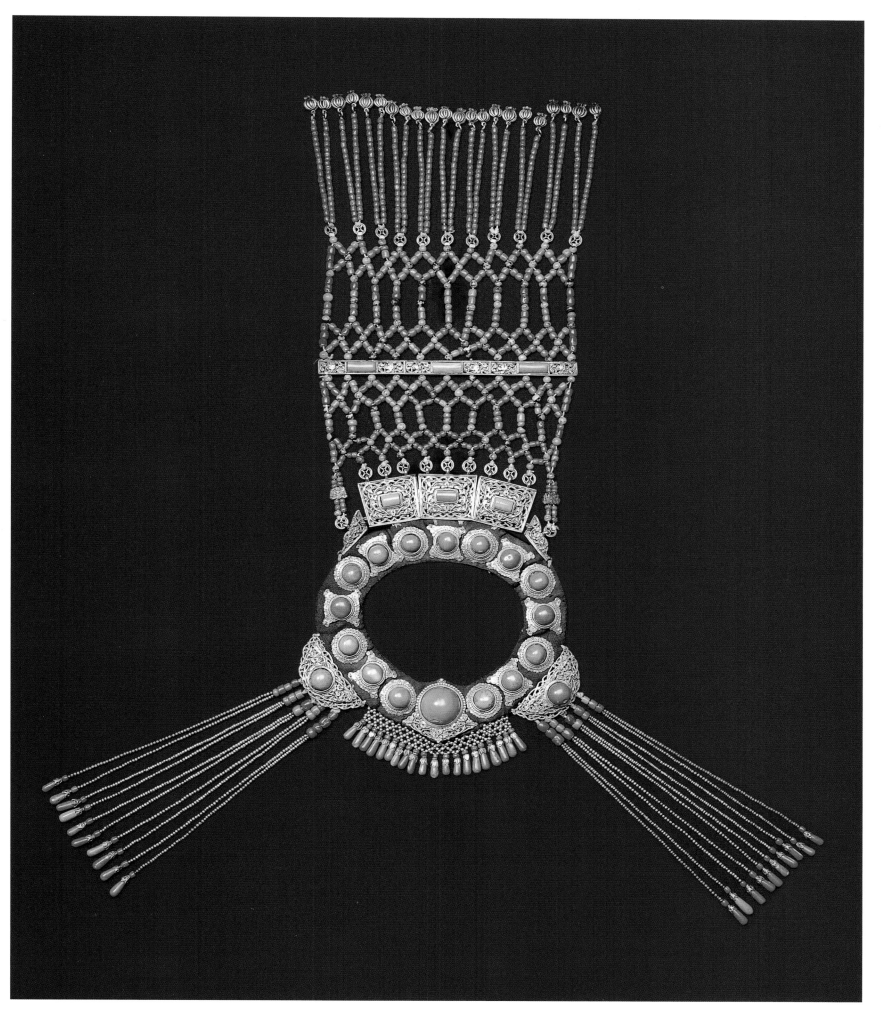

28. *Detail of Headdress*
(see previous pages)
Silver plates encrusted with red corals.

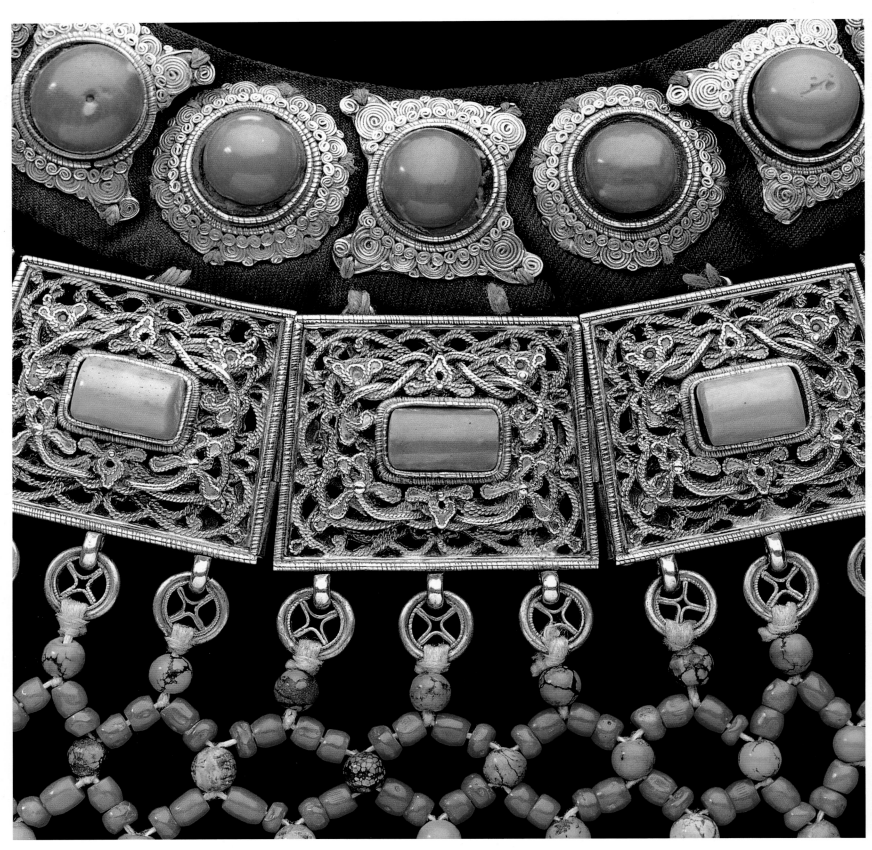

29. *Detail of Headdress*
(see previous pages)
Detail of the web plus silver band with
the depictions of the butterflies.

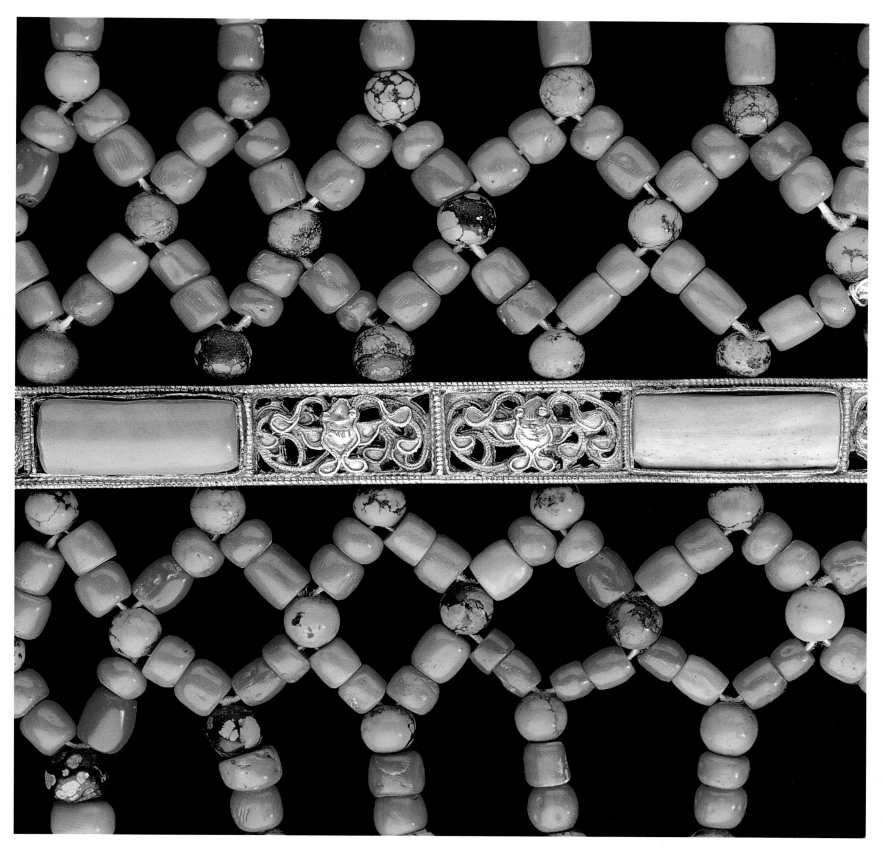

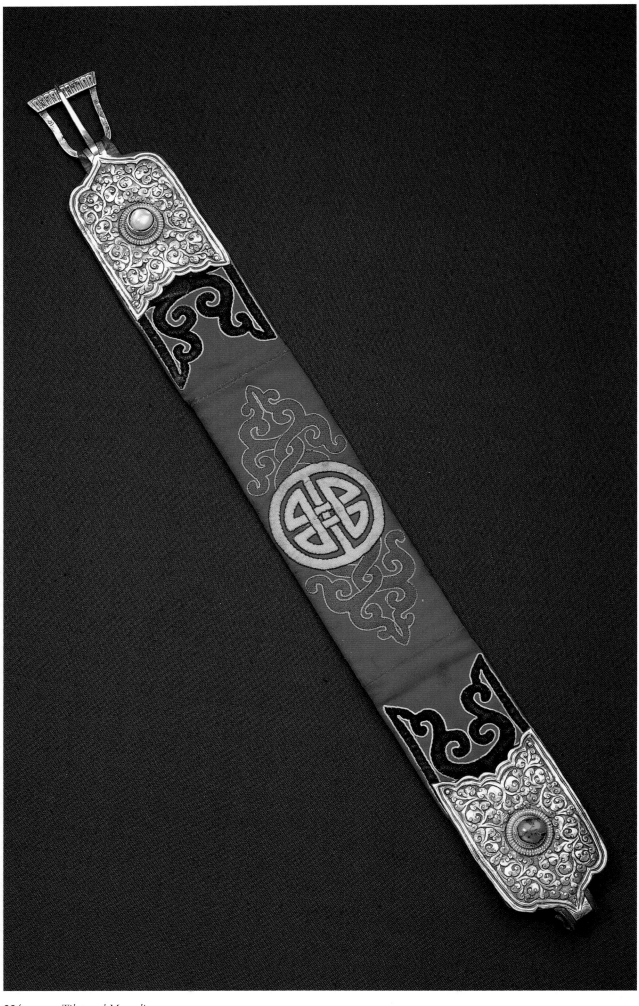

30-31. *Man's belt attached to cloth*
Plate: Ag 97%, Cu 3%; pin: Ag 80%, Cu 20%; setting: gold-coloured brass (Cu and Zn)
L 69 cm (+ leather belt of 55 cm at the back); 359 g
Early 20th century
Mongolia or Tibet
The ends of the girdle have silver plates with pieces of coral and turquoise; the central piece has fine patchwork; at centre, the Shou ideogram, which represents a wish for a long life.
Opposite page: detail with floral motifs on the silver ends.

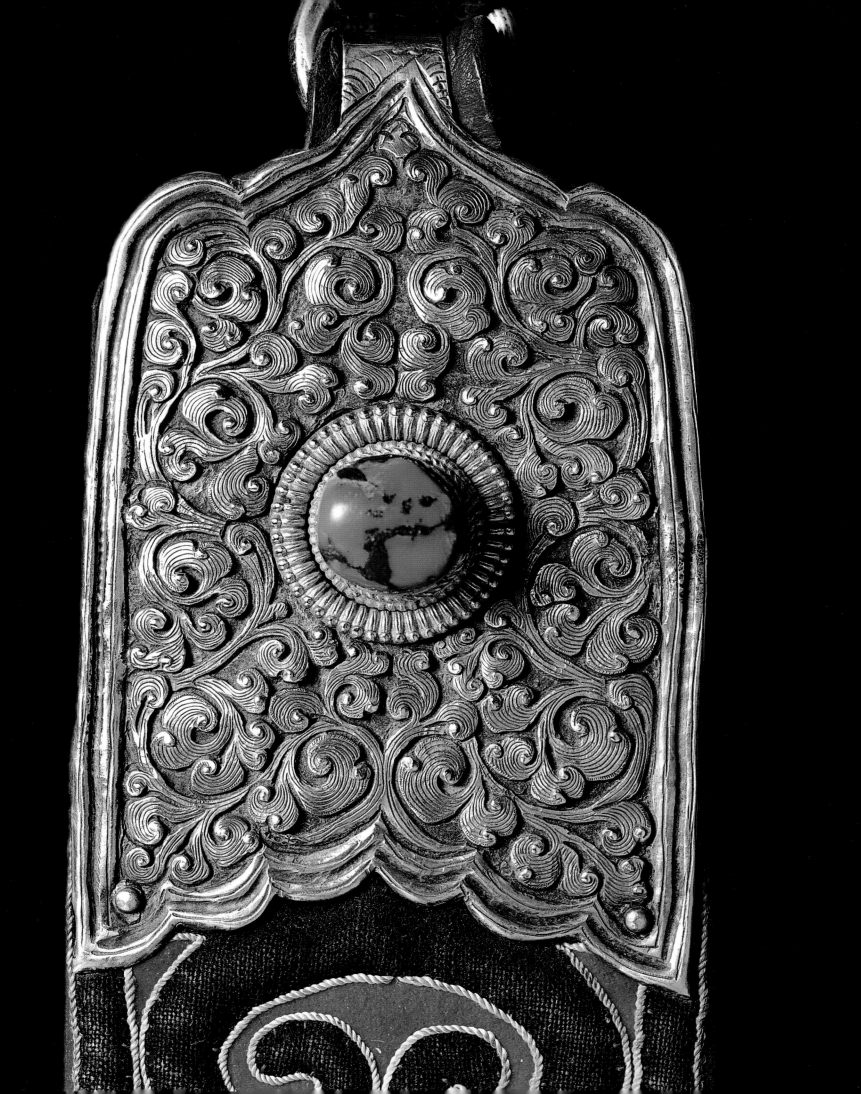

32. *Man's tobacco pipe*
Ag 88%, Cu 12%, horn, red coral
L 58 cm; 1140 g
19th century
Mongolia
Pipe with engravings.

33. *Cutlery set with tinderbox*
Wood, elephant ivory, leather, silver, steel
L 33 cm; 648 g (cutlery set,
tinderbox and chains)
19th century; Mongolia
Cutlery set:
Blade: Fe 84%, Mn 11%, Co 4%
Silver (tested at various places):
Ag 84%–95% Cu 16%–5%

Tinderbox:
Leather, silver, steel
Chains: Ag 97%, Cu 3%
Silver on leather: Ag 83%, Cu 17%
Steel: Fe 83%, Mn 13%, Co 4%
H 6.5 cm, W 9 cm; L with chains 63 cm
At centre, the depiction of a bat.

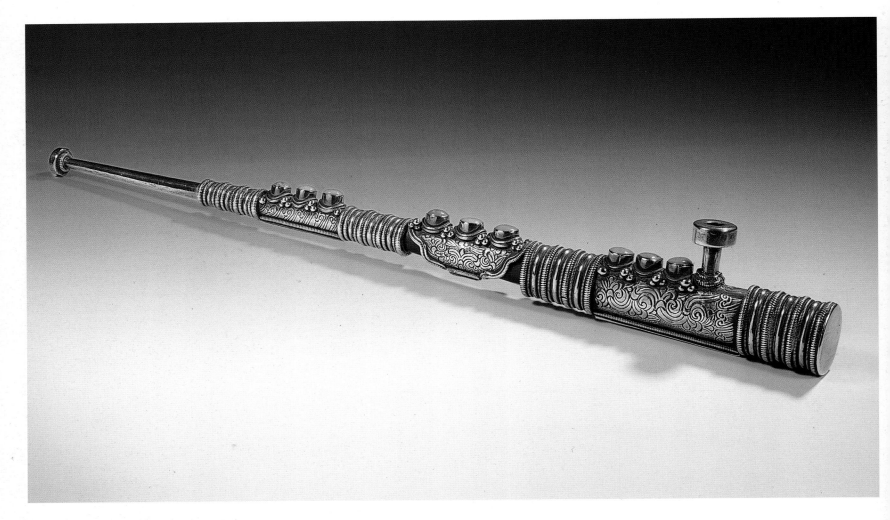

34. *Tinderbox*
Leather, iron
(Fe 85%, Mn 12%, Co 3%)
L 12.5 cm, H 9 cm; 222 g
Late 19th/early 20th century
Mongolia

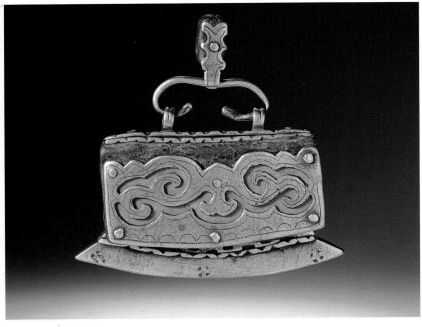

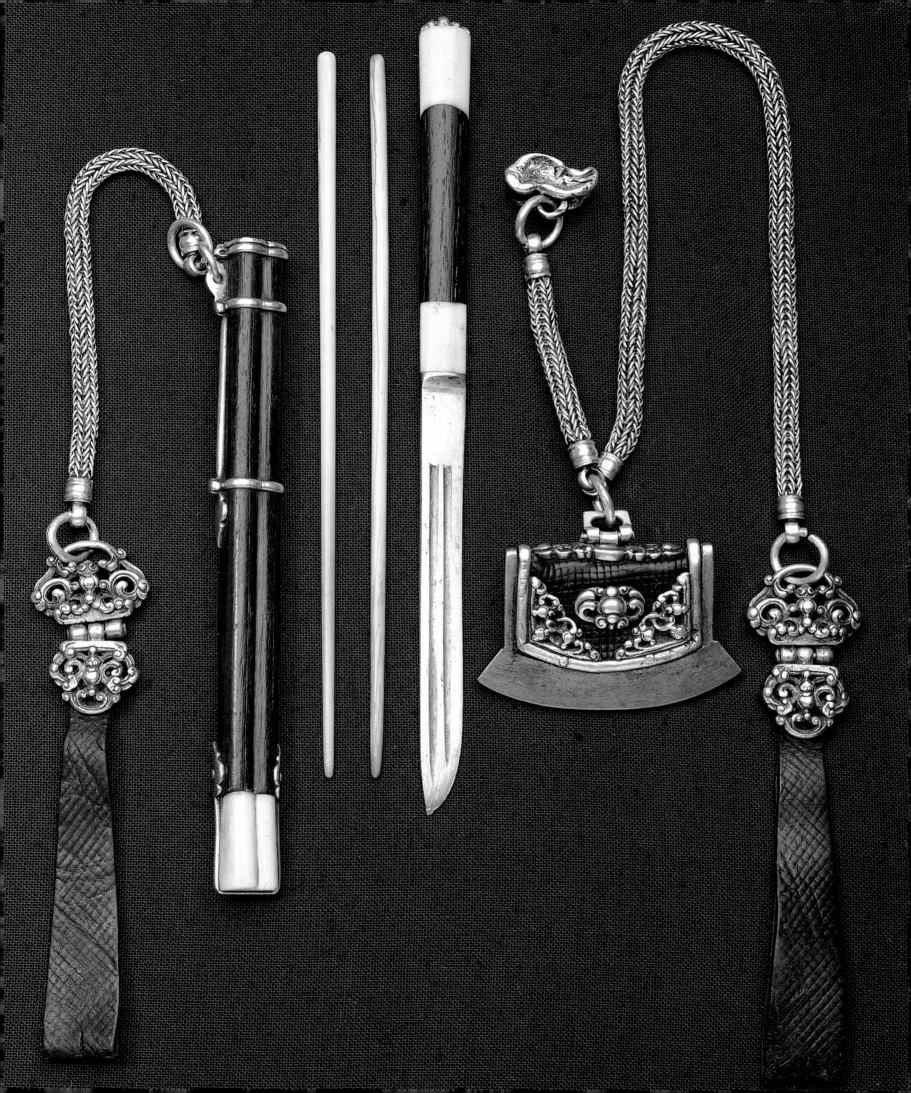

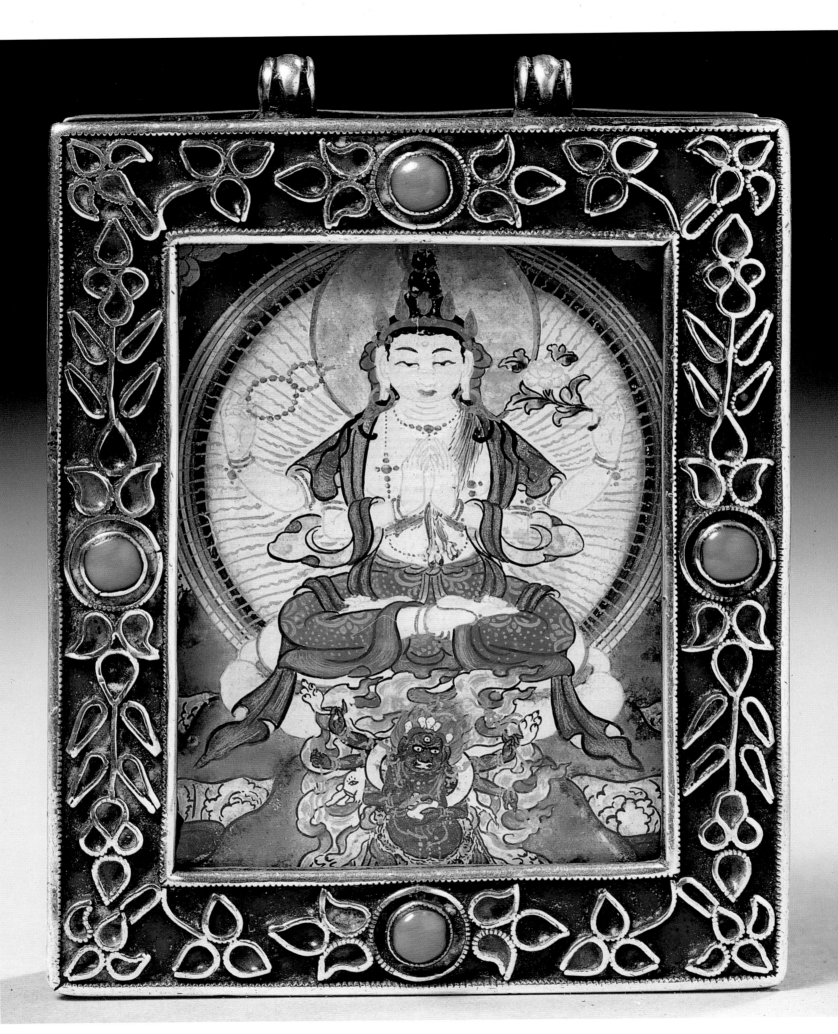

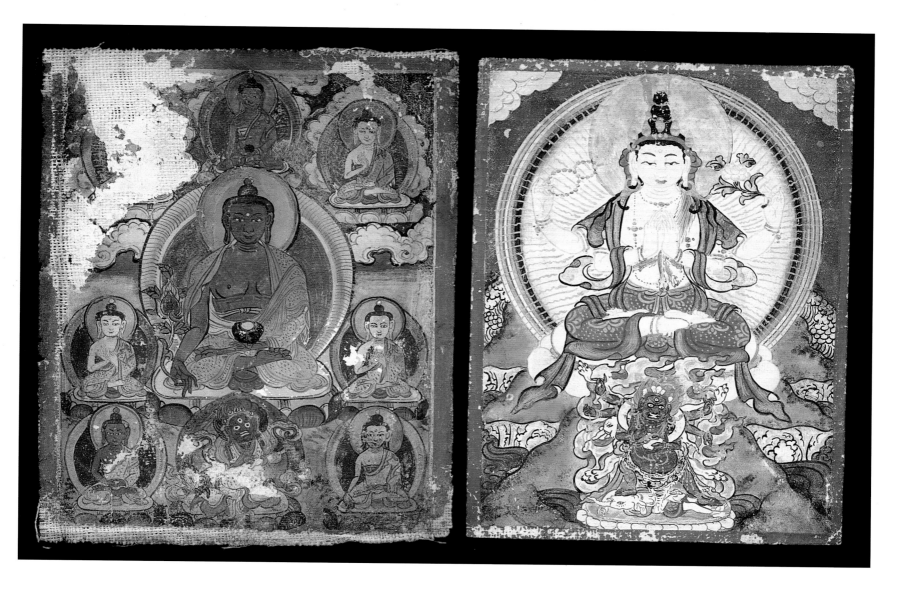

35-36. *Amulet container (*gau*) with two paintings*
Ag 96%, Co 4% (front), enamel, red coral
H 9.5 cm, W 7.2 cm, thickness 1.5 cm
168 g
19th century
Mongolia
The front is made of enamelled silver, the rest of copper; mantras (sacred words) inside the amulet container.
Painting 1 (right)
Shadakshari Lokeshvara, the four-armed manifestation of Avalokiteshvara, Lord of Mercy; below Sadbhujamahakala, the six-armed manifestation of Mahakala, one of the protective deities of Buddhism.
Painting 2 (left)
In the middle Bhaisajyaguru, the Buddha of healing and medicine, surrounded by seven Buddhas of the past; Mahakala depicted bottom centre.

37. *Amulet*
Ag 97%, Co 3%, red coral, teeth
L 5.5 cm, W 3.7 cm; 36 g
Early 20th century
Mongolia
Upper jaw of a small predator mounted in engraved silver.

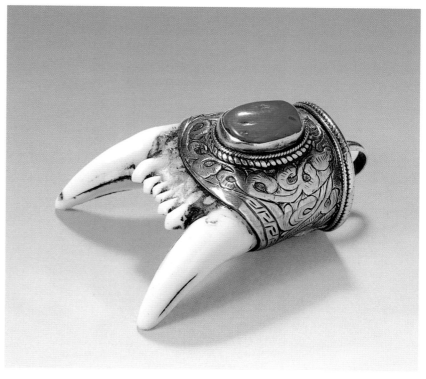

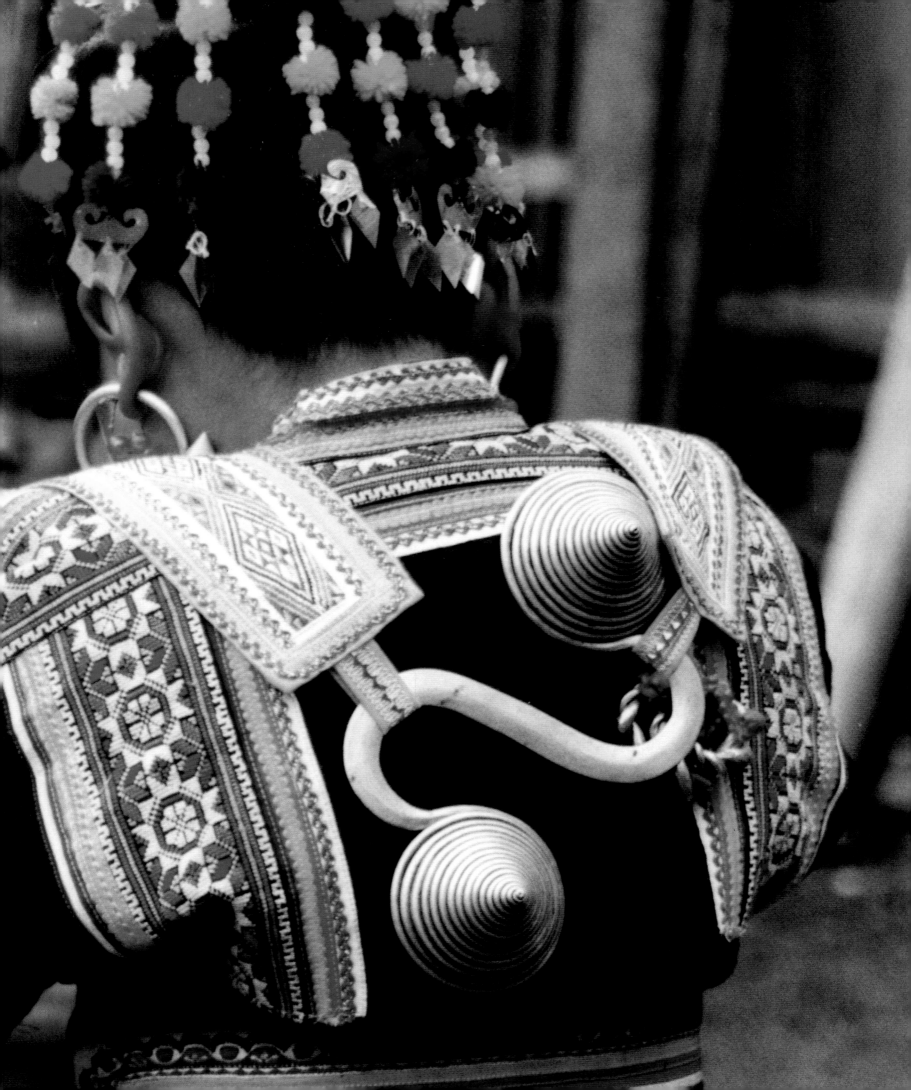

John Beringen

A Short History of Silver and Gold in Asia

In nature precious metals can often be found in their native form. They can exist as small lumps, called nuggets, or as veins or dust. Silver can also be found in the form of a number of chemical compounds, mostly sulphides, like argentite or proustite. From prehistoric times on, Man has used materials he finds in nature to make tools but also for decorative purposes. One of the most abundant metals to be found in nature as a nugget or in veins is copper. Very early on in history Man discovered that these copper and precious-metal nuggets could be hammered into different shapes and so the occupation of "smith" was born. The smith was somebody who enjoyed a contradictory social status: on the one hand, he always looked dirty and was therefore looked down on, but on the other, he had the seemingly divine power to create beautiful objects out of shapeless metal ores. In the beginning these nuggets were shaped directly out of the form they were found in, but soon Man developed the techniques to melt the nuggets down and cast the metal into the desired shape. In Iraq archaeologists discovered a copper pendant dating from 9500 BC and this illustrates how early in history these metals were used. Later, the first alloys were created. The use of an alloy is primarily to enhance the physical properties of a metal but also to alter its basic colour. Copper can be alloyed with tin and zinc to make it harder and to develop a yellow colour, and silver can be alloyed with copper to make it harder and to improve its casting characteristics. The copper, tin and zinc alloy is called "bronze" and was of crucial importance to Man's development. It is believed that bronze was discovered by accident. In the beginning bronze was actually an alloy of copper and the highly toxic material arsenic. At that time it was not possible to

produce pure arsenic but the alloy could be obtained by heating finely ground copper ores and arsenic ores together. About 3000 BC it was discovered that a better bronze could be obtained by alloying copper with tin and that this version was far less dangerous. It is thought that the use of metals first started about 12,000 years ago in the area around the Persian Gulf and that they arrived in China some 7,000 years later. The Chinese, more than any other ancient culture, were successful at producing bronze of extremely high quality. Famous are the big bronze vessels made during the Shang dynasty around 1600 to 1100 BC.

Not many objects made of precious metal made during this time have been found because China is not very rich in silver or goldmines. So where did the Chinese get their silver and gold from?

The trade between East and West was one of the oldest and most important routes known to Man. The route that joined the East and West was known as the Silk Route. Silk and other products were exported from China into Arabia and Europe and these were paid for with precious metals and gemstones. The Silk Route was not a single trading route but a series of interconnecting ones. Some examples are the Lapis Route, whereby lapis lazuli was traded from Badakhshan to the Middle East and India, and the Jade Route which took jade from China to Turkistan.

In addition to these land routes, sea routes took precious metals to Asia. One of the most important nations operating in this field, especially in the seventeenth and eighteenth centuries, was The Netherlands. The best-known Dutch trading company active in Asia was called VOC (Verenigde Oost-Indische Compagnie, or Dutch East India Company). It used anything it could lay its hands

Young Miao girl with back ornament, Guizui village.

231

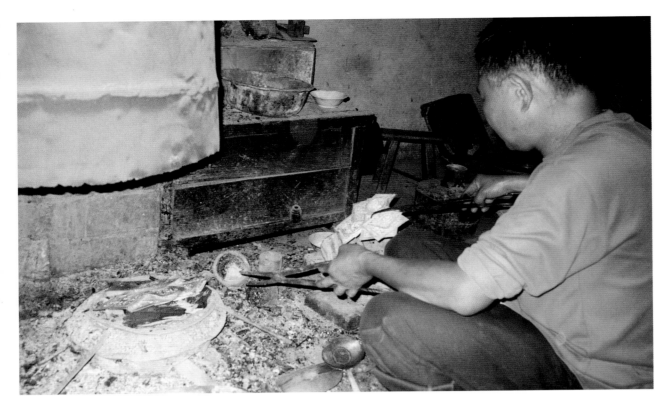

on for payment but primarily gold and silver bullion and coins. In those days Europe imported more from Asia than it exported back as the interest of Asian peoples in European products was not nearly as great as the reverse, consequently, the availability of precious metal was essential due to the lack of other trading goods. Europe on the other hand had a bountiful supply of precious metals imported from the New World by the Spanish. In the sixteenth and seventeenth centuries, the Dutch and English were at war with Spain and used a system of privateers (more or less pirate ships sanctioned by the state) to capture Spanish ships and take their gold and silver to be used in trading with Asia. To commemorate one of these brave Dutch privateers, the Dutch still sing a song about Piet Hein and his silver fleet.

As a consequence of this trade, the ships leaving the Netherlands had to take many boxes filled with gold and silver coins and bullion on their voyages to Asia. The total value of this cargo is estimated to have been about 6 million guilders per year at a time when the average monthly wage in the Netherlands was about 6 guilders.

The VOC tried to limit the export of precious metals to Asia as much as possible. Asia was not rich in precious metals so it was necessary for Asian kings and emperors to rely on trade to procure them, mainly to be used as coin metal. The Dutch used this to their advantage: an example of how they operated is the trading post they set up in 1613 just outside of Ayutthaya, 85 kilometres from present day Bangkok. They bought sappanwood (*Caesalpinia sappan*) and deerskins from the local king

which they then exported to Japan, a country that provided them with a rich source of silver. The silver was then sold to Thailand and in this way the circle was closed. In the middle of the seventeenth century the Dutch succeeded in receiving about 1.5 million guilders worth of silver from Japan in this way. This was also used to buy textiles in India which were in turn traded for spices from Southeast Asia, but in 1688 the Japanese government decided that the country could use its silver for its own trading purposes. In consequence the VOC was forced to switch over to gold bullion (known as the Kobang). Two other sources of gold the VOC could use were Africa (the Gold Coast, which was also a source of slaves) and Sumatra, where the VOC even operated its own gold mine.

Other countries, such as Spain, were also active in the export of silver to Asia. As mentioned previously, Spain profited directly from its many silver mines in the New World. In 1597 the exportation of silver (originally from Peru and Bolivia) to China reached a record quantity of 345 tonnes. So much bullion was needed to trade with India for textiles that around 1600 the English economy almost collapsed because of the enormous amount of silver taken out of (coin) circulation. It even became necessary to mint coins from lead. The reason for this crisis was that the English had no source of silver in the New World and that its economy was not as well organised as that of the Dutch.

Of all the Asian economies, the Chinese one in particular grew dangerously dependent on the import of European silver. The Chinese economy,

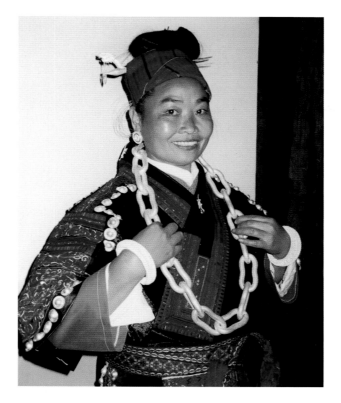

Silversmith's wife in Shidong, with her 5 kg silver necklace – wedding present from her husband on the occasion of their 30th wedding anniversary.

then the biggest in the world, received an enormous boost from the large amount of imported silver. The mines in China produced no more silver than the cargo of just one Spanish galleon leaving from Acapulco for Europe, and around 1640, during the Ming dynasty, even this source of silver started to dry up. This development had a dramatic impact on the economy, bringing a terrible recession that led to the fall of the dynasty.

The Analysis of Gold and Silver Alloys

The alloys of all the precious metal objects in this catalogue were tested for composition at the Dutch Assay Office in Gouda. In this investigation use was made of the following techniques:
- Touchstone testing
- XRF analysis

Touchstone testing of precious metals is one of the oldest analytical techniques known to Man. The Greek Theophrastus (371–288 BC) was the first to describe the process. This method, which is still in use today, is highly suited to giving rapid results about the composition of both gold and silver alloys but it is mainly used for the former. Touchstone testing involves a special kind of natural black stone called lydite. This stone has unique properties; it is very acid-resistant and is specially adhesive to metals. Touch needles – small brass rods with a small piece of very precisely alloyed gold or silver soldered to them – are used to rub a small amount of gold on the stone next to a rubbing made from the object under investigation. Great care must be taken to select a touch needle to approach the alloy of the object. A drop of touch acid is then placed on both rubbings and the reaction observed. From the differences in reaction conclusions about the amount of gold in the alloy can be made. The touch acid is a composition of chloric and nitric acid capable of dissolving gold and its alloys; this mixture of acids is also known as Aqua Regina. Touchstone testing is a good method but it has limitations in accuracy and the types of alloys it can be used on.

XRF (X-ray fluorescence) is, in contrast, a very modern investigative method. This is a "non-destructive" method in the sense that it is not necessary to remove any of the metal from the object. It is therefore ideal for testing museum objects. In this method the object is bombarded with X-rays so that the object starts to emit fluorescence radiation. The energy of this type of radiation is different for each element and its intensity is proportional to the amount of the element present. The energy spectrum emitted is detected by a sensitive instrument and analysed by computer. With this method it is possible to determine the composition of the alloy of which an object is made. For example, silver jewellery is mostly alloyed with copper but it is very possible that the alloy also contains zinc, tin and cadmium. Base metal jewellery can be made of alpaca, pinchbeck or brass, all of which are some form of copper, zinc or nickel alloy.

In the analysis of the Asian jewellery and other objects, the XRF method was used and the composition of each alloy expressed as a percentage of the total. Below are the international abbreviations used to represent the different elements that make up the alloys:

Au = Aurum, gold	Sn = Stannum, tin
Ag = Argentum, silver	Sb = Stibium, antimony
Fe = Ferrum, iron	Cu = Cuprum, copper
Cd = Cadmium	Zn = Zinc
Co = Cobalt	Ni = Nickel

The way the jewellery was made was also considered during analysis of the alloys. Depending on the composition, the metal has different properties. For many applications pure silver or gold is too weak to make a piece of jewellery, in which case they are alloyed with copper to make them stronger, or with zinc to be able to cast them better. By lowering the gold or silver content in the alloy the volume increases and it is therefore possible to make the item of jewellery much cheaper.

In practice we mostly find lower precious-metal alloys used when casting and higher alloys for

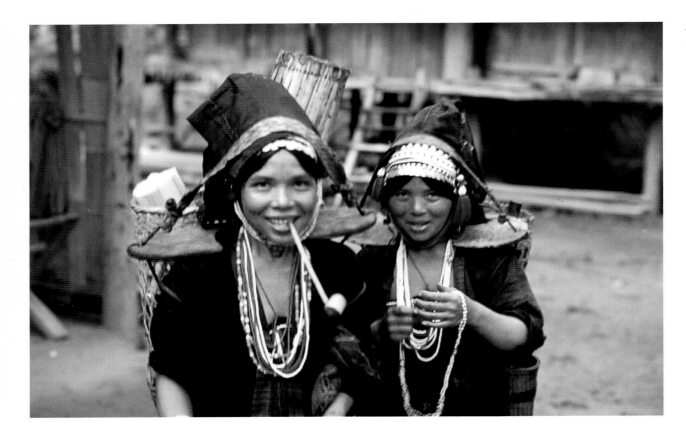

forged work. Higher alloys are used because lower alloys are much harder to work and are more prone to cracking when forged. The other reason for the differences in precious-metal alloys is that they are often bound by cultural traditions. In Europe, for instance, we see that gold in The Netherlands is mostly 14 carat, whereas in Germany and England 8 and 9 carats respectively are more frequently used. These differences are also found in Asia. In China it is a tradition to use very high alloys of gold and silver whilst the minority people from China often use much lower alloys. These traditions have their origin in the availability of precious metals and the economic circumstances of the people. In practice we see that one group of people may get their precious metal directly through mining or trade whereas another group is forced to melt down old jewellery or even old silver coins, though some of them are notoriously low in their content of precious metal. An example of such a coin is the Thai baht which contains only 65% silver. A lot of jewellery originating in the Golden Triangle is very heavy and solid. With this kind of jewellery it is possible to use pure silver without the risk of it being too fragile due to the softness of the metal. This is not only owing to the jewel's volume but also to the special way it is made. Often these objects are forged as a single piece without resorting to the use of solder to join the different parts. A unique property of silver plays a decisive role in this process: when forging silver the alloy becomes quite hard and stiff,

a property that is lost during the heating required to solder it. It is even possible to make the silver so hard that it cracks. If this happens the silversmith has to apply heat to temper the silver to be able to continue forging. The trick is to stop forging the silver at the right moment of hardness so that it is not necessary to heat the object again.

How did these people manage to join the different parts of a piece of silver jewellery without solder? A property of pure silver is that it does not oxidize when heated, so it is therefore possible to heat two parts to become red hot, then to forge them together and produce a virtually seamless connection. This process is not dissimilar to what a blacksmith does. In practice we see objects made with a combination of forging and soldering techniques. When the object is thus formed the surface is burnished rather than polished, and often afterwards decorated by using differently shaped punches to create complex geometric, floral or animal designs. Lastly, the piece of jewellery is enhanced with twisted wire, pieces of chain or links.

In addition to silver the minority peoples in China often make their jewellery using alpaca. This is not a precious metal alloy but is composed of copper, nickel and zinc. This is a silver-like alloy which in Europe is also known as "German silver" or "Nickel silver". In Europe it was used mainly as a cheap substitute for silver in the nineteenth century but as nickel can prompt serious allergic reactions its use is now waning. This alloy has been known in Europe since the early eighteenth cen-

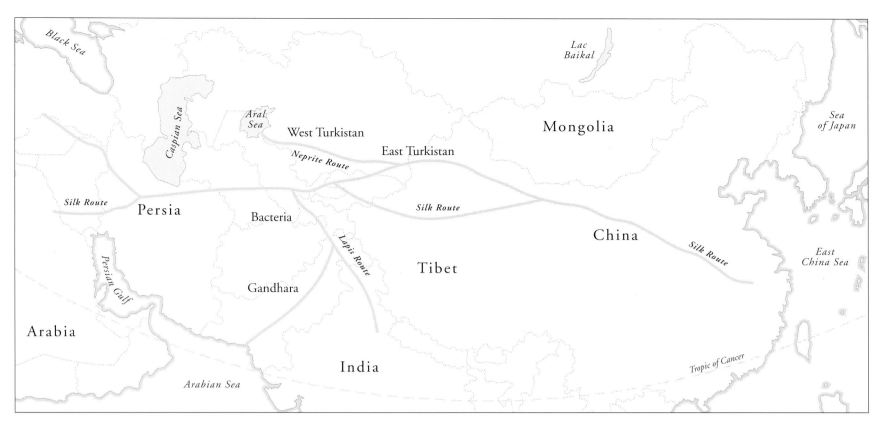

Map of the Silk Route.

tury after European traders brought back metal goods from Asia described using the Indian word *tutnenag* or the Chinese word *paktong*.

China has a long tradition of white base-metal alloys, many of which were invented by the Chinese long ago. A base metal alloy never looks the same as real silver so most of these objects are plated with a thin layer of the real thing. This can be quite deceptive to the untrained buyer and only some form of testing can reveal the difference. In this case, the best course of action to take would be to send the object for analysis or even to be hallmarked at a specialised independent laboratory, like the Dutch Assay Office (Waarborg Holland).

One of the other things that became apparent during the analysis of the Asian jewellery is the colour and darkness of the patina found on the silver objects. On an object made of pure silver, this patina has a characteristic brownish hue. A patina found on a low grade silver alloy is often much darker in colour and has a black or sometimes even greenish hue.

To understand these differences we must look at the chemical properties of silver and copper, the principal elements in most silver alloys. Pure silver does not oxidize but, under normal circumstances, will only form a chemical compound with sulphur. This compound, often composed of the minerals proustite and argentite, appears as a mixture of dark red and black. Copper, on the other hand, forms all kinds of chemical compounds under particular atmospheric conditions; it forms an

oxide called cuprite, which is red, and different copper hydroxides, which are often blue or green. When silver is alloyed with more copper the speed of the formation of patina increases and the type of hue changes, thus providing the trained eye with a clue to the composition of the object. This however can be deceptive if the object has a thick layer of plated pure silver on top and a low silver alloy or even a base metal underneath.

Index